SPECIAL EFFECTS

D0838808

FILM AND CULTURE JOHN BELTON, EDITOR

FILM AND CULTURE

A series of Columbia University Press

Edited by John Belton

SPECIAL EFFECTS
STILL IN SEARCH OF WONDER

MICHELE PIERSON

 COLUMBIA UNIVERSITY PRESS | NEW YORK

COLUMBIA UNIVERSITY PRESS

Publishers Since 1893

New York Chichester, West Sussex

Copyright © 2002 Columbia University Press

All rights reserved

Library of Congress Cataloging-in-Publication Data

Pierson, Michele.
 Special effects : still in search of wonder / Michele Pierson.
 p. cm. — (Film and Culture)
 Includes bibliographical references and index.
 ISBN 0-231-12562-3 (cloth : alk. paper) — ISBN 0-231-12563-1 (pbk. : alk.
paper)
 1. Science fiction films—History and criticism. 2. Science fiction.
 3. Cinematography—Special effects. I. Title. II. Series.

PN1995.9.S26 P54 2002
791.43′615—dc21

 2001055263

Columbia University Press books are printed
on permanent and durable acid-free paper.
Printed in the United States of America
Designed by Lisa Hamm
c 10 9 8 7 6 5 4 3 2 1
p 10 9 8 7 6 5 4 3 2 1

CONTENTS

ACKNOWLEDGMENTS

I have many people to thank for this book. Early versions of parts of some of the chapters that appear here have been published in *Postmodern Culture* 8.3 (May 1998); *Screen* 40.2 (summer 1999); and *Wide Angle* 21.1 (January 1999). I have the editors of these journals—Stuart Moulthrop, Sean Cubitt, and Timothy Murray—to thank for encouraging my early writings. I would also like to thank Martin Barker for so generously responding to the essay that appeared in *Screen*. His criticisms have been invaluable. This book began as a Ph.D. dissertation undertaken in the Department of English with Cultural Studies at the University of Melbourne. I would especially like to thank Simon During, my teacher and supervisor, for all his support of my research and teaching over the years that I spent there. Timothy Murray and Thomas Elsaesser agreed to examine this manuscript in dissertation form, and this book has also benefited greatly from their criticisms and comments. I have met many wonderful people through the University of Melbourne, people who have encouraged and inspired me in many different ways, and I would like to thank Clare McCarthy, Paula Amad, Damien Millar, Ken Gelder, Susan Conley, and Clara Tuite for their friendship and counsel. I feel especially lucky to have traveled this road with Helen Groth, without whom I might never have found myself in the nineteenth century. I would also like to thank my family, Cherill, Arion, Chris, Amanda, and Amy Pierson, Lyn Walker, and Wilhem Den Hollander for dinners, diversion, and much, much more. Most of all, I want to thank Patrick Tarrant for listening to all the versions of this book that never got written. This book is for him.

SPECIAL EFFECTS

INTRODUCTION
SPECIAL EFFECTS AND THE POPULAR MEDIA

You saw it famously in *Forrest Gump*, with the amazingly legless Gary Sinise, or Tom Hanks shaking hands with JFK. You saw it in *Jurassic Park*, the movie that put people on the same ground as dinosaurs, and did so realistically. And in *Titanic*, the movie that brought a dead ship back to life, and sank it all over again.

These movies amazed and enchanted audiences, but they also did something else. They educated audiences, and planted in our minds an unprecedented notion: the idea that with CGI, anything is possible.

This has profoundly transformed the psychology of movie-watching. Armed with the knowledge that anything is possible, conditioned to expect the incredible and to accept the unbelievable, modern movie-goers have become a jaded lot.

Movies, having finally acquired the unlimited power of illusion, have discovered they have lost one of its greatest powers, the power to amaze.

—Garry Thompson, *Philadelphia Daily News* (July 31, 1998)

I n *Movie Magic: The Story of Special Effects in the Cinema* (1974), John Brosnan went behind the scenes of feature filmmaking to interview some of the special makeup artists, model animators, special photographic cinematographers, and optical technicians who have been involved in feature filmmaking since the 1920s.[1] Drawn largely from the anecdotes and testimonies of effects producers themselves, this chatty and informal story of special effects in the cinema looks at how some of the people who have worked in the special effects industry came to be there, at what first attracted them to this aspect of filmmaking, and at how they remember their craft. Their personal biographies also provide glimpses into the industrial organization of the special effects industry during the middle decades of the last century, when the major Hollywood studios formed their own special effects departments and the rationalization of labor, technology, and skills that followed eventually resulted in the development of specialist subdisciplines. While it is Brosnan's own skills as an interviewer and a storyteller that make this book such an engaging and informative read, his narrative has also

been fleshed out with interview material that has been gathered from a mix of industry and fan-oriented publications. George Pal's comments on the difficulties he and Gordon Jennings, an effects specialist at Paramount Studios, had in designing and constructing the mechanical Martians for *War of the Worlds* (dir. Byron Haskins, 1953) have, for instance, been taken from an interview published in the literary science fiction magazine *Astounding Science Fiction* (191–93). Along with snippets of an interview that Eiji Tsuburaya (a special effects supervisor at Japan's Toho Studios during the 1950s) gave for *Famous Monsters of Filmland*, excerpts from an interview with stop-motion animator Jim Danforth that originally appeared in the fantasy filmzine *Photon* also appear here (180–83, 201). Other sources of professional commentary and review, all duly acknowledged and very much of a piece with Brosnan's own commentary, include *American Cinematographer, Popular Science Monthly,* and *Cinefantastique*.

This book grew out of a curiosity about these publications. For while many different types of writing about special effects—academic criticism as well as entertainment journalism and history—regularly reach into the popular archives for firsthand accounts of the business, technology, and craft of special effects production, the significance of these publications for the cultural reception of special effects has received no more than passing comment in even the few scholarly accounts of special effects that have specifically been concerned with theorizing their reception. Often consulted but rarely made the objects of analysis themselves, these magazines have played a role in the social formation of cultures of special effects connoisseurship, appreciation, and fandom that has largely gone unexamined. Brosnan's own brief reference to the popularity of magazines addressed to stop-motion animation fans in the early 1970s is actually more illuminating than most. His account of Ray Harryhausen's career ends with the observation that "when Harryhausen began his career there was no widespread interest in model animation but today the situation has changed. In America, and elsewhere, the profession has something of a cult-following which is large enough to support several specialized magazines" (176). Brosnan goes on to point out that these publications not only lent material support to a vigorous amateur culture but also fed many fans' aspirations of one day becoming professional animators themselves.[2] Over the years, many special effects techniques have come and gone without arousing the intense interest that stop-motion animation inspired. There are, however, identifiable reasons for this. Those special effects technologies and techniques that have sought to bring impossible, never-before-seen images to the screen have most often been the inspiration for fans' desire to participate in the production of special effects (whether in

a professional capacity or in the form of home production). At the same time, it is also important to remember that not all cultures of appreciation have been as strongly organized by amateur and/or protoprofessional discourses. Historically, connoisseurship and amateurism have offered mutually reinforcing modes of responding to special effects without necessarily needing each other to legitimate their very different forms of intellectual and affective engagement.

In the early part of the last decade, the spectacular computer-generated imagery (CGI) being featured in Hollywood genre films also became an object of intense fascination, curiosity, and scrutiny in the popular and mass media.[3] This book is very much a product of, and a reflection on, this moment. It was conceived as a historical and theoretical investigation into the role that cultures of appreciation have played in the cultural reception of the CGI effects featured in Hollywood cinema. Since even this task is too vast to be fully accounted for, however, decisions have had to be made about how best to focus such an investigation. One such decision has been to focus quite closely on teasing out some of the reasons that science fiction has so often been the catalyst for the social formation of these cultures. Because even though the effects-driven, blockbuster Hollywood cinema of today is by no means an exclusively science fiction cinema, the relationship between special effects and science fiction remains historically important. Indeed, even before cinema, special effects already had a special relationship to the kind of speculative fiction that has specifically been concerned with visualizing the future.

This investigation of special effects weaves together two quite distinct methodological and chronological lines of inquiry: the first, historical and contextual; and the second, critical and futurological. On the one hand, it is concerned with identifying, organizing, and interpreting the kind of primary, archival material that might count as evidence of the way that the cultural reception of special effects has been shaped by cultures of connoisseurship, appreciation, and fandom. In this context, the term "cultural reception" refers to culturally available modes of response. Although claims about the way particular audiences respond to special effects also get made here, a study of the cultural reception of special effects obviously cannot claim to be able to describe empirical audiences in the same way some of the traditions of audience research that have been developed within the context of media and cultural studies over the last twenty years can. In their study of audiences' responses to the film *Judge Dredd* (dir. Danny Cannon, 1995), Martin Barker and Kate Brooks identified a wide range of ways of conducting audience research. Among others, their list includes statistical studies of audiences, studies of the audience for a particular type of media product, studies of audi-

ence activities in fan groups and subcultures, studies of the management of audiences by the media, illustrative case studies of individuals, and studies of the history of audience responses.[4]

Along with Constance Penley's early study of the "slash" subculture associated with *Star Trek*, Henry Jenkins's and John Tulloch's research on science fiction audiences contributed to the early conceptualization and formulation of this project by pointing to the need to develop theories of media spectatorship that take into account the way that participants in fan cultures understand this activity themselves.[5] Indicating the scope for further research into the historical relationship between popular science and science fiction, Penley's more recent arguments for seeing popular science and science fiction as part and parcel of the same technoscientific imaginary that has kept popular support for NASA alive in the face of serious crisis—and *Star Trek* on television for more than three decades—have also been influential.[6] This book's investigation of the cultural reception of special effects nevertheless lacks the ethnographic component of these film and cultural critics' work, having opted instead for the longer historical reach that is afforded less localized forms of audience research. It begins, in fact, by looking at some of the contexts that were important for the cultivation of a technical and aesthetic appreciation of special effects in England and the United States during the latter part of the nineteenth century, arguing that the discursive networks that support more contemporary cultures of appreciation actually took on their distinctive contours over this period. While none of the methods identified in Barker and Brooks's list quite describes this project's mixed methodology, their description of research that attempts to study the discursive contexts that "help to set the terms of public response" to a particular type of media comes closest.[7] However, rather than trying to work with a general and homogenizing concept like the "public" or the "mass consumer," this investigation begins by looking at some of the discursive contexts that have been important for cultivating particular ways of looking at and responding to special effects—popular science, computer lifestyle cultures, genre film fandom—before moving on to trying to identify some of the institutions (corporate, media, educational) that have contributed to the wider dissemination and popularization of technical, aesthetic, and how-to discourses on special effects.

This book's historical argument is that we can't know what is new, or different, or special about currently available ways of responding to CGI effects if we don't know anything about the forms that popular information, speculation, and review of special effects took in the past. The first chapter thus proposes one way of thinking about the history of contemporary cultures of

special effects connoisseurship. In tracing this genealogy I have been guided by Robert D. Hume's suggestion that a historical critical practice "attempts to reconstruct specific contexts that permit the present-day interpreter to make sense of the cultural artifacts of the past and the conditions in which they were produced," while also remaining mindful of his admonishment that "carelessly constructed or cavalierly applied, contexts are worse than useless."[8] Whether the contexts suggested in this and later chapters are both specific enough and sufficiently well grounded in their respective archives to meet Hume's exacting requirements for a "properly" historical criticism, this attention to identifying and examining the discursive contexts that have been important for the cultivation of cultures of effects appreciation marks a serious attempt to view the cultural reception of special effects in historical terms. This means taking seriously Hume's own suggestion that "*all conclusions must be regarded as provisional*" (70). The point of comparing some of the ways that special effects have been written about and reviewed in the late nineteenth century with some of the ways that popular discourse about special effects circulates in the late twentieth and early twenty-first centuries is to illuminate differences as well as similarities between them. The publications, forms of entertainment, and consumer technologies chosen for comparison in this study provide the touchstones for a provisional mapping of the historical conditions of their reception. Rather than an "archaeological" analysis of these conditions, the historical-contextual focus of this investigation into the cultural reception of special effects is therefore best described as "cartographic." It is concerned with mapping, tracing, and delimiting the grounds for comparing a neglected aspect of the contemporary cultural reception of CGI effects with the way that special effects have been viewed and reviewed at other times and in other contexts.

No investigation of the cultural reception of a particular collection of artifacts can claim to be exhaustive. The historical and contextual axis of this investigation puts very specific limits on what can be claimed for this study. The popular print media that has been used as the basis for an examination of the cultural reception of a range of effects-oriented forms of entertainment is Anglo-American. Produced mainly, although not exclusively, in the United States, the avenues for its distribution in places such as Australia, Britain, Canada, and New Zealand are specialist bookstores, public libraries, individual subscription, and increasingly the Internet. The archival work of building the kind of contexts that would enable studies of the cultural reception of special effects in other parts of the world to be carried out still remains to be done. George Lucas remarked in 1977 that *Star Wars* (dir. George Lucas, 1977) had been "designed with the international market in mind. The French are

very much into this genre. They understand it more than the Americans do, and it is the same with the Japanese."[9] Special effects have more often been the subject of reflective commentary and review in French film magazines such as *Postif* and *Cahiers du Cinéma* than they have in American magazines addressed to similar readerships.[10] Identifying the similarities and/ or differences between the way special effects get analyzed and reviewed in these kinds of publications and the way they get analyzed and reviewed in the many French e-zines devoted to the study of science fiction film, television, and special effects would make for interesting comparative analysis.[11]

While this book argues that elements of the cultures of appreciation that will be examined in the next three chapters have entered into popular culture, becoming part of the way that many different groups of viewers think about and respond to effects imagery, these cultures have traditionally and predominantly been represented by young middle-class men and adolescent boys. The extent to which this situation is changing, particularly as women's professional participation in the special effects industry has increased, is difficult to track and cannot be speculated about with any certainty. What is clearer is that cultivating a detailed knowledge and appreciation of genre film and special effects can be both time-consuming and expensive, making it an activity that is more readily available to individuals with the disposable income to invest in the various magazines, books, videos, and Internet materials that support it. When the fantasy filmzine *Photon* conducted a survey of its readership in 1977, it not only asked readers to list the fan-related magazines they read regularly but also to estimate the amount of money they spend on their hobby. The magazine's editor, Mark Frank, noted "with a sympathetic nod to those who wrote that they spent 'to[o] much' yearly on the hobby and to those who marked the item with a question mark, [that] our data turned up a range of amounts for $0 to $1,300!"[12]

It is significant that in the 1990s computer-generated imaging technologies entered many people's homes. And significant too that along with the domestication of this technology, print and electronic publications, television programs, special edition videos and DVDs, and exhibitions at science and technology museums—all aimed at instructing, entertaining, and informing home-computer users about how special effects are produced for feature films and television series—proliferated. Even so, not all film viewers have the same access to, or interest in, these forms of information and review, and the work begun by Barker and Brooks—of investigating how younger working class viewers with less money to spend on entertainment also think and talk about special effects—again points to the desirability of further research in this area. As far as the following investigation is concerned, what

is interesting about Barker and Brooks's study of how a number of focus groups drawn from England's Bristol area responded to the film *Judge Dredd* is just how often the young people they spoke to described their interest in special effects in terms of wondering, of being curious about how these effects were achieved.[13]

In order to account for just some of the ways that special effects acquire significance for a culture—becoming objects of scientific curiosity, aesthetic appreciation, or even vocational inspiration—something more than an examination of the way they are described in the popular media is still called for. Gary Thompson made an important observation when he suggested—in the syndicated newspaper review quoted in the epigraph at the start of this introduction—that movies themselves have been a site of audiences' education about CGI. And it is another of this book's central arguments that we cannot expect to say anything about the cultural reception of CGI without speculating about how the industrial, institutional, and formal organization of Hollywood science fiction cinema also organizes viewers' responses to these effects. The critical and futurological axis of this study is therefore concerned in part with looking at how film and cultural studies scholarship on special effects has dealt with this task and, in particular, with the way that it has, or more likely hasn't, dealt with the task of theorizing their reception.

As film scholars begin to approach the study of special effects from new directions, we can expect to see more varied, diverse, and provocative histories of special effects in the coming years. The reasons there has been so little scholarly writing on special effects up until this point, and why attempts to theorize reception figure so infrequently in what little writing we have from the past, have to do with the intellectual traditions that have shaped contemporary thinking about film spectatorship, on the one hand, and analysis of the culture industries, on the other. Leger Grindon could not have been any more explicit about the need to rethink the way the relationship between film spectatorship and spectacle is theorized than when he argued in his "The Role of Spectacle and Excess in the Critique of Illusion" that "the usefulness of the critique of illusion as a paradigm for thinking about the cinema is coming to a close. As critical concepts the broad range and ambiguous nature of spectacle and excess ha[ve] hindered precision in thinking about the cinema and in especially studying the film image."[14] Grindon points out that the term "spectacle" has most often been used within contemporary theoretical discourse on the cinema to indicate a spectatorial economy in which spectators experience visual display and illusion as something so overwhelming that they are completely at a loss to make critical or evaluative judgments. The term "excess," on the other hand, has often been used within film studies to

indicate a spectatorial economy in which spectators recognize visual display and illusion as a form of direct address. Grindon's most important insight is that both these terms tend to function as the end point of analysis in contemporary writing on the role of spectacle in the cinema. Whether film theorists have assumed that spectacle elicits an emotionally regressive, primarily sensory response from spectators or whether they have assumed that spectacle draws attention to itself as a self-conscious mode of visual display that is recognized in these terms by spectators themselves, this work has rarely looked in any detail at the social, cultural, and institutional conditions that make particularized modes of spectatorship possible.

Every bit as influential for the course that theoretical writing on the role of spectacle in the cinema has taken over the last twenty years has been the legacy of Theodor Adorno and Max Horkheimer's writings on mass culture and the culture industries.[15] Adorno was to note on more than one occasion that Hollywood has always traded on its feats of technological ingenuity and visual display to entertain cinema audiences. But in the audience's "oh of astonishment" at being presented with new cinematic "tricks," he heard only the tremor that "lives off the excess power which technology as a whole, along with the capital that stands behind it, exercises over every individual thing."[16] Adorno argued that Hollywood represents a particularly powerful ideological apparatus because the pleasure audiences experience through the consumption of cinematic spectacle reinforces their appreciation of the role that technology plays in the "progress" of all industry (not just the film industry).[17] The role that cultures of appreciation and connoisseurship play in this process also drew his criticism. In the buff's cultivation of technical knowledge about the production process, Adorno identified a desire "to break away from the passive status of compulsory consumers"—to experience culture as if from the inside.[18] But he also saw in this desire the work of ideology, which simply functions to reproduce more appreciative consumers without bringing them any closer to having "even the slightest influence" on the production process (47). Signs of just how influential the critique of mass culture has been for some of the cultural critics who have written about special effects in years gone by can be found in Fredric Jameson's speculation that special effects may be "a kind of crude and emblematic caricature of the deeper logic of all contemporary image production," in which it is the "expense" rather than "significance" of the image that is valued; and in Herbert Schiller's critique of the special effects industry's role in expanding the market for a wide range of consumer electronics products that bring special effects into people's homes.[19]

The writings of these and other cultural theorists have highlighted the acquisitive, consumerist dimensions of popular interest in special effects and

the special effects industry. That contemporary cultures of appreciation and connoisseurship are consumer cultures—and that this shapes the forms that their interest in the technologies and techniques of cinematic illusion takes— is not in dispute here. It is only the assumption that their social and cultural significance has been exhausted by this observation that is being called into question. What the critique of mass culture misses is the utopian dimensions of these cultures. For if these can indeed be politically conservative or naive- ly technophilic, they can also be critical, progressive, and demanding. With- in all of them, special effects figure as sites of possibility, holding out the promise of a certain type of aesthetic experience. The critical and futurologi- cal axis of this investigation is thus concerned above all with mapping this experience. This entails looking at not only the history of scholarly writing on illusionism but also popular writing on special effects and science fiction for a language to describe it. It entails moving from a critical engagement with film and cultural studies scholarship on special effects and the intellectual tra- ditions that have helped to shape them to testing new lines of theoretical inquiry by suggesting other readings, other ways of understanding, special effects and the science fiction films that feature them.

In moving from an analysis of popular scientific demonstration in the late nineteenth century to an analysis of Hollywood science fiction cinema in the late twentieth century, this book draws attention to a number of popular cul- tural forms and practices that have shaped the cultural reception of special effects in socially significant ways but have so far fallen outside the scope of most of the stories that have been told about special effects and the cinema. With each chapter, the balance between analysis of the discursive contexts in which special effects get analyzed and reviewed and critical reflection on the films and other forms of popular entertainment that feature them shifts slightly. These two modes of analysis are offered not as mirror images of each other but as the terms of dialogue for a film and cultural criticism that seeks to grasp the implicitly social and cultural dimensions of aesthetic experience. It is not until the third chapter that a close analysis of the way that CGI effects have featured in the Hollywood science fiction cinema of the last decade is offered. The emphasis given, in these later chapters, to describing the cine- matic experience of special effects contains an argument about the role of cin- ema in an age of new media. For if special effects don't belong to the cinema any more than they belong to science fiction, they have long had a special place in it.

It is clear that new media technologies are transforming the way that Hol- lywood films are produced, distributed, and exhibited. What impact these technologies are having on how the visual effects imagery in these films

looks—and on the way that viewers think about and respond to this imagery—is difficult to discern without the luxury of hindsight. Strong claims are nevertheless made in the last chapter for the importance of speculating about the relationship between technological and aesthetic change before it becomes history. The computer-generated imagery in Hollywood films hasn't always looked the same. The aesthetic choices that are made with respect to a film's visual effects imagery tell us something not only about the conditions of its production but also about the conditions under which viewers are asked to formulate any sort of aesthetic response.

1

MAGIC, SCIENCE, ART
BEFORE CINEMA

Special effects have always been a magical form. Belonging to no single media, they flicker most brightly in the moment at which all media appears most modern. Before the emergence of cinema at the end of the nineteenth century, many different forms of public amusement enchanted audiences with their wonder-working special effects. Throughout the early part of the century, lavish displays of industrial light and magic were mounted in the form of phantasmagoria and magic shows, pantomime, exhibitions of new technologies, and science lectures and demonstrations. Visitors to these popular amusements were drawn by the expectation of having all manner of curious, mercurial, and startling images materialized before their eyes. Both the wonder-workers responsible for the creation and exhibition of this imagery and the popular media that circulated advertising and reviews of it invited audiences to view it as magic. At the beginning of the twenty-first century, computer-generated visual effects are not only a major attraction of Hollywood blockbuster cinema but one that, despite being produced within an industrial context that is more highly rationalized than ever

before, continues to be presented to contemporary audiences as magic. The artists, designers, and engineers working in this area of special effects production are revered as wizards and illusionists in the many different forms of media that now report on the current state of the art. Major exhibitions at metropolitan science and technology museums and Hollywood studio tours alike invite patrons to step behind the scenes of moviemaking and learn the secrets of special effects. Within the swirling eddy of hype and infotainment that is popular culture in an age of global media conglomerates, popular discourse on special effects still circulates in and through the language and iconography of magic. None of this has been lost on contemporary commentators, who have tended to assume that whatever magic special effects might have for contemporary audiences is only a dull form of commercial hocus-pocus. Where once magic might have appealed to audiences' curiosity about the invisible forces guiding the hands of ingenious industry, the attraction of Hollywood special effects is assumed to lie elsewhere: in childish enchantment, in base stupefaction, in adolescent technophilia.

I have already suggested that speculation about the popular reception of special effects in Hollywood cinema—and especially science fiction cinema—might be better approached by looking at some of the contexts that have been important for the cultivation of contemporary forms of effects connoisseurship. In this chapter I want to suggest that the discursive networks that support these modes of reception actually took on their contemporary contours in the late nineteenth century. Central to this argument is the claim that in the United States popular science periodicals played a key role in the cultural reproduction of special effects connoisseurship after 1870, when the staging ground for special effects production moved from the science lecture and the magic stage to more drama- or narrative-oriented forms of spectacle. While programs of popular scientific entertainment declined in popularity over the next decade, other forms of spectacular entertainment did not. One consequence of this was that it was left to popular science periodicals to provide a context for speculation about these other, less overtly scientific sites of effects production. Of all the periodicals in circulation during this period *Scientific American* stands out as a particularly important site of such instruction. It paved the way not only for the slew of other popular science magazines that have come and gone since it began publication in 1845 but also, and in a much more formative sense, for the science fiction fan magazines that began offering detailed analyses of cinematic special effects in the 1970s and the computer lifestyle magazines that sprang up to cover digital effects production in the early 1990s.

In keeping with its broadly cartographic concerns with mapping, tracing, and delimiting the historical and discursive coordinates of contemporary forms of special effects connoisseurship, this chapter begins by speculating about the traditions of popular scientific demonstration that shaped audiences' emotional and intellectual engagement with the optical illusions and special effects featured in two popular series of lectures in the 1860s: the first delivered by John Henry Pepper at London's Royal Polytechnic Institution in 1862/63 and the second delivered by Henry Morton at Philadelphia's Franklin Institute in 1867/68.[1] The stage directions and descriptions of apparatus left behind by Pepper and Morton reveal that while all special effects were presented to audiences as startling feats of science and technology, the class of effects most often credited with exciting the imagination and stimulating the intellect were those that took the form of novel, if not always "never-before-seen," imagery. Neither Pepper nor Morton was a scientific demonstrator in the same way that someone like Michael Faraday—lecturing at London's Royal Institution in the 1830s and 1840s—had been. In his wide-ranging study of the "place," "performance," and "process" of Victorian scientific experiment, Iwan Rhys Morus has argued that two distinct and to some extent antagonistic trends of scientific experimentation began to emerge in England in the 1830s. On the one hand, "elite, largely middle-class gentlemen centered at institutions such as the Royal Society or the Royal Institution fostered an image of science as the province of highly trained, vocationally minded specialists," and, on the other, "another set of experimenters—popular lecturers, instrument-makers, or mechanics—fostered a different image and a different practice."[2] Rather than being oriented toward the pursuit of basic research, the practices of this second lot of experimenters centered on the display of spectacular phenomena and the instruments used to produce it.

In the early 1860s Pepper's closest contemporaries were not eminent associates of the Royal Institution but other educators, entertainers, and writers like himself. While he would on occasion claim that innovations in the art and craft of stage illusion tended to trickle down from the scientific to the conjuring professions, he was at other times happy to allow that the techniques of optical illusion and visual display made popular by magicians and popular science lecturers alike tended in fact to trickle across and between these overlapping spheres of entertainment.[3] So frequently did they borrow from each other that the origins of a particular illusion or effect often became obscured by subsequent adaptations in remarkably short time. In *Lives of the Conjurors* (1876), Thomas Frost attributed the design of Pepper's famous ghost illusion to the magician Alfred Sylvester, who was, according to Pepper,

only responsible for one of several improvements made to his and Henry Dircks's patented design.[4] *Lives of the Conjurors* nevertheless provides an important point of reference for this chapter, for in plotting the history of magic in terms of the contributions that both magicians and popular science demonstrators made to the popularization and democratization of the idea of "rational entertainment," the genealogy for popular science that emerges from this book locates the nineteenth-century popular science lecture within a tradition of public performance stretching back to turn-of-the-century phantasmagoria shows and, going back still further, to the courtly practice of natural magic. More recently, Thomas Hankins and Robert Silverman have argued that natural magic has never really disappeared but has instead been "subsumed under new categories such as entertainment, technology, and natural science"—to which the category of science fiction might be added.[5] Many of the key architectural features and instruments used in Pepper's and Morton's lectures—a darkened theater, a mirror, a spirit lamp with a salted wick, a magic lantern—were used in the practice of natural magic. Nineteenth-century popular science not only inherited its instruments from natural magic but also a tradition of public performance that subordinated the visual articulation of instruction and amusement to the intensification of aesthetic effect. Therein lay the secret to turning science into entertainment.

Just as nineteenth-century science was split in England between a scientific elite pursuing an increasingly abstract form of basic research and popular educators like John Henry Pepper, the American scientific establishment firmly distinguished between different types of scientific activity. Historians concerned with examining the professionalization and institutionalization of American science between 1830 and 1870 have laid particular emphasis on the role that the professoriat played in this process. Revising an earlier tendency to place this group of science professionals in the same category as scientists engaged in more or less full-time research, Nathan Reingold has argued that the professoriat was largely and necessarily "concerned with teaching, administration, applied developments, and other essential, grubby tasks." Compared with the full-time researchers "who were their friends and teachers," these educators and administrators made far fewer contributions to basic research.[6] Reingold's claim that the expansion of this class of science professionals was brought about by increased opportunities for social participation in the sciences—as much as by increasing specialization—draws attention to the professoriat's interest in maintaining demand for scientific education. Significantly, representations of science in newspapers, magazines, and courses of public lectures did not make distinctions between researchers and educators, and publicly at least the professoriat enjoyed all the authority and prestige

that on a professional level tended to be more generously bestowed on the research scientist. Up until the early 1870s many of the country's most prestigious educators combined their regular teaching duties with some form of public lecturing. Some also contributed to the popularization of science by writing for leading periodicals. Henry Morton, for instance, occasionally contributed articles to *Scientific American*, while Louis Agassiz was a regular contributor to the *Atlantic Monthly*.[7] But the popular "lecture system," as it was called, was not as institutionally localized in the United States as it was in Britain. While at places such as the Franklin Institute in Philadelphia and the Cooper Institute in New York courses of public lectures had long been seen as an important means of raising revenue and attracting prospective students, popular science lectures were not only, or even mostly, associated with these established institutes of education. As J. G. Holland pointed out in the *Atlantic Monthly*, they were also organized on a much more ad hoc basis by library and lyceum associations equally interested in the idea of replenishing their treasuries through public education.[8]

Holland's 1865 essay "The Popular Lecture" was the inspiration for another essay on the American lecture system a few years later. In this essay the writer, minister and social activist Thomas Wentworth Higginson, begins by imagining a railway construction train moving westward across the American prairies and into the wilderness: "These iron rails once laid, all else follows—all the signs and appliances of American social order: the farm, the workshop, the village, the church, the school-house, the *New York Tribune*, *The Atlantic Monthly*, and—the popular Lecture-system."[9] If the gesture of harnessing the future of the nation to the railway was to be repeated in a variety of forms of representation well into the twentieth century, the idea that the progress of the nation might be tied to something called the popular lecture system proved to be rather more fleeting.[10] Both Holland and Higginson suggest that American enthusiasm for the form could be calculated in direct proportion to its ability to tap into the vernacular culture. And in this they agreed that lecturers were aided by the sheer diversity of styles of presentation and address that could conceivably pass muster in the public arena. As Holland warmly puts it, in America "the word 'lecture' covers generally and generically all the orations, declarations, dissertations, exhortations, recitations, humorous extravaganzas, narratives of travel, harangues, sermons, semi-sermons, demi-semi-sermons, and lectures proper, which can be crowded into what is called a 'course.' "[11] Nevertheless, both authors also single out history and science as the subjects that struggled hardest to find widespread public favor in this form. Holland speculates that the education system's success in making science part of the elementary curriculum may

already have made it an unsuitable subject for a forum that relied so heavily on novelty to attract an audience. But the United States did produce some exceedingly popular lecturers in the field of science. Henry Morton's and R. Ogden Doremus's lectures set the stage for some of the period's most lavish visual effects extravaganzas, adopting a form that, as Holland himself conceded, never failed to meet with audiences' approval.[12]

While this chapter includes an examination of the way Morton adapted the traditions of scientific demonstration and performance associated, on the one hand, with natural magic, and, on the other, with the turn-of-the-century phantasmagoria, it is worth remembering that there were still other popular science lecturers who were not science professionals but skilled orators and showmen. Among the most vocal critics of this group of popularizers was E. L. Youmans, one of the founding editors of the *Popular Science Monthly*.[13] Setting himself the task of staving off the degeneration of science into mere amusement and recreation, Youmans signaled his scholarly and pedagogical aspirations for his new journal with a monthly format that included essays commissioned from professional scientists and lengthy literature reviews. Holland had begun his 1865 essay on the American lecture system by pointing out that its "downfall" had "been confidently predicted" for "the last fifteen years."[14] When his turn to survey the state of the popular science lecture came in 1873, Youmans sensed that its future was unlikely to be decided by the professoriat, even though he was a long way from being reconciled to the direction in which it appeared to be heading. In "Scientific Lectures" he wrote:

> That lectures will always continue to be, as they always have been, a valuable mode of public instruction, there can be little doubt; but that what is called the lecture system is going to prove an agency of rational regeneration, may be seriously questioned. In so far as it is in any sense a system it has degenerated to a mere catering to public amusements. The platform is crowded with readers, singers, declaimers, dramatists and buffoons, and the "course of lectures" is transformed into a "series of entertainments."[15]

In fact, the small but popular lecture circuit that had been maintained by distinguished professionals like Morton had already seen its heyday some years before John Tyndall made his thirty-five-lecture tour of the United States in 1872/73. While the *Popular Science Monthly* continued to keep the world of commercial entertainment at bay, it was to *Scientific American*—the country's most widely circulated popular science periodical—that interested spec-

tators could still turn for informal instruction in the reception of new entertainment technologies and their artifacts.

NATURAL MAGIC

The Magician and the Cinema (1981)—Erik Barnouw's well-known monograph on the traditions of trickery that played such a vital role in the early days of cinema—was one of the first books to demonstrate how much the development of early film culture owed to the performative traditions of stage magic and, later, magic theater.[16] In this slim book, the social and technological intersections between these traditions and those associated with nineteenth-century popular science and spiritualism—the latter circulating less as popular science's dark nemesis than as its shabby next of kin—have been threaded together to suggest a genealogy for cinema that continues to inspire new scholarship on the precinema history of moving picture technologies. Embedded within this narrative is the genesis of another story: this one about the precinema history of special effects. For Barnouw's story begins in fact with the observation that cinemagicians such as Georges Méliès and Robert R. Booth "played a pioneer role in animation"; their trick films laying "the foundations for the field of 'special effects' in the modern cinema" (6). By the book's conclusion, this story has given way to an elegiac rumination on what has happened to magic now that tradition and craft have at last been outrun by industrialization. Reflecting on the attractions of contemporary media images, Barnouw finds himself wondering if the central element in their power might not be "the astonishing fact" that they "are no longer seen by the public as optical illusions offered by magicians, but as something real." The "new industrialized magic may," he concludes, "be closer to 'black magic' than to 'natural magic' " (112).

While attentive to the subtle transformations that the staging of magic underwent as a consequence of magicians' experiments with new apparatus, new techniques of visualization and projection, and new modes of dramatic presentation, Barnouw's history of the illusionistic arts is still primarily narrated as a series of high points in the careers of the nineteenth century's best-known practitioners. Any impression of how popular discourse on magic actually circulated outside magicians' professional networks has to be pieced together from his scattered reflections on the scientific spirit animating the age. Inspired by David Brewster's *Letters on Natural Magic* (1832), Barnouw uses the term "natural magic" to describe the scientific temper of the times, but in doing so he also passes over some of the more subtle and even unex-

pected ways that Brewster's own thinking on natural magic was shaped by a much older tradition of scientific experiment and display. Writing about the history of magic and its relation to popular science a century before Barnouw, Frost boldly suggested that it was in fact in Giovanni Battista Della Porta's *Natural Magick* (self-published in Naples in 1558) that "the real character of the conjurer, as a public entertainer, was, for the first time, fairly set forth."[17] This claim follows close on the heels of Frost's brief commentary on two other books that touched on the subject of conjuring in the late sixteenth and mid-seventeenth centuries: Reginald Scot's *The Discoverie of Witchcraft* (1584) and Thomas Ady's *A Candle in the Dark* (1655). Scot's discourse on the "art of naturall magicke" is clearly indebted to Porta's earlier and at the time still untranslated text.[18] But where Scot hoped that dissemination of the techniques of cunning illusion and legerdemain would take away any admiration for the conjurer beyond that due the practiced entertainer, Porta saw in the same process the opportunity to cultivate a greater appreciation of the magician's virtuoso command of nature.

Appearing some thirty years after the original, the second edition of *Natural Magick* (1589) was expanded from four to twenty books, their subject matter ranging from cookery lessons and instructions on how to make perfumes, makeup, and invisible ink to guides for performing experiments in optics, magnetism, and physics. It is the first book, however, that contains Porta's most explicit treatment of his subject matter. The chapter entitled "What Is the Nature of Magick" begins by proposing that "there are two sorts of Magick; the one is infamous, and unhappy, because it has to do with foul spirits, and consists of incantations and wicked curiosity; and this is called Sorcery; an art which all learned and good men detest." The "other magick" is "natural" and "opens onto us the properties and qualities of hidden things, and the knowledge of the whole course of Nature."[19] In this frequently cited justification for the practice of natural magic, it emerges as a variant of natural philosophy. But it has also been described as a "preternatural philosophy," a term that Lorraine Daston and Katherine Park use to evoke more strongly the occult dimensions of a philosophical tradition dedicated to the cultivation of virtuosity and connoisseurship.[20] For Porta also claimed to be privy to the secret workings of nature, to a knowledge glimpsed in the vast network of resemblances linking the natural world to the divine. The effects created with this knowledge were in this sense more preternatural than natural, their ultimate causes remaining hidden even as their modus operandi was revealed, for instance, in Porta's cryptic instructions for reproducing the many experiments described in his book. While natural magic finds its moral justification in this work in being conceived as nature's handmaid and servant—serv-

ing no other function than to instruct through the production and elucidation of nature's wonderful effects—it is revealed that nature herself requires the hand of the craftsman to make her bounty apprehensible to the eye. In this way, Porta slyly insinuates that the wonder that nature's effects inspire finally rebounds upon the magician who is able to bring them to fruition without revealing his hand in the process.

The concept of natural magic could not be brought into line with the positivist, pedagogical preoccupations of nineteenth-century popular science without first being shorn of its early predilections for the preternatural and the occult. Brewster introduces the subject of natural magic to readers by pointing out that "in its widest range, it embraces the history of the governments and the superstitions of ancient times, of the means by which they maintained their influence over the human mind, of the assistance which derived from the arts and the sciences, and from a knowledge of the powers and phenomena of nature."[21] His own affection for the subject seems to have been whetted by a desire to see "natural magic" become a term for distinguishing between the practices of illusion and spectacular display associated with popular scientific cultures and those associated with the supernatural. In the role of public performer, this new practitioner of natural magic is therefore conceived as one who seeks not to bamboozle audiences with mystifying illusions but to draw their attention to the science that lies behind them. On the one hand, it could be said of Brewster that he, as much as anyone, recognized that the democratic potential of natural magic had the best chance of being realized by the popular arts: the arts of the fairground, the lecture room, and the public gallery. All kinds of arcane and baroque recreations have been created in the spirit of blending instruction and amusement, but he found that spirit being fanned most strongly in the halls of entertainment. On the other hand, Brewster recognized the need to augment the popular reception of these amusements with some other form of instruction because the techniques of popular scientific demonstration that he describes actually suppress the overtly scientific dimensions of the startling images and illusions they were designed to bring before audiences.

If the traditions of scientific demonstration that developed at places like the Royal Institution struggled to make the process of scientific experiment transparent to viewers, the traditions of popular scientific demonstration inherited from natural magic labored to keep the secret workings of their instruments and apparatus under the cover of darkness.[22] In so many of the settings for popular scientific display this was not only figuratively but literally the case. Darkness, Frost points out, "was as necessary to the exhibition of the pagan mysteries as to the reproduction of the dissolving views at the

Polytechnic; and it served besides to stimulate curiosity and inspire awe."[23] Like the natural magicians whose instruments they inherited, popular science demonstrators did not concern themselves with demonstrating scientific process. Of the three forms of scientific demonstration identified by Hankins and Silverman—display of an object, display of a phenomenon, and confirmation of a theory—popular science concerned itself only with the first two.[24] In order to intensify viewers' experience of these objects and phenomena, popular science lecturers utilized all the techniques known to the conjuring professions for eliciting surprise and curiosity. To illustrate the advantages of a demonstration that conceals its modus operandi over one that does not, Brewster offers the example of the distorted image that is reflected in a mirror whose surface has a variable curvature. This type of mirror can still be found in the old-fashioned fun palaces at fairs and amusement parks. Brewster suggests that while a skilled performer will be able to produce some amusing effects while performing in front of such a mirror before an audience, these effects "lose in the simplicity of the experiment much of the wonder which they could not fail to excite if exhibited on a grand scale, where the performer is invisible, and where it is practicable to give an aerial representation of the caricatured figures."[25]

Brewster regarded his own *Letters on Natural Magic* to be a blow struck for science against those pretenders to the supernatural who profited from keeping the techniques of illusion secret. But as his description of this simple demonstration illustrates, he was also fascinated by the theater and stagecraft of illusion, by all the elements of dramatic entertainment that were brought to bear on the transformation of science into art and entertainment. This is why he lingers so long over the optical attractions of the phantasmagoria, leaving them only because, as he says, "it would lead us into too wide a field were we to detail the immense variety of resources which the science of optics furnishes for such exhibition" (164).

Jonathan Crary has suggested that the problem with Brewster's program for the democratization and mass dissemination of the scientific principles and techniques of illusion is that it implies the dissimulation of the viewing subject, "transforming each observer into simultaneously the magician and the deceived."[26] This is certainly how many twentieth-century film scholars—compelled by the subtle provocations of psychoanalysis—have theorized cinema spectatorship. The film spectator that is so movingly sketched, for instance, in Christian Metz's classic work on the subject, is one who "adopts a very particular *visée de conscience*," combining, overlapping, and alternating between consciousness of the illusion of reality produced by the film and surrender to the aleatory play of fantasy and remembering that the

film's illusionistic effects invite.[27] I want to suggest, however, that in Brewster's descriptions of optical effects and illusions, another mode of spectatorship—one conceptualized in terms of connoisseurship—is faintly limned.

In what is itself a wonderfully vivid essay on the experience of wonder, Philip Fisher provides a way of understanding Brewster's deep and abiding fascination with visual images and effects. Wonder, he proposes, is best understood as "a relation to the visible world."[28] Within this conceptual framework, only visual effects have the power to elicit the aesthetic experiences of amazement, admiration, and delight associated with wonder and the intellectual curiosity that it excites. One of the attractions of this way of thinking about wonder is that it makes thought a component of aesthetic experience, returning to it an incitement to curiosity and contemplation that it has not always been credited with.[29] But even more than that it suggests that wonder is a response to aesthetic novelty that leads the imagination on to scientific inquiry. Cartesian in inspiration, Fisher's poetics takes wonder to be an aesthetic experience that takes shape in a single moment of recognition and understanding. In nineteenth-century writing on popular science, anecdotes describing such moments typically make the scientist—rather than a member of the lecture audience—the privileged subject of this experience. Such is the case in a story related by Pepper, who recalls taking Michael Faraday behind the scenes of the Polytechnic theater in which his ghost illusion was first exhibited. Unlike the magic lantern effects featured in the turn-of-the-century phantasmagoria, this effect owed its invention to mechanical engineering. Its staging required two major modifications to be made to the theaters in which it was shown. First, it required a second stage—set lower than the ordinary stage—to be constructed. Second, it required that two glass screens be erected, the first set at a ninety-degree angle above the lower stage, and the second in front of it. As Pepper explains it, "Spectators will not observe the [second] glass screen, but will see the actors on the ordinary stage through it as if it were not there; nevertheless the glass will serve to reflect to them an image of actors on the hidden stage when these are illuminated."[30] Even with the architecture of the theater laid out before him, Faraday is reported to have been at a loss to comprehend how the illusion was achieved. It is only when Pepper places the philosopher's hand on the second, as yet undetected pane of glass that Faraday is given to exclaim "Ah! now I comprehend it; but your glasses are kept so well protected I could not see them even behind your screens" (35).

Audiences in the theater, on the other hand, were prepped in another way to experience wonder. Popular science lecturers took great care with the staging of visual effects, often transforming the lecture stage with lavishly illus-

trated sets and backdrops. With his subtle dissection of this aspect of the mise-en-scène of demonstration, Fisher invites the speculation that these elaborate stage effects were themselves available to be interpreted by viewers as signs that the scene had been set by someone who has learned how to execute an effect in a dramatic way, the very "artificiality of the circumstances" tipping them off.[31] Neither Brewster nor Pepper, however, seems to have been entirely satisfied that the mise-en-scène of popular scientific demonstration was enough to guarantee that the images conjured in this setting would be seen in the way that they were intended to be seen. Indeed, the clearest indication we have that they regarded a receptiveness to wonder to be something that needs to be cultivated outside the lecture theater is the books that they left behind. Their very existence suggests that it was on the circulation of these pamphlets, and primers, and theoretical essays that ultimately rested their hopes of opening up the channels of human inquiry and interaction that would cultivate, nurture, and sustain a popular scientific culture of wonder.

SCIENCE FICTIONS

With its distinctive techniques of scientific visualization, the turn-of-the-century phantasmagoria's significance for the popular performance and demonstration of science was subtle and far-reaching. The story of its migration from the Continent to England has been told many times before, giving rise to some dispute over who should be credited with developing it first.[32] Although phantasmagoria showmen invited audiences to view their spectral theater of the dead as a form of scientific entertainment, not everyone who has written about these shows has been convinced that the most obvious way of responding to the disembodied spirits and floating heads that miraculously materialized in these darkened halls was to recall that these ghostly emanations were after all being conjured by scientific means. In her thought-provoking essay on the phantasmagoria, Terry Castle suggests that for contemporary audiences the most compelling aspect of these shows was in fact their capacity for re-creating "the emotional aura of the supernatural" and not, as might be supposed, the fact that their ostensive purpose was to disabuse credulous spectators of their atavistic belief in spirits.[33] This argument is based on a series of subtle analogies strung together to illustrate similarities between otherwise very different contexts for the manifestation of phantasmagorical illusions. Pointing out that phantasmagoria shows were seen by many contemporary commentators to be peculiarly adept at setting the scene for exciting mixed emotions in spectators—the very term becoming, through

a series of metaphoric displacements, a figure for a form of phantasmatic reverie in nineteenth-century poetic and philosophical discourse—Castle argues that phantasmagorical illusions functioned throughout the nineteenth century as a popular analogue to late romantic and nascent scientific theories of the mind. While this line of reasoning is persuasive on a number of counts, a consequence of it is that the contemporary reception of the phantasmagoria ends up being filtered through a romantic aesthetics of the sublime. In this context, it is an aesthetics that very nearly threatens to eclipse the social and domestic pleasures of connoisseurship.

The temptation to imagine that to be a witness to science's phantasmagorical effects was to encounter the sublime—to experience, in Kant's sense, the inability to resolve their strange claims on the imagination with their objective existence—exerts less force once it is remembered that this experience was also likely to have been tempered by spectators' own awareness of the intervening hand of the showman, whose privileged (if often unseen) position in the unfolding drama provided them with a powerful site of authority and reassurance.[34] Historical research in this area suggests that the novelty of the phantasmagoria's ghost illusions was also balanced by audiences' familiarity with other aspects of the program into which they were inserted. Both Theodore Barber's research into the way that phantasmagorical illusions were exhibited in the United States and J. E. Varney's study of their exhibition in Madrid give particular emphasis to the ways they were domesticated for local cultures.[35] Varney points out that in Madrid the theaters in which phantasmagoria shows were staged had long been venues for a range of programs of entertainment, some presenting acrobatic feats or exhibitions of curiosities, others offering scientific entertainments, and still others presenting a variety of shadow puppet theater. An advertisement for a phantasmagoria program shown at one of these theaters reflects this mix of the novel and the familiar, its attractions beginning "with various physical, metaphysical and arithmetical tricks, &c., followed by the illusions of the phantasmagoria in which will appear the celebrated ferry over Acheron, and the entertainment will conclude with the burlesque Dance of the Witches."[36] While the variety format of phantasmagoria programs lent itself particularly well to being adapted for local markets, the specifically phantasmagorical parts of these programs—those featuring the ghost illusions—over and over again exhibited a tendency to present this imagery within the context of dramatic vignettes adapted from well-known myths and stories. Indeed, what is striking about descriptions of phantasmagoria shows is the extent to which they embed the instructional dimension of public demonstrations of science in elaborate science fictions, eschewing overt forms of explanation in favor of

visualizing the transformative powers of science through science fictional imagery. This tendency toward science fictionalization gave phantasmagorical amusements a remarkable mobility, enabling them to continue, with some significant iterations, to be reproduced in a variety of contexts up until the early 1870s, when they were given a new lease of life not only by prominent lecturers in both England and the United States but also by magicians answering renewed demands for spiritualist séances.[37] Although there are important differences between Pepper's protodramatic science fictions and Morton's more loosely conceived form of phantasmagorical theater, both gave their popular scientific entertainments a visual grammar that is still being adapted for science fiction cinema more than a century later.

Some of the attractions highlighted in the *London Times* reviews of the Christmas entertainment for 1862 are the gymnastics at the Crystal Palace, conjuring at the Colosseum, and Pepper's lecture at the Polytechnic.[38] Continuing the variety format of many other such programs, the entertainment listed for the Polytechnic's Christmas program includes "cosmoramic pictures, dissolving views, magic, curious experiments with Greek fire and submarine explosions, ventriloquism, a perfect Christmas pantomime (the most curious and humorous specimen of its order), and, above all, there is what is called 'A Strange Lecture' by Professor Pepper."[39] A more detailed description of "A Strange Lecture" can be found in Pepper's *The True History of the Ghost; and all about Metempsychosis* (1890), which traces the etiology of the stage design for the lecture's ghost illusion from its genesis in a model constructed by Henry Dircks some years earlier to the improvements suggested by Pepper and Sylvester. In addition to chronicling the patenting and licensing of the illusion for use at popular theaters such as the Britannia, Haymarket, and Drury Lane, Pepper also gives an account of the case brought against him by music hall proprietors contesting the validity of his patent and even offers a defense of his treatment of Dircks, who expressed some resentment over licensees' advertising of the illusion as "Pepper's Ghost."[40] It is Pepper's descriptions of the lecture's dramatic conception and stage production, however, that shed the most light on the way the ghost illusion featured in the lecture. Adapting and abbreviating a format familiar to Polytechnic audiences, "A Strange Lecture" unfolded as a series of dramatically illustrated stories in which Pepper assumed the role of narrator. The most famous was adapted from "The Haunted Man," Charles Dickens's Christmas story of 1848. Of the very first story on the lecture program, Pepper recalls that it "had a very simple plot. It represented the room of a student who was engaged burning the midnight oil, and, looking up from his work, sees an apparition of a skeleton. Resenting the intrusion he rises, seizes a sword or a hatchet which is ready to

hand, and aims a blow against the ghost; which instantly disappeared again and again to return."[41] Pepper adds that the ghost in this story was admirably performed by his assistant, "who, wearing a cover of black velvet, held the real skeleton in his arms and made the fleshless bones assume the most elegant attitudes, the lower part from the pelvis downward being attired in white linen" (29).

In its populist blending of the novel and the familiar—in the articulation of new techniques of illusion to well-worn dramatic forms—"A Strange Lecture" clearly continued a tradition of scientific demonstration established by the phantasmagoria. But while art and science conspired in this instance to transform any explicitly scientific referent into a special effect, it would be wrong to infer that science had in fact been completely subsumed by the extant pressures of science fictionalization. Reviews by contemporaries suggest that Pepper's protodramatic entertainments continued to be distinguished from other forms of entertainment that shared their emphasis on visual spectacle, both by the novelty of their techniques of illusion and by the scientific authority vested in Pepper's very presence on the stage.

It is on the first of these grounds that Frost, for instance, contrasts the experience of seeing one of Pepper's ghosts for the first time with the experience of viewing "the effects introduced in the various entertainments combining dissolving views and vocal illustrations with a recital of some popular story, for which the Polytechnic has so long been famous."[42] Instead of being treated to the magic lantern effects they were accustomed to seeing at the Polytechnic, the "wondering spectators" at Pepper's lecture "saw figures appear and disappear, not gradually, as in the dissolving views, but instantaneously, upon a stage arranged as for a drama; and other figures pass through these, though apparently not less real, as if they were as unsubstantial as vapour" (314). Frost's description of the lecture emphasizes the way in which the dramatic action of these stories contrived to foreground the novelty of the ghost illusion. In each story the impossible interaction between spirit and flesh is staged anew, the action of these little dramas having been conceived to illustrate this hitherto never-before-seen effect.

While popular science never developed a single grammar for the presentation of visual effects and illusions, the mode of presentation adopted for this lecture was both familiar and prescient. Far from being integrated into the drama, Pepper's ghost illusion appeared before Polytechnic audiences in the form of a startling visual transmutation of the relatively mundane—if not exactly everyday—technologies of dramatic entertainment. In the tradition of natural magic and the phantasmagoria, the ghost illusion's modus operandi remained concealed, its suppression acting, within the context of the lec-

ture, as an incitement to public speculation. This challenge was met in the *Times* with the speculation that "this last entertainment, which consists of a series of the most wonderful optical delusions ever placed before the public, is intended to illustrate Charles Dickens' idea of the haunted man, and by means of an apparatus called a 'photodrome,' invented by Mr. Rose of Glasgow, the illusions and fancies of the haunted man are represented in a manner which baffles all who attempt to explain them."[43] For all its failure to identify the origins of this invention correctly, this review reveals rather a lot about the direction that contemporary speculation about the apparatus of illusion took under the pressure to approach this task scientifically. The reviewer's readiness to identify new techniques of scientific illusion not only with their inventors but also with futuristic developments in existing imaging technologies—the photodrome suggesting perhaps some new kind of photographic apparatus—reveals the extent to which new techniques of illusion had come to be associated with state-of-the-art technologies.

In the hands of the professoriat, the American popular science lecture was conceived along much more traditionally discursive and didactic lines. The aspects of these lectures that most impressed contemporary reviewers, however, were the scale of the event, the emphasis on visual spectacle, and the lecturer's ability to bring a sense of drama to the presentation of experiments. In 1866 the Mercantile Library of Brooklyn organized a series of three lectures to be presented by R. Ogden Doremus—a professor of chemistry and toxicology at Bellevue Hospital in New York City—at the Academy of Music in Brooklyn. Reviews of these lectures in *Scientific American* focus on the meticulous plotting and execution of experiments but also on the sheer scale on which they were conducted.[44] From the printed page these evenings of instruction and entertainment emerge as a dizzying montage of experiments. Against a painted backdrop depicting geological formations on a gigantic scale, a blowpipe is held to a steel sword to produce a fifteen-foot shower of sparks; a water-filled tank extending across the entire theater is scattered with potassium pellets resulting in the "most brilliant coruscations of violet and yellow sparks and flames." According to the review, "experiments succeeded each other so rapidly, that the audience was entertained and delighted to the close."[45] The pedagogical legitimation for these visual effects extravaganzas may have been to solicit audiences' interest in science by addressing them as interested students, but reviewers' deepest impressions were of Doremus's own unassailable virtuosity.

While Henry Morton's lecturing style was very much within this tradition, his lectures were also decidedly more phantasmagorical than his con-

temporary's more conventionally illuminated monologues. Chairman of the Department of Chemistry at the University of Pennsylvania and secretary of the prestigious Franklin Institute of Pennsylvania, in 1870 Morton left to take up the position of president at a new technical school (the Stevens Institute of Technology, in Hoboken, New Jersey). Although this move meant he was no longer able to pursue his lecturing activities in the manner he had previously enjoyed, his assistance in the preparation of a particularly beautiful experiment is mentioned in John Tyndall's *Six Lectures on Light Delivered in America in 1872–1873* (1873).[46] But it was during his time at the Franklin Institute, where he was also editor of the *Journal of the Franklin Institute of the State of Pennsylvania, for the Promotion of the Mechanic Arts*, that Morton's reputation as a popular science lecturer was established. Stepping into the role of public lecturer at a time of regeneration for educational institutions and associations across the country, he delivered a course of lecturers—"Lectures on Electricity and Light" (1867/68)—that was subtly animated with the spirit of the phantasmagoria. The first lectures in the series proved so popular that Morton was forced to move them from a lecture room at the institute providing seating for 350 people to the Academy of Music in Philadelphia, which was much more commodious, with 3,500 stalls.[47] He then went on to repeat this success with a lecture tour that included appearances in New York, Baltimore, Providence, and New Haven.[48] Although no reviews of these lectures appear in *Scientific American*, they are vividly re-created in a series of articles that Morton wrote for the *Journal of the Franklin Institute*.

Successive editors would infuse the journal with their own interests and professional enthusiasms, but its policies on publication remained the same: it was to become, in Bruce Sinclair's terms, the Franklin Institute's "grand lever" for advancing the reputation of American scientists and American science in the international arena (195–216). Morton's most significant contribution to the *Journal of the Franklin Institute* was a long-running series of articles entitled "The Magic Lantern as a Means of Demonstration." "One is apt," he wrote in an editorial outlining his objectives for this series, as well as for the editorial direction of the journal as a whole, "to underrate the value and importance of some literary record, which, however inadequate as an exhibition of the true beauty, grandeur, or efficiency of what it describes, will yet, by its ability of universal diffusion, do more for the general reputation and perpetual fame of the constructor, than the most sublime actual monument of his skill, and will at distant time and in far-off places, prove a grateful memento and witness of successful labor."[49] For Morton, the value of a journal lay in the promise of an archive—in the satisfaction of a personal and

professional desire for a purchase on "an external place which assures the possibility of memorization, of repetition, of reproduction, or of reimpression"—and the opportunity to secure a place in the future.[50]

As his records show, many of Morton's experiments were adaptations of tried and true favorites found in books such as Brewster's *Letters on Natural Magic* and Pepper's *The Boy's Playbook of Science* (1860). With both these writers, Morton shared an interest in the phantasmagorical, and his choice of experiments reflects this preference. In one important respect, his lectures even more closely replicated the phantasmagorical style of popular scientific demonstration honed by turn-of-the-century showmen than Pepper's more literal interpretations of it would permit. For even as they engaged spectators as wondering admirers, Morton's lectures also made them participant-observers in the unfolding spectacle.[51] In his description of one experiment, "the audience themselves" have become part of the special effect, their faces and clothing becoming the screen on which the most "peculiar effects" of light are reflected for each other. Morton sets the scene for this experiment thus: "The stage being set with the most brilliant scenery and colored decorations, suddenly illuminated by yellow light thus developed, the ordinary gas light being turned down, presents an appearance of ghostly change, which cannot be appreciated until seen, while sufficient light reaches all parts of the house to allow the audience to repeat the observation of strange metamorphoses upon their neighbours."[52] Instead of working, as Pepper had done, through the techniques of narrativization and dramaturgy to give his experiments dramatic focus, Morton placed spectators inside his science fictions. Projected on to huge screens erected at the front of the hall, his magic lantern experiments redefined the space of the theater and audience members' place within it. Stagecraft and technology combined to transform the music hall into an immersive environment, creating a sensory, interactive interface between audiences and the visual effects of science.

The most memorable lantern effect described in Morton's journal articles involves the use of a "megascope": a lantern that has been modified to allow for the projection of opaque objects. In the darkened lecture theater over which Morton presided, what appeared to be solid, three-dimensional objects miraculously materialized at the front of the hall, appearing for all the world to hover just over audience members' heads. Describing the effect of using the megascope to project an image of his hand in this manner, Morton writes that

> an image of the hand, of gigantic size, will then appear on the screen, which, if other things are in good order—*i.e.* the lime-light bright and the

room dark—will, on the first trial, astonish the operator as much as any-
one else. . . . I can yet remember my own hand in the lantern, and giving
to my fingers the motions I saw repeated on the screen, it required an
effort to realize that the image seen was something depicted on a flat sur-
face and not a huge solid body projecting into the room, and capable of
seizing anything which approached.[53]

Even though distinctions between science (defined as an increasingly special-
ized field of rational inquiry) and technology (used more broadly to refer to
both technical knowledge and material artifacts) were beginning to be made
by the mid-nineteenth century, the fact that popular science made scientific
visualization its privileged mode of demonstration meant that this distinc-
tion was never made so clear.[54] On the one hand, the phantasmagor-
ical imagery conjured up by Morton was presented as visible evidence of
the transformative power of scientific knowledge (which was clearly vested in
the scientist himself). But his lectures also directed audiences' attention to
the astonishing imaging power of the apparatus of scientific experiment (and
this even when much of that apparatus remained unseen).

New technologies figured more widely in popular scientific discourse as
the material signs of modernity but also as the future objectified, with reports
of new technological developments frequently stressing their promise for the
future. More insistently and confidently than any other contemporary dis-
course of modernity, American popular science opened itself up to the nov-
elty of the future. Within the context of the popular science lecture, special
effects appeared like eruptions of the future in the spatiotemporal fabric of
the now, making the unforeseen powers of novel imaging technologies (like
the megascope) suddenly and spectacularly visible. This early technofutur-
ism—a term that will take on important aesthetic connotations in chapters to
come—was very much a part of contemporary ideological discourse on new
technologies. In the mid-to-late nineteenth century, popular scientific dis-
course was explicitly framed in terms of public education. Just what form this
project should take was a matter of ongoing and even acrimonious debate,
but whatever coherence it had coalesced around an understanding of science
and technology that was positivist and future-oriented.

In the 1870s and 1880s the popular science lecture found itself facing
increasing competition for English audiences from less overtly scientific fic-
tions. Some historians have suggested that in fact its place was taken by all
kinds of dramatic and spectacular forms of exhibition well before the last
quarter of the nineteenth century.[55] It is magicians' own reflections on their
experiments with narrativization that perhaps best illuminate the differences

between the way that Pepper's protodramatic science fictions and the variety of magic theater that enjoyed such immense popularity in England during the 1880s addressed their respective audiences. In his autobiographical work *My Magic Life* (1931), David Devant credits John Nevil Maskelyne—with whom he worked at the Egyptian Hall in London—with being "the first to introduce the magical sketch or playlet," a form of magic performance in which magical effects were presented within the context of a dramatic scenario or narrative.[56] According to Devant, the difficulty of the genre lay in finding "a plausible cause for the effect; either the drama kills the illusion or the illusion kills the drama" (67). In an earlier book, Nevil Maskelyne (who also worked with Devant at the Egyptian Hall) had attempted a more theoretical account of the challenges that this form of magic theater presented for magicians. In *Our Magic* (1911) he argued that unlike the traditional magic show, which unfolds as a succession of climactic effects, the magic show that embeds its effects in a dramatic scenario is bound to some extent to work toward the integration of the effect into the drama.[57] Not surprisingly, the Aristotelian framework that is clearly in evidence in Maskelyne's insistence that the principles of dramatic unity at all times require the subordination of spectacle to drama sits uneasily alongside his rather more workmanlike observation that all magical effects rely on surprise or repetition to engage spectators' attention and solicit their admiration of the illusion performed.[58] Maskelyne's desire for a specifically aesthetic understanding and appreciation of magic does, however, indicate the extent to which the experiment had given way to the attraction in the narrativization of magical performance: to a further intensification of the dramatic dimensions of public presentations of new techniques of illusion that in turn invited less studied forms of spectatorial engagement.

In the United States, Morton's popular science extravaganzas were succeeded by the visual attractions of the dime museum and the variety stage but also by the circus and the "pyrotechnical drama."[59] Even the venerable Franklin Institute opened its doors to the entertainment-seeking public, with exhibitions such as its popular "Novelties Exhibition" of 1885.[60] The late nineteenth century's most successful "pyrotechnists"—the international entrepreneurs Charles and Henry Brock and James Pain—packaged the pyrotechnical extravaganzas staged in London at the Crystal Palace and in the United States at huge, outdoor arenas such as Manhattan Beach not as philosophical recreations but as mass entertainment.[61] A review of Pain's New York production "Burning of Moscow" reveals that the most popular dramatic premise for these performances was the great battle of history, rendered, in the spirit of imperial romance, as a dazzling, hyperkinetic feat of science and engineering.[62] In the 1880s the magicians, dramatists, circus operators, and

pyrotechnists vying for custom in an increasingly competitive entertainment market appear to have been as dedicated as ever to the pursuit of visual novelty and the development of new techniques for arresting the restless gaze of spectators grown accustomed to being solicited in this way. However, without any explicit challenge from the presenters and promoters of these popular forms of entertainment to study and reflect on their startling, visual attractions, there arose the need to develop some other context for cultivating a specifically scientific appreciation of them. After 1870 the staging ground for speculation about the techniques of optical illusion, special effects, and stagecraft moved from the public stage to popular science periodicals: from the site of spectacular effects production to the site of their cultural reproduction. For even as the gatekeepers of the arts continued their centuries-old attack on the anesthetizing effects of spectacle on the imagination, the effects that drew such huge crowds to Pain's pyrotechnical dramas, to Barnum's circus, to novelty exhibitions and the variety stage, all found a context for aesthetic evaluation and scientific legitimation in popular science periodicals.

Through the cultivation and popularization of particular ways of looking at special effects, popular science periodicals made the special effects created for a diverse range of popular amusements identifiable as specifically scientific achievements. Away from the public spaces of scientific amusement and instruction, instructional pamphlets and handbooks aimed at the amateur magician and drawing-room entertainer had for a long time provided a form of private instruction in the art and science of magical effects.[63] Henry Dean's *The Whole Art of Legerdemain; or, Hocus Pocus in Perfection* (1722) is widely regarded to be the best-known eighteenth-century book on conjuring.[64] Concerning itself with the art of legerdemain—"an Operation whereby one may feem to work wonderful, impoffible, and incredible Things, by Agility, Nimblenefs, and Slight of Hand"—it principally consists of descriptions of sleight-of-hand tricks done with balls, coins, and cards.[65]

Dean's book is a slight text, containing only the briefest descriptions of a modest collection of tricks. While nineteenth-century conjuring books also provided instruction in the art of legerdemain, they also tended to be much more encyclopedic.[66] Commenting on this tendency in the introduction to *Modern Magic* (1876), Professor Hoffman observed that the "general ambition of compilers" seems to have been "to produce books containing nominally some fabulous number of tricks," an ambition that was frequently realized by devoting a great deal of space to "chemical and arithmetical recreations."[67] These publications obviously had a role to play in the cultivation of the cultures of amateur magic and connoisseurship that were so important for the repro-

duction of the traditions of magic performance and stagecraft. But in terms of the range and type of effects that they covered, they were also limited, containing little behind-the-scenes information about the most spectacular and innovative effects and illusions exhibited on the public stage. Not until Hoffman's own *Modern Magic* did a book on conjuring provide detailed descriptions of some of the illusions staged at the Polytechnic, and by then the illusions referred to had become historical and dated. One reason for this is that books on conjuring were principally addressed to dedicated amateurs desiring instruction in the domestic reproduction of magical effects. In his chapter "Stage Tricks" Hoffman acknowledges that "by reason of the cumbrousness or costliness of the apparatus," most of the effects described in this chapter are "beyond the scope of the ordinary drawing-room performance" (437).

Because conjuring books addressed a readership restricted to collectors and amateurs with a specialist interest in magic, they also did not include descriptions of the kinds of scenic effects and stage illusions that might, for instance, be seen at the theater or opera. The fact that conjuring books were much less readily available in the United States than they were in England—where the overwhelming majority of them were published—also draws attention to one of the reasons that, in the United States, a culture of effects connoisseurship was cultivated through popular science publishing networks.[68] In 1898 the publishers of *Scientific American* published *Magic: Stage Illusions, Special Effects, and Trick Photography*, a book that consists entirely of material taken from articles previously published in *Scientific American* and the French popular science periodical *La Nature: Revue des sciences et de leurs applications aux arts et à l'industrie*.[69] Established in 1873 *La Nature* was edited by Gaston Tissandier, who also wrote a number of popular books on photography, aeronautics, and popular science. The distinguishing characteristic of effects coverage in *Scientific American*—and one that is indicated by the title of this book—is that it identified many more sites of innovative effects production than could possibly be confined to a single genre of entertainment (magic, the circus, novelty exhibitions, pyrotechnical dramas, science lectures), a single class of effects (optical, mechanical), or a single mode of production (public, domestic). Its coverage of special effects included both domestic applications for commercially available apparatus and reviews of a range of effects seen on the public stage.

Nor was scientific reflection on special effects restricted to the popular arts. Throughout the 1880s and 1890s the spectacular scenic effects featured on the opera, ballet, and theater stage also came under the appreciative gaze of a select list of popular science periodicals. Far from being regarded as a lamentable distraction from the ethically instructive dimension of dramatic

composition, the techniques of stagecraft were instead treated to pictorial scrutiny in the popular science periodicals *La Nature* and *Scientific American*. The traditional bias against elevating the achievements of the scene painter, machinist, craftsman, and mechanic over those of the poet or dramaturge was in this context inverted. These magazines' articles on this "most complex and refined of arts" are addressed to a spectator for whom knowledge of how an effect is achieved adds a heightened sense of awareness and pleasure to the experience of watching it unfold onstage.[70] It is a mode of spectatorship predicated, moreover, on developing an appreciation of the history of this form of effects production, on cultivating the ability to detect the changes that new techniques and apparatus bring to bear on all aspects of stagecraft. Reprinted in *Scientific American* from *La Nature*, a review of the effects for a popular new opera entitled *The Magician* (Massenet, 1891) is, in this vein, prefaced with the observation that "each new spectacular piece reveals to us some novel innovation, and, in truth, it is an occupation not without interest or utility to study the modifications and improvements that have been made in time to the same scenic effect."[71] Instead of falling between the interstices that kept the categories of science, engineering, and art separate in more specialist publications, special effects emerge from the annals of *Scientific American* as an aesthetic form that not only rewards but demands the studied attention of the connoisseur.

SCIENTIFIC AMERICAN

Barbara Maria Stafford has suggested that comparison of the "simple science 'playbooks'" popular in the mid-nineteenth century and the more sumptuously illustrated books that embodied the instructional practices of the previous century reveals just how completely the Enlightenment ideal of visual education had been eclipsed by the nineteenth century. For Stafford, a book such as Pepper's "playbook"—with its exclusive focus on "informational content"—only testifies to "the increasing specialization of the sciences even at the most elementary level."[72] Offering a much longer and more exhaustive elucidation of the scientific principles and experiments featured in the much abridged *Scientific amusements for young people* (1861), *The Boy's Playbook of Science* is indeed a forbidding tome, offering few concessions to readers uninitiated in the specialist vocabulary and abbreviated syntax of scientific discourse. It was not, however, to a general reading public that Pepper turned when he imagined a readership for this book but to memories of half-holidays spent at Kings College in the genteel, collegial pursuit of scientific recreation.[73]

Nor did English popular science periodicals necessarily offer a more accessible source of scientific information and review in the middle decades of the century. In her review of this literature, Susan Sheets-Pyenson points out that in the 1860s general science periodicals became markedly less concerned with keeping their broad-based readerships abreast of new developments in applied science or with publicizing the activities of amateur societies than with lobbying on behalf of professional science.[74] More specialist publications maintained even more exclusive readerships by emulating the discursive protocols of professional publications. Not only natural history periodicals but also the numerous engineering and electrical science magazines addressed themselves to dedicated amateurs prepared to master the specialist discourse of professional science.

If by the 1860s English popular science periodicals regarded the popularization of the achievements of professional scientists to be their primary objective, this was exactly the role that Youmans mapped out for the *Popular Science Monthly*. A review of Hermann Helmholtz's book *Popular Lectures on Scientific Subjects* (1873) contains one of the journal's most explicit treatments of its aims and objectives. The reviewer (very likely Youmans himself) writes: "Science itself being comprehensive, its great army of workers is constantly engaged in extending and correcting it by numberless processes of original investigation, while it is the office of popular science to bring its conclusions, applications and results, into the sphere of common thought."[75] Although *Scientific American* had also made the cultivation of public support for scientific research and development one of its primary objectives by 1870, it was, in contrast to both the *Popular Science Monthly*, and its twentieth-century namesake, a decidedly—even irremediably—populist publication.[76] In what is a useful polemic on the history of U.S. popular science, John C. Burnham notes that *Scientific American* was "designed primarily for upwardly mobile artisans and mechanics."[77] By the early 1860s, however, it had grown into a specialist (broadly scientific) publication catering to diverse reading publics. Burnham makes only passing reference to it in his own research, explaining that it had become "virtually all technology" by midcentury (147). Given the importance that new inventions assumed in the magazine—each issue contained a list of the claims for all the patents issued from the U.S. patent office during the previous week—this perception is understandable. Science and technology were not, however, to be so easily separated.

With its overriding concern with bringing new inventions to the attention of readers, *Scientific American* certainly contributed to the popular but by no means novel perception that new technologies are the material signs of scientific progress. Over time the certainty that history itself is technologically

driven also fueled the magazine's withdrawal of its early tacit support for the struggles of organized labor. In 1863 the magazine published a short article questioning the value of strikes, which nevertheless saw fit to conclude with an expression of support for the suffering workman and a reminder that the laborer "is worthy of his hire."[78] By the time the magazine returned to this issue in 1871, any such identification with the striking worker—whether at home or abroad—had well and truly disappeared.[79] With no small degree of hubris, an article entitled "How Labor Enslaves Itself to Capital" proposes that the problem with organized labor is that those involved in its struggles "have no grand principle for which they struggle; no definite idea of a finite adjustment between capital and labor; nothing that looks forward to a time when the interests of both shall be recognized and mutual." By contrast, "capital, guided by intelligence, is stronger than they in all except brute force."[80] In less than ten years, the striking workman had become an anachronistic figure, his failure to recognize the historical necessity of his situation representing a retreat from the novel demands of modernity.

In the early 1870s *Scientific American* still offered an eclectic blend of opinion and letters pages, regular columns on how to reproduce new photographic and magic lantern effects at home, reports on the current state of technological development in the fields of industrial science and manufacturing, condensed biographies of eminent scientists, and reviews of scientific novelties and toys. With the exception of the letters pages, all these features regularly combined editorial comment with advertising and product reviews. A long article entitled "The Magic Lantern" (1870) begins, for instance, by commenting on its usefulness for scientific demonstrators, noting that "the success of some of the most celebrated demonstrations of Faraday, Tyndall, Doremus, Morton, and others, was due to the skilful use of the magic lantern."[81] The article's chief concern, however, is to extol the virtues of the "sciopticon," a new lantern designed specifically for the education and domestic markets by Lorenzo J. Macy of Philadelphia.[82] From the 1880s onward this kind of editorializing would become much more aggressively nationalist, with the promotion of domestically manufactured consumer technologies being used to bolster consumer confidence in U.S. industry. Historians have identified the last decades of the nineteenth century as a period of widespread economic and institutional restructuring, marking the transition from an unregulated to a "corporately and state-administered" market economy.[83] During the 1860s and 1870s no single figure was mentioned more often in *Scientific American* than Michael Faraday, who, even after his death, embodied the spirit of creative genius that was still the romantic, human face of science.[84] In the 1880s and 1890s the face of a specifically American science was

Thomas Edison: inventor and entrepreneur, scientist and businessman, and the perfect ambassador for the new corporate science.

What makes the early 1870s a particularly interesting period in the magazine's history are the articles reflecting on the diversity of the contemporary market for periodical literature and the magazine's place within it. *Scientific American* responded to the continuing expansion of the market for periodical publication with a number of articles that sought not simply to reiterate the magazine's claim to being the most widely circulated and influential American magazine of its type but, perhaps for the first time, to defend this claim against critics.[85] In a report on the growth of "Specialistic Journalism" in newspapers and magazines, its own success in building an unrivaled subscriber base is attributed to "the fact, that at the outset, it recognized the demand for a paper devoted to the topics which constitute its specialty, and that, while it has never been a medium of instruction to the masses, it has never allowed itself to lose sight of the fact that, to instruct the masses, it is necessary not to assume a greater standard of general information among them than they really possess."[86] The office of Munn and Co. recognized that a popular science periodical could never hope to achieve mass circulation, but it did hope to produce a publication that would appeal to readers with different levels of scientific and technical knowledge. On the whole it avoided publishing material that assumed a lot of prior knowledge about the issues or topics covered, discouraging "dry speculation on abstract science" in favor of reporting on "the facts that enter into the routine of everyday life, in the shop, the mill, and the lab."[87] An exception to this general principle was made for the magazine's regular columns on photography and the magic lantern, the serial nature of which meant that there was some scope for assuming readers' familiarity with basic terminology. The "handy hints" and "scientific recipes" scattered throughout the magazine also highlighted the relation between science and many everyday activities pursued at home, school, and work, giving it, and the magazine, the appearance of having something to offer everyone.

Burnham's claim that nineteenth-century popularizers saw it as their job to "translate and interpret professional science for a lay audience" was not made with *Scientific American* in mind.[88] Its editors would not have articulated their duty of instruction in these terms either. But they did understand the popularization of science—not just professional science but also the mechanical arts that featured more prominently in their own magazine—to entail the work of translation. Two articles comparing English and American popular science periodicals reveal something of the way the task of translation was approached in *Scientific American*. In the demotic spirit of a vaudeville comedy, all the most unflattering stereotypes of English culture duly

make an appearance. The English are long-winded and overly technical, their letters given to "long preambles and excess verbiage."[89] They are also cliquish and petty, drawn to pet schemes and theories, or else mordantly Bohemian. Thus it is left to the Americans to show how far a little levity can go toward making scientific and technical journalism more open and democratic. Not that differences between English and American popular scientific cultures cannot also be traced in this conceit. The English periodicals under review in "English and American Scientific, Mechanical, and Engineering Journalism" are technical, trade-oriented journals such as the *Artizan*, the *Engineer*, and *Engineering*. One of the characteristics of American popular science that Sinclair sees as being formative for a vernacular culture is an antipathy to the "guildhall thinking" associated with old-world craft guilds.[90] Because of their resistance to technological change and the fierceness with which they shielded craft secrets from public scrutiny, these were liable to be regarded with suspicion by republican-minded mechanics and artisans in the early part of the century.[91] It is perhaps the mnemonic trace of this antipathy that remains legible in the suggestion that the editors and publishers of English technical journals are either unable, or unwilling to imagine "that a technical journal can become a vehicle of popular information to the mass of mankind, instead of being the organ of a small clique of professional engineers or wealthy manufacturers, such as seems to hold control of the columns of *Engineering*."[92]

In response to the criticisms made of English periodicals in *Scientific American*, *Engineering* retaliated with a review of "American Technical Journals" in which it criticized *Scientific American* for the brevity of its articles, the undue prominence given to trifles ("the concoction of soup, the treatment of burns"), the incongruity of its contents ("'Buzzing Up,' spiritualism, the most civilised method of destroying bed bugs, and so forth"), the practice of mixing trade announcements with editorial content, and above all its shameless promotion of trifling patent improvements.[93] Not to be outdone by the burlesque treatment that its own contents received at the hands of the Yankee editors, analysis of one of *Scientific American*'s "better" issues finds that "the first article is an obvious patent advertisement, then follows cuttings, a reprint of a lecture on 'On the water we drink,' then paste and sheers, ditto, ditto, ditto, occupying three columns: more apparent editorial puffs, and No. X of 'Perpetual Motion' (Mr. Dircks should see this); paste and shears, a column of letters, and paste and shears" (126).

The respondent for *Scientific American* was less concerned by the suggestion that the magazine lacked original content than by the assumption that because it rejected the essay format found in English technical journals its own claims to being a medium of popular instruction were compromised

and even fraudulent. He objected that the English essays invariably assumed a level of technical and scientific literacy that was simply inappropriate for *Scientific American*'s readership. Or, as he had put it in the article that sparked off this exchange: "American readers prefer their mental food cut in thin slices. A single point well made and well wrought out in a short article suits them better than exhaustive essays; and facts, rather than theories are sought by them. Few have leisure to peruse very long essays; and if they have, they prefer them published in book form rather than serially."[94] Clearly, the transformation of "facts" into the short, illustrated articles favored by *Scientific American* did not involve the same process of translation as that used to produce the lengthier, more theoretically inclined essays found in other journals. The key to understanding this difference—and to understanding how the knowledges and forms of engagement associated with the connoisseurship of effects were organized in this magazine—lies in identifying the different attitudes to reception that these two forms of translation implied.

A nineteenth-century popularizer such as Youmans regarded the translator's task to be one of transposing the discourse of professional science into a form that conveyed the depth and complexity of professional scientific discourse. The desire to reproduce this discourse as faithfully as possible broached no complaints from readers, who either had the "concentration of mind" to "grasp and assimilate [its] contents" or not. Magazines, declared Youmans, "are of two kinds: the entertaining kind which cater to mental laziness, and can be skimmed over without mental effort; and the instructive kind, which contain articles that must be read twice."[95] The more closely popular scientific discourse resembled the discourse of professional science in its "magnitude" and "intellectual seriousness," the more perfectly it fulfilled the popularizer's task. To stray too far from this mode of translation was to do science the grave injustice of treating it superficially. When Walter Benjamin wrote about translation in the preface to his translation of Baudelaire's *Tableaux Parisiens*, it was just this way of thinking about translation that he sought to overcome. "The traditional concepts in any discussion of translation are," he wrote, "fidelity and licence—the freedom of faithful reproduction and, in its service, fidelity. [But] these ideas seem to be no longer serviceable to a theory that looks for other things in translation than reproduction of meaning."[96] The other things that a theory of translation might be permitted to look for did not, however, include a theory of reception: not for Benjamin and not for his brilliant and faithful translators.[97]

The fact that Benjamin only ever considered translation from the perspective of the interlingual translation of a literary work in some ways makes his writing on this subject an unlikely point of reference for an examination of the

modes of translation found in nineteenth-century popular science periodicals. From the very first paragraph he makes it clear that what he is attempting is a theoretical consideration of the translation of specifically literary work. The rest of the essay reveals that where literature is concerned, the purpose of translation is neither communicative—in the sense of conveying meaning—nor poetic. It is rather "suprahistorical" and messianic, "for the great motif of integrating many tongues into one true language is at work."[98] The messianic function of translation is imperfectly realized in the translator's search for a pure language. What a translation must not do, if it is to remain true to this project, is anticipate its reception. Indeed, it is because Benjamin's theory of translation also looks to the romantics for confirmation that art cares nothing for its reception that Jacques Derrida can suggest, against every assertion that the tasks of the poet and the translator are utterly distinct and different, that, for Benjamin, "translation is a poetic transposition."[99]

The intensity with which Benjamin turns away from consideration of the social functions of translation—including all the pressures exerted by the practical and everyday contexts in which the activity of translation is embedded—is the most striking feature of his treatment of it. For all its promise of liberation from the dead weight of fidelity, his is a theoretical model that remains steadfastly opposed to the idea that translations might also mold the material they have to work with in anticipation of fulfilling some perceived need in their recipients. But not all translations of Benjamin's preface have followed him along this path. In turning Benjamin's writing on translation to the task of thinking about what is involved in the translation of a culture—with all its many systems of signification—for the medium of cinema, Rey Chow seizes upon his suggestion that a good translation is achieved "by a literal rendering of the syntax which proves words rather than sentences to be the primary element of the translator."[100] Here Chow takes Benjamin at his word, suggesting that it is the most literal translations of a culture that best fulfill the translator's task of giving that culture a "transmissible" and "accessible" form, of ensuring, in Benjamin's own words, that it will have an "afterlife."[101] In terms that have obvious resonances for thinking about the way particular types of scientific knowledge were translated in *Scientific American* during the period under consideration in this chapter, she argues that once we begin to think of translation from the perspective of its cultural transmissibility it becomes possible to "say that the 'literalness' of popular culture and mass culture is not 'simplistic' or 'lacking' as is commonly thought. Rather, in its naïve, crude and literal modes, popular and mass culture is a supplement to truth, a tactic of passing something on."[102] Chow's explanation of the means by which Benjamin's theorization of translation has been pushed

toward this conclusion, asks us to remember Benjamin's own attempts to show how the material artifacts of mass culture translate the past for us. The novelty of her reading lies in the implicit restitution of a theory of reception. For transmissibility and accessibility only become the condition of a translation in the way that her theorizing of translation implies when its success or failure is seen to hinge upon its reception.

With its short articles, advertising pages, and illustrated tabloid format, *Scientific American* was designed to be as accessible to the occasional reader as it was to the dedicated subscriber, as appealing to the browser as it was to the student. Fragmented into a number of subsections, the magazine addressed its readership not as an abstract populace uniformly in need of the same type of instruction but as a number of potential constituencies. The magazine's coverage of new entertainment technologies treated amateurism and connoisseurship as mutually reinforcing, sometimes overlapping, but nevertheless socially and technologically distinct modes of participating in scientific recreation. It is tempting to try to divide the magazine's coverage of effects into those which, ostensibly addressed readers as dedicated amateurs and home producers of photographic or magic lantern effects and those inviting reflection on the kinds of visual effects extravaganzas seen on the public stage. But while the reviews of commercial entertainment that appeared in *Scientific American* are an obvious and obviously important site for the cultivation of a specifically aesthetic appreciation of special effects, examination of its articles on photography and the magic lantern also reveal a nascent appeal to a discourse of connoisseurship.

In the early 1870s *Scientific American*'s regular articles on photography were only secondarily concerned with reporting on the range of consumer applications being developed by commercial laboratories. Although this would change over the next two decades, with the opening up of a mass market for such consumer technologies as the Kodak roll-film camera (1888), photography was still seen as an artisanal form of production in the 1870s, requiring amateurs and professionals alike to be involved in every stage of the production process. Patricia Zimmerman argues that in fact amateur photography—defined, more strictly than it is here, as a social formation dependent on mass production—only emerged between 1880 and 1920.[103] The social history of amateur photography that she traces links amateurism to the corporate monopolization of industry and the rise of professionalization. Against the forces of economic rationalization, amateurism comes to be associated with craft, individual expression, and personal freedom (6–11). Many of the articles on photography that appeared in *Scientific American* were concerned with the dissemination of practical information, providing photographers with tips on

how to color and tint photographs or how to improve the emulsions mixed for developing plates. On the other hand, articles examining techniques for creating novel photographic effects were not necessarily geared to domestic reproduction at all. The magazine's exposés on spiritualist séances and spirit photography adopted a tone of convivial skepticism that flattered readers without diminishing the obvious entertainment to be had from participating, even in a critical way, in a little humbug. An article offering would-be spirit photographers a comparative analysis of two techniques for reproducing spirit photographs contains very little practical advice about how to re-create the desired effects. The relative merits of each technique are assessed with respect to the likeliness of detection, the ingeniousness of the method, and the aesthetic quality of the effect. The principal difference between them concerns the way the glass slide that is placed between the photographic plate and the camera lens has been prepared. Instead of preparing the glass with a thin, photographic positive of the spirit image, the article advocates painting the image on the glass using a solution of sulfate of quinine (which becomes invisible to the eye when dry). Because the effect produced by the first technique is created using a photographic image of the spirit, it might be thought that it would be judged the more scientific. But it is the latter technique for spirit actualization that is pronounced the "more new, interesting, and scientific method" of the two in *Scientific American*.[104] Lacking the flair, the novelty, and the inspiration of invention, the mechanical compositing of two photographic images is ultimately not rated as a particularly scientific achievement. It is the painted effect—its patent artifice declaring the hand of the artisan—that is judged to be the more scientific on this occasion. If all this was offered in the spirit of a little light entertainment, it succeeds by exercising a subtle discursive deflection. For in this, as in so many other instances, the discourse of practical instruction merely provides the rhetorical gloss for a more widely accessible discourse of instruction in the aesthetic appreciation of novel photographic tricks and effects.

George M. Hopkins would most certainly have hoped that his own articles on the use of the magic lantern for scientific recreation would prove useful for readers seeking practical instruction. He might even have hoped that they would inspire a few others to take up this instrument. An educator and popular science writer, Hopkins was president of the Department of Physics at the Brooklyn Institute.[105] He later revised these articles for publication in *Experimental Science: Elementary, Practical and Experimental Physics* (1889), a two-volume collection of science experiments that was also published by Munn and Co.[106] Recognizing the need to bring the apparatus of experiment within reach of the workingman, student, and apprentice, Hopkins enthusi-

astically promoted the use of toy lanterns for scientific projection, and the chapter entitled "Lantern Projection" includes a number of experiments suitable for this type of lantern. (For more elaborate experiments, however, readers are advised to invest in a good-quality lantern equipped with an oxyhydrogen burner and electric light source.) While all the effects described in this book have as their raison d'être the illustration of some principle of applied physics, descriptions of the experiments typically highlight the figurative and graphical dimensions of effects imagery. An experiment for illustrating the principle of cohesion involves little more than placing a small amount of Vaseline mixed with alkaline between two glass plates. The "arborescent figures" that appear on the screen "grow as the plates are further separated, appearing, . . . like a growth of cactus or fern."[107] Other more technically difficult experiments promise to put the lanternist in command of rainbows and fountains of light, while demonstration of the refraction of air and sound waves anticipates a more abstract, graphical form of animated display.

It can be assumed that only readers who already possessed a high degree of mechanical skill and technical proficiency—achieved through hours of dedicated, practical application—would have been able to reproduce these experiments successfully at home. It cannot be assumed, however, that descriptions of these experiments in *Scientific American* necessarily repelled less technically literate readers. For as burdened with technical detail as these articles were, they also appear to have been organized to make it easier for readers to identify important information at a glance. At the very least, subject headings and illustrations identified the basic apparatus of experiment, putting readers in possession of a visual if not a practical or theoretical understanding of their modus operandi. Like amateurism, connoisseurship partakes in a discourse of possessive individualism that not only enables individuals to feel they possess special skills or knowledges but also provides them with a mode of social engagement with their chosen object of study. But unlike amateurism, which attaches great importance to the material production of artifacts, the mode of effects connoisseurship that begins to emerge from *Scientific American*'s regular articles on photography and the magic lantern places primary importance on what technical know-how can contribute to an appreciation of aesthetic novelty. Hopkins's articles on the use of the magic lantern for scientific visualization provided a site for the articulation of an aesthetic appreciation of effects imagery that looked—to borrow François Dagognet's evocative phrase—"to save the image from torpor."[108]

It was *Scientific American*'s reviews of the effects seen on the public stage that provided the most accessible site for the articulation of a popular discourse of effects connoisseurship. These reviews dispensed altogether with

detailed, technical descriptions of the apparatus of illusion, appealing to the imagination with illustrations and more discursive accounts of the dramatic contexts for the presentation of effects. *The Cabaret Du Neant* is described in *Scientific American* as a performance "based upon the principles of the well known 'Pepper's ghost.' " The action of the performance is meticulously re-created. Entering the theater via a long corridor, audience members find themselves in a spectral theater-restaurant. The tables have been arranged around a stage, at the back of which stands a coffin. Once seated, they are waited upon by a mournful mute, while a lecturer directs their attention to novel aspects of the mise-en-scène and instructs them not to smoke (lest it interfere with the illusion by fogging up the glass). Having provided readers with this virtual tour of the theater, the review then takes them behind the scenes to look at what happens to an audience member who has been chosen to take part in the staging of the main illusion. What the spectators watching the illusion from their tables see is the audience member standing in the coffin wrapped in a white sheet: "Now as the spectators watch him, he gradually dissolves or fades away and in his place appears a skeleton in the coffin. Again, at the word of command the skeleton in its turn slowly disappears, and the draped figure of [the audience member] appears again." Rather than describe the apparatus of illusion in detail, this information is translated visually. The reviewer in fact boasts that "our large illustration shows precisely how it is done and so clearly that an explanation is hardly needed" (figure 1.1).[109]

Similarly, an illustration of the stage for Pain's "Burning of Moscow" provided *Scientific American* with one of its more spectacular covers. The set of the Kremlin is framed by exploding rockets to form a fabulous tableau inset with smaller views: "illustrations, as seen from the rear of the stage, of the hinged and braced scenery, some parts turning on pivots, and all arranged to be quickly thrown down in such semblance of ruin as shall best carry out the idea the piece is intended to represent" (figure 1.2). The reproduction of the *Scientific American* images in Albert Hopkins's *Magic: Stage Illusions, Special Effects, and Trick Photography* lacks some of the visual integrity of the original illustration.[110] Instead of a pictorial assemblage depicting the event and the modus operandi of illusion on the same page, Hopkins breaks the illustration up into its aggregate parts. Inside *Scientific American*, a scientific analysis of pyrotechnical effects is given general discursive treatment in the review itself, the writer observing only that "the selection of materials for the effects desired is always governed by the laws of chemistry, as illustrated in every description of combustion, well known laws of mechanics being invoked to turn the forces of chemical combination to the end sought—a work in which no small amount of practical expertise and manual dexterity is required to service the best

THE CABARET DU NEANT.

A most interesting performance, based upon the principles of the well known "Pepper's ghost," is now on exhibition in this city, with sundry somewhat fantastic accessories and developments justifying the title of "The Cabaret du Neant," or "Tavern of the Dead" ("non-existing"), which has been given to it by its proprietors. It is a recent importation from Paris. While the principal interest of the exhibition centers in the ghost effects, which we illustrate, a word or two may be said of the sequence of acts.

The spectators pass through a long hall hung with black and find themselves in a spectral restaurant. Along the walls coffins are placed for tables, and on the end of each coffin is a burning candle. From the center of the ceiling hangs a what is termed "Robert Macaire's chandelier," made to all appearances of bones and skulls. The spectators are here at liberty to seat themselves at the tables and are served with what they desire by a mournful waiter dressed like a mute with long crape hanging from his hat. Around the walls of the room are placed pictures to which the spectator's attention is called by the lecturer. Seen by the light of the room these pictures are ordinary scenes, but a new aspect is given to each when lights directly behind it are turned on; the figures in it appear as skeletons, each picture being in fact a transparency giving a different effect as it is lighted from the rear or as seen simply by reflected light. The second chamber is now entered; it is hung with black throughout. On the walls tears are painted, and in close juxtaposition are two somewhat incongruous inscriptions, "Requiescat in pace," and "No smoking." The reason for the latter admonition, which is also given by the lecturer, is that for the success of the illusion an absolutely clear atmosphere is essential. At the end of this second chamber, at the back of a stage, is seen a coffin standing upright, in which one of the audience is requested to place himself. Entering the stage by the side door, he is conducted by an attendant to the coffin and placed in it. Blocks of wood are placed for him to stand on in quantity sufficient to bring his head to the right height so that the top of it just presses against the top of the coffin, and the attendant with great care adjusts his height according to the predetermined position. Two rows of Argand burners illuminate his figure, which is then wrapped in a white sheet. Now, as the spectators watch him, he gradually dissolves or fades away and in his place appears a skeleton in the coffin. Again, at the word of command the skeleton in its turn slowly disappears, and the draped figure of the spectator appears again. The illusion is perfect to the outer audience; the one in the coffin sees absolutely nothing out of the common. His interest, if he knows what is going on, is centered in watching the changing expression of the spectators, being increased by the fact that at their period of greatest astonishment he is absolutely invisible, although directly before them and seeing them more plainly than ever. After the restoration to life one or more auditors are put through the same performance, so that the recent occupant of the coffin sees what he has gone through.

The third chamber is now entered, somewhat similar to the second, but on its stage is a table and seat, all the walls being lined with black. One of the auditors is invited to seat himself at the table on the stage. He does it, and, as before, sees nothing. While the description of the lecturer and the appearance and comments of the audience tell him that something very interesting is going on, the remarks will probably disclose to him the fact that this time at least he is never out of their sight. He leaves the stage and his place is taken by another, and then he understands the nature of the drama in which he has been an unconscious participator. He sees the other spectator seated alone at the table. Suddenly a spirit, perhaps of an old man, appears at the other side of the table, while a bottle and glass, are seen upon the table.

When exhorted to help himself to the liquid, the performing spectator's idle gestures show that he certainly does not see the glass, through which his hand passes unobstructed. Or perhaps it is a woman who appears and makes the most alluring gestures toward him who never sees her. This concludes the exhibition which as accessory has the strains of a funeral march, the ringing of deep sounding bells as room after room is entered, and the appearance of a brown robed Charon to introduce the spectator to his place in the coffin. In one of our illustrations we show, side by side, the coffin with its living occupant draped in a sheet and in the other the skeleton which appears in his place. Two other cuts show the scenes between the spectator at the table and the specters, illustrating how active a part the specters take, they being no mere painted appearances, but evidently living, moving things. Our large illustration shows precisely how it is done and so clearly that an explanation is hardly needed. The floor of the stage is represented. To the left are seen the spectators and the performer at the piano discoursing his lugubrious melodies. To the right is seen Charon, and directly in front of him the coffin with its living occupant. When lighted up by the burners shown near him, the other burners being turned down, the coffin with its occupant is all that is seen by the spectator. Directly in front of the coffin, crossing the stage obliquely, is a large sheet of the clearest plate glass, which offers no impediment to the view of the coffin with its occupant, when the latter is fully illuminated. At one side of the stage, in back of the picture, is a painting of a skeleton in a coffin with its own set of Argand burners. It is screened from view. When strongly illuminated, and when the lights of the real coffin are turned down, the spectators see reflected from the glass a brilliant image of the pictured coffin and skeleton. By turning up one set of burners as the others are turned down a perfect dissolving effect is obtained, skeleton replacing spectator and vice versa at the will of the exhibitor.

The magic lantern operator always realizes that to secure a good dissolving effect perfect registration is essential. In the securing of this lies the secret of the coffin exhibit of the Cabaret du Neant. By the blocks on which the occupant of the coffin stands, and by the adjustment of his head by the attendant, the head is brought into perfect registration with the reflected head of the skeleton. The wrapping of the sheet, presumably the enveloping in a shroud, is done with a purpose. It covers the body from the shoulders down and extends to the very bottom of the coffin, covering the blocks also, thus doing away with all defects of registration which would be incurred in the persons of spectators of different heights. In other words, the exhibition fits out everybody with a skeleton of precisely the same height, however tall or short he may be, the draping of the sheet and accurate position of the head concealing from the spectators this inaccuracy, the skull occupying precisely the place of the head, the rest taking care of itself.

Still referring to the large cut, it will be seen that it serves to explain the exhibition in the other chamber. Instead of the coffin there is the table and chair, and in place of the pictured

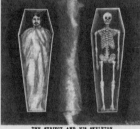

THE SUBJECT AND HIS SKELETON.

AN X RAY ILLUSION UPON THE STAGE—CONVERSION OF A LIVING MAN INTO A SKELETON.

THE SHEETED GHOST.

THE FEMALE SPIRIT.

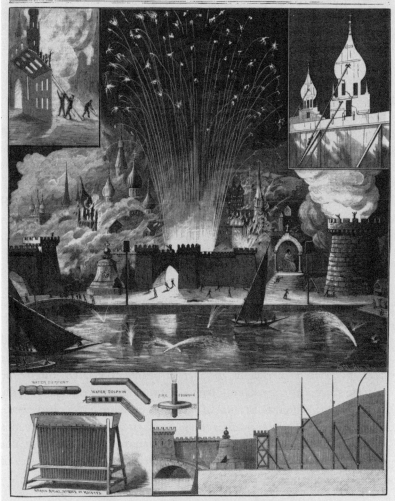

FIGURE 1.2 Pain's "Burning of Moscow"—A Pyrotechnical Drama at Manhattan Beach (1886, *Scientific American*)

results." The drawings and descriptions of this evening's entertainment attest to the variety and abundance of effects exhibited. But the review also offers an unusually self-conscious articulation of the kind of spectatorial pleasure that effects-oriented forms of entertainment have to offer. On the one hand, the reviewer suggests that "to obtain the largest possible amount of enjoyment from an exhibition of this kind, one should, probably, as far as possible, try to forget all of the 'machinery' of the business, and to be oblivious of the short-comings of the actors, to thus aid the imagination to call before the mind the real historical event." And yet, he continues, "all who see it are inclined to ask how the effects are produced." In the very process of calling attention to some of the "shortcomings" of this type of entertainment—the bad acting, the skimpy plot, the implausible action—the review suggests that a culture of con-noisseurship asks *particular* things of this type of entertainment. In this con-text, then, it's not just that knowing something about the machinery of pro-duction increases spectators' appreciation of what has actually been achieved on the public stage but also that it makes aesthetic demands on those aspects of these performances that are of special interest (i.e., the effects) and is less demanding of those that aren't.[111]

One of the most significant characteristics of the popular literature of effects connoisseurship discussed in this chapter is that it provides both a guide to would-be spectators and a memento after the fact. One might even say, after Benjamin and Chow, that reviews of special effects in *Scientific American* gave these spectacular visual transmutations an "afterlife," making it possible for readers to return to them again and again. Nor was it simply a matter of revisiting the scene. These reviews let readers step behind the scenes, prolonging and extending their contemplation of the artifact. By pro-viding a retrospective entrée to the scene of production, they also cultivated an expectation of novelty in the future. When Fisher argues that "wonder does not depend on awakening and then surprising expectation, but on the complete absence of expectation," he is not speaking to the experience of the connoisseur.[112] Within a discourse of effects connoisseurship, the experience of wonder depends on knowing enough to be surprised. Wonder, in this sense, is taking delight in having one's expectations met. Or, to turn this proposition around, connoisseurship expresses desire for the experience of wonder as a demand.

MILLENNIAL MAGIC

If the attempt to illuminate the present by excavating the past is becoming a well-worn trope in contemporary commentaries on new film and media

technologies, one of the aims of this chapter has been to demonstrate that it still offers the best antidote to all those narratives of convergence—industrial, technological, and cultural—that have taken the novelty of convergence to mean that all the old ways of organizing viewers' emotional and intellectual responses to special effects have been swept away. Barnouw's concern that late-twentieth-century audiences were not being tutored in the scientific and aesthetic appreciation of cinematic illusions is not altogether surprising. The idea that the cinematic presentation of visual effects revolves around a mode of spectatorial address that not only rewards spectators' willingness to suspend disbelief but also their capacity for childlike enchantment has, after all, received support from the Hollywood directors most involved in bringing this imagery to cinema screens.

When asked to address a professional forum on the subject of using digital imaging technologies to create special effects for feature films, Hollywood director James Cameron naturally enough turned to magic to describe audiences' fascination with this new type of effects imagery. Originally presented before a film industry workshop hosted by the Society of Motion Picture and Television Engineers in the months immediately following the release of *Terminator 2: Judgment Day* (1991), Cameron's speech was later published in *Cinefex*.[113] Before *Titanic* (1997) loomed in the Hollywood record books, Cameron was widely credited with demonstrating the dramatic and aesthetic potential of computer-generated imagery to a skeptical film industry with such films as *The Abyss* (1989) and *Terminator 2*.[114] Reflecting on his collaboration with the special effects company, Industrial, Light, and Magic (ILM) during the making of *The Abyss*, Cameron describes the decision to use computer-generated imagery for the film's key visual effects sequence as a brave foray into uncharted territory. In one sense, this was true. No one had yet conceived of a project on the scale of the luminous, shape-shifting pseudopod that Cameron imagined for this film. In another sense, this imagery was only conceivable because rendering and animation software developed at companies such as Pixar, Alias Research, and Paralax finally offered solutions to many of the problems that had plagued attempts to integrate computer-generated images with live-action footage in the past. On the occasion of this address, Cameron wisely did not allow the dramatic tension of his version of events to be interrupted by this kind of inventory. While he conceded that computer graphics software "was just then at the cusp of respectability, with years of hard work finally coming to fruition," the scenario that he went on to sketch is one in which he is single-handedly poised to make computer graphics history.[115] It is ultimately a two-character scene in a one-act drama that has the computer animation department at ILM

laboring for nine arduous months to create exactly what Cameron "had seen in [his] mind's eye." At the end of it all, he said, "I realized that it was an almost crystalline, perfect act of pure creation. It was like the Krell dream of pure creation" (7). Like all Hollywood creation stories, Cameron's is an adventure narrative: the story of how a digital neophyte with imagination and verve harnessed the technical expertise of the effects wizards at ILM to create the most astonishingly photorealistic computer-generated images ever seen on a cinema screen. In his own words, "we were going to be blazing a trail" (7). Cameron's narrative reproduces the standard topos for popular histories of science and technology. Drawing on the iconography of pioneering and the frontier, it represents the cinematic future of CGI as a space of endless and untrammeled possibility.[116] Of course, in suggesting that it takes the vision of a creative director to harness the technical virtuosity of the effects wizards— the effects supervisors, engineers, and computer animators whose job it is to take this imagery from conceptualization to rendering—Cameron also aggregates for himself the position of grand wizard.

This was the early nineties, a time when concerns about what computer-generated images would look like in a future in which every effects designer and animator in Hollywood would be working from the same handful of software packages were not yet a whisper. And a time when Hollywood had much to gain by promoting Cameron and Spielberg as the genius directors of the new imaging technologies. What is most interesting about the way Cameron imagines the audience response to the visual effects he describes is just how removed from that experience he is. His own dream of an unmediated cinema, a cinema without instrumentality, is revealed in a citation from Arthur C. Clarke: who, he says, "had a theorem which stated that any sufficiently advanced technology is indistinguishable from magic." And that, added Cameron, is "how it's supposed to be—for the audience. We (the filmmakers) *want* them to think it's magic."[117] Describing audiences' reaction to seeing the computer-generated sequence in *The Abyss* for the first time, he goes on to explain that "they got the joke; they understood intuitively what was magical about the scene. They were seeing something which was impossible, and yet looked completely photorealistic. It defied their power to explain how it was being done and returned them to a childlike state of pure entertainment" (7). These brief comments actually contain two propositions about the history of computer-generated visual effects. The first, which the next chapter will examine, is that in Hollywood the production of computer-generated imagery has been driven by one aesthetic principle: the creation of photorealistic imagery. The second, related proposition is that audiences' perception of this imagery is filtered through their own desire

for a cinema of astonishment rather than of wonder, for the dumb enjoyment, in Fisher's words, "of the state of not knowing how, or why."[118]

Historical examination of the popular reception of new imaging technologies reveals, however, that the development of new apparatus and techniques of illusion has almost always initiated two further developments: the creation of a domestic market for these technologies and stimulation of the market for the instructional and recreational literature associated with connoisseurship. The irony of Cameron's address to the Society of Motion Picture and Television Engineers is that it was published in *Cinefex: The Journal of Cinematic Illusions*, a publication addressed to all the animators, modelers, puppeteers, makeup artists, and visual effects supervisors and engineers working in the contemporary effects industry but also to all the film, video, and multimedia producers and students who specialize in knowing about the techniques of cinematic illusion, without necessarily having a professional stake in this knowledge.

Although popular science was still an important site for the cultivation of effects connoisseurship in the 1990s, *Scientific American* had not fulfilled this role for a very long time. The Times-Mirror publication *Popular Science* belatedly announced the arrival of "the digital age" in 1993. A cover story on computer-generated special effects prompted readers to "recall the most impressive special effects (SFX) you've seen on film in the last decade, the kind that cause audiences to gasp, that elicit a collective *Wow!* Chances are, they were digital, all or in part."[119] Like the rest of the magazine, this article takes the development of new technologies to be a sign of the inexorable march of progress: "First the silents. Then the talkies. Now, the digitals" (86). With its report on the way digital technologies are transforming the entertainment industry sharing the same issue as a feature on a "next-generation" fighter plane offering greater "speed," "agility," and "stealth" than the soon-to-be-superseded Harrier "jump-jet"—and with both squeezed between advertising for cars, consumer electronics, exercise equipment, and army recruitment—this magazine certainly seems to bear out cultural critics' fears that popular science has become a repository for consumer fantasies answering to the needs of an ever-expanding military-industrial-entertainment complex.[120] Despite the overwhelming evidence to support this view, popular science and its even more popular science fictions have, however, also been sites for popular criticism of this very same fantasy formation, its neo-colonialist impulses feeding the post-Watergate conspiracy theories of a popular television series such as *The X-Files*.

Ironically, it is the English popular science weekly *New Scientist* that now most resembles the *Scientific American* of old. In the mid-1980s Barry Fox

took up the role of effects historian, instructing readers on the difference between in-camera and optical effects and demonstrating how special effects are created for feature films with sets, models, miniatures, matte paintings, and makeup.[121] A residual craft ethos clings to this report. The techniques of cinematic illusion are not quite dignified with aesthetic traditions, but neither are they treated as standardized modes of production. Over the last decade *New Scientist* has also provided readers with instruction in the new vocabulary of visual effects in regular reports on the digital imaging techniques being developed by British and American visual effects companies. The cover story for a 1992 issue was entitled "Pixel Tricks Enrich Flicks." Inside the magazine, the table of contents recalls some of the old preoccupation with trifles and arcana that had so bothered *Scientific American*'s nineteenth-century critics. The article "The Taste of Tea" asks "What's the secret of a really good cuppa?" while the subtitle for another suggests that the "medieval art of argument by 'casuistry' is making a comeback." Addressing a readership consisting of both archivists and initiates, the article on digital effects proposes that "for cinema audiences there is a growing fascination with spotting the latest computer effects—even among those who claim to prefer the days of B-movie flying saucepan lids to the brave worlds of synthesised reality."[122] One of the things that makes this proposition contemporary is the assumption that special effects have a unique historical relation to science fiction cinema, but it is also the author's sense that at the end of the twentieth century effects connoisseurship takes diverse forms. While the fan cultures associated with stop-motion animation in the 1960s and 1970s cultivated a nostalgic appreciation of the craft of a bygone era, digital lifestyle magazines such as *Mondo 2000* and *Wired* have cultivated a very different relation to the computer-generated image. Although *New Scientist*'s coverage of special effects technologies has made digital imaging technologies its primary focus, it has also published articles on stunt work, pyrotechnics, and animatronics. But it has always been the most technologically intensive forms of effects production—stop-motion and computer animation, special photographic effects, electronically controlled models, and computer animatronics, rather than pyrotechnics or makeup and prosthetics—that have generated the most literature on special effects outside of genre film fandom. This is because it has been these technologies that have most often been employed to produce the technological artifact for display.

It has become commonplace to assume that the late twentieth century saw the culture of the printed word give way to a culture of the image. We read everywhere that we late moderns have been returned to "an oral-visual culture" in which our relation to the image has become less and less mediat-

ed by the printed word.[123] To argue, however, that the printed word has continued to be important for the cultivation and reproduction of contemporary forms of effects connoisseurship is not necessarily to impose on these cultures an antiquated, nineteenth-century understanding of the primacy of textual literacy. Distinctions between textual and visual literacies too often fail to register their many shared histories. These not only include the long history of illustrated periodical publication that has been so important for the cultivation of a scientific and aesthetic appreciation of the techniques of visual effects production but also the history of new media environments such as the Internet.

2

FROM CULT-CLASSICISM TO TECHNOFUTURISM
CONVERGING ON WIRED MAGAZINE

Commentaries on the aesthetics of the computer-generated image are always commentaries on the reception of this imagery. These commentaries may be more or less explicit, more or less self-conscious, about the extent to which this is the case, but all assume that there is some relation between aesthetics and reception. To suggest that effects connoisseurship expresses desire for the experience of wonder as a demand is to take a subjectivist approach to mapping this relation. It is to accept, in Gérard Genette's avowedly relativist terms, that what makes an object specifically an aesthetic artifact in the eyes of its receiver "is the impression, warranted or not, that it proceeds from an intention that was at least in part aesthetic."[1] The risk a subjectivist theory of aesthetics takes is that it will be seen to have replaced the regnant idealism of Kantian aesthetics with a naively individualistic understanding of what an aesthetic appreciation of an artifact involves. Genette points out, however, that the term "subjective" does not necessarily mean "individual."[2] The aesthetic judgments of the connoisseur, aficionado, or fan express a relation to an object that has always in some sense been

arrived at collectively. To describe an image as an artifact for display is also, however, to assign an aesthetic intention to it. It is to assume that the displayed artifact also solicits an aesthetic appreciation from viewers. Computer animators' frustration with the way the term "computer-generated animation" sometimes gets used by entertainment journalists stems from their concern that all such intentionality is occluded by the automaticity that this term seems to imply. Speaking about his work on the computer-animated short films *Luxo Jr.* (1986), *Red's Dream* (1987), and *Tin Toy* (1988), John Lasseter insists, for instance, that "it's not computer-*generated* animation, it's animators using the computer to create animation."[3] A later chapter examines filmmakers' claims that the computer is merely a tool—that its relation to aesthetic production is facilitating rather than constitutive. It is Lasseter's desire to represent computer animation as an expressive (albeit commercial) art form that is of interest here. For while film scholars will have no trouble identifying the many limitations that the Hollywood film industry places on aesthetic expression, this chapter looks at the reasons why it has also been important for a discourse of connoisseurship to represent CGI effects in this way.

Film and cultural criticism of CGI effects has on the whole been preoccupied with demonstrating the extent to which the aesthetic dimensions of this imagery reflect the film and entertainment industries' obsession with realism, photorealism, simulation, and illusionism, terms that have increasingly come to be used interchangeably. In this context, Hollywood has typically and justifiably been viewed as a technologically and aesthetically conservative institution. But while it has reacted conservatively to the introduction of new technologies in some areas of film production, it also has a history of opting for technological and aesthetic novelty over any strict calculus of risks in others. To take an example from the early 1950s, the aesthetic project governing Hollywood's experiment with 3-D formats was less obviously conservative— in the sense, say, of being driven by a centuries-old quest to reproduce three-dimensional perception technologically—than spectacularly novel.[4] The 3-D process was plagued by technological problems from the beginning: the cameras were bulky, film stock and printing costs were exorbitant, and the synchronization of projection was rarely achieved.[5] Most of the films made in 3-D between 1952 and 1953 used a dual-strip process, which required two strips of film to be projected onto the screen simultaneously. If the projectors weren't in perfect sync and/or the right distance from each other, the two images would not be perceived as a single, three-dimensional image when viewed by audiences through special polarized glasses. Films made in 3-D formats were widely pilloried by critics of the day. They were criticized for being

gimmicky and juvenile or for having stupid stories—or no stories at all. For a time, however, they were also popularly perceived to be the most visually exciting movies showing in theaters.

Hollywood's experiments with 3-D in the 1950s differ in many important respects from its experiments with CGI in the early 1990s. The transformation of the Hollywood studio system into a system of globally networked and vertically and horizontally integrated entertainment conglomerates has had important implications for the production and reception of new film technologies. The effects of using 3-D and CGI technologies in conjunction with traditional film formats are also very different. Most 3-D films do in fact draw on the visual grammar of effects presentation, with the dramatic action being staged around a series of off-screen effects. However, these visually startling transmutations of cinematographic space are in fact optical illusions. Unlike CGI effects, they have no phenomenal existence as images or artifacts and none of the aesthetic range that effects created either in whole or in part with picture or image-making techniques have. For this reason alone the novelty of this one effect was always bound to wear off, worn out by poor registration and deadening repetition.

Identifying the differences as well as the similarities between CGI effects and other techniques of cinematic illusion necessitates the development of historical methods capable of mapping the points where the histories of their production and consumption both converge and diverge. Philip Hayward and Tana Wollen address just this issue in the introduction to *Future Visions: New Technologies of the Screen* (1993), a book that, along with the *Leonardo* supplemental issue *Digital Image, Digital Cinema* (1990), was one of the first to initiate speculation about the impact of digital technologies on the future of cinema.[6] In their work, Hayward and Wollen argue that new methodologies are needed just to deal with the cross-media nature of new computer technologies. Something like CGI, their work points out, is not anchored to cultural institutions in the same way that something like film is anchored to cinema (4). And the fact that the history of CGI spans so many applications has implications for the way that history gets written about even when it is narrowed down (as it is here) to the way CGI has featured in Hollywood science fiction films. This last point is an important one, for even as it may be possible to insist there is something particular about the way CGI effects are exhibited in science fiction films—or that there is something about cinema that focuses audiences' attention on the computer-generated image in a way that other media don't—it is just as clearly the case that consumers' reception of this imagery has also been shaped by their engagement with the many dif-

ferent forms of print and electronic media that feature computer-generated images.

Since one of the arguments of this chapter is that we won't fully understand the kinds of claims CGI effects made—and continue to make—on audiences' attention if we persist in describing them solely in terms of photorealism or simulation, it may be necessary to preface this chapter's treatment of this issue by pointing out that it is not a matter of trying to do away with these terms either. "Photorealism" has an important place in the descriptive language that has evolved to describe computer-generated effects. One need only turn to the chapter on "Painting Science Fiction Textures," in *PhotoShop 5 3D Textures: F/X and Design* (1999)—a manual designed to assist users of this software package to create textures for sophisticated 3-D models—to be reminded of just how important this aesthetic project is to aspiring animators.[7] But neither "photorealism" nor "simulation" has the same kind of aesthetic valency that terms such as "illusionism" and "realism" have. And while there are circumstances in which the relation between them can be described as isomorphic, this is not always or necessarily the case. The fact that contemporary commentaries on the computer-generated image often fail to distinguish between simulation (most often understood in terms of the copying of physical or phenomenal reality), photorealism (the copying of photographic or cinematographic reality), representation (an action enabling the depiction of one thing by another according to a logic of resemblance/metaphor/difference or similitude/metonymy/simulacra), and realism (a mode of representation claiming some correspondence—whether of truth or of likeness—to physical, historical, or subjective reality) is only unimportant if it can be clearly established that there are no circumstances in which—or subjects for whom—distinctions among these terms matter. In the case of computer-generated images produced for the cinema, we clearly need a language for describing visual effects imagery that takes photorealism to be a condition and not the end of aesthetic production. Everything we know about the cultural reception of special effects in the past—and especially about audiences' desires to have this imagery meet their demands for a particular kind of aesthetic experience—invites us to be suspicious of narratives that represent the aesthetic project governing the production of computer-generated visual effects as one that necessarily values realism or photorealism over visual novelty.

The discipline of art history takes it for granted that "the world of art is not a collection of autonomous objects, but a magnetic field of reciprocal influences and activations," but attempts to apply this assumption to a historical analysis of computer-generated visual effects imagery remain rare.[8]

And yet fan-oriented publications such as *Cinefantastique* and the now-defunct *Sci-Fi Universe*—magazines concerned with developing an aesthetic (and to a lesser extent critical) vocabulary for describing computer-generated images—already apply something like an art historical framework to their analysis of computer animation. An article on *Toy Story* (dir. John Lasseter, 1995) in *Cinefantastique* attempts, for instance, to establish the legitimacy of computer animation as an artistic practice by demonstrating its affiliations with other aesthetic practices and movements (i.e., traditional celluloid animation/surrealism) but also by highlighting producers' own self-consciousness about their aesthetic choices. A quotation in which Lasseter explains that his design sense for *Toy Story* involved "taking elements from reality and making them into a heightened reality, because I didn't want to make it photo-realistic" thus appears in a caption box bearing the heading "Cartoon Surrealism."[9]

Both this chapter and the next are concerned with interrogating film and cultural critics' reluctance to treat this kind of aesthetic discourse seriously or even to acknowledge that it exists (in however piecemeal a fashion). This investigation is staged, in the next chapter, around an examination of the institutional nexus of science fiction cinema and the fan cultures cultivated through genre film fan publications, cultures, I will be arguing, that form part of a much wider, more diffuse network of readerships and audiences with a special interest in CGI effects. Because these fan-oriented publications already address such diverse readerships, they provide an unusually rich site for investigating the relation between aesthetics and reception. Through their coverage of stories and issues related to the production of science fiction television series, they have, for instance, not only provided a context for distinguishing between the aesthetic concerns of cinema and television but also for distinguishing between those of different television series. In his discussions with *Star Trek* fans at MIT, Henry Jenkins found that the students he spoke to often displayed "a detailed knowledge of how the special effects were done, how much different types of effects cost to produce, and the relative strengths and weaknesses of different designers." Such "insider knowledge," he noted, "is acquired either directly from fan-orientated publications such as *Starlog* and *Cinefantastique*, or indirectly from general discussions on the computer nets."[10] Over the years, the various art directors, production designers, and effects supervisors involved in rendering the *Star Trek* universe for television and cinema screens have been quick to point out that the aesthetic demands of fans do feed back into production and effects design. Fans' insistence that new *Star Trek* productions conform to their own sense of the series' "prevailing realist aesthetic" has shaped the look of these productions in important

ways.[11] However, the effects supervisors whose job it is to coordinate the visual realization of the otherworldly vistas, environmental anomalies, and never-before-seen artifacts of the *Star Trek* future also point out that realism doesn't quite capture the sense of visual novelty they are expected to bring to these futuristic wonders and marvels. Mark Wendell, a visual effects supervisor at Santa Barbara Studios, makes the point, for instance, that even though "there's a certain realism that you have to go for," because "most of the imagery that you're generating is purely fantastic," there is also some scope for bringing other aesthetic criteria to bear on the creation of this imagery once this basic requirement has been met.[12]

Beginning with a critique of the narratives of convergence found in the influential writings of Paul Virilio, this chapter argues that these narratives have unduly simplified the place of special effects in the history of computer imaging.[13] While this book is more broadly concerned with demonstrating that the contemporary cultural reception of CGI effects has been organized by some of the same institutional structures and discursive practices that organized older forms of effects connoisseurship, it is also concerned with mapping their transformation in the digital age. The second part of this chapter looks, then, at the kind of aesthetic discourse that circulated around stop-motion animation in the fantasy film fanzine *Photon*. Making its debut in 1963, this self-published zine addressed a culture of special effects fandom long before the first prozines appeared in the late sixties and early seventies. Its detailed reviews of "classic" animation films and in-depth interviews with effects animators and special effects cinematographers continued, however, to find a niche audience throughout the 1970s. Questions about the relation between special effects and realism, special effects and illusionism, and special effects and expressionism were regularly raised in these interviews and reviews. In addition to bringing a different focus to contemporary arguments about how these questions should be resolved, this chapter's examination of the culture of effects fandom addressed by *Photon* is concerned with identifying those aspects of aesthetic discourse on special effects that have undergone the most significant changes in the last twenty years.

The final sections of this chapter look at the kinds of cultural fantasies brought to bear on the cultural reception of CGI effects in their early years by the United States' best-known digital lifestyle magazine, fantasies and desires that cannot be understood without reference to science fiction cinema but cannot be entirely explained by it, either. Digital imaging technologies had been used to produce special effects for a number of science fiction films made in the seventies and eighties, films such as *Futureworld* (dir. Richard T. Heffron, 1976), *The Black Hole* (dir. Gary Nelson, 1979), *Looker* (dir. Michael

Crichton, 1981), *Star Trek II: The Wrath of Khan* (dir. Nicholas Meyer, 1982), *Tron* (dir. Steven Lisberger, 1982), and *The Last Starfighter* (dir. Nick Castle, 1984). However, detailed discussion and review of these effects rarely circulated beyond the readership of genre film magazines (*Cinefantastique, Starlog, Starburst*) and the even more restricted readership of *American Cinematographer*. In addition to a new crop of science fiction (or SF) fan magazines, a number of different types of publications sprang up to cater to the growing demand for information about computer-generated effects in the 1990s.[14] While publications such as *Cinefex* and *Computer Graphics World* continued to focus on the technical aspects of special effects production, in *Wired*—a second-generation computer lifestyle magazine—special effects acquired more rhetorical and even metaphorical functions, becoming the sign around which readers might imagine a place for themselves in the new media future.

THE LIMITS OF CONVERGENCE

In the inaugural issue of *Convergence: The Journal of Research into New Media Technologies* (1995), Roger Silverstone warned, "Convergence is a dangerous word." Part of what makes it such a risky and difficult concept to work with is that there are so many different types of convergence: industrial, technological, and sociocultural. Silverstone identifies a more serious problem with the word "convergence," however: namely, that it is often used to suggest there is a necessary connection between each of these domains, so that "convergence in one domain, usually the technological," is seen to have "inevitable consequences" for another domain of convergence, usually the sociocultural domain of technological use. "Yet we know," he argues, that the future of both old and new media technologies is "neither certain nor predictable" and that "technological change is neither determined in its development nor determining in its use."[15] These comments reflect Silverstone's desire to see research into new media and communications technologies move away from the globalizing abstractions of many contemporary forms of theorization toward more sociological forms of engagement with the meanings technologies acquire through everyday use.[16] His skepticism of contemporary narratives of convergence has, however, been shared by scholars working with very different historical and theoretical models. Identifying the issues that many of these narratives raise for film and media historians, Thomas Elsaesser has also voiced concerns about attempts to give very different applications for digital technologies a common evolutionary history. Elsaesser chooses "multimedia," "virtual reality," "telepresence," and "digital

sound" as examples of digital technologies that "have their own serendipitous and leap-frogging histories," pointing out that "it requires some feat of the synthesising imagination to conceive of them as belonging together, let alone, sharing a common evolutionary ladder."[17] Concerned not just with recovering the illusive origins of instruments and artifacts and still less with demonstrating their progressive refinement, the technological and cultural "archaeology" of new media technologies that Elsaesser calls for is concerned with thinking about the ways these technologies have been shaped by existing institutions. That the institutional histories of many new media technologies have important points of convergence is not a matter for dispute. What is being contested by the kind of archaeohistoricism that he proposes is the assumption that these histories will necessarily determine the ways these technologies are taken up by different institutions further down the track or the kinds of demands that consumers will make on them in the future.

The idea of convergence is much older than our familiarity with the word would suggest. Articulated to a critique of mass culture, it has its critical-theoretical roots in the writings of Frankfurt School theorists like Adorno and Horkheimer. In the hands of theorists such as Baudrillard and Virilio, the logic of convergence has come to stand in for the motor of history, hurtling us toward the end of days. It is no coincidence that the history of CGI effects has more often than not been subsumed in more general histories of computer imaging technologies. While there are signs that this is about to change, the fact that narratives exploring how computer graphics technologies have been adapted to meet the requirements of the special effects industry have rarely figured in histories of computer imaging technologies in part reflects a situation in which special effects have received very little sustained scholarly treatment of any kind. The less information there is about the patterns of production and consumption governing the use of new technologies in relation to older cultural forms, the more compelling do narratives of convergence become.

The special effects industry has long drawn on the skills of people who primarily regard themselves as artists and artisans. All kinds of special effects, and not just CGI effects, are in fact complex assemblages. The finished artifact has often passed through a number of different stages of assembly requiring, in addition to the skills of technicians, mechanics, or engineers, input from people trained in art and design. As this chapter reveals, at least some of the people who became involved in producing computer-generated imagery for Hollywood feature films during the 1970s and 1980s were first trained in other media, only later learning how to adapt and apply their skills as artists and animators to the production of CGI. The perception within the special

effects industry that computer animation is a medium for aesthetic expression—the limits of which are determined by the budget, genre, and style of the film that it is being produced for—sets it apart from other industries that produce computer-generated imagery. The computer animators who produce the computer-generated imagery used in scientific visualization or in flight simulation are not being called on to respond to the same kinds of aesthetic demands that animators working in the special effects industry must meet. If this seems like an obvious point to make, it is not one that has been made very often. It has more often been assumed that so far as the history of computer imaging is concerned, the principle casualty of convergence is the very category of the aesthetic.

The seductions and pitfalls of looking for the contemporary significance of special effects in the history of the technologies used to produce them is nowhere better illustrated than in the work of Paul Virilio, whose writings on cinema and the autonomization of vision in *War and Cinema* (1984) and *The Vision Machine* (1988) have provided contemporary thinking about the history of computer imaging with a particularly powerful—and, just as importantly, institutionally influential—way of framing that history.[18] In the first of these two books, Virilio posited that the development of cinematic applications for optical technologies originally developed for military purposes had caught up cinema in the logistics of military perception, in many ways making it a rather blunt instrument of militarist power. In an attempt to circumvent any objections that film historians might have to this monumental narrative of convergence, he argued that his historical concerns were "not with film history but with the osmosis between industrialised warfare and cinema."[19] But Virilio did not want to tell a story about osmosis so much as he wanted to be able to show how much the cinematic apparatus owes to military research and development of surveillance technologies, without having to be concerned with whether the empirical evidence used to support this view could be used to support another view of film history altogether. At one point in *War and Cinema* readers are advised "not to forget that the Dykstraflex camera made by John Dykstra for the film *Star Wars*—a camera in the service of a computer which records its own movements—was actually descended from a pilot training system" (87). On this occasion, it is the philosopher's methods that seem naively empiricist, for a more archaeological take on the history of this technology might indeed try to link it to earlier motion-control systems. At least one version of the history of motion-control technology has traced it back to an early system devised by one of Edison's cinematographers in 1914. According to an article by Nora Lee in *American Cinematographer*, James Brautigan developed an entirely mechanical

means of repeating the movements of his camera for a scene requiring him to double-expose ghosts.[20]

In his next book, Virilio was concerned with thinking about what happens to perception once it has been given over to computer-generated imaging technologies. *The Vision Machine* offers a glimpse into a world that has entered into the final stages of "the industrialisation of the non-gaze."[21] While the link between empiricism and historicism is every bit as attenuated in this book as it was in the last, Virilio finds in this attenuation the freedom to extrapolate. We are left, toward the end of *The Vision Machine*, with an apocalyptic vision of a society sinking into the darkness of a voluntary blindness. Like many more popular and conventional futurologies, this is a story about the emergence of an all-perceiving, all-controlling artificial intelligence. Virilio calls this terrible vision machine, the Perceptron.

If these kinds of narratives have the advantage, in W. J. T. Mitchell's terms, of making "the need for a global critique of visual culture [seem] inescapable," they do so by confounding some very real distinctions between the circumstances in which different types of computer-generated images are produced and consumed.[22] In making this critique, it may be necessary to insist that pointing out these differences does not have to vitiate all political and moral judgment, although it may make it more difficult to articulate these judgments in global terms. Arthur Kroker is right to insist that Virilio's theorization of technology makes up for its "low epistemological profile" with "a surplus of strategic significance."[23] At the same time, however, this is what ultimately limits its significance for a study of how computer imaging technologies have been applied to the production of cinematic visual effects.

Many of the computer animation techniques that came out of MIT, Bell Laboratories, and the University of Utah during the 1970s—for example, computer-controlled rotoscoping and texture mapping—didn't just facilitate the development of military, medical, and industrial applications for computer graphics technologies (i.e., flight simulation, scientific and medical visualization, and computer-aided design), they also facilitated the development of the computer graphics tools used to produce special effects for Hollywood films in the 1970s and 1980s. Writing about the history of computer imaging at the very start of the 1990s, Andy Darley pointed out that "it is possible to discern developments whereby realistic imaging techniques developed in one domain, cross-over and are applied in the other."[24] To illustrate the transfer of personnel and techniques from science and industry to entertainment, Darley offered the examples of Ed Catmull, a graduate of the University of Utah, who worked on the development of flight simulation software at the NASA Jet Propulsion Lab at the California Institute of Technology before joining the

digital research arm of Lucasfilm (later to become the independent company Pixar); and Gary Demos, who also worked in the aerospace industry before teaming up with John Whitney Jr. to form the Motion Picture Design Group at Triple—I (and, later, Digital Productions).[25]

If anything, the flow of people and technology from science- and military-based projects to the entertainment industry has increased in the years that have lapsed since Darley's essay was written.[26] In the United States a steady reduction in spending on military and aerospace research left many hardware and software development companies looking for new contractors in the early 1990s. In 1994 *Variety* published an article that looked at some of the difficulties facing many of the engineers and software designers who found themselves jobless and looking for work in Hollywood. A manager in charge of a Los Angeles County job-placement project suggested that the crossover was never going to be easy, if for no other reason than that "a lot of these people have no idea what the entertainment industry does or requires."[27] Even the article's success stories stressed the level of retraining needed to "combine engineers with art" (20). These kinds of testimonies are a reminder not only that in the messy collaboration between art and engineering that occurs in the field of entertainment, people still provide the material support for any kind of technological transfer but also that people with different types of training bring different skills to this process. This is important because contemporary accounts of the history of computer imaging still tend to emphasize the contributions of engineers over those of artists.

A history of computer imaging that also tried to trace the crossover of personnel and techniques from the art world—and the educational institutions that help to sustain it—might begin by acknowledging the significance of an institution like the California Institute of the Arts. The animation lab founded by Ed Emshwiller has provided a training ground for many animators who have gone on to work in the field of special effects. In its first years faculty included Jules Engel (founder of the experimental animation program), Gene Youngblood, and Pat O'Neill (an artist and experimental filmmaker who also started the special effects and optical printing company Lookout Mountain Films, in 1974). Describing O'Neill's influence on the student community at Cal Arts, William Moritz recalls that "O'Neill, in addition to the inspiration from his fascinating, exquisitely-complex animation/live-action films, influenced a generation of Cal Arts students, including Adam Beckett, Robbie Blalock, Chris Casady and Larry Cuba, who all worked on special effects for the landmark 1977 science-fiction feature *Star Wars*."[28] In his way, Moritz has done more than just about anyone else to demonstrate how entangled the histories of experimental computer animation and special

effects were in those early days. And this has been the case even on those occasions when he has been concerned with treating them separately. In the late 1990s he contributed a brief history of experimental animation to an online festival (Absolut Panushka) produced by Christine Panushka and sponsored by Absolut Vodka. On this occasion he wanted to make the history of experimental animation a history of films that, as he says, have been made by artists who have tried "to make something personal, exploring techniques to find exactly the right look to express it—something new, fresh, imaginative, dealing with significant subject matter, made independently and often single-handedly."[29] This meant excluding cartoons and animated films produced by major studios.

One of the most interesting figures to appear in Moritz's list of filmmakers who experimented with computer animation in the 1970s is Emshwiller himself. Over a twenty-year period Emshwiller also provided hundreds of cover illustrations for magazines such as *Galaxy Science Fiction* and *Fantasy and Science Fiction*. The history of science fiction illustration is the story of a commercial art form that sought over time to test the boundaries of the "rather strict representationalism" that governed the genre in the 1940s and 1950s.[30] In the sixties and seventies science fiction illustrators increasingly looked to other aesthetic movements—to surrealism, to German expressionism, and American abstract expressionism—to bring a sense of visual novelty to their imaging of the future. Moritz describes the resplendent, pulsating golden face that emerges from a mass of animated lines of color radiating from the third eye of the monochrome figure that begins Emshwiller's animated film *Sunstone* (1979) as "one of the classic computer graphics images."[31] As with so much science fiction imagery, it is in the play between representation and aesthetic experiment—between this image's graphic anthropomorphism and its novel electronic effects, between its familiar iconicity and its surprising luminosity, plasticity, and dimensionality—that its aesthetic ambition, its virtuosity are displayed.[32]

While it would be naive to imagine that the entertainment industry has cultivated anything like the same margin for aesthetic experiment, audiences do make demands on special effects that they don't make on other types of computer-generated images, and this has put the producers of this imagery in the position of having to find new ways of soliciting audiences' attention once the aesthetic novelty of a particular technique has worn off. One of the less convincing aspects of the claim that all the computer-generated images produced by the film industry have the same aesthetic goal is that it doesn't look at the range of aesthetic functions visual effects fulfill in popular cinema. It is the subjective dimensions of cinema spectatorship—social and collective as much

as private and individual—that get lost in these general histories of computer imaging. Even Lev Manovich, who has done so much not only to identify differences in the way computer-generated images function in different media (cinema, computer games, virtual reality) but also to show why these differences matter, has on occasion relied on a master narrative of illusionism to describe CGI effects. His early essay "Computer Simulation and the History of Illusion" begins by narrating the first part of a story that appears in E. H. Gombrich's *Art and Illusion* (1960).[33] The way Gombrich tells it, this is the story, relayed by Pliny, of "how Parrhasios trumped Zeuxis, who had painted grapes so deceptively that birds came down to peck at them." Parrhasios got the better of Zeuxis when he "invited his rival to his studio to show him his own work, and when Zeuxis eagerly tried to lift the curtain from the panel, he found it was not real but painted, after which he had to concede the palm to Parrhasios who had deceived not only irrational birds but an artist."[34] Manovich's story makes no mention of Parrhasios's triumph, ending instead with Zeuxis's success in deceiving the witless birds. To the extent that this story is intended to illuminate something important about illusionism, it functions as a fairly simple story of deception. The real story for Gombrich, on the other hand, is what happens next. Parrhasios succeeds in deceiving Zeuxis because he sets up a situation in which Zeuxis's expectation of seeing Parrhasios's work helps to carry the illusion off. Illusionism, Gombrich would famously argue, relies on the power of expectation (which he would also call the "beholder's share"). It is the subjectivist emphasis of Gombrich's theorization of illusionism that has had readers returning to it again and again. Often, it must be said, in some puzzlement and frustration.

As a number of Gombrich's readers have discovered, *Art and Illusion* is a work that oscillates between offering a naturalistic theory of vision—which suggests that at some level we perceive all illusionistic imagery to be a natural sign—and an argument for looking at how perception is shaped by cultures of appreciation and connoisseurship.[35] With respect to the first of these concerns Gombrich points out that illusionism in no way depends on realism to achieve its goal. Illusionist imagery can just as effectively take the form of comics and cartoons. The question for him is whether certain images "suggest a reading in terms of natural objects."[36] Do certain types of visual effects naturally solicit such a reading? More promising is Gombrich's suggestion that the "social context" in which viewers acquire an appreciation of an artist's virtuoso control over his (or her) medium and knowledge of the techniques used to create certain kinds of visual effects "has hardly been investigated." Artists, he argued, create their own elite, "and the elite its own artists" (234). But if Gombrich seems at moments like this to be suggesting that view-

ers' appreciation of illusionistic images lies in a cognitive appreciation of the image as art and artifact, he is at other moments compelled to argue that it is "the power of [natural] expectation rather than the power of conceptual knowledge that molds what we see in life no less than art" (225). The closest he ever comes to reconciling these two opposing ideas about the aesthetics of illusionism is to suggest, after the German critic Konrad Lange, that "all reading of images demands what Coleridge calls a 'willing suspension of disbelief.' To him all aesthetic pleasure in art was rooted in our oscillation between two series of associations, those of reality and those of art" (238).

If this compromise is not entirely satisfying, it does raise the possibility that within a culture of connoisseurship, appreciation of an illusion lies less in any desire for a natural object than in an appreciation of the illusion as aesthetic artifact. The question, I would suggest, is whether certain types of illusions specifically solicit this kind of appreciation from viewers. Certain types of cinematic visual effects may in fact be described as simulationist, being geared, on the one hand, toward the representational simulation of objects in the natural world and, on the other, toward the phenomenological simulation of photographic or cinematographic reality. But within a culture of connoisseurship even visual effects images that can be described as both illusionist and simulationist may still be appreciated as aesthetic objects. Still other types of visual effects imagery may, however, be geared more strongly toward eliciting a specifically aesthetic appreciation of the image as art and artifact. Determining whether this is the case admittedly poses certain problems, but none that are not already familiar to film history and criticism.

One way of approaching this task would be to examine how certain types of visual effects images are presented. What is their relation to the narrative? How are they formally—that is, spatially and temporally—organized on the screen? Is there anything particular about the kind of spectatorial relation to the film that is being solicited at these moments? These, in fact, are questions for the next chapter, which includes an examination of the history of art-and-effects direction in recent science fiction cinema. Another approach would be to examine the testimonies of effects producers: how do they describe their aesthetic intentions? And, more important, how, and in what contexts, are those intentions communicated to viewers? Then there is the possibility of trying to demonstrate the ways in which certain types of visual effects draw upon or rework the aesthetic conventions associated with other popular aesthetic forms and practices. This chapter utilizes both of these approaches. There is no question that computer-generated imaging techniques have necessitated a rethinking of aesthetic practice for both producers and fans of special effects and that this rethinking is reflected in the way computer-gen-

erated images have featured in a contemporary magazine such as *Wired*. The language of aesthetic appreciation, the social organization of effects connoisseurship, the relation between amateurism and professionalism: all these relationships have undergone significant changes since the 1960s and 1970s, when another type of dimensional animation captured the attention and imagination of cinema audiences.

PHOTON AND STOP-MOTION ANIMATION

In his editorial for *Photon*'s tenth anniversary issue, Mark Frank recalled that "back in 1963, the field of filmzines was filled with but a few isolated examples of creativity and imagination. *Gore Creatures*, *Garden Ghouls Gazette* and *Orpheus* immediately come to mind. Now, a decade later, the genre of filmmaking which we have adopted has come into at least a modicum of acceptance, and new magazines, both fan and professional, are appearing all the time."[37] *Photon* had also undergone a few changes over those years, particularly in the areas of printing, layout, and design, which gradually assumed many of the graphical conventions of the prozines (although it continued the practice of reducing the font size for selected sections of text—usually the letters pages—in order to maximize space). Published (irregularly) out of Brooklyn, New York, between 1963 and 1977 and sold mainly through subscription but also through selected bookstores and newsstands, each forty-eight-page issue could be relied on to contain—in addition to Frank's regular editorial—fan art, film reviews, letters pages, and a glossy black-and-white collectible film still.[38] But beyond these regular features, *Photon*'s contents varied widely from one issue to the next, with features ranging from annotated filmographies and retrospective studies of film classics to interviews with special effects and film industry professionals. Ronald V. Borst's meticulously researched filmography of vampire films not only took up half of two consecutive issues (1969–70) but was succeeded by another nineteen pages of "Additions and Corrections" (1971) in a third and final installment.[39] Here, as elsewhere in the magazine, genre film fandom reveals its attachment to the archive. The fan filmographer is concerned with the retrieval, recovery, and (re)memorization of details about the filmmaking process that have either never been committed to memory or have since been forgotten. Far more significant than any differences of style and presentation, this desire for comprehensiveness—for in-depth coverage of topics—most distinguishes ∨hoton from a later prozine such as *Starlog*. In the 1970s only *Cinefantastique* matched and, with its greater resources, even outstripped the

detailed level of coverage of topics found in *Photon*. Frederick S. Clarke and Steve Rubin's extraordinary sixty-two-page retrospective of the making of *Forbidden Planet* (dir. Fred McLeod Wilcox, 1956) remains the most valuable source of information on that film's production history.[40] Rubin's meticulous research and skillful interviewing of writers, artists, and production crew for retrospectives of other science fiction films of the 1950s earned him the informal byline of "film-archaeologist."[41]

A tantalizing profile of *Photon*'s readership emerges from the results of a reader survey conducted in 1976. In interpreting these results, Frank cautioned readers to remember that while they shed "some light on the type of person who reads a magazine devoted to imaginative cinema, care must be taken not to generalize too widely from the data obtained."[42] Of the 500 questionnaires sent to subscribers, 212 were returned, representing approximately 5 percent of the magazine's total readership.[43] That the survey was designed, among other things, to debunk popular stereotypes of fans as obsessed loners is apparent from the kinds of data collected. In addition to being asked to give details about education, occupation, income, and marital status, readers were also asked to describe their "non-fan social life." With obvious satisfaction, Frank noted that only "7% checked lonely, which will perhaps surprise those who would prefer to categorize all of fandom with that adjective." On the other hand, he also noted that the same proportion of respondents were female, adding hopefully that the "ever-increasing number of women attending conventions is a promising portent." But perhaps the most interesting results of this survey are those that reflect fans' hopes and fantasies of one day becoming involved in professional filmmaking. Among those respondents who were either employed in occupations unrelated to their fan activities or still in college, the overwhelming majority expressed a desire to find "fandom-related jobs such as film actor, writer and artist," while just under half the sample claimed to have made their own 8mm or 16mm fantasy films. "Of course," Frank added, "one wonders how many of those who wish to be filmmakers, actors, and such will actually be able to fulfill their dreams." While we still can't speculate about this outcome with absolute certainty, it is clear that the professional-fan nexus cultivated by fanzines focused fans' attention on the filmmaking process—on the actual making of films—quite as much as it did on the finished artifact. This desire to look behind the scenes, to force the craft of filmmaking to reveal itself or even to imagine what it would be like to be at the scene of production, suggests a model of spectatorship that challenges the modernist assumption that mass culture appeals to the senses over the intellect, offering mere sensory

distraction in the absence of any possibility of contemplation. For what we find in *Photon* is the cultivation of an attentional complex that is principally concerned with aesthetic evaluation and judgment.

Calling itself a fantasy filmzine, *Photon* took an interest in all the genres that make up the cinema of the fantastic: fantasy, horror, and science fiction. In response to the question, "What is your favorite genre film?" *King Kong* (dir. Merian C. Cooper/Ernest B. Schoedsack, 1933) emerged as a clear favorite. Of the other six films listed, half were science fiction films: *Invasion of the Body Snatchers* (dir. Don Siegel, 1956), *The Thing* (dir. Christian Nyby/Howard Hawkes, 1951), and *The Day the Earth Stood Still.* Notably absent from this list is *2001: A Space Odyssey* (dir. Stanley Kubrick, 1968), a film that, in a twice-printed review, had been dubbed "a classic par excellence."[44] But as another reviewer had pointed out some years earlier, "One's favorite movies are not necessarily those one thinks are the best—my favorite movie is *Forbidden Planet*; the one I think best is *2001.*"[45] The comparison between *2001* and *Forbidden Planet* is suggestive. In contrast to the former's emphasis on visual abstraction and social satire, *Forbidden Planet* recalls an older, much more discursive model of science fiction. The critical reception of the film tended to focus on its self-conscious reworking of Shakespeare's *The Tempest*, but with the mad scientist Dr. Morbius in the role of lecturer and showman—taking viewers on a tour of the "wonders" of the Krell laboratory—its visual attractions also recalled those of the phantasmagoria.

It was against the backdrop of science fiction's turn toward parody and satire in the 1960s and 1970s, in films such as *The Monitors* (dir. Jack Shea, 1969), *Dark Star* (dir. John Carpenter, 1974), and *Dr. Strangelove; or, How I Learned to Stop Worrying and Love the Bomb* (dir. Stanley Kubrick, 1964), that the 1950s emerged as the decade of "classic" science fiction cinema. Nostalgia for the films of the 1950s can in part be seen as a reaction against these films' loss of faith in the future. In the science fiction films of the 1950s, the artifacts of modernity and its futures were sites for all kinds of anxieties about the role of technology in the modern world. In many of these films, the progress of science and technology portends disaster, thwarting all efforts at containment and threatening to bring about the end of the world. In *Forbidden Planet* the Krell's dream of a "civilization without instrumentality" unleashes the monster from the id: the violent underbelly of scientific rationality and an unforeseen consequence of the conquest and colonization of deep space. But the destruction and disillusion of the Krell dream is not without its compensations. The film ends as it began, back onboard a spaceship, with the astronauts of the future enjoying the comforts of modern space travel. In *The Day the Earth Stood Still*, the alien Klaatu warns the warring nations on Earth that

their violent ways will not be tolerated by alien populations on neighboring planets. If his own species' neocolonialist solution to ending conflict—a police force of robots that has been given the power to punish aggression without discretion—points to a future that is not without its terrors, it is also not without its scientific and medical marvels. This appeal to the marvelous, to a future of exploration and adventure made possible by amazing technologies, also has to be reckoned among the attractions of a film such as *When Worlds Collide* (dir. Rudolph Maté, 1951) and even *Earth vs. the Flying Saucers* (dir. Fred F. Sears, 1956). But it was certainly not the only way the science fiction films of the 1950s engaged audiences' hopes and anxieties about the future. In contrast, *Invasion of the Body Snatchers* drew viewers into a noir nightmare from which there was no waking up.

The 1960s also saw changes, both in the economic circumstances of the Hollywood studios and in the aesthetic and sociopolitical ambitions of filmmakers, that contributed to a shift away from genre filmmaking. By the end of the decade enough of the major studios had shut down their effects departments to make fans' hopes of a science fiction revival seem a remote possibility. In an interview with David "Stan" Horsley—head of Universal Studios' Special Photographic Effects Department from 1945 to 1954/5—Horsley and his interviewer took the opportunity to reminisce about this "bygone era" of visual effects production, an era, according to Horsley, that began to draw to a close when "the science fiction cycle petered out in the late fifties."[46] But despite shrinking opportunities to work in the field of special effects, one area of visual effects production continued to attract fans with aspirations of working in the film industry: stop-motion animation. *King Kong*'s popularity among genre film fans is itself an indicator, in animator Jim Danforth's words, of the "aura which tends to surround this profession."[47] *Photon* was very much a part of the culture of appreciation surrounding animation and animation films, receiving support from two of the best-known animators working in the United States (Danforth and Dave Allen) and devoting numerous articles to detailed analyses of the work of Ray Harryhausen. The fact that Harryhausen was an independent effects producer, working out of his own studio in London for much of his career, even gave fans reason to hope for a professional life beyond the Hollywood studios.

It was not only fans who frequently imagined fandom to be preparation for a career in animation; animators' own accounts of their careers tended to confirm this view. In interview after interview, Harryhausen has been asked to describe his relationship to Willis O'Brien, who was responsible for the animation in *The Lost World* (dir. Harry D. Hoyt, 1925) and *King Kong* and with whom he worked on *Mighty Joe Young* (dir. Ernest B. Schoedsack, 1949). In

most versions of this story, the experience of viewing *King Kong* as an adolescent assumes the importance of a primal scene, the vision of its monstrous couplings feeding the young Harryhausen's fantasies of reenacting them himself. Even after twenty years in retirement he is still delighting fans with his confession that "I went to see it again and again. I was a *King Kong* addict! I loved the way the film took you from the mundane world into the surreal."[48] Although Danforth didn't begin his career in special effects until the early sixties, he tells this story too. But in his interview with Frank he also added that "if it had been left only to the work that O'Brien did, I might not have carried on or might have only fooled with animation as a hobby."[49] For, as he went on to explain, it was Harryhausen who inspired the animators of his generation to think that they could make a living out of special effects. He was, as Danforth put it, "something to idolize and aim for" (12). Early in the interview Danforth draws a distinction between "knowing about" and "knowing how to," explaining his perception that "a lot of young people may spend time in this field without realizing how much work is actually involved and how much exacting technical preparation is necessary" (17). His own identification as a fan—his sense of being part of a generation of animators who are also fans—nevertheless speaks loudest to the magazine's readership.[50] Because in identifying fandom as a mode of identification that cuts across the professional/nonprofessional divide, an imaginary continuum has the potential to open up in its place. At the very least, the fact that fandom was seen, even part of the time, by the professional animators who contributed to *Photon* as a mode of identification and subjective engagement shared by amateurs, enthusiasts, and professionals alike—and not as a way of distinguishing consumers from professional producers—enabled nonprofessional fans to address their opinions and criticisms to professionals as participants in a shared culture.[51]

Toward the end of one of his best-known essays on mass culture, Benjamin proposes that "reception in a state of distraction, which is increasing noticeably in all fields of art and is symptomatic of profound changes in apperception, finds in the film its true means of exercise." The "film," he continues, "makes the cult value recede into the background not only by putting the public in the position of critic, but also by the fact that at the movies this position requires no attention. The public is an examiner, but an absent-minded one."[52] The distinction that Benjamin draws in this essay between "distraction" and "attention" is based on the perception—shared by other modernist thinkers of his generation—that mass cultural forms do not solicit the contemplative attention of audiences. Benjamin's own attitude to the reorganization of reception under the conditions of mass culture has none of the melancholy or determined negativity of that of some of his contempo-

raries. In response to Duhamel's characterization of film spectators as "worn-out creatures" consumed by a spectacle "which requires no concentration and presupposes no intelligence," he impatiently observes that this is "the same ancient lament that the masses seek distraction whereas art demands concentration from the spectator" (232). If Benjamin had any reservations about the masses' receptivity to distraction, they found compensation in what he took to be its historical consequence: the disenchantment of art. For the values that he associates with the cult reception of artworks—the romantic values of genius, universalism, aesthetic tradition, and *l' art pour l' art*—all the values, in fact, that give artworks their auratic power over the beholder in bourgeois culture, are the same values in his view that make that culture receptive to something like fascism.

Like Kracauer before him, Benjamin had grasped something important about the way the reception of film differs from the reception of older cultural forms, but some of the cult values he describes have also been taken up and reinterpreted by contemporary cultures of connoisseurship and fandom.[53] It is precisely under the conditions of mass culture—conditions, one might even say, that are not of these cultures' own making—that the need to find ways of making mass cultural forms meaningful, of investing them with social and historical significance, has become more insistent. These cultures clearly cannot be accounted for by a theory of reception that is predicated on a model of distraction. Nor, interestingly enough, do they conform to Jonathan Crary's suggestions for rethinking this model. Crary's recent attempt to sketch some outlines of a genealogy of attention since the nineteenth century has, in his own words, sought to qualify "some assumptions that have been part of a long-established critical characterization of modernity in terms of experiences of distraction."[54] Rather than seeing attention or contemplation as a mode of reception that has been succeeded by distraction, Crary argues that "attention and distraction cannot be thought outside of a continuum in which the two ceaselessly flow into one another, as part of a social field in which the same imperatives and forces incite one and the other" (51). Some of his descriptions of the way attention gives way to distraction and reverie under conditions of intense concentration succeed rather wonderfully in producing a jolt of surprise and recognition. Here, however, it is important to point out that even as the act of "paying attention" may in certain circumstances suspend individuals' sense of relation, collectivity, and social participation in the act of viewing (and/or listening)—momentarily isolating, separating, and immobilizing them in the way Crary describes—it is in the process of remembering, translating, and representing this experience for themselves and others that it has the potential to be retrospectively construed as a shared experience. Cultures

of connoisseurship and fandom cultivate an attentional complex in which it not only becomes important to "pay attention" at the movies but also to attend to discussion and evaluation after the fact.

The aura that surrounds stop-motion animation in *Photon* is every bit the product of its cult reception. But if this mode of reception resembles the romantic model sketched by Benjamin in its valorization of the effects wizard-auteur and nostalgic re-creation of a bygone era of classic images, these ideas also proved to be more mutable, more open to contestation and debate in popular translation. Fans certainly had no doubt they had found a bona fide auteur in Harryhausen, whose control over every aspect of visual effects production seemed to them to have given him undisputed authorship over his animation work.[55] Although he provided animated effects for a number of science fiction and science fantasy films, his preferred canvases were fantasy extravaganzas like *The Seventh Voyage of Sinbad* (dir. Nathan Juran, 1958), *Jason and the Argonauts* (dir. Don Chaffey, 1963), and *The Golden Voyage of Sinbad* (dir. Gordon Hessier, 1974), all quest narratives set in mythological settings that serve as colorful backdrops to a succession of increasingly complex effects sequences. As with many other such reviews, the review of *The Golden Voyage of Sinbad* in *Photon* is primarily concerned with developing an aesthetic vocabulary for describing the kind of viewing pleasure that this type of film offers. Much of the discussion is structured around a detailed critique of the film's media reception. How is it, the review asks, that so few critics failed to associate the name "Harryhausen" with what "would at the very least be an accomplished technical work." Reviewers for the *New York Daily News*, *New York Post*, and *New York Times* are taken to task for criticizing a fantasy film for its lack of realism, for failing to recognize the craftsmanship that went into producing the film's intricate effects sequences, and for misrecognizing the film's audience (since "there seems to be no end to 'the kids will love it' approach"). On the other hand, reviewers for a wide range of smaller publications—among them, the *Catholic Film Newsletter*, the *Long Island Catholic*, *McCall's Magazine*, and the *Village Voice*—are commended for, "wonder of wonders," actually using "such names as Harryhausen, Schneer [producer], Clemens [writer], etc., as if their readers were generally aware and need this information for legitimate purposes."[56] Demonstration of these "legitimate purposes" is indicated through a series of citations from Leonard Maltin's review in *Good Times*, which is singled out for special praise: "Maltin, who teaches a college-level course in film animation, continues: 'the film marks (in this viewer's eyes) the most sophisticated special effects to date from Ray Harryhausen's bag of tricks. This artist and craftsman got his inspiration from *King Kong*, and forty years later has reached the apex of perfection in his

own model animation' " (14). Maltin's review recognizes fans' desire to have the craft of effects animation treated as a legitimate (i.e., authored and hence authorized) form of aesthetic expression. That the animation sequences in a Harryhausen film specifically solicit their appreciation of this artisan's handiwork is something that fans take for granted. They demand, and reward, films that submit these sequences for their prolonged attention, granting them time to linger over the image and to pick out any innovation in technique. Thus a review of *The Valley of Gwangi* (dir. James O'Connelly, 1969) praises the film for its editing, which "does not short change us on animation" by cutting "from animation to live-action in very brief takes."[57] "Show me the monster" is the animation fans' most insistent request. And it is this demand, so curious and wondering, so desirous of an intellectual engagement with the process of animation—however much it is also implicated in more private and less tangible fantasies—that has been so little commented on outside fan circles.

Susan Sontag's cool appraisal of the aesthetics of the science fiction films of the 1950s barely touches on the creature cycle of films, among which Harryhausen's animation in *The Beast from 20,000 Fathoms* (dir. Eugène Lourié, 1953) looms large.[58] It is perhaps because these films are so much less discursive—so much less concerned with plot, or science, or the future—than other films of this period that they have been passed over. The "creature features" have after all been cordoned off from the genre of science fiction on these grounds on many occasions since.[59] Of course, other films in this cycle eschewed expensive stop-motion animation for low-budget solutions to realizing their menacing creations. *Tarantula* (dir. Jack Arnold, 1955) used optical printing techniques for combining traveling mattes with background scenery to make footage of real arachnids appear impossibly large. While *Them!*, a film about a colony of mutant ants grown gigantic as a result of atomic radiation, relied on full-scale articulated models and partial models (equipped only with heads and antennae) for its hairy critters. The make-do aesthetic of many model effects (used extensively in Toho Studios' *Gojira/Godzilla* cycle of films), with their proximate, "near enough is good enough" approach to cinematic realism, meant that they were as likely to be viewed negatively by nonfans of the genre (i.e., as lacking in realism), as they were to be appreciated for their preparedness to risk this same critique by fans. In contrast, the effects sequences in the stop-motion animation films in this cycle were illuminated by a technical brilliance that made them objects of curiosity and wonder. The fact that this imagery outstripped fans' and aspiring animators' ability to fully conceptualize its reproduction was part of its attraction, for knowing about the process did not make its domestic repro-

duction any more feasible for amateur producers, who both recognized and delighted in the fact that the sheer scale of these productions would always outstrip their own resources.

Did audiences—fan audiences—not also look to these films to imbue this imagery with a certain realism? The answer is yes. In the *Photon* review of *The Valley of Gwangi*, a description of the film's "two most amazing technical shots" emphasizes the insertion of "real" live action into the animated sequences: "An animated pterodactyl swoops down and smoothly scoops a real body off the back of a burro. And a real man leaps onto the fallen, animated reptile and breaks his neck; his real hands grasp its miniature head in an almost perfect use of Dynamation [the term Harryhausen coined to describe the combination of stop-motion animation with live actors and live-action backgrounds filmed in color, which had the added advantage of distinguishing stop-motion animation from cartoons]" (figure 2.1).[60] The reviewer's appreciation of these shots demonstrates an ability to identify the techniques used to create the illusion of interaction between animated and live-action characters. The animation fan is no naive realist. Within the context of genre film fandom, effects connoisseurship is, among other things, an education in the techniques of perspectival realism, the acquisition of which opens the door to forming a preference or a taste for a range of visual styles.

Although all visual effects imagery is more or less bound by the conventions of perspectival realism, Harryhausen's preference for romantic, storybook narratives set in fantastic or mythological worlds was based on the freedom it gave him to treat his animated characters more expressively once institutional demands for a "certain realism" had been met. He had no qualms about the formative tendencies of his own brand of cinematic illusion and was happy to be associated with what Danforth identified as "effects oriented" rather than "people oriented" films. Danforth's own assertion that effects should be used in a film to augment a strong story, instead of functioning as its main attraction, continues to reverberate in the contemporary context. Of *Gwangi* he wrote: "As far as being a film it's just dreadful. It violates all the rules of character development and screenplay writing, and how anybody could spend the amount of money that they did and the time that they did, and make a picture like that on such a wheezy foundation is totally beyond me."[61] On the whole, however, genre film fans have been more tolerant than Danforth of films that violate the conventions of classical Hollywood filmmaking, identifying them as the not unwelcome outcome of a shift from character to action oriented narratives. As the reviewer for *Gwangi* happily admits, "The characters, of course, are stereotypes, which like a simple

FIGURE 2.1 *The Valley of Gwangi* (1969, copyright Warner Bros.)

plot, is generally desirable in a fast-paced action picture."[62] Fans still want to be moved, to experience a sense of emotional engagement with these films. But it is the visual realm, not just visual effects imagery but also mise-en-scène—all the elements that go into creating a visually exciting alternative to the real world—that becomes an especially important site of affect. Even more conventional narrative cinema offers pleasures beyond narcissistic identification with characters or the director or the secretive, voyeuristic pleasures of seeing without being seen. All cinema offers its cineasts the aesthetic pleasures associated with an appreciation of craft, including the art director's, costume designer's, makeup artist's, cinematographer's, and editor's crafts. Appreciation of the stop-motion animator's craft begins with an ability to recognize the painstaking and meticulous labor it involves.

While he had written it with the intention of persuading aspiring animators of the need to create more sympathetic animated characters, Dave Allen's essay "Dramatic Principles in Stop-Motion" has much more to say

about how this special effects technique came to lose its purchase on the future. His reading of *King Kong* is wildly romantic, seductive in its desire for a cinema distinguished by its aesthetic vitality, recklessness, and informality. Against "realists" like Danforth, Allen identifies these qualities with an effects-oriented style of filmmaking that puts the effects artifact on display, granting animators some small freedom to pursue less strictly conventional aesthetic objectives than those governing the production of live-action sequences. This "sort of 'effects license' is," he argues, "almost non-existent today, because effects work tends to be chiefly augmentative in nature, and is thus forced to cut realistically with the whole."[63] But the "modern sterilizing tendency" that Allen identifies with this pressure to make effects sequences more simulationist, more illusionistic is, in his view, also an effect of technological standardization. The atmospheric style of *King Kong*'s animated effects—which display all the signs of having been "*designed*, painted and built by hand"—is attributed to "the fact that the *absence* of such technical apparatus often forced the greater burden upon *artisans*, who had to substitute art for technique simply because no other means existed" (27). Nostalgia for a culture of artisanship seeps into aesthetic discourse on stop-motion animation in anticipation of its imminent dissolution. For the problem, as Allen identifies it, is that the vitality of stop-motion animation would not survive the rationalization of aesthetic effect that the standardization of technique brings with it. That way, he felt, lay an intolerable repetition. What Allen doesn't say is that stop-motion animation had also come to be associated with a limited range of images. After so many years its gargantuan monsters were losing their auratic power over all but the most dedicated audiences.

In the more than twenty years since he made his last animation film, Harryhausen has been asked to speak about his career at animation festivals all over the world. In an interview that he gave in conjunction with one of these appearances, he was asked for his impressions of the contemporary special effects industry. How did he see effects animation now that it was being produced digitally? And did he have any advice for young people wanting to enter the profession in 2000? Although cautious about dispensing advice, Harryhausen conceded that it is his impression that digital technologies have completely transformed effects work. Faced with an industry in which effects sequences are subcontracted out to different companies and elements of the same sequence are produced by separate departments, he admitted that "now when I see five people listed as producers before the title—I worry that this will be a film made by a committee rather than individuals." Later he added, "I don't see the same room for individual touches."[64] Harryhausen is not

alone in seeing in the disappearance of an artisanal culture the end of craft, of individual expression and art. This has been the basis of many a critique of CGI. At the same time, others have argued for a rethinking rather than a jettisoning of these terms. From the beginning, *Wired* has been a site for the renewal of a futurist discourse on computer imaging that has invited just such a rethinking of aesthetic expression.

CORPORATE FUTURISM/TECHNOFUTURISM

The November 1997 issue of *Wired* featured a special report on the future of Hollywood filmmaking ("Hollywood 2.0 Special Report: The people who are reinventing entertainment").[65] In the future conjured up by this report there is no film—theaters bear little resemblance to the suburban multiplex so familiar to cinemagoers in the late twentieth century—and feature films are being created on desktop computers for less than $1,000. The cinema of the future promises at once to deliver filmmaking into the hands of home-computer users and to make actually going to the movies an entertainment experience more akin to a trip to a theme park. Hollywood 2.0 is do-it-yourself cinema and Holodeck Enterprises Pty. Ltd. all rolled into one. The greatest curiosity of this industrial artifact is, however, its special effects industry. For despite the closing of a number of high-profile special effects houses in 1996/97 (Buena Vista Visual Effects, Warner Digital Studios, and Boss Film Studios), the special effects industry is still the next-best thing to this fantasy elsewhere that Hollywood 2.0 has to offer.[66]

The "Hollywired Index" that accompanies this special report plots the emergence of Hollywood 2.0 in terms of the history of computer-generated imagery in Hollywood cinema. A checklist of "firsts" for CGI in feature films lists the first completely computer-generated sequence in a feature film ("Genesis effect" in *Star Trek II: The Wrath of Khan*), the first completely computer-generated character ("Stained-glass knight" in *Young Sherlock Holmes*), the first morph (*Willow*), and the first computer-generated main character ("T-1000" in *Terminator 2*). Similar lists have been a recurring feature in this magazine that was launched just as public interest in computer-generated special effects was nearing its peak. The very first issue featured an article on the special effects company Pacific Data Images ("Beyond the Valley of the Morphs"). Subsequent issues featured articles on effects house Digital Domain ("Digital Deal"), on Digital Domain's cofounder, James Cameron ("Cameron Angle"), and on ILM's George Lucas ("Beyond *Star Wars*"). Special effects were also the cover story for the December 1995 issue, which

featured an article on the history of the Hollywood special effects industry ("The New Silicon Stars") and another on the making of *Toy Story* ("The *Toy Story* Story").[67]

The regular features on the Hollywood special effects industry, interviews with computer animators, and reviews of entertainment applications for computer graphics-based programs have been only the most obvious sites where special effects figure in the magazine as content. In "Fetish" (a regular section reviewing the latest consumer electronics products for self-proclaimed and would-be hardware fetishists), readers are regularly addressed as producers of special effects. This is a trope that also appears in advertising for computer hardware.

Wired was by no means the first magazine to feature articles, advertising, and artwork that appealed to readers in this way. *Mondo 2000* may have seen its heyday by the time *Wired* came along, but it was once the lifestyle magazine of choice for anyone with designs on the digital future. And along with the crash courses in "DIY TV" and interviews with the Hollywood digerati, it too fed readers' home-production fantasies with sumptuous, digitally enhanced photomontages and glossy computer-generated images. It is *Wired*, however, with its saturation level advertising, digital art effects, and extensive coverage of the entertainment and consumer electronics industries, that provides the best site for examining some of the economic, technological, and aesthetic rationalities that shaped the way new media consumers and would-be producers looked at CGI in the 1990s.

In the years between its launch in 1993 and its takeover by the global publishing corporation Condè Nast Publications in 1998, *Wired*'s postfeminist posturing and consistent editorial support for a free-market, technolibertarian stance on government regulation of the way that the information technology and communications industries do business was the focus of intense criticism from academics, journalists, and readers alike.[68] Paulina Borsook's pointed critique of the magazine's editorial policies under editor/publisher Louis Rosetto and managing editor John Bagatelle seemed to confirm feminist suspicion that readers' demands for greater coverage of women's contributions to the "new digital culture" that Rosetto had identified as the magazine's editorial domain were being met with indifference.[69] More difficult to pin down, the magazine's visual gestalt also captured the attention of cultural critics interested in speculating about the ramifications of a design sense that appeared to many to have made of the computer-generated image not so much a new kind of aesthetic object as a new kind of corporate logo. *Wired* differs from other publications that regularly report on the special effects industry in being neither a magazine that is specifically produced for indus-

try professionals (e.g., *Cinefex, American Cinematographer, Computer Graphics World*) nor one that is primarily addressed to genre film fans (*Cinefantastique, Starlog, Sci-Fi Universe, SFX*). What sets it apart from these other publications is that in *Wired* readers' interest in computer-generated imagery is solicited visually as much as discursively. While this is not something that has escaped the attention of the magazine's critics, how *Wired*'s own computer-generated artworks have contributed to readers' visual education in the aesthetic possibilities of CGI has.

This is certainly not the first time that reflection on the visual style of this magazine has centered around some kind of rumination on, or invocation of, computer-generated visual effects. In "*Wired* Unplugged"—a version of a review that originally appeared in *Educom Review*—Mark Dery suggests that the magazine's layout and design in fact simulates the polymorphous perversity of a "computer graphics effect."[70] Invoking an already iconic moment in the history of CGI in Hollywood cinema, Dery wonders if *Wired* isn't "actually the shape-shifting android from *Terminator 2*, disguised as a magazine." In its use of digital production technologies, he likens it to "the liquid metal T-1000, whose 'mimetic polyalloy' enables it to morph into anything it samples by physical contact" (par. 1). Dery is a perspicacious commentator on contemporary technocultures. His analysis of the subcultures that have emerged among underground roboticists, cyberbody artists, postmodern primitives, and cyberpunk rockers in *Escape Velocity* (1996) is happily devoid of the kind of "cyberdrool" that sometimes passes for theoretical reflection at the more ecstatic end of cultural commentary on the liberatory and communitarian potential of new technologies.[71] The appeal of these subcultures for Dery is that while they take it as a given that "technology is inextricably woven into the warp and woof of our everyday lives," they also manage to "short-circuit the technophile-versus-technophobe debate" that tends to follow this assumption.[72] Some, it would seem, even go so far as to turn a critical eye on that ubiquitous new formation "the military-industrial-entertainment complex."

The same, however, cannot be said for the readership that Dery imagines for *Wired*, this magazine simulating a simulation. If he chastises Langdon Winner for taking *Wired*'s hyperactive visual design to be a sign that the magazine lacks substance, it is because Dery is too perceptive a critic not to recognize that *Wired*'s slippery, refracting visual style reverberates with meanings of its own. Curiously, he posits its "aesthetic of overt manipulation—of 'overdesign'—as the graphic equivalent of the opening sentence in William Gibson's *Neuromancer*: 'The sky above the port was the color of television, tuned to a dead channel.' " It's an odd choice, not least of all because the flick-

ering fuzz that appears on a television set tuned to a dead channel appears to be strangely monochrome. It is not an image, in other words, that is readily identifiable as the textual equivalent of *Wired*'s Day-Glo graphical interface. The point of this reference is, however, clear enough, for having drawn a parallel between Gibson's vision of the future and *Wired*'s professed desire to produce a magazine that looks "as though it had literally landed at your feet as a messenger from the future," Dery suggests further that "both Gibson's world and *Wired*'s remind us that technology is transforming our environment into a profoundly denatured, digitized—and, increasingly, corporate—place." One of the discursive effects of this review's rhetorical drive for similitude is that it becomes impossible to distinguish between *Wired*'s visual style and something approximating its worldview. On one level, this seems entirely appropriate, for as Dery himself points out, it is not for nothing that Marshall McLuhan is listed as "Patron Saint" on the magazine's masthead. The problem with this thinking lies not in trying to ascertain the cultural meaning of *Wired*'s visual style. Much less does it lie in refusing to separate style from content (or medium from message). For much of this review it lies, rather, in the assumption that *Wired*'s world is so dominated by the view of "corporate futurists, laissez-faire evangelists, and prophets of privatization" that nothing and no one can escape it.[73] Every aspect of the magazine's aesthetic gets unilaterally retrofitted as corporate futurist.

Despite the fact that *Ray Gun*'s founder, David Carson, has been commissioned to produce advertising campaigns for Pepsi, Nike, Citibank, and *TV Guide* or the fact that far more advertisements have been inspired by Carson's approach to design, the magazine's reputation for having pushed back the boundaries of conventional layout and design has largely remained untarnished.[74] *Ray Gun* is also the publication that *Wired* has most often been compared to. "*Wired*," Dery offers, "is the limit case for postmodern technodazzle in graphic design, pushing the eyestrain envelope to just this side of unreadability," in parentheses adding that it "falls to magazines with a younger, fringier demographic, like *Ray Gun* and *Poppin' Zits*, to shatter the legibility barrier into postliterate fragments."[75] For Dery, comparisons between *Wired* and *Ray Gun* are intended to raise questions about the fate of critical thinking and rationality in a "postliterate" design space. But neither *Wired*'s broad-bandwidth broadcasting of the corporate-futurist message nor its simulation of the cyborg's terminal gaze allows much room for the fragmentation of meaning that we have been given to understand occurs in this space. As far as critical ciphers go, both metaphors suggest the restitution of an organizing rationality that even leaves readers to be made over in its own image.

Looking back over the magazine in those early years, there are aspects of

Wired's visual design that do seem to be tuned in to the antiformalist, cut-and-paste expressionism that was being explored in fringe culture magazines such as *Ray Gun* and *Inside Edge* in the early nineties. Both *Ray Gun* and *Wired* made dramatic use of Barry Deck's expressionist typefaces (which have names like Caustic Biomorph, Cyberotica, and Template Gothic). Even now, the contents pages of each issue of *Wired* are preceded by a four-page digital art spread that often includes quotations from an upcoming article. This regular feature—along with the contents pages themselves—has experimented with a variety of graphical and typographical styles over the years, including those emanating from the cyberdelic end of the techno fringe. Images and typeface are combined in ways that suggest the editorial brief for these pages has been to try to capture a mood, attitude, or tone. Not even ideas but snippets of ideas flash up from the page, to be skipped past or pored over according to readerly interest and caprice.

It fell to cyberskeptic Keith White to offer a reading of *Wired*'s design strategy that resolves some of the ambiguities of Dery's review. If Dery's own reading is perhaps best understood as a discontinuous series of short takes on a theme—chosen more for their strategic impact than any real desire to think about the kinds of cultural fantasies that this magazine appeals to—White's review is the monotheistic voice of rationalist indignation. Originally published in the *Baffler* (subtitled "The Journal that Blunts the Cutting Edge"), the review wastes no time in cutting to the chase: *Wired*'s much-touted design sense speaks nothing so much as good marketing.[76] "Don't be sucked in" is the White message: whatever this packaging owes to new edge publications such as *Ray Gun*, *Sassy*, and *Inside Edge* has most certainly been emptied of any genuinely radical potential. White sees *Wired*'s co-optation of the radical look of these magazines as an extension of the same logic that launched Apple's Macintosh computer. The famous 1984 Chiat/Day television commercial presented the Macintosh to its Super Bowl audience as a conformity-smashing innovation in computer design. Thereafter, suggests White, the course that ideologues of the computer should take had been set. In putting together an "ideological packaging for information technology that screamed nonconformist," *Wired*'s founders simply "picked up where the TV advertising left off" (par. 7–8). White's claim that *Wired*'s vision of the good life is remarkably consistent—"money, power, and a game boy sewn into the palm of your hand"—has real critical bite (par. 13). It might also be acknowledged, however, that the cultural history of computer technology being sketched in this review turns a blind eye to some of the more messy and ambiguous routes that this technology traveled before entering consumer culture. The argument that throughout the sixties, seventies, and early eighties the com-

puter industry suffered from a massive public relations problem that stemmed back to the cold war has to some extent been ratified by historians such as Leo Marx, who identifies the late 1960s as a period in which public confidence in technology began to be seriously eroded.[77] But White's argument is rather more bold. His claim is that this was a time when the ideology of the counterculture and the ideology of corporate America were united in their suspicion of computer technology. If information technology was "to achieve proper acceptance in the business world," then it "would have to undergo a gigantic face-lift." According to White, this was achieved by appealing to the business world's increasing fascination with "notions of chaos, revolution, and disorder."[78]

Here, then, is the missing link between *Wired*'s chaotic, disorderly—to say nothing of revolutionary—visual style and its corporate, free-market ideology. The only problem with it is that it relies on a strange cultural bifurcation. Where, for instance, do the first technofreaks—with their whole earth lifestyles, low-tech equipment, and high-tech predilections—fit into this picture? Allucquère Rosanne Stone's account of the first communities of computer programmers that sprang up in places like Santa Cruz County in the 1960s and 1970s reminds us that these communities were an important site for the development of a sensibility—if not yet an aesthetic—that was fascinated by chaos, disorder, and random phenomena.[79] Not all the fringe technocultures that clustered around the first bulletin board systems (BBSs) in the mid-1970s simply disappeared into Start-up Valley ten years later. Many of the contemporary "ravers, technopagans, hippie hackers, and other cyberdelic subcultures" that come in for such close critical scrutiny in Dery's *Escape Velocity* have their technocultural roots in these kinds of communities. Dery's own criticism of these subcultures occasionally bristles with impatience. His most scathing comments are reserved for their "techno-transcendentalism" and "high-tech millenarianism"—all that flaky cyberbabble about "consciousness technologies" and "magickal programming." And well it might be. His fear that "their siren song of nineties technophilia and sixties transcendentalism seduces the public imagination with the promise of an end-of-the-century *deus ex machina* at a time when realistic solutions are urgently needed" may in fact turn out to be well founded.[80] What's worth remembering about this cyberdelic fringe, however, is that its DIY ethos was nourishing future experiments in digital art—fractal art, genetic art, computer animation—well before the PC boom of the mid-1980s.

Finally, it was "Cyberhype," McKenzie Wark's review for *World Art* magazine, that offered what is perhaps the most familiar reading of how spectacular image production and the commodity form converge in *Wired*. Like Dery's

and White's reviews, it is not Wark's argument so much as his rhetorical style that persuades in this piece. His avatar for this essay is a "jaded, bloated 30-something former punk" whose street-weary intellectual cool has been sharpened on a critique inherited from the Situationists.[81] And like Dery and White he casts a jaundiced eye on what he identifies as *Wired*'s corporate-cultural mission: the production of cyberhype. Cyberhype is hype about hype: it is hype about multimedia, cyberspace, and virtual reality. It is "the swanky image of nothing but the promise of ever niftier images" (66). And it is (virtually) indistinguishable from marketing hype. *Wired* and its sister publication *Mondo 2000* emerge from Wark's review as magazines for the "first off-the-shelf revolution." His reflection on the spectacular imagery in these magazines leads him to speculate that the commodity form and the spectacular image form have in fact become one. Advertising, he argues, is no longer the sole preserve of the big manufacturers and media outlets: "Now anyone can sell!" And not just classifieds and garage sales: "Anyone can make images of themselves and sell themselves as makers of images, and distribute those images through the endless capillaries of the new micromedia: cable TV access channels, do-it-yourself zines, covert and even overt self-promotion on the Internet" (69). But what is most worrisome about this proliferation of images and image makers?[82] If Wark clearly doesn't mean to signal the impossibility of art in an age of electronic reproduction, he does come close to arguing that it is the increasing availability of computer animation and multimedia authoring technologies—the fact that they are within reach of "a great number of the ever expanding info hacking class"—that has led to the conflation of image production with something called cyberhype, or the spectacle, or the commodity.[83]

None of these reviews was specifically written for an academic audience. Written quickly for readerships eager to see the magazine put under more critical scrutiny after its honeymoon reception from the mass media, they sought to cut through this cozy arrangement with ballast-bursting precision. Although all were concerned with trying to make sense of the magazine visually, only Wark's review comes close to asking why the image or in fact the aesthetic assumes the importance in this magazine that it does. Having identified *Wired*'s solicitation of readers' desires to see themselves as producers or at least potential producers of images as one of the magazine's chief attractions, he nevertheless passes up the opportunity to examine this fantasy formation any more closely. The long view of history would suggest that critics' expressions of uneasiness about any inflation of aesthetic production brought about by the domestic consumption of image-making technologies have their own periodicity, becoming most insistent at the moment when these technologies first begin to be produced for a mass market. But it isn't a

simple case of the realists doing battle with the futurists over the likelihood of securing a better, more democratic future through mass production. The real terrain of struggle is over the value of images that owe their aesthetic to popular culture.

Along with Gene Youngblood's *Expanded Cinema* (1970), Douglas Davis's *Art and the Future* (1973) offered an early exploration of the social and institutional formations that framed artists' engagements with new computer and video technologies.[84] Specifically concerned with mapping these engagements in art historical terms, Davis's book draws on the very different writings of Herbert Read and Walter Benjamin to explore a number of possible futures for electronic art. In the early 1970s Davis was not confronted with the kinds of populist expressions of aesthetic ambition that confronted *Wired*'s critics. But in principle at least his "prophecy" for the future of digital art embraced rather than recoiled from the prospect of the domestication of digital technologies. Citing laser technology as an example of a technology that was beginning to lose its aura of exclusivity in the art world, he wrote: "I sense a growing disenchantment inside the art system with laser light as a material. At precisely the same moment, the laser has become broadly accessible. . . . I cannot believe that this convergence is either accidental or prompted by esthetic exhaustion."[85] Davis's futurological treatise on digital art now seems touchingly utopian in its imagining of a future in which the institutions of art and art criticism have lost all control over the production, circulation, and consumption of artworks.[86] He had hoped that the mass production of new technologies for producing, distributing, and exhibiting digital art would eventually make these institutions redundant.

Twenty years later, Daniel Pinchbeck surveyed the "State of the Art" for *Wired* magazine. The situation he found was one in which digital artists were not only still dependent on corporate and institutional largesse but actually still struggling just to get their work acknowledged by an art establishment that, in the words of David Ross, director of the Whitney Museum of American Art, "maintains a bias towards the notion of handicrafts." Meanwhile, the entertainment and communications industries had been making their own claims on the future of digital art. Pinchbeck's own projection for the future points not, as Davis's had done, to a renewed rapprochement between science and art but to a rapprochement between art and popular culture. The "digital revolution may," he proposes, "eventually blur the boundaries between radical and commercial art."[87] Although Davis had hoped to see digital art lose its dependence on the museum, it is not at all clear that he envisioned a future in which popular and mass cultural forms would themselves be seen as sites of a new digital aesthetic.

Pinchbeck offered the dream worlds of MOOs and MUDs as examples of new "communal aesthetic forms" that have begun to surface on the Internet (158), but not all the magazine's treatment of these emergent cultural forms has been particularly concerned with trying to articulate a new aesthetic. In "Street Cred," *Wired*'s consumer review section, aesthetic evaluation of MUDs and other Web-based interactives—as well as computer games, multimedia, and computer animation—is liberally informed by a crude form of technofuturism. Hayward and Wollen use the term "technofuturism" to describe the rationale behind the production and marketing of new media and communications technologies. Technofuturism, they argue, works as a classic ideological paradigm, always representing new technologies as an improvement on older ones.[88] In "Street Cred," the tendency to evaluate digital media in these terms is strongest in reviews of games and weakest in reviews of experimental multimedia works. Here, in fact, the old dualism between commercial and radical art is more often than not upheld. The magazine's coverage of the special effects industry also exhibits a strong tendency to see the state of the art as technologically determined. An article on the new "silicon stars" of Hollywood begins by emphasizing the collaborative nature of digital effects production, drawing a picture of a "class of collaborator" that is "so new it's still being defined."[89] But it's the imaging "capabilities" of new computer software and hardware and not those of this new "digital artisan" that receive the most detailed attention. The observation—made by Darley and Manovich—that these capabilities are often expressed in terms of a capacity for greater realism is also borne out by this article, which looks forward to "a day when none of us can be really sure that the image onscreen is real" (202).[90]

Another way of framing the relationship between technology and the aesthetic can also be found in *Wired*, however. If the aesthetic goals of the digital realists do not lack for representation in the magazine, other aesthetic possibilities for CGI have also been raised and, more important, visualized within its pages. In its early years the magazine continually circled the questions: What is digital art? What is a digital aesthetic? Although these questions have received various answers, many have been variations on Steven Holtzman's proposition that a digital aesthetic is one that exploits the qualities that are unique to digital media.[91] In a book that sought to make discussion of the aesthetic possibilities of digital media accessible to a nonacademic readership, he used the term "repurposing" to describe an aesthetic practice that borrows from existing paradigms, expressing the hope that the practice would prove to be transitional and eventually lead to the discovery of entirely new worlds of expression.[92] The most obvious criticism to make of this aesthetic project is that it appears to harbor a modernist faith in the possibility

of making a radical break with aesthetic tradition that leaves its own depend-ence on a rhetoric of abstraction unexamined. Jay David Bolter and Richard Grusin have taken this criticism even further, arguing that Holtzman has failed to grasp the aesthetic significance of what he calls "repurposing." It is their claim that "repurposing as remediation is both what is 'unique to digi-tal worlds' and what denies the possibility of that uniqueness."[93] Whereas Holtzman had used the term "repurposing" to describe the process whereby new media draw on and rework the aesthetic conventions of older media, Bolter and Grusin use the term "remediation" to "express the way in which one medium is seen by our culture as reforming or improving upon anoth-er" (59). Remediation thus implies both mediation and reform. According to this logic, a digital aesthetic refers not to a quality that is unique to digital media but to the digital remediation of other media.

On the one hand, Holtzman has offered a way of conceptualizing a digital aesthetic that seems disturbingly idealist, a revenant of a modernist imagi-nary that has yet to come to terms with the aesthetic concerns of popular and mass cultural forms. On the other hand, Bolter and Grusin have proposed that a digital aesthetic can only exist under a sign of erasure, as symptom and artifact of a failure to achieve transparency. Neither of these possibilities—impossibilities both—quite describes the kind of aesthetic discourse on digi-tal media that we find in *Wired*. Holtzman's suggestion that a digital aesthet-ic is one that foregrounds the digital properties of new media does, however, come closest. And it is for this aesthetic project that I want to reserve the description "technofuturist." Popularly translated, this idea is not in compe-tition with the kind of recombinant aesthetic practices that we find in popu-lar culture. Whatever else a technofuturist aesthetic might refer to in this con-text, it is necessarily an aesthetic that works within a representational mode. When Holtzman has turned his own hand to writing about new media for *Wired*, this is something that he too has had to acknowledge. His review of a three-dimensional sculpture of a school of fish—that can only be viewed through a VR head-mount display—appeared in *Wired* under the title "What Is Digital Art Really?"[94] The aesthetic concerns of this work are clearly more representational than abstract, but even Holtzman concedes that this doesn't mean that the sculpture isn't really digital art. In a virtual environment with-out weight, mass, or gravity, viewers of the sculpture experience a relation to the computer-generated artifact that cannot be reproduced in any other media. And in this sense it succeeds in expressing something that is in fact unique to the medium of VR.

Much of the computer-generated imagery that found popularity with cin-ema audiences in the early to mid-1990s represented the refinement not of a

realist aesthetic that took the cinematographic image as an absolute point of reference but of a hyperreal electronic aesthetic that took the cinematographic image as a possible point of departure. In their creation of this imagery, directors, effects designers, and computer animators were also responding to the knowledge that by the early 1990s audiences' familiarity with new media technologies had altered their perceptions of the kinds of effects that can be achieved digitally. This point was illustrated in *Wired* by "lone cinemagician" Scott Billups. Reflecting on the expectations that a generation of film viewers raised on computer and video games have of special effects imagery, Billups suggests that one of the things they want is "high chrominance"—which, as he says, "is not a film attribute: There are colors you can get in the electronic realm that you just can't get on film."[95] While Billups himself is probably best known for his part in the development of a digital character based on Marilyn Monroe, it would be more accurate to describe him as a digital pragmatist than as a digital realist. He has deftly diffused the potential for media hysteria over the suggestion that computer-generated characters may one day replace live actors in Hollywood feature films by soberly pointing out that the Hollywood cult of celebrity makes it necessary to "look at what synthetics can do and can't do. Aside from their characters and the roles they play, an actor's real commodity is his or her private life" (202).

The question of what synthetics can and can't do is a question about the aesthetic limitations and possibilities that digital media have for cinema. Computer-generated morphing entered cinema through the genres of comedy and *cinefantastique*: science fiction, fantasy, and horror. While it is now a familiar special effects technique—having been used in countless television commercials, music videos, television programs, and Hollywood films—it might be remembered that it too endows the cinematographic image with a distinctly electronic elasticity. And even though it has been demonstrated far too many times to strike contemporary audiences as being particularly arresting (let alone novel), morphing still gets used to create the kind of subtle (and not so subtle) visual puns that were so finely honed by traditional cel animation artists for cartoons, contorting and stretching subjects beyond known physical limits. At the turn of a new century, the future of the morph is uncertain. Some contemporary commentators have wondered if it is not in fact on the verge of disappearance, on the way to finding a future in cinema as a cinematic clause or transition akin to the cut or the dissolve.[96] But if as a result of its ubiquity, its sheer familiarity, and its reproducibility it no longer arouses curiosity and aesthetic reflection in the way that some of its science fictional incarnations did in the early nineties, it remains an evocative reminder of a future for cinematic visual effects that never quite came to pass.

In the early days of *Wired*, it was the magazine's own artwork that most strongly evoked the technofuturist possibilities of computer generation. An article focusing on the graphical possibilities being explored in online environments such as graphical MUDs—virtual worlds in which animated avatars interact with each other and their environment—comes accompanied by three double-pages of spectacular and somewhat satirical visual interpretations of the synthetic inhabitants of these new electronic worlds by artists Steve Speer, Lynda Nye, and Michael Crumpton.[97] Speer's world is a riotous reanimated nightmare of mutant dolls, grotesque cartoon characters, monstrous hybrids, and tiny, one-bit 2-D figures. Synthesized from images plucked from children's toys, advertising, and film and television—Mr. Gumby, the Pillsbury Doughboy, *Psycho*, *Communion*—this electronic assemblage is also a virtual wonder cabinet, stuffed to overflowing with a range of electronic design artifacts. Each image expresses its digitality differently. Within this chaotic virtual space, it's not all smooth photo finishes and ideal plastic forms. Mocking any attempt to see these artifacts in terms of an evolution in electronic design, some figures retain the contours of the primitive rods and cones from which they have been assembled.

Some of the best examples of imagery that features the visual punning characteristic of the work of these contemporary artists can be found in the TBWA Chiat/Day Absolut Vodka campaign featured on the back covers of *Wired*. Andy Warhol kicked off the Absolut Vodka campaign in 1985 with his rendition of the Absolut Vodka bottle.[98] Since then, the campaign has featured (and advertised) the work of many painters, sculptors, jewelers, fashion designers, and photographers. Much of the artwork featured in this campaign has been produced specifically for the magazine. Covers by Speer and the computer graphics designers and artists at Troon Ltd. have also taken the synthetic, hyperreal properties of the electronic visual field as their aesthetic horizon.[99]

On the printed page, these glistening images lack the luminosity and hyperchrominance they would have in an electronic format. For the moment, however, the printed page still reproduces a more lustrous, higher-resolution image than many online delivery systems, which in most instances still take some time to download. The computer-generated imagery that glosses the pages of *Wired* magazine is visually more spectacular than anything that *Hotwired*—the magazine's online counterpart—has to offer. In comparison, *Hotwired*'s clunky frames, Day-Glo wallpaper, and occasional animated gifs offer a computer graphics environment lacking in visual effects. Even when it is being transposed for the printed page, the creation of three-dimensional computer-generated imagery remains a labor-intensive

enterprise that, in addition to requiring the long periods of gestation, conceptualization, and experimentation familiar to artists working in any medium, also involves long periods of rendering time. Other considerations of application and technique aside, it is not a medium that lends itself particularly well to the make-do, fly-by-night ethos of monthly magazine production. This is one of the reasons computer-generated images are actually so scarce in *Wired*. Sprinkled across a design space in which collage and photomontage—not even *dètournement*—still define the graphical style of the magazine, these images are designed and placed to arrest the gaze of the magazine browser like so many special effects.

HOME PRODUCTION

Although advertising for new media technologies in *Wired* regularly appeals to consumers' fantasies of becoming image makers themselves, one of the interesting features of this advertising is that it tends not to try to represent this possibility visually. This is especially noticeable in a magazine that is otherwise filled with images. Some advertising campaigns in *Wired* are sites of spectacular image production—the Absolut Vodka campaign is a case in point—but ads that actually advertise computer imaging technologies are more likely to refer to their placement in a magazine already filled with images and high-profile image makers to invoke the imaging capabilities of a particular product. An ad for Autodesk's 3-D animation software (*3D Studio Release 4*) claims, for example, that with the company's vast range of plug-ins, "you'll not only be doing things typically reserved for high-end workstations today, you'll be doing the hottest things in this magazine tomorrow."[100] Perhaps the most interesting feature of much similar advertising is its appeal to consumers who are not in the market for high-end workstations. While the advertised cost of something like Media 100's video editing system (under $30,000) clearly put it out of range for the vast majority of home producers of digital media in 1995, much of the advertising for new media authoring tools that has appeared in *Wired* over the years has been pitched to the home producer. And in fact the entire magazine is still rather uniquely structured to appeal as much to the fantasies of would-be home producers as to the purchasing power of image-making professionals.

Stories about special effects featuring comments from independent filmmaker and effects designer Billups feed consumers' fantasies of home production in a number of ways.[101] Most obviously, Billups himself is represented as something of a home producer (of low-budget genre features). One such article was promoted on the front cover with an invitation to "Make

Special Effects in Your Basement." Inside, the title page brazenly declares: "Who needs ILM? Completely digital movies will be made by lone ranger cinemagicians like Scott Billups. Welcome to Basementwood."[102] In the article itself, much is made of the fact that for his current filmmaking project, a space western entitled *Precious Find* (dir. Philippe Mora, 1996), Billups is to be single-handedly responsible for seeing through the production of twelve minutes of digital effects imagery, fourteen virtual sets, and a cast of virtual actors who will appear in the film as extras, from the design stage to final rendering. The vice president of the production company funding the film put his own futurist spin on the project, predicting that it will "create a lot of opportunities for independent studios and independent filmmakers" (201–202). This dream is still selling expensive computer systems in the twenty-first century. Like articles in other publications that report on new technologies being developed by and for the special effects industry—*Cinefex, American Cinematographer, Computer Graphics World*—this article contains the usual product reviews. Again, however, what's noteworthy about Billups's reviews of available graphics platforms ("pound for pound, dollar for dollar, the new 150-Mhz PCIs render at least two times faster than comparable SGIs") and software packages (ASDG's *Elastic Reality* Morphing package gets the thumbs up) is that they are evaluated in terms of how affordable and/or user-friendly they are (204). It matters less that the cost of these tools still puts them beyond the reach of the majority of would-be home producers—or that attaining the level of knowledge and degree of proficiency needed to use them effectively may entail long periods of trial and error (not to mention expensive training)—than that their advertised accessibility makes them available as objects for consumer fantasies of home production.

One of the most powerful ways that the logic of image production is bound to technological consumption in *Wired* is through fantasies of home production. And in the magazine's advertising, special effects have not surprisingly figured as a metonym for spectacular image production. Nowhere has the appeal of producing special effects been illustrated more clearly than in a long-running advertisement for the Kingston Technology Corporation. The ad, which first appeared in the December 1995 issue of *Wired*, features a sepia-tinted photograph of a woman hysterically pulling at her hair. Her hairdo and clothes are circa 1950s. The text box beneath the image reads: "You're creating special effects for the next blockbuster, so why are you using B-movie memory?" In the decision to spectacularize the subject of production (represented as the hysterical, and notably feminine, image maker), over either the object of production (special effects) or the advertised product (Kingston memory), the ad draws attention to the arbitrary relation between

image and product: to the fact that its appeal is directed less to the desirability of the product itself than to the fantasy of spectacular image production. That this fantasy is both consumerist and utopian is undeniable. That the language and iconography used in much of the advertising and artwork that appears in *Wired* is at best ambiguously gendered and at worst smugly masculinist is also undeniable. On these grounds alone, more rather than less criticism of the magazine is still to be welcomed.

It has been the argument of this chapter that *Wired* provides a window on to some of the ways that special effects acquired significance for consumers of new media technologies in the 1990s. What we also need to remember about this period is that growth in the consumer market for computer imaging technologies was also being stimulated by the education sector. Advanced education institutions all over the United States, Britain, and Australia began offering certificate, diploma, and degree courses in computer animation and interactive multimedia for the first time in the last decade. The result has been that more and more young people are imagining futures for themselves as producers of images.[103] In the early 1970s Allen had warned aspiring animators that their hopes of working in the film industry were bound to be disappointed.[104] In the contemporary context, desire still outstrips demand. But this is also where the kind of micromedia production that Wark identified with the off-the-shelf revolution in animation and multimedia authoring software becomes important. The postsubculturalist, *South Park*-raised youth cultures currently amusing themselves with widely pirated animation packages such as *Flash* (Macromedia) and *3-D Studio Max* (Kinetix) may still have an eye on the entertainment and communications industries, but they may also be looking to get out from under social and cultural norms that put pressure on youth to define themselves by the jobs they might or might not have (or get). For more and more young people, fooling around on a computer may be becoming a way of defining themselves and their relation to the world in terms other than those posed by the perennial question: But what do you do? Or, what do you want to be? In the face of diminishing opportunities for full-time employment and limited opportunities for creative employment, home production is not so much a leisure activity—in the way that amateurism, for instance, was—as a site for disarticulating doing from being, where the latter is identified in terms of the status (or lack of it) attached to professional employment. The absence of a discourse of amateurism in *Wired* plays directly into this desire. If in practice amateurism has never only existed in a negative, compensatory relation to professionalism, it has also never quite managed to shake off this association. Its end is signaled in *Wired* through the romantic, consumerist representation of all new media produc-

tion as creative. Today, the allure of becoming adept in the production of new media is still the promise of professional employment, but it is also the allure of art.

In the past, *Wired* has seduced readers by addressing them not only as consumers of new media but also as producers and potential producers. Most important, it has given their desires for creative self-fulfillment a more expansive palette by blurring distinctions between special effects and art, commerce and art, and advertising and art. The demand for an urgent inquiry into "artistic practices that work with images using the same technological devices as art directors and marketing people" has become the clarion call of media critics in the digital era.[105] But what much of this criticism has so far failed to address is that as much as it serves the interests of consumer culture, this inflation of aesthetic practice also appeals to widely held desires for creative (self)employment. As for the very different concern that digital effects production is not a medium that lends itself to individual self-expression, the technofuturist avengers of the computer-generated future counted on holding audiences' attention not by revealing the hand of the artist but by putting together images that capture something of the glint from the machine.

3

THE WONDER YEARS AND BEYOND
1989–1995

I n the flurry of mass media attention that accompanied the opening of two blockbuster special effects events in 1997—the rerelease of the *Star Wars* trilogy and the release of *The Lost World: Jurassic Park* (dir. Steven Spielberg)—it would have been easy enough not to notice that an important period in the brief but spectacular history of computer-generated special effects had already passed. All the signs of this passing were, however, already in evidence the year before. For science fiction fans, the year 1996 was a year for anniversaries. In that year the *Star Trek* franchise celebrated its thirtieth anniversary with yet another round of merchandising and a convention billed, somewhat hubristically by the organizers at Paramount, as "the Woodstock of *Trek* events."[1] Special effects house Industrial Light and Magic was also celebrating its twentieth anniversary in 1996. And to mark the occasion *Cinefex* produced "A 20th Anniversary Salute to Industrial Light and Magic."[2] In addition to providing a comprehensive survey of all the film, television, and theme park attractions that ILM had provided special effects for during the period 1976–1996, this issue also contained interviews with founder George

Lucas and effects supervisor Dennis Muren. The magazine's cover featured a still taken from the 1977 film *Star Wars*, ILM's first feature film project and, according to Lucas, the reason for setting up the company in the first place.

Trailers announcing the 1997 release of the digitally remastered *Star Wars* first began appearing before screenings of *Independence Day* (dir. Roland Emmerich, 1996), which opened in the United States on July 3, 1996. The trailer began with a shot of a television set showing scenes from the original *Star Wars* film. A voice-over explained that "for an entire generation, people have experienced *Star Wars* the only way it's been possible—on the TV screen. But if you've only seen it this way, you haven't seen it at all." Then, as a blast from a rebel X-wing fighter burst through the television screen, the image on the TV reformed to fill the entire cinema screen. "Finally," the voice-over continued, "the motion picture event the way it was meant to be experienced": on the big screen and "with newly enhanced visual effects and a few new surprises." Some of these "surprises" were in fact previewed in the trailer. But more extensive previews of two scenes containing new special effects also appeared in *Special Effects . . . Anything Can Happen* (dir. Ben Burtt, 1996), a film produced by Nova/WGBH Boston and distributed by the Imax Corporation. To make the film the producers went behind the scenes of four films requiring extensive special effects: *Star Wars: Special Edition, Kazaam!* (dir. Paul Michael Glaser, 1996), *Independence Day*, and *Jumanji* (dir. Joe Johnstone, 1995). The behind-the-scenes footage of the *Special Edition* looked at how the special effects for two shots that were substantially altered for the new version of the film were produced. Articles reporting on the film and its new effects appeared throughout the year in *Starlog, Cinefantastique, Sci-Fi Universe*, and the British magazine *SFX*. But only *Cinefex* managed to secure an interview with Lucas himself. More fan-oriented publications had to make do with the usual publicity department releases. Online speculation about the *Special Edition* also continued to build steadily throughout the year. Fans began collating as much information as possible about the exact changes that would be made to the original film, and the results of these fact-finding missions were widely published on the World Wide Web, accompanied in some cases by detailed scene-by-scene reviews of the altered footage (or as much of it as anyone had seen).

Amid wagers about whether *Star Wars: Special Edition* would gross more at the weekend box office than *Independence Day* and arguments about how the CGI anyone had seen compared to the old footage, newsgroup discussions also occasionally centered around speculation about Lucas's reasons for pursuing the project in the first place. The suspicion that the rerelease of *Star Wars* merely represented advance publicity for the first installment in the

soon-to-be-released prequel was regularly if tentatively raised in these forums, and especially by those most concerned with quashing it. Reporting on an advanced screening of some early clips, one intrepid poster ventured the opinion that "it generally looked like Lucas cared about this, not in a 'hey let's make a lot of money off sci-fi dweebs' [way], but rather, [in a] 'let's make something we can be proud of,' sorta way."[3] Not surprisingly, Lucas himself represented his decision to take advantage of new computer-generated imaging technologies—both to redo the special effects in some scenes and to add completely new imagery to others—as an artistic one. His promise to fans was that the *Special Edition* would actually be truer to his original vision of the film than the 1977 version was.[4] Such assurances aside, not all fans could be persuaded that digitally remastered necessarily meant digitally enhanced. In a new column devoted to special effects in *Sci-Fi Universe*, David J. Hargrove ventured the opinion that "we needed *Star Wars: Special Edition* about as much as we needed new-formula Coke."[5] Taking up the matter in his regular editorial, the magazine's then editor-in-chief, Mark A. Altman, was equally skeptical of Lucas's claim that he had to wait until the technology had improved to remake the film the way he had always imagined it. For a time *Sci-Fi Universe* cut out its own little niche in an increasingly crowded market by insisting that it was the only critical, reflective, and sexually and racially antidiscriminatory SF fan magazine in circulation, on occasion dismissing its most popular competitor (*Starlog*) as "a collection of fluffy press releases." Altman described the magazine's mission as being to try to "get sci-fi fans to think critically about what they're seeing on the screen and not blindly accept mediocrity."[6] His own criticisms of Lucas's decision to remake *Star Wars* were the topic of much online argument and debate. Altman's provocation lay not only in raising the possibility that the *Special Edition* would mean losing a classic piece of SF film history but in suggesting that Lucas might have better harnessed his vision of a new and improved *Star Wars* by creating something genuinely new.[7]

Star Wars: Special Edition was certainly not the first Hollywood science fiction film to be digitally remastered. Steven Spielberg released three different versions of *E.T.—The Extra-Terrestrial* (1982) in 1996. Both the video and laserdisc versions featured some digitally remastered effects, a remastered soundtrack, and new footage. The "Special Laserdisc Set" also came with a ninety-minute documentary on the making of the film. Nor was this a first for Spielberg. *Close Encounters of the Third Kind* (1977) was rereleased for video in 1980 with new scenes and the addition of outtakes from the original shoot. And there have been others: *The Abyss, Aliens* (dir. James Cameron, 1986), *Terminator 2*, and *Independence Day* have all been rereleased as special

editions. The big difference between these films and *Star Wars*, however, was that the latter was released theatrically and not just for the small screen. Had Lucas merely rereleased the film for the home entertainment market, it would never have garnered the kind of attention that it did. As one reviewer for a popular newsgroup put it, "*Star Wars* wasn't a great movie; it was, however, an extraordinary movie-going experience. . . . That movie-going experience is what this re-release is all about."[8] Every aspect of the film's marketing campaign emphasized the social, participatory pleasures of viewing the film in a theater filled with expectant moviegoers, many of whom hoped to recapture an experience remembered from childhood or adolescence or to share that experience with audience members too young to have seen the film the first time around. The film's distributor, Twentieth Century Fox, arranged an advance screening several months before the film was released in order to video audience members responding to it with a collective show of exuberance. Footage of this scene—so powerful in its appeal to an imaginary community of viewers bound together in a moment of collective remembering—was then used for the film's television advertising campaign.

Like the decision to rerelease the film itself, the aesthetic choices governing the production of the new CGI effects for *Star Wars: Special Edition* were basically conservative. But what is interesting about the film's new visual effects imagery is not in the end how it actually turned out but the fact that it became the focus for so much media scrutiny and public debate in the first place. For at a time when art-and-effects direction in Hollywood science fiction cinema seemed to be moving away from a technofuturist aesthetic—with its insistence on the centrality of the computer-generated image—the rerelease of *Star Wars* renewed speculation about the aesthetic possibilities of computer-generated imagery in the popular and mass media. This chapter develops the proposition that big-budget, effects-oriented science fiction films were popular with contemporary fan cultures in the early to mid-1990s because they offered them the opportunity to participate in a popular cultural event that again put the display of a new type of effects imagery at the center of the entertainment experience.

The aesthetic project governing the production of CGI effects for SF films has most often been represented in terms of simulation, but this period of visual effects production also marked the emergence of a popular, technofuturist aesthetic. This is not, however, an aesthetic that describes all computer-generated visual effects imagery in Hollywood science fiction cinema. It neither describes the CGI dinosaurs in *Jurassic Park* (dir. Steven Spielberg, 1993) nor the assortment of computer-generated animals in *Jumanji*. And while the CGI in *Star Wars: Special Edition* does not exhibit the same drive for realist

SPECIAL EFFECTS AS GENRE

MARKETING - POPULARITY - PUBLIC EXPECTATION/EVALUATION

simulation that characterizes the special effects in these films, the film's new computer-generated effects have, in Mandelbrot's words, little of the "plastic beauty" of some of the computer-generated effects in films such as *The Abyss*, *Terminator 2*, *Johnny Mnemonic* (dir. Robert Longo, 1995), and *Virtuosity* (dir. Brett Leonard, 1995).[9] Aimed at preserving the visual integrity of the original film, the CGI in *Star Wars* is better described by an aesthetic project that takes simulation, or assimilation, as its aim. Art director TyRuben Ellingson's brief to computer animators working on the film contained the warning that "you can't let your CG aesthetic get in the way of that."[10]

Genre film fan magazines provide an important cultural site for examining the reasons CGI had such a special place in the Hollywood science fiction cinema of the last decade. For more than thirty years these magazines have provided a forum for directors, art directors, production designers, cinematographers, and effects supervisors (as well as magazine editors and contributors) to assess the range of special effects techniques that work best, not just for particular kinds of effects shots but also for particular film genres. By and large, this has not been an editorializing process (or at least not until recently). It has been a formative one, however. Over the last ten years the number of print publications and online forums that have emerged as sites for discussing and evaluating various applications of CGI in terms of their ability (or failure) to meet audiences' expectations of how they should look has greatly increased. But in the early years of Hollywood's experiments with CGI effects the only publications where this kind of analysis could be found were genre film magazines. And although more technical, industry-oriented publications such as *Cinefex* and *American Cinematographer* now give more consideration to aesthetic issues in their behind-the-scenes coverage of the film industry, they have hitherto tended to be much more focused on what Brooks Landon has dubbed "the mechanics rather than the aesthetics" of special effects.[11]

In addition to publishing the science fiction stories that it is most readily remembered for, the literary SF magazine *Astounding Science-Fiction* occasionally published articles on special effects in the 1950s. During the 1960s and early 1970s, when demand for information about stop-motion animation was at its peak, fans with aspirations of working in the film industry had a range of publications to choose from for analysis and review of special effects. Magazines such as *Special Visual Effects by Ray Harryhausen* and *Famous Monsters of Filmland*—which has also extensively covered the techniques of special makeup effects and prosthetics—specifically addressed amateur fan cultures. The genre film fan magazines that began publication later addressed a less restricted readership. *Cinefantastique*, *Starlog*, and *Starburst* cultivated a cul-

ture of effects connoisseurship that was only weakly tied to a discourse of amateurism. Again it was in relation to stop-motion animation that the appeal of amateurism remained strongest. For the long article on stop-motion animation that he wrote for *Cinefantastique* in its first year of publication, Mark Wolf produced a history of this animation technique that included tips for amateur animators along with a critical assessment of the state of the art.[12] Such extensive treatment of the history and techniques of special effects production was not reproduced in other genre film magazines. The inspiration for *Starlog* came both from the examples of *Photon* and *Cinefantastique* and from the organized fandom associated with the television series *Star Trek*. In 1976 the magazine's publisher-editors had to convince distributors that a magazine "devoted not just to *Star Trek* but to all science fiction TV shows and movies, all SF books and comics, all SF conventions and fan activities, with a dash of space exploration, special FX, illustration and other ingredients that spice up the science fiction universe" could support a national readership. One of the ways they did this was by collecting newspaper articles and best-seller lists attesting to science fiction's popularity among a broad range of media consumers, and not only those involved in organized fandom.[13]

In the 1990s a succession of blockbuster science fiction films meant that anyone wanting to publish an SF magazine no longer had to convince distributors there was a mass audience for science fiction. But distributors did need to be convinced that more fan-oriented publications could compete with the global publishing companies targeting an expanding market for behind-the-scenes coverage of genre film and television with mass-mediated facsimiles of fan publications. When it first began publication in 1994 *Cinescape* was an example of this type of publication.[14] Containing no reviews of fanzines, no accounts of fan conventions, and few retrospectives of classic films, the magazine focused instead on providing previews, synopses, and industry news about film and television series in production. It was initially dismissed by genre film fans and even some specialist booksellers as too mainstream to appeal to dedicated fan cultures. Unlike other fan magazines, it also lacked the editorial signature of an acknowledged fan. Describing himself as "a futurist and a professional science-fiction fan," *Starlog*'s founding editor and publisher, Kerry O'Quinn, often used his regular editorial "From the Bridge" to address issues of particular interest to fans old enough to remember the days before science fiction had become part of mass culture and science fiction fandom an everyday mode of reception instead of a way of life.[15] Altman likewise gave *Sci-Fi Universe* a strong fan focus. Under his direction the magazine's imagined readership was made up of fans "who were born in the '60s, grew up in the '70s, went to college in the '80s (and edit sci-

fi magazines in the '90s)" and whose sense of fandom is postsubculturalist and generational.[16]

Global publishing economics have shaped the market for fan-oriented publications in important ways since the mid-1990s. Altman's term as editor of *Sci-Fi Universe* ended when it was bought by the Sovereign Media Group (publishers of *Sci Fi Entertainment: The Official Magazine of the Sci-Fi Channel*) in 1997, and the magazine ceased publication under that title in 1999. Since then he has been involved in numerous writing projects, including cowriting a romantic comedy about a couple of *Star Trek* fans and contributing a bimonthly column to *Cinescape*.[17] Under its new owners, the media and Internet company Fandom Inc., *Cinescape* has become part of a network of print and online magazines that includes official licensed publications for such popular television series as *The X-Files* and *Buffy the Vampire Slayer*. The online *Cinescape* has links to fan-run Web sites, fan discussion groups, and information about upcoming conventions. But with its extensive links to mail-order and online shopping sites, the Fandom Network could also be said to address fans less as genre film and television's watchdogs—in the manner, for instance, of *Sci-Fi Universe*—or, in the manner of *Cinefantastique*, as dedicated cineasts than as potential cross-media consumers of new genre film and television "properties."

When *Cinefantastique*—subtitled "the magazine with a sense of wonder"—began publication in 1970, its editor, Frederick S. Clarke, declared his intention of producing a magazine that would be devoted to the serious study of horror, fantasy, and science fiction.[18] As had been the case in the self-published fanzines that nourished a culture of dedicated genre film fandom throughout the previous decade, part of any serious study of a science fiction film would have to include close analysis of its special effects. From the beginning *Cinefantastique* shared with *Photon* an openness to different ways of thinking about film. David Macdowall's critique of *2001*—first published in *Photon* in 1968—drew on the language of (literary) new criticism to offer an insightful reading of the film's symbolism, themes, and use of irony and allusion.[19] In *Cinefantastique* critical analysis of classic and contemporary film and television has drawn on ideas encountered in psychoanalysis, in theories of the avant-garde and postmodernism, and, more recently, in entertainment economics. The magazine's appeal to a readership conversant in the language of contemporary film criticism is one of the things that it has in common with nongenre publications addressed to the literate if not necessarily college-educated cinephile. Articles flagged in the magazine as "analysis" have often been written by people who also write books and essays on genre film and television for academic publishers and teach college-level courses in film, media,

and journalism studies. Whereas in the early days authors' bylines promi-
nently acknowledged their academic posts and publications, these days
analysis written by academics is offered without announcement. In a publi-
cation that brings together many different types of specialist knowledge and
expertise, it is simply presented as another way of describing how and why
genre films matter. The language of aesthetic appreciation and the language
of critical analysis differently engage readers in thinking about how the aes-
thetic experiences offered by genre films give expression to shared cultural
memories and desires. Features focusing on the technology and craft of film
and television production and articles offering more critical and interpreta-
tive analysis of the viewing experience also both share the fan filmographers'
appreciation of the productive limits that genre imposes on filmmakers.
Readers looking for an account of how the special effects for a particular film
or television series were produced can turn to magazines such as *American
Cinematographer* and *Cinefex* for more detailed, technical information than
they will find in *Cinefantastique*. But for commentary that offers a glimpse
into the way directors, art directors, production designers, cinematogra-
phers, and effects supervisors decide the look of a film, genre film fans know
there is no more valuable resource than *Cinefantastique*.

In one important respect, all fan publications are a scarce resource. Some
are archived in public libraries, but other archives only exist as private collec-
tions, where the stories they have to tell about the cultural reception of genre
film and television wait to be unpacked. Even a magazine like *Cinescape*
reminds us that special effects, and especially computer-generated visual
effects imagery, came into focus for a mass audience at a very specific moment
in their history. In many ways, the magazine's appearance on the global me-
diascape in the mid-1990s indicates just how widespread and diffuse the net-
works for disseminating information, speculation, and review of special
effects had become by then. Both before and after the release of the special edi-
tion of *Star Wars*, the *Los Angeles Times* and the *New York Times*—newspapers
that have been particularly successful in attracting global readerships through
online publication—carried regular reports on the film's new visual effects
imagery.[20] Drawing on the kinds of consumer fantasies examined in the last
chapter, a review of several new 3-D modeling and animation programs in the
New York Times on the Web suggested that "some of the brand new 'Star Wars'
Special Edition effects can be done on a standard PC with an array of new
three-dimensional tools available for the budding new director."[21] Other arti-
cles directed online readers' attention to fan Websites featuring more detailed
information about the making of the film and its effects, in this way bringing
fan cultures into the mass media's orbit.[22] Along with genre film publications

a diverse range of popular and mass media—infotainment television pro-
grams, making of movies, special edition video and DVD releases, Web and
Usenet sites, IMAX films, and special effects exhibits at science and technology
museums—contributed to the popularization of technical, aesthetic, and
instructional discourses on CGI effects. Television specials on the making of
Hollywood movies regularly take late-night viewers behind the scenes of film
and effects production. Whether viewers are fascinated or bored by these pro-
grams—whether they can recall a lot or almost nothing about their content—
they have become part of the contemporary entertainment experience, shap-
ing the way viewers look at special effects both before and after the cinematic
event. A range of popular cultural narratives about CGI and its relation to cin-
ema, art, and the future now vies for the attention of audiences, whose interest
in these narratives increasingly reflects their navigation of popular and mass-
mediated fan networks.

The last chapter noted that the history of CGI effects has all too often been
subsumed within more general histories of computer imaging. Here, I want to
begin to consider these effects in what used to be thought of as their "cine-
matographic specificity." This means looking more specifically at how they
functioned in the genre cinema of the last decade. Much of this chapter is
therefore concerned with expanding on the claim that an aesthetics of CGI
effects initially developed along two contiguous axes: the first, simulationist;
and the second, technofuturist. Both types of imagery exhibit the photorealis-
tic capabilities of contemporary digital imaging systems, but whereas a simu-
lationist aesthetic is geared both toward the phenomenological simulation of
photographic or cinematographic reality and the representational simulation
of objects in the natural world, technofuturism describes a hyperreal, elec-
tronic aesthetic that is not entirely commensurate with either of these projects.
This difference is not the result of a failure to achieve total computer-gener-
ated simulation. Nor is it an accident of the production process. Whether con-
scious or not, it represents a response to audiences' own demands for aesthetic
novelty. Technofuturism also describes an aesthetic that in cinematic terms
can barely be imagined outside science fiction cinema. So it is to the recent his-
tory of this relationship that this chapter now turns.

ON GENRE

While the action-oriented genre films that have been coming out of Holly-
wood for more than two decades are a hybrid lot, genre has traditionally
exerted considerable influence over the kinds of special effects that feature in
these films. With its "biomechanoid" alien-monster, *Alien* (dir. Ridley Scott,

1979) not only revived the creature film for a whole new audience but also redefined the look of science fiction film for decades to come.[23] The horror film genre, which had long played on audiences' fears and anxieties about the body—in particular its propensity to leak, splatter, and ooze under pressure—again commingled with science fiction in the form of the new creature feature. At the turn of the century the boundaries separating fantasy, horror, science fiction, and action cinema had become more fluid than ever. The epic, historical-fantasy films *Titanic* and *Gladiator* (dir. Ridley Scott, 2000) made such extensive use of computer-generated sets, props, and extras that it seemed clear that digital imaging techniques had already been fully integrated into the filmmaking process. The question that hadn't been asked yet, however, was how this development would impact on the future of special effects.

Even in this new era of effects cinema the historical association that some genres have had with particular types of special effects can still be discerned in the decisions that contemporary filmmakers make with respect to which types of effects will be foregrounded for audiences' attention and aesthetic appreciation and which will be allowed to recede into the background. Audiences have come to expect the spectacular stunts and pyrotechnics featured in action cinema and to insist too on the makeup and prosthetics that give the gore effects in horror films their special visceralness and viscosity (not even *The Sixth Sense* (dir. M. Night Shyamalan, 1999) could entirely do without them). Recognized as staples of the genre, the look of these effects can also bear a high degree of repetition. In the case of science fiction films, however, phantasmagorical projections of the future often only achieve the glamour and allure of the truly novel in that brief moment before the techniques used to bring them to the cinema screen have grown too familiar.

The most concerted attempts to think about special effects from a critical and historical perspective that includes some consideration of the regulatory function of genre have thus far come from film scholars such as Albert J. La Valley, Vivian Sobchack, Scott Bukatman, and Brooks Landon, all authors of seminal works in the field of science fiction studies. In their own way, these scholars have each sought to shed light on the reasons science fiction cinema has always been a cinema of special effects. As this chapter will show, all have made claims that share some similarities with the arguments I have been advancing here, although none has looked quite so specifically at the discursive contexts in which an aesthetic discourse on special effects first began to be articulated. But even before these film scholars began to turn their attention to special effects, Christian Metz hinted at the scope for such research in an essay that made special effects objects of theoretical reflection in a way they hadn't been before.

METZ

Contemporary theoretical discourse on computer imaging has made it difficult to conceive of the computer-generated image in its cinematographic specificity; similarly, some of Metz's contemporaries were preoccupied with trying to apprehend the totality of cinema's effects, a move that resulted in the occultation of the special effect. Convinced that spectators were drawn back to the cinema by their longing to be taken in—to be deluded—by the simulacrum, Jean-Louis Comolli argued, for instance, that spectators had to make every effort to maintain their disavowal of cinema's artifice at the highest level of intensity, for any less effort on their part could only lead to disillusionment.[24] Metz felt no less strongly than his contemporary that the double logic of disavowal lay at the heart of spectators' enjoyment of cinema. Drawing on Octave Mannoni's study of theatrical illusion, he argued that spectators know very well that the impression of reality cinema is capable of producing is in fact a fiction, but they choose to believe in these fictions all the same.[25] At the same time he also recognized that special effects have a grammar and syntax all their own, and in his essay "*Trucage* and the Film" he set about trying to identify their special features.[26] The first distinction that he makes in this essay is between "profilmic" and "cinematographic" effects. On a strictly denotative level this distinction clearly corresponds with the distinction we now make between special effects and visual effects: between effects that take place before the camera (i.e., physical and mechanical effects) and effects that either take place during filming (in-camera techniques such as split-screen photography, mirror shots, superimpositions, and stop-motion photography) or during postproduction (2-D and 3-D computer animation, optical and digital compositing). But the connotations that Metz brings to bear on this distinction now seem faintly old-fashioned, for it is also his claim that only visual effects, or what he calls "cinematographic effects," belong specifically to cinema. More than twenty years later there are a number of reasons for rejecting this distinction.

What makes certain types of effects specifically cinematographic is in Metz's view the fact that they belong to the filming (to the camera, or the editing room, or the laboratory) and not, as in the case of profilmic effects, to the filmed. But even before the advent of digital imaging systems, many effects were complex composites of multiple techniques. In the digital era it is not unusual for an effects shot to contain dozens or even hundreds of separate elements. Metz offers stunts as an example of a profilmic effect, arguing that even though all sorts of preparations must be made to carry this type of ruse off, the final effect is achieved before the camera. The filmmaker chooses a stunt man (or woman) "of the same general appearance as the actor or actress [who is to be replaced]; the wardrobe and make-up departments achieve the

'resemblance'; [and] the cameraman is careful to film him [or her] only at a certain distance and from certain angles" (662). Although stunt doubles are routinely used in Hollywood action films, digital technologies have also given filmmakers more opportunity to use actors to perform their own stunts by making it easier to remove the visible signs of any supporting apparatus in postproduction. Even when stunt doubles are used for action filming, digital compositing enables stunts to be carried out in controlled environments that stand in for location shooting when combined with background footage in postproduction (as in the opening sequence of *Vertical Limit* [dir. Martin Campbell, 2000], which combined footage of stunts performed on a pur-pose-built, 120-foot wall in a New Zealand film studio with footage of Castle Rock in Monument Valley to create the illusion that the stunts had been filmed on location in Utah).

Metz's second reason for claiming that effects that rely on camera or post-production techniques are more specifically "cinematographic" than physi-cal or mechanical effects is based on his sense that instead of being unique to cinema the latter are shared by other systems of signification: having their genesis in magic and stagecraft, in techniques of illusion shared by the opera, the theater, and pantomime. The reality, however, is that the techniques of special makeup and prosthetics, of puppets, miniatures, and animatronics, have specifically been developed within the context of the film industry and are as much of the cinema as any other special effects technique. Cinema's ability to manipulate viewers' perceptions of scale and space through the use of miniatures is not, for instance, shared by the stage. The distinction that Metz makes between profilmic and cinematographic effects ultimately rests on a narrow identification of the technology of illusion with its instruments. Quite apart from the fact that the techniques of physical and mechanical illu-sion have provided the cinema with some of its most memorable images, that these images could not have been brought to the screen without the accumu-lated experience and expertise afforded the film industry makes them specif-ically cinematographic. Science fiction and horror cinema's assorted minia-ture, puppet, and animatronic monsters, aliens, and dinosaurs owe their screen life to a mix of culture and industry—artisanship and capital—that doesn't exist anywhere else.

If Metz intended the division between profilmic and cinematographic effects to refer to differences among the ways various types of special effects are made, it is how he distinguishes among the ways various types of special effects are read that relates most directly to the topic of reception. If we fol-low his own reasoning, all special effects are to some extent avowed machi-nations, functioning at one and the same time as elements of the diegesis (in

this sense reinforcing what he calls the "reality of fiction") and as signs of the enunciative powers of cinema (and thus confirmation of the "fiction of reality"). The balance between diegetization and display can also tip one way or the other. While certain types of effects keep confession of the technology of illusion to a minimum, others come much closer to putting "the *tour de force* of which the cinema demonstrates it is capable" on display (668). At one end of this spectrum are "invisible" and "imperceptible" effects; at the other end, "visible" effects. For Metz, however, it makes no sense to ask what spectators actually see when they look at any of these effects, since spectatorship is predicated on the denial of perception. What the cinematographic establishment avows, the spectatorial economy denies. This is why Metz's typology does not have a category for effects that are seen. There are effects that are sensed without being seen (invisible effects) and effects spectators are aware of but have not noticed (imperceptible effects), but no effects that specifically solicit spectators' aesthetic attention. When Metz refers to "visible effects" he has in mind those effects that, like any change in film speed or the use of superimposition to suggest the mental state of a character, seem to hover between illusion and "clause."

The problems raised by this approach to theorizing spectators' perceptions of special effects are best illustrated by example. Take the image of legless Lieutenant Dan Taylor (Gary Sinise) in *Forrest Gump* (dir. Robert Zemeckis, 1994), an example chosen not at random but from the epigraph that began this book. Metz suggests that what makes an effect invisible is the fact that "the spectator could not explain how it was produced nor at exactly which point in the filmic text it intervenes" (664). Since in his terms "the most naïve spectator" is unlikely to lose sight of the fact—"even in the midst of his [or her] passionate interest in the plot"—that the images of Sinise as a double amputee "were of necessity obtained through some special technique," this effect is clearly not invisible in the way that Metz has in mind (668). How, then, to decide whether the effect should be described as imperceptible or visible? Here it is not spectators' knowledge of the effect that is at stake but the extent to which their perception of the effect has been organized by that knowledge. According to Metz, an effect is imperceptible when spectators have not noticed it, when instead of being drawn to reflect on the process, on the technique, skill, and even virtuosity involved in carrying the illusion off, their emotional engagement with the film remains firmly rooted in the diegesis. In fact, there is no way of knowing in the abstract whether it is the pressures of grammaticization or diegetization that spectators experience most strongly when they view any type of special effect. We have, however, already seen that perception is shaped by cultures of effects connois-

seurship and fandom in ways that do not require spectators to make a choice between them.

Metz was of course right to argue that very few special effects are actually supposed to be seen. In the contemporary context, digital effects are routinely used to add all kinds of environmental effects that spectators are not supposed to notice, from generating huge crowds from a few dozen extras to building virtual sets and backgrounds or grafting an image of an actor's face on to a stunt or body double (this latter technique is now used so regularly in action cinema that it is simply referred to in the film industry as a "face replacement"). Of course, even some effects that are intended by filmmakers to be invisible may be apprehensible to the practiced eye of the connoisseur.[27] It is not only the visual effects professional who is able to identify these effects, either. Genre film fans who take a special interest in visual effects also make distinctions between effects that are supposed to be seen and effects that are not, and their evaluations of both types of effects are guided by these perceptions. Effects that are perceived to have been designed for the express purpose of integrating the effect into the visual and narratological space of the cinematographic frame—having no aesthetic function beyond that of maintaining focus on the action or drama and driving the narrative along—are judged according to how closely they approximate this goal. Within a discourse of connoisseurship, evaluation of special effects always involves identification of the parameters for making aesthetic judgments. In this, viewers are guided by their familiarity with the aesthetic conventions of film genres and, within those parameters, by the formal organization of the films themselves.

Metz also recognized that spectators' perceptions of special effects are regulated by genre. Nowhere does he address how this observation specifically applies to the genres of *cinefantastique*, his own references to fantasy and the burlesque serving as much as anything to locate his thinking about special effects in a particular time and place. His understanding of how the spectatorial economy is regulated by genre most resembles Gombrich's views on the relation between perception and aesthetic convention. Just as Gombrich had argued that there is no necessary relationship between illusionism and realism, Metz argued that the fact that some genres require less realism from their effects than others is naturalized for spectators by their familiarity with the conventions of genre. At no point, however, does Metz gesture toward the need for an analysis of the social conditions of spectatorship or, as Gombrich had done, toward the possibility of teasing out some of the ways the aesthetic concerns of professional and artistic cultures and those of cultures of appreciation infiltrate and inform each other. Even though CGI effects no longer belong to science fiction cinema in the way they did at the beginning

of the last decade, it is no accident that this is where audiences first encountered this imagery. Indeed, it could not have been otherwise. The expectations that audiences have of this cinema put very specific demands on the visual effects imagery in science fiction films, demands that film scholars have only begun to try to account for fairly recently.

Reformulating Metz's arguments to come very close, in fact, to making the case for comparing contemporary science fiction cinema with the early cinema of attractions, Albert J. La Valley pointed out that science fiction and fantasy films seem to "hover between being about the world their special effects imply—i.e., about future technology and its extensions—and about the special effects and the wizardry of the movies themselves."[28] In both types of films key special effects function simultaneously as an element of the narrative and as a distinct and distinctly reflexive form of cinematic spectacle. La Valley also felt, however, that science fiction films "demand more realism from their special effects than fantasy does, which permits greater stylization and whim" (146). On the surface the thinking behind this proposition is straightforward enough. It even echoes Harryhausen's own fondness for working with the themes of Greco-Roman mythology over those of science fiction. Even so, the history of science fiction cinema is still not one that has ever been solely governed by a realist aesthetic, and especially not if realism is to be conflated, as it tends to be in La Valley's essay, with the camera eye of photorealism. Writing about special effects several years before CGI looked like becoming the visual effects attraction that it became in the 1990s, the effects La Valley describes differ from CGI in a number of important respects. Nevertheless, it is not only from the perspective of thinking about the aesthetic characteristics of some of the CGI effects that featured in the science fiction films of the early nineties that the emphasis he places on the realist dimensions of SF imagery fails to satisfy.

To some extent, these objections are anticipated in La Valley's own analysis of *Forbidden Planet*, which he identifies as having awakened a tradition of science fiction film that put the aesthetic enjoyment of its special effects at the very center of the film-viewing experience. This much-loved film also has an important place in the history of science fiction cinema sketched by fan historiographers. Clarke and Rubin's 1979 retrospective of the making of the film identified it as "the direct forerunner of *Star Trek*, *Star Wars* and the big-budget science fiction films of today."[29] I noted in the last chapter that other science fiction films of this period also put their special effects center screen. A handful of creature features offered their exquisitely crafted creations for the aesthetic appreciation and knowing admiration of stop-motion animation fans. Following Clarke and Rubin, La Valley suggests that *Forbidden*

Planet was the first Hollywood film of this era to be set in the distant future, a move that enabled science fiction to recover an emphasis on imagining future technologies that had been an important feature of literary SF from the very beginning. But earlier science fiction films had also made the imagining of future technologies a primary site of visual interest, for alien technologies often function allegorically as possible futures for human technological development in the films of this period. From *Earth vs. the Flying Saucers* to *Dark City* (dir. Alex Proyas, 1998), exploration of the complex temporalities put into play by alien technologies has been a recurrent theme of science fiction film. What *Forbidden Planet* did, however, was to shift the action of the future from a mundane, earthbound present to a richly imagined other time more clearly than any other film of the 1950s. The historical lessons of this, and other films of the period, are about the variety of aesthetic considerations brought to bear on the imaging of this other time.

At any stage in the history of science fiction film, the parallel universes of SF fiction, comics, space art, and illustration have served as important referents. Science fiction has always risked an element of art and artifice alternately incomprehensible and unrecognizable to audiences unfamiliar with this wider world. It is now easily forgotten that one of the production decisions that set *Forbidden Planet* apart from many other SF films of the period was the decision to shoot the film in glorious Technicolor. Other films shot in Technicolor include *Destination Moon* (dir. Irving Pichel, 1950), *When Worlds Collide*, and *The War of the Worlds* (dir. Byron Haskin, 1953), all of which were produced by George Pal. Less extensively written about than these other films, *When Worlds Collide* drew inspiration for its (Academy Award–winning) special effects from a culture that had made space its future as never before.

The film transposes the story of Noah's Ark to another time that is at once familiar and earthbound and totally fantastic. The only way that any of the citizens of the world (i.e., the USA) can survive a collision between Earth and an oncoming star is to repatriate to a newly discovered planet. Addressing the film's enfolding of the future in the present, a world leader sitting at a meeting of a council of nations tells a scientist that he believes in theories "but when you tell me it is possible to build spaceships to fly to another planet, I tell you that you are living in a dreamworld of the impossible." And it is in this dreamworld of the impossible that the film's second and third acts are set. In the disaster sequence that transpires early in the film, a shot relying on miniatures to create the effect of a tidal wave sweeping a house off a cliff and another combining a miniature set with matte paintings to show the streets of a city filling with water risked being judged aesthetic failures in any day. As

having failed, that is, to represent the scale of these events convincingly. But the need to meet demands for aesthetic realism has also been interpreted differently across the two temporal orders that set the scene for special effects in this film.

In the film's second act a series of dramas concerning the question of just who is going to be able to escape to the new world is played out against the construction of the rocket ship that is to take the lucky few to safety. Used in combination with a model of the rocket, shots of Jan Domela's matte paintings punctuate these dramas at regular intervals. The inspiration for these highly stylized, color-saturated vistas is immediately recognizable from the covers of the pulps. Offered in lieu of any more technically ambitious effects, these futuristic tableaux also set the scene for audiences' reception of the effects sequences that feature the rocket's launch, spaceflight, and landing. Such compositions defer not to the camera eye of mechanical reproduction but to a tradition of science fiction illustration that drew its own vision of a moderne, streamlined future from the covers of *Flash Gordon* and the styles of industrial design popularized by designers such as Walter Dorwin Teague, Norman Bel Geddes, and Buckminster Fuller. Against this warmly embraced vision of the future, the shot of the rocket's takeoff could thus accommodate the artificiality of this scene without courting audiences' disappointment. Effects sequences depicting the rocket's journey through space likewise have a formal composition that shows off the sleek, aerodynamic lines of the miniature rocket (designed by the renowned space artist Chesley Bonestall) and give material, three-dimensional expression to a popular, science fictional artifact that had only rarely been seen in this way before. From the Bonestall-designed rockets of *Destination Moon* and *When Worlds Collide* to the menacing Martian war machines of *War of the Worlds* and the flying-saucers in *Earth vs. the Flying Saucers* and *Forbidden Planet*, models of spacecraft in fifties' science fiction films lifted images of the future best known from the pulps and turned them into little miracles of mechanical and electrical engineering in their own right.

Like *War of the Worlds*, *Forbidden Planet* was that peculiarly science fictional Hollywood phenomenon, a B-picture film with a below-the-line budget of well over a million dollars.[30] Far more than any other SF film of this period, the production, art, and effects design for this film embraced the aesthetic possibilities of filming a science fiction film in color, using the expressive potential of the medium to give the effects image a reality as art and artifact beyond that usually associated with the conventions of cinematic realism. Not that realism was never a consideration for some of the people involved in the production of this film. Clarke and Rubin reveal that Fred McLeod

Wilcox, the film's director and an astronomy buff, consulted with engineers and scientists at major research institutions about design decisions related to such details as the arrangement of the crew's quarters (aboard the spaceship, United Planets Cruiser C-57D) and the color of the sky (green) on Altair IV (the planet on which most of the action is set) (18). After the graphic, comic-strip abstraction of the credit sequence, which also introduces the looping, hyperbolic electronic tonalities of the film's original score—so different to the sound of the theremin used in the score for *The Day the Earth Stood Still*—all the elements of mise-en-scène in this film continue to give its narrative manifestations another dimension beyond the strictly analogical. It is this film's special effects, however, and especially the way 2-D animation is used in combination with other effects techniques, that appeals most strongly to that old aesthetics of wonder.

Just as photography had done before it, cinema moved quickly toward developing new ways of layering the cinematographic image to create illusionistic effects: first using in-camera and later optical printing techniques to produce complex, composite images. In the mid-twentieth century, films such as *Tarantula* and *The Incredible Shrinking Man* (dir. Jack Arnold, 1957) made extensive use of traveling mattes to produce their remarkable cinematographic articulations (figure 3.1). Images of the incredible shrinking man in flight from a cat many times his size or in mortal combat with a tarantula declare themselves tricks through their sheer impossibility. The wonder of these effects lies in speculating about how they were achieved or alternatively, and more satisfyingly, in being able to identify their improvement on older methods of combining images filmed at different times (e.g., the filming of live action in front of a screen on which another film is being projected). What made traveling mattes an improvement on older techniques for combining film images was their ability to mask their techniques of illusion more effectively. But like any special effect that functions in this way their effectiveness was quickly dulled by repetition.

Split-screen traveling mattes are used extensively in *Forbidden Planet* to make images appear and disappear in the old way of "now you see it, now you don't." In a demonstration of what he later refers to as a "bit of parlor magic," Dr. Morbius (Walter Pidgeon) makes a piece of fruit disappear by throwing it into a piece of household technology dubbed "a household disintegrator beam" by an appreciative onlooker. Commander Adams (Leslie Nielsen) later uses his weapon to vaporize a pouncing tiger in midair in one of a number of similar such effects shots. Neither the piece of fruit nor the tiger simply disappears. Their vanishing coincides rather with the appearance of vivid flashes of color. In addition to adding another layer of complexity to the shot, these ani-

FIGURE 3.1 *The Incredible Shrinking Man* (1957, copyright Universal Pictures)

mated flourishes heighten and extend the moment of transubstantiation. The most elaborate special effect of this type is seen during Morbius's demonstration of the Krell's "plastic educator" (which he describes as a mental imaging device used to produce three-dimensional images). The scene of demonstration is a tarnished silver disc set low in the angled display area of the machine. In a single shot a cloud of tiny white particles appears from nowhere and is just as suddenly transformed into a flat white disc. Then, out of its center an electrical charge appears, fanning out from white to blue, until it begins to form a central vaporous column that is joined by daubs of white, pink, and red, all spinning and whirling and gradually forming an impression of a human figure. Never quite cohering as a stable image, the figure turns blue and disappears, and a moving, photographic image of Morbius's daughter, Altaira, finally, haltingly appears (figure 3.2). By transforming the cinematographic image into a complex effects assemblage—that superimposed film footage of the charge from an electrical generator and hand-drawn animation with a traveling matte cut from film footage of Altaira (Anne Francis)—the moment of final revelation is artfully suspended, and viewers are left to wonder at the details of this elaborate composition. Almost all of *Forbidden Planet's* special

effects are presented as demonstrations of the wonders (and terrors) of the lost world of the Krell, whose dream of a civilization without instrumentality is ultimately revealed to be dangerous, brutal, and destructive. But even if we accept Metz's proposition that representation is always in the service of diegetization in narrative film, by now it should also be just as clear that the aesthetic interest that the intricately layered effects assemblage in *Forbidden Planet* invites remains in an important sense extradiegetic.

Nearly thirty years after this film was first released, La Valley realized just how important an appreciation of the technology and craft of visual effects design and production was becoming to increasing numbers of young people drawn to search out and repeat the aesthetic experience of watching the cinematographic image be put through some other, hopefully hitherto unseen transformation. But he also worried that they were being drawn to accept a science fiction cinema that in the process of offering up ever more spectacular effects had lost the analogical dimension of critique found in the films of the 1950s and 1960s and become an "escapist art."[31] But "escapist" in what sense? It has certainly been the case that the science fiction films that La Valley refers to—*Star Wars* (1977), *The Empire Strikes Back* (dir. Irvin Kershner, 1980), and *Close Encounters of the Third Kind* (1977)—have been consistently derided by critics for what has generally been perceived to be their puerile and unreflective technophilia. Joanna Russ summed up the feelings of more than a few disaffected cultural critics when she argued that "*Star Wars*—which is being sold to the public as 'fun'—is in fact racist, grossly sexist, not apolitical in the least but authoritarian and morally imbecile, all of this is both denied and enforced by the opportunism of camp (which youngsters in the audience cannot spot, by the way) and spiced up by technical wonders and marvels, some of which are interesting, many of which are old hat to those used to science fiction."[32]

When critics use the term "escapist" to describe a film or its reception, they often mean that it repels critical reflection by appealing to the senses over the intellect or, and this is Russ's point, that the marketing of it as entertainment heads criticism off at the path by appealing to the (largely manufactured) consensus that only spoilsports engage in it. Used to describe a more or less self-conscious mode of spectatorship, escapism also implies a socially and politically conservative desire to retreat into an imaginary world in which all the rules of the old, real-world social order no longer apply. So what about fan discourse? To what extent has the cultivation of a culture of effects connoisseurship and appreciation or, more broadly, of science fiction fandom been implicated in these kinds of fantasies and desires? It is certainly true that until quite recently the popular media that has taken the most

FIGURE 3.2 *Forbidden Planet* (1956, copyright Warner Bros.)

interest in special effects and the forms of entertainment that feature them—popular science publications, genre filmzines and magazines, and new media and computer lifestyle magazines—have not shown a great deal of interest in, or concern for, the kinds of ideological criticisms that Russ makes of *Star Wars*. There have always been exceptions, however. The popular literature of fandom is deeply invested in the discourse of auteurism, and the authors, screenwriters, and directors associated with genre fiction and genre filmmaking have always been highly valued contributors to fan publications and forums. In these contexts it has been SF fiction writers who have most often performed the role of iconoclast, challenging popularly held opinions about a form of science fiction that they have not always been particularly well disposed toward in the first place.

It was this arrangement that gave *Future* magazine (1978–1981)—yet another of O'Quinn's many publishing ventures—its critical edge. Mixing science fiction with science fact, *Future* was filled with behind-the-scenes articles on the making of science fiction television series, surveys of science

fiction film and literature, interviews with science fiction authors, and regular articles on space art and science fiction illustration. It also published numerous articles on NASA, popular explications of scientific theory (i.e., quantum physics), and every conceivable variety of futures speculation (scientific, artistic, financial). It was a popular science magazine in the mode of what Constance Penley calls "NASA/TREK," a "collectively elaborated story that weaves together science and science fiction to help write, think, and launch us into space."[33] O'Quinn himself described the magazine as a "very specialized" publication, appealing "not to the mainstream public but to those individuals with a unique idealism about the possibilities of the world of tomorrow—people with a healthy obsession for the exploration of space, with a lively interest in the drama of science fiction, with a keen curiosity about the advances of science and technology."[34] O'Quinn would in fact continue to refine "the future life philosophy" of the magazine throughout its period of publication.[35] And, in certain respects at least, it was a philosophy that lent itself to politically conservative articulations, concerned as it was with elaborating the need to protect individuals' "natural" rights to the pursuit of happiness, personal liberty, and freedom against any restriction of those rights by the legislative arm of the state. "The future," O'Quinn declared, "is dependent upon individual liberty. Every new idea—every scientific theory and invention—comes from single minds—minds that cannot be turned on or off by their owners."[36] In aligning science with the freedom of individuals to pursue scientific research unfettered by ideological and commercial imperatives, O'Quinn had of course drastically underestimated the extent to which scientific research has always been driven by political and market forces. His insistence that the way to a better tomorrow lay in rejecting the political pragmatism of governments, in holding to the view that the conditions for human life can be improved, and in upholding the right of individuals to pursue their own happiness free from the threat of force also places his "future life philosophy" within a tradition of American utopianism that stretches at least as far back as the nineteenth century.

O'Quinn took very seriously the idea that futurists could best protect the right of individuals to self-expression by cultivating forums in which even unpopular opinions had a chance of being heard. Of all the publications that he has been involved with as editor and/or publisher, *Future* came closest to realizing this ideal. Not that the opinions of just anyone got a hearing. It took someone of Harlan Ellison's stature in the science fiction community to get a license to exercise his particular brand of cultural critique and social satire in a regular column entitled "An Edge in My Voice." In addition to receiving

numerous Hugo and Nebula awards for his short stories, Ellison has published more than a dozen novels, written episodes for a long list of television series (which include *Star Trek*, *The Outer Limits*, and *Alfred Hitchcock Presents*), acted as a "Conceptual Consultant" on *Babylon 5* (a title devised specifically for him), and been involved in the development of a comic series for Dark Horse Comics. In *Future* he performed the role of agent provocateur, regularly managing to insult his readership ("the word *weird* ennobles some of you") and alienate fellow writers ("is [Norman] Spinrad becoming a crypto-reactionary?") within the space of single column.[37] It was equally Ursula K. Le Guin's accomplishments as a science fiction author (among her many novels, *The Left Hand of Darkness* [1970] and *The Dispossesed* [1975] received both Hugo and Nebula Awards) that enabled a space to be made within the magazine for her subtle, critical review of *Close Encounters of the Third Kind* and *Star Wars*, "this funny silly beautiful movie."[38] Lamenting its nostalgia for the comic-book adventure stories of a bygone era and infatuation with the boys'-own militarism that goes along with them, Le Guin's criticisms of *Star Wars* are couched in the kind of progressive futurist terms that have enabled feminism and the utopian tradition of American science fiction to find common cause in their desire to get to somewhere else. On this occasion the utopian dimensions of critique are writ as a refusal to accept that this is where science fiction has arrived. Exercising all the intelligence and lyricism for which her best writing has been remembered, she writes: "Through the impasto of self-indulgence and the comic-book compulsion to move-move-move, there breaks a childlike, radical, precise gesture of the imagination: and you glimpse what a science-fiction movie might be like, when they get around to making one" (18).

Barbara Krasnoff, a regular contributor to *Future*, also included *Star Wars* in a critical survey of the roles available for women in SF media.[39] In this article Princess Leia Organa is seen as a transitional character: cute, spunky, and capable of action—and obviously to be preferred over the evil exotics and decorative damsels that spice up the rest of the science fiction universe—but still not brave or "heroic" enough to be considered a fully fledged heroine. Krasnoff cites the self-reliant, female protagonists in films such as *Alien* (Lt. Ellen L. Ripley, played by Sigourney Weaver) and *Altered States* (Emily Jessup, played by Blair Brown) as examples of the kind of heroine she has in mind, concluding, rather hopefully, that the sex role stereotyping more typical of SF film and television may finally be on the wane. The fine but gnarly vein of polemic and sociopolitical analysis that runs through *Future* was not typical of SF fan publications in the late 1970s and early 1980s. The very fact

that the magazine's parameters for speculation and review were less well defined than those of a magazine such as *Starlog* allowed it considerably more scope for discursivity.

Much more narrowly focused on the technology and craft of film and effects production, the more popular genre film magazines have generally demonstrated a relatively high tolerance for the racial, ethnic, and sexual stereotypes that so often people Hollywood genre films. The identification of some films as more effects oriented than people oriented has facilitated this tolerance, allowing fans to misrecognize ideology as convention and to dismiss Hollywood's role in the cultural reproduction of racist and sexist stereotypes as typical of a particular style of filmmaking. Fan criticism of genre films has, however, developed social criteria of its own for distinguishing the "classics" from more mediocre fare. And it is impossible to grasp what special effects can, and do, mean for fans without also being able to recognize that a discourse of aesthetic appreciation does not necessarily imply the disarticulation of social from aesthetic issues. In the case of science fiction films, fans still want a speculative cinema, a cinema which, in a Wellsian sense, raises questions about the human condition or the fate of human societies through its depiction of future scenarios. They want, in Altman's terms, films "that make us question the future and ask where we are headed as a nation and a cosmic community."[40] Since in the contemporary, action-oriented science fiction film ideas tend not so much to be discussed as visualized, fans also want a science fiction cinema that opens on to new vistas, offering new terrain for the imagination in the form of novel effects and richly drawn future worlds. That genre filmmaking is above all regulated in Hollywood by the economic bottom line is something that the industry savvy reader of a fan magazine like *Cinefantastique* or *SFX* (and *Sci-Fi Universe* when it was still around) has had to come to terms with. It is the films that, in their recycling of images, plot lines, and themes from previous blockbusters, appear to make no real attempt to offer something new that fans still accuse of being too blatantly commercial.[41]

The same discursive networks that support the diverse fan cultures that now take a special interest in special effects have also been important sites of identification and discourse for effects professionals. Publications focusing on the making of special effects have been around a lot longer than the film industry and certainly a lot longer than CGI. By the 1980s magazines and books about the making of special effects were already attracting readerships that extended way beyond their traditional fan bases. The networks for popularizing aesthetic and how-to discourses on special effects were established in large part through the publishing activities of the genre film prozines that

began publication in the early 1970s. As well as providing an important forum for behind-the-scenes discussions about special effects, magazines such as *Cinefantastique* and *Starlog* also stimulated the market for books on the subject. *Starlog* first began publishing its popular series of photo-guidebooks—which included titles on toys and models, spaceships, space art, robots, fantastic worlds, and special effects—in the 1970s. *Cinefantastique* has also been an important publisher of works on genre film and genre filmmaking, becoming one of the largest publishers of unauthorized guidebooks on *Star Trek*. And long before personal computers introduced the technology for producing computer-generated imagery at home, *Cinemagic* was instructing readers on how to become producers of special effects. *Cinemagic* was another of the publications launched by *Starlog*'s extraordinarily energetic editor and publisher. Aimed at Super 8 filmmakers (and would-be filmmakers), each issue focused on a particular special effects technique and offered readers practical advice about how to produce special effects using this technique at home.

In interviews, special effects luminaries like Denis Muren (who has more than a dozen feature film effects credits with ILM) and Douglas Trumbull (whose effects filmography includes *2001*, *Close Encounters of the Third Kind*, *Blade Runner* [dir. Ridley Scott, 1982], *Brainstorm* [dir. Douglas Trumball, 1983], and a growing number of location-based entertainment attractions) will often recall their childhood experiences of watching science fiction.[42] These experiences are invariably described in terms that emphasize the intensity with which they scrutinized effects images for clues about how to make them. In the interview that he did for the ILM edition of *Cinefex*, Denis Muren, for instance, recalls spending hours trying to remember every detail about the images produced by Harryhausen.[43] Stories like Muren's have helped to popularize the belief—long cherished by SF fans—that the special effects industry represents a guild of skilled artisans who have honed their craft by first watching and later working on science fiction films. While this is obviously an idealized view, it has also been shared by many of the modelers and animators working in the special effects industry. The attitude of SF fans, who have treated all branches of special effects as cinematic art forms unto themselves, and the attitude of effects producers, who until recently have struggled to have their work recognized in these terms within the Hollywood film industry, have therefore been mutually reinforcing.

By providing a space within which the aesthetic concerns of special effects production were taken seriously, genre film magazines also created more opportunities for effects supervisors and designers to think through and explore these concerns in more detail themselves. This in turn has arguably

had consequences for the aesthetic direction that effects production took over the period that spans the late 1970s to the mid-1990s. For as readerships for aesthetic and how-to discourses on special effects broadened, art-and-effects direction in science fiction cinema could more confidently opt for a presentationist mode of exhibition that put the visual effects image on maximum display. This does not mean that visual effects images were never explicitly presented to audiences in this way before the late 1970s or that all special effects imagery produced during this period can be described in these terms. Hollywood's first big experiments with CGI did, however, give this style of art-and-effects direction its sharpest focus yet.

REINVENTING THE CINEMA OF ATTRACTIONS

In order to signal his intention of looking at the history of science fiction cinema in "film-specific" rather than "narrative-based" terms, Brooks Landon called his introduction to *The Aesthetics of Ambivalence* (1992) "Separated at Birth." At the end of the last decade, this was still the only scholarly, book-length study of science fiction film to make special effects technologies its central focus. Landon's work challenged many of the critical assumptions that had been made about science fiction cinema in the past, but perhaps his most thought-provoking claim was that the tradition of art-and-effects direction that emerged from the science fiction cinema of the late 1970s marks a return to the aesthetics of early film. A decade after this book was published, this is now a familiar argument, so influential have some of Tom Gunning's essays on the early cinema of attractions been for the small but developing field of scholarship on special effects that has since emerged.[44]

Following on from Noël Burch's identification of the need to rethink the early history of film not as a developmental narrative that would have classical cinema emerging from its primitive state into a fully fledged narrative cinema but as a story about the uneven development of two distinct modes of cinematic representation, Gunning argued that "telling stories" did not become cinema's dominant concern until somewhere around 1906.[45] Much early cinema, he has argued, was an exhibitionist cinema, a cinema of attractions, "less a way of telling stories than a way of presenting a series of views to an audience" (63). This reevaluation of early filmmaking techniques has been supported by a number of other scholars writing about this period of cinema history in the 1980s and early 1990s.[46] André Gaudreault, Miriam Hansen, and Charles Musser have also produced work in this area that argues that the presentational dimensions of early cinema made it a different kind of cinema from that which would come after it.[47] Their work suggests that in many of

the nonactuality films made during this period, scenes and images were presented in ways that emphasized the novel capabilities of the new moving picture technologies rather than their ability either to suggest a story or to represent the world at large. Both Gunning and Musser have also cautioned against representing early cinema purely in terms of what Musser has called its "presentationalism." They point out that although films made during this period tended to place less value on the realism of the images being presented to audiences than on their sheer visual impact, they also displayed signs of being organized by some of the representational concerns that would later come to dominate narrative cinema. Nevertheless, it is the importance that both film historians place on the presentational dimensions of early cinema that has captured the imagination of film scholars writing about contemporary cinema. And it is also why the films of Georges Méliès hold a particular fascination.

André Gaudreault's revaluation of Méliès's films challenged the view held by an older generation of film historians that Méliès's style of filmmaking was more theatrical than truly cinematic.[48] Arguing that these historians associate narrativity only with "those narratological aspects that mark the early films of Griffith, such as the development of psychological characters, the creation of suspense, and the illusion of realism," Gaudreault outlined all the ways that Méliès's trick-motivated films utilized systems of articulation that are specific to the cinema (such as the use of editing to manipulate point of view or to create temporal overlaps) to develop an alternative style of narrative filmmaking rather than one that was strictly nonnarrative (112–14). In the special privilege that Méliès's films assign to tricks and picturesque tableau, Gaudreault identified a mode of spectatorial address that not only exhibits "no particular allegiance to the maintenance of diegetic realism" but actively solicits spectators' appreciation of the techniques of illusion (113). If this description alone seems to invite comparisons between this form of early cinema and the science fiction cinema of the late twentieth century, it was further helped along by Gunning's suggestion that the cinema of attractions did not disappear once the hegemony of narrative cinema had been established "but rather [went] underground, both into certain avant-garde practices and as a component of narrative films, more evident in some genres (e.g., the musical)." In "some sense," Gunning offered, "spectacle cinema has reaffirmed its roots in stimulus and carnival rides, in what might be called the Spielberg-Lucas-Coppola cinema of effects."[49]

When Landon was writing, speculation about the imaging capabilities of new digital technologies was just beginning to take off in the mass media. The publication of *The Aesthetics of Ambivalence* was sandwiched between the

release of *Terminator 2* (1991) and *Jurassic Park* (1993). Here was a cinema that seemed to many people not only to be making its powers of simulation its feature attraction but also to be on the verge of disarticulating science fiction film from the very institution of cinema itself. In the buildup to *Jurassic Park*'s release, speculation about the film's computer-generated dinosaurs generated far and away the most publicity for the film. And in fact no other film so perfectly exemplifies certain aspects of Landon's description of the way special effects imagery functions in the science fiction films of this period. In the first scene in which one of the much-anticipated computer-generated dinosaurs is finally unveiled—both to the characters in the film and to the cinema audience in the theater—the narrative all but comes to halt, the music gradually builds, and shots of characters reacting to the appearance of the dinosaur with wonder and amazement are interspersed with long takes displaying the computer-generated brachiosaur center screen.

One of the most powerful discourses on computer-generated imaging technologies centers on the possibility that this technology might one day produce images that so perfectly simulate the look of objects in the real world that it will be impossible to tell that they have been computer generated. This is the dream of simulation that Landon rightly points out has long been debated and explored, both in science fiction film and literature and in what he calls "science fiction thinking." Reviews of CGI effects in the mass media have also taken a particular interest in this dream, often presenting the latest Hollywood SF blockbuster as an invitation to participate in the technoscientific adventure that the dream of total computer-generated simulation represents. But alongside these dreams other popular aesthetic discourses also molded and shaped the look of CGI in science fiction cinema. And while Landon's representation of the aesthetic discourses governing the production and reception of CGI effects for the most part consists of speculation about these dreams, other possibilities—other ways of understanding the aesthetic direction that CGI effects have taken over the years—might yet be gleaned from the technocultural matrix he describes.

Landon's meditation on the future of science fiction film mirrors aspects of Vivian Sobchack's analysis of electronic space in the last chapter of her landmark study *Screening Space: The American Science Fiction Film* (1987).[50] But whereas Sobchack adopted a critical stance toward the deflation of deep space and excess of surface detail that she associated with the computer-generated image—seeing in it the same aesthetic characteristics that have been invoked by Fredric Jameson to describe the constitutive features of postmodernism—Landon was unabashedly celebratory. From Sobchack's description of electronic space he took only its denotative characteristics, refiguring them in the

image of a much shinier future. Written more than a decade ago, these critics' very different meditations on CGI effects attempted to grasp the cultural logic that seemed to be driving the production of electronic images for a range of digitally produced media, from special effects and computer games to theme park rides and emergent forms of VR. Sobchack has since had occasion to reconsider the homogenizing effects of these attempts to map the field of electronic culture in global terms, pointing out that "it is now time to move beyond general analyses and broad critique of our digital culture to a more focused theory and criticism that distinguishes among a variety of quite specific digital articulations."[51]

This has proven to be a timely intervention. For without being able to account for the expectations that consumers of different types of computer-generated images have of them—and some of the myriad activities that mediate their experiences of viewing these images in the cinema, or on video, or in the form of computer games or experimental new media—the socially significant dimensions of these experiences cannot be accounted for, either. It may just be that the first step toward recovering some of this variety in accounts of the cultural reception of special effects lies in remembering that it is not only technologies that decide the fate of cultural institutions. What attempts to draw comparisons between the computer-generated visual effects imagery featured in Hollywood cinema and the computer-generated environments of computer games have had to consider, for instance, is the very different expectations people have of these media. A number of critics who have looked at the convergence between film and computer games have pointed out that video and computer games have not only adapted many of the techniques of narrative filmmaking to suit the action-oriented idiom of gaming but that the mining of games for source material (e.g., *Street Fighter* [dir. Steven E. De Souza, 1994] and *Mortal Kombat* [dir. Paul Anderson III, 1995]) is only the most obvious way contemporary genre films have in turn drawn on computer games.[52] Moreover, if one of the features of a computer game aesthetic has always been the privileging of rendering speed over resolution, as the techniques for enhancing visual resolution have continued to improve the visual integrity of the graphical interface the trade-off between the two has become less and less determining. The narrative and experiential frameworks of games and films nevertheless remain very different, and different visual design protocols have evolved for different types of game platforms. As reviews of video and computer games in a publication such as *Sci-Fi Universe* make clear, the language for describing what makes for a good game experience is not at all the same as that used to describe a good movie-going experience elsewhere in this magazine.

To give all applications for computer-generated imaging technologies the same aesthetic horizon is to risk allowing a whole other history of the institutional mediation of cultural forms to disappear and along with it one of the things that holds the analogy between contemporary science fiction cinema and the early cinema of attractions together in the first place. Because if it is indeed the case that like the early cinema of attractions science fiction film relies on the novelty of its attractions to capture and sustain the attention of viewers, it has also been patrons' emotional and intellectual attachment to the cinema—to the particular kind of experience that it offers—that has continued to lure them away from the television set, the video or DVD player, the games console, and the computer screen. In the form of the suburban multiplex, the space of the cinema has been integrated into the surrounding video arcade, shopping mall, and fast-food outlet that sell the licensed consumer products that have vastly increased the commercial spoils of genre filmmaking over the last twenty years.[53] In its blockbuster form the genre film is itself one node in a vast entertainment complex that includes the game and theme park attractions that are now produced concurrently for its staged release. Within this new production-consumption matrix the demarcation between the cinema and the other spaces of consumption that surround it, as well as that between the film and its many "appliances" (they can no longer be considered mere spinoffs), has blurred without disappearing altogether.

Of all the features of the cinema that make it different from other forms of entertainment—the architectonics of sound and screen, its protocols for regulating audience participation and interaction—the two factors that have continued to be important for drawing audiences back to it have been the temporal privilege that, at least for the time being, is still reserved for the cinematic event and the social and public dimension of attending a theater (away from home). Genre film fandom has always attracted the amateur archivist and historian, whose investment in the cinema is very often laced with a nostalgic longing to return to a classic age of filmmaking and cinemagoing, but genre film fandom, and especially science fiction fandom, has also been articulate about its investment in the future of cinema, just as often seeing fans as genre cinema's watchdogs. Fan discourse on the institution of cinema has become especially articulate about the socially symbolic value of the cinematic event. Television theorist John Thornton Caldwell has pointed out that dramatic, prime-time television series have become increasingly cinematic since the 1980s, citing the rise of the television producer-auteur (Aaron Spelling, Steven Bochco, Chris Carter, David E. Kelly), the greater emphasis given to visual style and the cultivation of a distinct look or aesthetic, and the foregrounding of the use of new production technologies (and especially special effects tech-

nologies) as just some of the ways that serial television production and design have come to resemble feature film production.[54] Remarking on this tendency in *Sci-Fi Universe*, Altman once noted that even though "the irony is that today's SF movies are becoming more like television, and SF television more like the movies," the cinema still provides a more spectacular, more communal viewing experience than television does.[55]

This attachment to the cinema—an attachment that is fostered most strongly through cultures of appreciation and connoisseurship—has roots in a host of cultural practices and institutions (including educational institutions) that continue to invest the cinema, and cinemagoing, with social and cultural value. Where the comparison between the blockbuster SF cinema of the 1990s and the early cinema of attractions is especially instructive is in reminding us that demands for novel attractions virtually ensure the limited lifespan of any technological, stylistic, or aesthetic innovation. As far as this cinema's special effects have been concerned, it should therefore come as no surprise that the novelty of a simulationist aesthetic would be the first to wear off, driven as it is, in this context, by the logic of similitude and the simulacra. In a spoof of the behind-the-scenes article that typically contains interviews with the people involved in film production, *Sci-Fi Universe* went behind the scenes of *The Lost World* in 1997. This pastiche has as one of its targets the fatuous, self-congratulatory tone of so many a Hollywood press interview. The interview with the "ILM F/X Guy" begins with this ersatz wizard explaining that "we start with a wire frame model and then digitally texture map the dinosaur skin. We spent a lot of time meeting with actual paleontologists to insure the accuracy of the dinosaurs we portrayed in this motion picture." Before the "F/X Guy" gets a chance to finish giving the details about "the render time involved in creating these creatures," the *SFU* interviewer interjects: "Oh, that was fascinating. What can we expect in this film that we didn't see in the last"?[56]

DIGITAL ART EFFECTS

During the early part of the last decade, the special effects imagery in science fiction cinema was bracketed for audiences—both by the formal organization of the films themselves and by the formal and informal networks of information about special effects that now play such an important role in the contemporary entertainment experience—as both a technoscientific tour de force for the special effects industry and a special kind of aesthetic object. In films such as *The Abyss*, *Terminator 2*, *Lawnmower Man* (dir. Brett Leonard, 1992), *Jurassic Park*, *Stargate* (dir. Roland Emmerich, 1994), *Johnny Mnemon-*

ic, and *Virtuosity* the presentation of key computer-generated images produces a distinct break in the action. These temporal and narrative breaks might be thought of as helping to establish the conditions under which spectators' willed immersion in the action—their preparedness to being carried along by the ride—is suspended long enough to direct their attention to the display of a new kind of effects artifact. In these films, effects sequences featuring CGI commonly exhibit a mode of spectatorial address that—with its tableau-style framing, longer takes, and strategic intercutting between shots of the computer-generated object and reaction shots of characters—solicits an attentive and even contemplative viewing of the computer-generated image. It is these types of effects sequences that effects professionals usually have in mind when they refer to a film sequence as an effects sequence. Sometimes, of course, the decision is made *not* to allow an effects image to distract from the narrative and/or action in this way. Referring to such a scene in *Star Wars: Episode I—The Phantom Menace* (dir. George Lucas, 1999), visual effects supervisor Denis Muren explains that "when we cut to the outside, we didn't want to linger too long and make it an effects sequence. That way the audience is interested in 'Are they [the characters in the scene] going to get away or not?' rather than how neat the creatures look."[57]

In the case of effects sequences that do solicit an aesthetic appreciation of the visual effects image as art and artifact, sound also has an important role to play in organizing viewer's attention at these moments. Brad Fiedel, whose many feature film credits include *The Terminator* (dir. James Cameron, 1984) and *Johnny Mnemonic*, used a synthesizer to create a postindustrial soundscape for the musical score for *Terminator 2*. An important musical motif is established in the film's credit sequence, which depicts a future war scenario in which soldiers are battling it out for survival with the machines that now walk the earth, their metal skeletons literally crushing humanity underfoot. Sarah Connor (Linda Hamilton) provides the voice-over narration that begins and ends this sequence, a device that is used to convey a back story essential to the plot. Underscoring the action are all the sounds of battle—machine-gun fire, explosions, the crush of metal, the whine of aircraft—but these are overlaid by a musical score that is dominated by a droning, atonal bass sound rising above the rest of the soundtrack like some strange foghorn. As the narration that bookends the sequence resumes, this distinctive sound effect gives way to a musical score now dominated by a percussion track that has been running throughout the sequence but, brought up in the mix, now heralds the return to the present-day time of the film. Both these elements of the musical score—the machine drone and heraldic drum beat—provide important aural cues throughout the first half of the film. From their first

sighting of the T-1000 disguised as a police officer (Robert Patrick), viewers are, for instance, cued to associate this human figure with the sound of a machine future.

Sound and image tracks work together to clear the way for the presentation of one of the film's key CGI effects sequences: the revelation of the T-1000 in its liquid metal state. This sequence is preceded by a visually and aurally frenetic chase sequence, in the course of which the T-800 (Arnold Schwarzenegger) attempts to protect the future leader of the human resistance movement, John Connor (Edward Furlong), from the deadly advances of the T-1000. The sequence ends with the truck being driven by the T-1000 exploding into a spectacular fireball. After all the noise and hyperkinetic action of this sequence, its vertiginous shifts in point of view, increasingly short edits, and succession of stunts unfolding in a dizzying montage, there is a moment of stillness and quiet, when the low roar and crackle of the flames that now fill the frame are the only sounds to be heard. A horn blast announces a burning tire as it rolls out from the fire toward the T-800 and his charge and is swiftly followed by a familiar drumbeat. This auditory cue is important, because even as John Connor and the T-800 leave the site of the burning wreckage, spectators have been cued to anticipate something else. With the flames from the burning wreckage again filling the frame, nothing is allowed to compete for their attention at this moment. Out of this brief suspension in the action, a luminous, chrome-like figure begins to emerge from the flames, its shimmering, reflective form morphing into the familiar figure of the police officer as it moves out of the fire. This is the moment that effects fans who went to the cinema to see this film in 1991 had been waiting for, the moment when the imaging capabilities—and aesthetic possibilities— of the digital technologies they had heard and read so much about took center screen.

All the action-oriented SF films of the early 1990s exhibit this self-conscious showcasing of a new type of effects imagery. Everything about them is designed to magnify its aesthetic impact. No fabulous or picturesque tableaux, no monumental vistas or lush sets, compete with the effects image. This is a cinema of interiors. There are none of the densely layered exterior spaces that gave the "overexposed city" in *Blade Runner* the monumental grandeur that Bukatman and others have described so well.[58] In *The Abyss* the setting for the film's key effects image—the presentation of the protean seawater pseudopod—is the confined, only half-domesticated space of an underwater oil rig, its cramped, industrial interior providing a monochrome backdrop to the appearance of this alien intruder. The virtual reality sequences in both *Lawnmower Man* and *Johnny Mnemonic* likewise function

as a visual counterpoint to the mundane, dimly lit interiors where the bodies of these films' virtual travelers remain parked. The world of *Lawnmower Man* is a world where domestic violence is never farther away than next-door and where instead of offering an escape virtual reality leads only to the magnification of that violence. The film suspends this demoralizing realization as long as it can, first making the basement of a suburban home and then a government-funded lab the setting for its visual flights of fancy. The last gasp of a cyberpunk future, *Johnny Mnemonic* forwent any attempt to draw its future world anew, instead allowing the detritus of the postindustrial past to stand, as it had so often done before, as the sign that the future isn't what it used to be. Except that it was. By now, the film's survivalist aesthetic had lost whatever novelty it had once held for audiences, but against the shopworn look of the film's dark interiors the computer-generated VR sequences burnt up the screen with an electronic intensity like nothing else around it.

Among this group of films *Virtuosity* occupies a kind of limit point for a mode of art-and-effects direction that Hollywood filmmakers were already beginning to lose confidence in. With its smirking virtual villain Sid 6.7 (Russell Crowe) serving as the screen for the film's soft-porn schtick, and a scene in which Sid, rather in the mode of "Troma Does *Invasion of the Body Snatchers*," is reborn in the real world as a nanotech android, the film rarely manages to stay on the right side of pastiche. In a rare discursive moment the wonders of nanotechnology are demonstrated by a lowly member of the scientific team at the Law Enforcement Technology Center, where the first half of the film is set. The spiel that accompanies this lab dweller's demonstration of the marvels of nanotechnology includes such banalities as "If you separate the character module from the polymer neural net you get nano-death." The film's visualization of what "millions of nanomachines suspended in a colloidal solution" look like in a regenerative state was nothing science fiction audiences hadn't seen before, but in a formal sense at least it offered spectators rare pause to enjoy a patently computer-generated effect while they still could.

In an essay that significantly widened the scope for historical research on special effects, Scott Bukatman identified a very different tradition of art-and-effects direction in films such as *2001*, *Close Encounters of the Third Kind*, *Star Trek: The Motion Picture* (dir. Robert Wise, 1979), and *Blade Runner*.[59] Instead of it being a matter of disrupting cinematographic space—of inserting, or installing, a markedly different kind of technological and aesthetic object into a relatively restricted visual field in the manner just described—Bukatman points out that key special effects sequences in these films are designed to integrate the virtual space of the spectacle with the physical space

of the cinema theater. Instead of being directed toward establishing the conditions under which viewers might obtain some sense of distance from the object being presented, the sheer scope and magnitude of these spectacular vistas—which typically entail the presentation of a massive technological object or environment—is designed to create an immersive experience for cinema spectators. This kind of special effects sequence is aimed, as he puts it, at making spectators feel that *"[they] are there* (even if [they're] not)" (263). One of the things that distinguishes Bukatman's phenomenology from others discussed in this chapter is that it draws together a diverse collection of classical and popular modes of visual display. In a number of memorable visual effects sequences supervised by Douglas Trumbull, he locates a form of spectatorial address that has its antecedents in all kinds of spectacles and exhibition practices, from Renaissance and aerial perspectives, panoramas, and landscape paintings to the precinematic phantasmagoria and the early cinema of attractions (269). While there is a strong tradition of this type of art-and-effects direction in science fiction cinema, it was much less in evidence the last decade, only occasionally resurfacing in films such as *Star Trek: First Contact* (dir. Jonathan Frakes, 1996), with its opening shot of the Borg colony and panoramic displays of the Starship *Enterprise*, and *Contact* (dir. Robert Zemeckis, 1997), which treated viewers to a deep-space star tour during the opening credit sequence and a rollicking, sim-style ride through a CGI wormhole later in the film.

A Trumbull effects sequence, according to Bukatman, "is less the description of an *object* than the construction of an *environment*" (270). During the 1980s and 1990s a handful of SF films staged encounters with the new technological spaces of cyberspace and VR. *Tron, Lawnmower Man,* and *Johnny Mnemonic* all used CGI to render these high-tech environs for film. However, the totally computer-generated effects sequences in these films are not, for all that, fundamentally different in kind from those effects sequences in which cinematographic space is disrupted by the insertion of a computer-generated object at the level of the shot. In sequences in which a computer-generated object—a pseudopod, shapeshifter, stargate, energy ribbon—is composited with live-action footage, the electronic properties of the digital artifact (with its high chrominance, intense luminosity, and electronic plasticity) establish a stark contrast between the computer-generated object and the cinematographic space that frames it.[60] This is the case even where an entire shot is computer generated. Although the computer-generated imagery in *Lawnmower Man* or *Johnny Mnemonic* is not, for instance, inserted into cinematographic space at the level of the shot—as it is with CGI and live-action composites—it still represents a mode of visual display that differs

markedly from the visual style of the dramatic and/or action scenes that flank it. In both types of effects sequences, then, the presentation of CGI effects is characterized by a visual and temporal disruption in cinematographic space. Sobchack makes a similar point in her analysis of the electronic effects in films such as *The Last Starfighter* and the *Star Trek* series. "The privileging of electronic depiction," she argues, "here depends upon its *marked difference* from cinematographic space rather than upon its *integration* with it (however much integration may be 'promoted' by the narrative)." Her argument nevertheless differs from the arguments being made in this book for identifying certain types of visual effects images with a mode of visual display that specifically solicits viewers' aesthetic appreciation, because it is also her contention that the punctuation of cinematographic space by the electronic effect serves to affirm "the dimensional representation of the cinematographic image as 'real' by contrast."[61]

The anticipated social audience for the Hollywood science fiction films that began featuring CGI in the early 1990s was first and foremost an audience for whom this imagery was identifiable as computer generated.[62] Beginning with *The Abyss* the art-and-effects direction for films produced in the first half of this decade emphasized the alterity of the CGI effect by formally bracketing its presentation from the action. The technological specificity of this imagery was also highlighted aesthetically. Pulled, on the one hand, toward photographic realism and, on the other, toward a synthetic plasticity, the computer-generated imagery in films such as *The Abyss*, *Terminator 2*, *Lawnmower Man*, *Stargate*, *Johnny Mnemonic*, and *Virtuosity* exhibits an aesthetic that plays across these two poles. It is this electronic reconfiguring of the cinematographic image that also gives key CGI effects in these films their special reflexivity. For a brief period in the history of computer-generated visual effects, the drive for simulation—long acknowledged within the industry to be something of a digital mantra in the field of CGI effects production—was visibly rendered as just one aesthetic possibility among others.

Still missing from this account of the cinematographic specificity of the visual effects image in SF film is more of a sense of how—and under what conditions—CGI effects came to be perceived by effects professionals themselves not only as the privileged mode of visualization in SF film but also as the cultural sign of an emerging popular aesthetic, an aesthetic I have been calling "technofuturist." Despite the popularity of technicist discourses on special effects, the development of this aesthetic has not been governed solely by technological criteria. Advanced computer-generated imaging technologies have enabled effects producers to create photorealistic images that could not have been produced using the technologies available a decade ear-

lier. But the application of digital imaging technologies to the production of special effects continues to require the people involved in this process to make aesthetic decisions.

In the many articles covering CGI effects production that have appeared in genre film magazines, the development of techniques for rendering images that simulate the physical properties of objects in the natural world have been discussed, debated, and speculated about in (graphic) detail. But even as far back as the mid-1980s—a long time in computer graphics terms—there was some suggestion that the aesthetic goal for producing feature film effects for Hollywood science fiction films may not have been to produce images that could simply be described in terms of realist simulation. In a series of articles that appeared in *Cinefantastique* on the making of the computer-generated imagery for *The Last Starfighter*, there seems to have been little consensus among producers, fans, and critics of this new imagery about how it should look. This is made clear in an article featuring interviews with members of the computer graphics team from Digital Productions. Staged around discussions of the aesthetic merits of the film's special effects, the article begins with a double-page spread featuring an image taken from the film. The caption accompanying the image suggests that "the aesthetics are a matter of taste. Fans would say it looks more real than real. [While] detractors [would] point to the same surreal quality as a defect of the technique."[63]

Designers and animators commenting on the film's CGI effects elsewhere in this issue are divided between those who see the project as an opportunity to demonstrate how much closer computer-generated imaging technologies are to being able to simulate the look of complex three-dimensional objects and those who are more interested in experimenting with the hyperreal aesthetic properties of this new electronic medium. It is the opinion of Ron Cobb—effects designer on *The Last Starfighter* and spokesman for the first camp—that "we tend to associate this technology with a lot of garish, candy-apple colors because, essentially, a lot of technicians who developed this technology were in charge of making images, and they tended towards a tasteless excess." Cobb is even prepared to implicate these geek meisters in *Tron*'s 1982 box-office fizzle. His assessment of where the film went wrong rests on his sense that "while *Tron* has some fairly nice colors occasionally, these often tends [*sic*] to be exaggerated, color-blind, horrible colors and I wasn't sure whether that was an inherent limitation in the system or whether it was just the way the people [i.e., technicians] had been doing it." In the case of *The Last Starfighter* his own aesthetic impulse was, he says, to go for "earth tones." The film's central image, the Gunstar battleship, is all ochers and sand colors. His explanation for this color scheme is that "we were vacillating

between not having it too yellow or too brown, nor too metallic" (29). But for Art Durinski the same aesthetic choices that Cobb so unequivocally derides can be seen as the sign of an emergent—specifically computer-generated—aesthetic. An effects designer on *Tron*, Durinski readily concedes that the computer-generated imagery featured in *Tron* and *The Last Starfighter* "does not look real." But, he adds, "it has a quality that is unlike anything else." For him, "the real, exciting, creative aspect of computer graphics" lies in being able "to make something that appears real, and then [in being able] to totally destroy that reality to serve the storyline or serve a design element." An advocate for the hyperrealism camp, he insists that computer graphics effects are "an art and a look all to [themselves]" (30).

Whereas developing a technical and aesthetic appreciation of special effects imagery was something that tended to be restricted to a dedicated fan audience before the 1990s, aesthetic and how-to discourses on computer-generated special effects rippled out in many different directions over this period. To a large extent the momentum for this development came directly from the special effects industry itself, which opened up the market for animation software by repackaging for the home computer market the software it had developed for feature film effects projects. But if home computer users were already snapping up hundred-dollar morphing packages in 1994—already fantasizing a place for themselves in some fantastic image-making future—it was science fiction cinema that was producing the most spectacular computer-generated imagery.[64] The experience of watching this imagery unfold on the cinema screen promised not only to engage spectators in a form of private contemplation but also to involve them in the public and social screening of a form of visual spectacle that became, for the briefest moment, a sign of the future. Through its CGI effects the cinema of this period not only animated public speculation about what the future of computer-generated imaging might look like but in a broader sense helped to create a visual landscape in which imaging the future was again an exciting prospect. In every other respect these films were lacking in the richly imagined future worlds that SF writers and fans had been demanding from contemporary science fiction films for quite some time.[65] Instead the future had been telescoped into just a few, wonder-working artifacts. Only *Star Trek* films continued to offer an alternative universe to the bland dystopias that had replaced the cyberpunk futures of the previous decade.[66]

Musing on the state of contemporary literary SF, Fredric Jameson suggested, some time ago now, that the horizon of expectations in which SF fantasies of the future are imagined is such that "we no longer entertain such visions of wonder-working, properly 'S-F' futures of technological automa-

tion." These visions, he argued, "are themselves now historical and dated—streamlined cities of the future on peeling murals—while our lived experience of our greatest metropolises is one of urban decay and blight."[67] Jameson's suggestion that the only progressive futurist project for SF is one that dispenses with imaging the future in favor of imaging the present as past nevertheless forecloses on attempts to imagine a future in which technology figures as a force to be reckoned with at all. As often as not the artifacts of the machine future that burned so brightly in the SF films of the early 1990s were bracketed by narratives that were rather more anxious than hopeful about how humanity's close encounters with these terrible machines would pan out. But in again making the visualization of amazing technologies its central focus the science fiction cinema of the early 1990s also put its faith in a technofuturist aesthetic that for the first time in a long time gave audiences a future that they hadn't quite seen before.[68]

RETROFUTURE/RETROVISION

Although CGI effects did not disappear from SF film after this period, they no longer occupied the same kind of visual and narratological space they had occupied in the SF films produced during the first part of this decade. The specifically electronic properties of the computer-generated imagery in *The Fifth Element* (dir. Luc Besson, 1997) and the fantasy/science fiction film *Dark City* tended, for instance, to be absorbed by the more painterly, expressionistic look of these films. The costuming, art direction, and production design for *The Fifth Element* recycled designer styles and lifestyles from the last half-century of fashion, architectural, and industrial design in a camp dissembling of the future. The fantasy world pictured in *Dark City* was even more phantasmagorical, except that in this film an aesthetic drawn from the ghostly projection of dreams past was also given narrative motivation. As one of the film's characters, a Stranger, puts it, Dark City is a city fashioned "on stolen memories, different eras, different pasts, all rolled into one."[69] With costuming, sets, and visual effects all providing points of aesthetic interest, the look of these films is cluttered, baroque. Only occasionally is a CGI effect brought into focus. As it is, for instance, for the genetic reconstruction of Leeloo in *The Fifth Element*. Or in *Dark City* whenever John Murdoch (Rufus Sewell) exercises his surprising ability to tune (the ability to change physical reality by will alone) or, most spectacularly, in scenes of the rebuilding of the city. But the overall effect on these occasions is one of anamorphosis, with the image only ever cohering as a special effect in the brief moment before the bigger picture is restored. In one sense this had been the future for CGI all

along. After all, repeated demonstration of some of the digital imaging techniques used to exploit and explore the otherworldly, nonindexical properties of digitally produced images meant that filmmakers could no longer rely on these techniques to arouse audiences' curiosity in the way they once had. Techniques like morphing had, for instance, long since lost their aesthetic interest. On the other hand, the move to treat computer animation not as a specifically effects-oriented medium but as the ground for all cinematic figuration seemed to mean using digital imaging techniques to remake film in the mode of something closer to traditional feature film animation.

In more ways than one, science fiction film took a decidedly retrofuturist turn in the latter half of the 1990s. With his finger ever on the pulse of the zeitgeist, Mark Dery wondered in 1999, why now? Why had the futuristic designer styles of the mid-twentieth century come into vogue now, at the end of this millennial decade?[70] Outside the cinema the retro look of the future was selling designer lifestyles, computers, and cars, having seeped into the *Wallpaper*-endorsed world of interior design and provided the inspiration for Apple's old-for-new range of computers. A review of the iMac in *Wired* magazine described it as having "the same inexplicable emotional appeal as a New Beetle."[71] The production design for *The Fifth Element*, *Gattaca* (dir. Andrew Niccol, 1997), and *Men in Black* (dir. Barry Sonnenfeld, 1997) also indulged this latest bout of nostalgia for futures past. Dery singles out *Men in Black* for special mention, pointing to those Arne Jacobsen Egg chairs in the examination room of the MIB headquarters and the same building's foyer, modeled on the TWA terminal at JFK International airport, as evidence of retrofuturism's newfound appeal.[72] Most spectacularly, the film's climax takes place on the site of the 1964 World's Fair in Flushing Meadows, New York, the last time, it has been suggested, that "such an unqualified celebration of technological optimism" would be attempted.[73] This, Dery offers, is what retrofuturism is really all about. It recalls a time when it was still possible to be wildly optimistic about the future, ironically turning another generation's extravagant gestures toward tomorrow into something that now just seems "campy and kitschy and harmlessly fun."[74]

This is certainly how the writers on *Men in Black* saw the film. Working from an idea that began as a comic-book series, they described it as their job to come up with a story "that was both satisfying on its own terms, on the terms of what our humans reveal, and the ride that the audience was taken on, but also as a platform for our ideas and special effects and concepts."[75] The script in fact moves from one comedic vignette to another. Mixing physical comedy with sight gags and lots of old-fashioned schtick from human and alien characters alike, it is a platform not often associated with science

fiction film before the mid- to late 1990s. This is in large part because pastiche is so antithetical to an aesthetics of wonder. In film, as in the visual arts, the impulse of pastiche is retrovisionist: quite literally, backward looking. The madcap energy of some of the comedy SF films that started appearing after 1995 (*Independence Day*, *Mars Attacks!* [dir. Tim Burton, 1996], *Men in Black*) sprang from their irreverent take on the very idea of the modern, the future, and the new—all the ideas that have traditionally been at the foundation of science fiction. In the case of *Men in Black* this aesthetic sensibility also informed the design and production of the film's alien and creature effects. With the leading effects credit going to makeup artist Rick Baker, for "Alien Make-up Effects," audiences were cued to expect a bag full of physical effects—plenty of rubber and latex, some snazzy suits, and maybe even a puppet or mechanical monster or two—even before the film got started. And with a computer-generated dragonfly speeding across a black desert sky to a theme song grabbed from *Dragnet* and James Bond, they could also expect these effects to be funny. The credit "Visual Effects by Ray Harryhausen" used to function the same way, letting audiences know just what was in store for them. But that was before the blended technology approach to creating a whole new generation of wisecracking aliens meant using physical effects in combination with CGI.

This is the approach that director Barry Sonnenfeld decided on for *Men in Black*. *MIB* is a much less crafty film than a Harryhausen film. Its aliens have been designed to draw a laugh, not wonder (figure 3.3). Many of its alien effects are not strictly makeup effects at all but a combination of physical and CGI effects. There is nothing new about digitally enhancing or augmenting physical effects. This practice is now ubiquitous, and not only within the newly expanded genres of *cinefantastique*. Even *Terminator 2*, which has mostly been remembered for effects shots in which a computer-generated image morphs into a photographic image, took a blended technology approach to assembling a number of effects sequences. Among the early crop of new creature features, the horror SF film *Species* (dir. Roger Donaldson, 1995) also used a blend of rubber, latex, and CGI for some of its creature effects shots (although the effects editing and direction for this film also reveals a distinct lack of confidence in its CGI at other moments, relying in a couple of shots on rapid fades or lighting effects to create a strobing effect that makes close scrutiny of the effects image impossible). Special makeup artists have had to be prosaic about this development. Which has also meant learning to live with its implications for the way their work gets viewed. In an interview for *Cinefex* Dick Smith— who began his career as a special makeup artist at NBC Television in 1945— pointed out that when it has come to judging makeup effects for the Academy

FIGURE 3.3 *Men in Black* (1997, copyright Columbia Pictures)

Awards, not even film industry professionals have always been clear about what they are seeing.[76] It is his view that there have "been a couple of times in recent years where a film has won for make-up effects when, in fact, voters were probably swayed by some showy puppet or CG work" (88). Not all effects professionals have been as sanguine as Smith about the challenge that the use of computer-generated imagery in combination with traditional special effects techniques makes to the way both professionals and fans have traditionally thought about the craft of effects production.

Hadn't it been, after all, out of a desire to identify special effects with the aesthetic ideal of innovation within a historically defined mode of production that a culture of appreciation had grown up around them? Don't special effects lose their aesthetic integrity when it is no longer possible to identify them in this way? And if an appreciation of technique is no longer to play such an important role in the reception of special effects, where is the impetus for aesthetic innovation to come from? According to a report in *Cinefantastique* on the making of the effects for *MIB*, it was these kinds of concerns

that prompted Carlos Huante, the artist originally hired to design the film's alien makeup effects, to leave before production finished.[77] Huante has clear ideas about what CGI should be used for, and in his view it shouldn't be used to replace the techniques traditionally used for creature effects. The "problem with a lot of the people in the industry who are in charge," he offers, is that "they don't understand or know how to compose shots with creatures in them to make them look really cool, and you get a lot of bad stuff. They do great technical stuff like spaceships in flight, but then they show a CG monster and it's like 'What the heck is that'—they light it too much, they don't show it properly, they show the wrong parts" (25). For Huante, the problem isn't just that CGI is not an expressive medium for character animation but also that audiences aren't being given the same opportunities to develop an appreciation of traditional effects techniques. With these traditions already under threat from an industry that is always looking for ways to reduce effects budgets, Huante's concern is that the hands-on effects work of makeup artists, model makers, and puppeteers will simply continue to be whittled back through lack of demand.

In this scenario CGI effects end up looking like poor facsimiles of the other, craftier, more expressive, subtle, and visually varied effects techniques they have been designed to replace. Huante cites *Mars Attacks!* as an example of everything that is wrong with CGI, dismissing the film as "basically a cartoon" (24). But what's most interesting about this star-studded pastiche of the fifties' B-grade alien invasion movie is less the mere fact that CGI was used to simulate the look of physical and mechanical effects than the clear indication that this was the direction that CGI effects would continue to take in the future. The inspiration for *Mars Attacks!* came from a series of bubble-gum cards that, as the fan magazines gleefully report, had trouble getting distribution back in 1962 because of parental outrage over their blood and gore.[78] The antirealist, cartoon flavor of the film's effects animation was intended to recapture both the lurid quality of these treasured cult artifacts and the heroic failure of so many B-grade SF films to persuade audiences to take them seriously. In this respect, however, the film takes a rather liberal approach to the way it remembers the B-grade SF film. Ed Wood's *Plan 9 from Outer Space* (1958) provides one point of reference, but so does *Forbidden Planet*. All SF film from the 1950s is thus remembered as the same. It is this kind of revisionism that also turned stop-motion animation into a makeshift effects technique. Tim Burton had originally planned to use stop-motion animation for the film's Martian characters but was persuaded by computer animators at ILM that the feeling of stop motion could more easily be reproduced with CGI. Seen through the dehistoricizing lens of pastiche,

a costly, highly specialized, and labor-intensive process looked not just old-fashioned but hysterically inept. For Burton, CGI was perfectly suited to this kind of historical reenactment. The computer-generated image artfully recast stop-motion animation in the role of a less realistic, less illusionistic moment in the history of effects animation.

But the behind-the-scenes story of *Mars Attacks!* is only partly a story about how the techniques of visual effects animation are being lost to CGI. In the late 1990s Hollywood science fiction cinema was again in the process of folding back in on itself, offering up so many versions of a retrovisionist future in which the expressive possibilities of computer generation were no longer the central focus. Whether it be the low-tech aesthetic of *Escape from LA* (dir. John Carpenter, 1996), the make-do-cum-B-grade aesthetic of *Independence Day*, the schtick and pastiche of *Mars Attacks!* and *Men in Black*, or the expressionist camp of *The Fifth Element*, computer-generated special effects had ceased to figure in these films as objects of curiosity and wonder. In the scene in which the first computer-generated dinosaurs appear in *The Lost World: Jurassic Park*, exclamations of wonder from the characters on-screen are gently parodied: "Ooh, Ahh . . . that's how it always starts," says Jeff Goldblum's character, Ian Malcolm. "And then later, there's running and then screaming." Instead of being displayed as objects of aesthetic interest in their own right—bracketed off from the temporal and narrative space of the action—the CGI dinosaurs share the same space as the characters in the scene, threatening to trample all underfoot in a sequence that integrates live action footage and CGI effects in a dynamic composition that pushes the action to the fore. Every now and then a CGI effect would pop up and again turn an image of the future into an occasion for lingering over an unexpected aspect of its conception or design. But for the moment, at least, the future had once more dropped out of sight in Hollywood science fiction cinema.

4

CRAFTING A FUTURE FOR CGI

There is nothing quite like speculating about the future for raising questions about the way we remember the past. The early to mid-1990s can now be identified as a formative if short-lived period in the production, circulation, and cultural reception of computer-generated special effects in Hollywood SF cinema. These were the wonder years, a period in which CGI effects became the focus of intense speculation not only for cinema audiences but also for the special effects industry itself. In this, the age of the Hollywood blockbuster, critics could be forgiven for thinking that science fiction cinema might have become a forgotten cinema. After all, any claims that its most recent action attractions have made on our cultural memory have often appeared tenuous in the face of a mode of exhibition that has increasingly turned their public screenings into events to be experienced rather than to be remembered. In the early part of last decade it was nevertheless science fiction cinema that made the public and social screening of the computer-generated image an occasion for speculation about the future of cinema itself. Much of this speculation focused on the question of how long it would be before digital imaging technologies totally replaced physical and

mechanical effects. Would the production of special effects on set one day be a thing of the past? Did the wholesale shift from analogue to digital formats in other areas of film production—most notably sound and editing—portend the future of special effects production? More than half a decade later it still remains for film and cultural critics to wonder what will happen next.

In his essay "The SF of Theory" Istvan Csicsery-Ronay Jr. identified a need for including a futurological dimension in research into the cultural implications of new technologies.[1] It is, he argues, only by attempting to limn the possible directions of evolution and by clarifying the ethical principles that one wishes to see guiding action that intellectual work can "maintain a sense of connection with the breakneck acceleration of technological innovation."[2] Although these comments are not specifically directed at film and cultural critics working in the field of digital imaging technologies, they have important implications for this research. In response to Csicsery-Ronay's challenge I want to make identifying some of the ethical questions that are being raised in relation to the changing field of CGI effects production part of this chapter's futurological project. Some of these questions were raised at the end of the last chapter, which looked at the impact the practice of using CGI in combination with traditional effects techniques is having on the way both effects professionals and fans think about and relate to the hands-on work of special effects production. What is clear is that not only the future of traditional effects techniques is under threat from current film industry practices; so is the future of CGI itself. In this chapter I want to take a more speculative, philosophical, and meditative approach to examining current trends in the production of digital effects imagery for science fiction film. For if it is indeed the case that with *Star Wars: Episode I—The Phantom Menace* George Lucas was "attempting to reshape cinema—from a production-based medium into an elaborate post-production process," then it seems important to ask what this says about the state of the art: the state of SF cinema and the state of CGI effects.[3] This is not, however, to be a futurology in the mode of what Csicsery-Ronay calls "theory-SF." Theory-SF is a mode of theorizing that imagines a future that cannot simply be extrapolated from the past. Among the virtuoso stylists of this new futurology Csicsery-Ronay includes Baudrillard, Haraway, and Deleuze and Guattari, a list that could be expanded to include Virilio and McLuhan. Each of these theorists has sought at particular moments to imagine a future that also calls for new ways of conceiving of the past. Each has offered up a kind of historiography—of the sign, of the body, of the assemblage—that is as hyperbolic and estranging as any futurology. And as different as their respective theoretical projects are, each has, in Csicsery-Ronay's words, "attempted to formulate a global theory in what is essentially a lyrical mode."[4]

The real brilliance of this mode of analysis lies in a gift for metonymy, in the unexpected conjoining and serializing of discourses and events that might not otherwise have been brought together. In a work like Baudrillard's *America* (1986) or even Gilles Deleuze and Félix Guattari's *A Thousand Plateaus* (1980) metonymic associations proliferate and mutate in a conceptual matrix that eschews the kind of frameworks and concepts familiar to most historians of technology.[5] As a result, the narratives of technological convergence offered up by these and other works of theory-SF also appear strangely removed from the materiality of historical phenomena. Because even though any future course of development is represented as being subject to striation and rupture, the scale on which these ruptures occur is vast and epistemic. Local, parallel, and discontinuous narratives of technological development, circulation, and cultural reception simply disappear in the wake of the hyperbolic abstractions of theory-SF. A less globalizing futurology might be prefaced, on the other hand, with the observation that it is not just that speculation about the future is as important to any attempt to think through the social, cultural, and ethical implications of technological development as speculation about the past but also that all speculation about the future is already a form of historical commentary.

Digital technologies have not just transformed the filmmaking process at the level of technical operations. They have also transformed the way the people who make films physically and mentally engage in the production of artifacts. Coming to terms with the materiality of these transformations necessitates being able to theorize digital production positionally and relationally. This means being able to think of digitality in relation to particular filmmaking practices, each with its own mode of organizing, training, and accrediting people to perform specific tasks. Furthermore, these practices in turn need to be situated in relation to the diverse contexts that give films a public life. But in addition to being able to think of digitality in the particular instance, it is also important to be able to account for digital systems of production and reproduction in more general and even global terms. One of the problems with the kind of discourse on technology that has been dubbed theory-SF is that the global characteristics of technological systems tend only to be represented in terms of irreducible limits. While all technologies function within determinant parameters, it is necessary to be able to distinguish between those characteristics of technological systems that function as irreducible limits and those that function as organizing frameworks. Heidegger's concept of technological "enframing" provides a useful handle for conceptualizing these frameworks, but only if it is interpreted against Heidegger's own tendency to see this enframing in universal and absolutist terms. The ambiguity of this concept—

which suggests an organizing framework that both reveals and conceals the conditions of possibility for human interaction with technological systems— itself enacts the possibility of multiple forms of interaction.[6]

Software is a global feature of many digital systems, including those used for computer animation and digital editing, that are now routinely used in the production of Hollywood films. Software for these systems limits the way users interact with the machinery of digital systems by offering global level controls. These controls do not necessarily represent irreducible limits to interaction, however, because opportunities may still exist for rewriting the script for these controls at the level of programming. Even allowing for different levels of programming expertise, questions remain about the extent to which software organizes users' perceptions of electronic artifacts. And what about the screen of the electronic interface itself? In what sense is it to be considered a global characteristic of digital systems?

This chapter's meditation on the future of CGI begins with a comparative analysis of the effects the transition from mechanical to digital, nonlinear editing systems have had on the way films are edited in Hollywood. Central to this analysis is a consideration of the possibility of theorizing digital film-making practices in terms of craft. Even though there have been attempts to conceive of craft outside the reductive association of craft with "handicraft" before now, craft has traditionally been associated with artisanal forms of production. Against the standardization of mass production processes it has stood for a "workmanship of risk."[7] Not just the application of a technics—a body of knowledge, a set of skills—craft has traditionally been defined by an intuitive relation to the materials of its making. This way of thinking about craft—with its emphasis on the haptic dimension of workmanship and the construction of material artifacts—poses some obvious problems for transposing craft into the digital realm. But rather than abandoning this project I will argue here that if the legacies of the crafts are indeed traditions of production, then the emergence of new forms of production necessitates a rethinking of craft.[8] This requires something more than the reduction of craft to a technics. For among the rich confluence of associations that give meaning to the term, virtuosity is undoubtedly the most important. In the digital realm virtuosity in craft is to be found in the production of artifacts that give expression to a new aesthetics: a specifically digital aesthetics.[9]

THE CASE OF EDITING

As early as 1994 technical operations executives at Warner Brothers estimated that 90 percent of the studio's feature films were being digitally edit-

ed.[10] Within the industry this development prompted speculation about the effects of digitization on the editor's craft. Would a new generation of editors trained in the use of digital editing platforms have the same sense of rhythm, scale, and pacing as the editors trained on the old upright (Moviola) and flatbed (Steenbeck, KEM) machines? What if anything was being lost in the transition from physically handling film to manipulating images electronically? Tom Rolf shared his first editing credit for *The Glory Guys* (dir. Arnold Laven, 1965). Still working in Hollywood, his career spans more than thirty years and over thirty feature films. Rolf describes himself as a "convert" to digital editing, but he still keeps an old Moviola on the job as a material reminder of the tactile pleasures of handling film.[11]

Theoretical and philosophical meditations on the haptic dimensions of craft have long claimed the superiority of the hand over the rationalized logic of automation. Within the diverse traditions of inquiry collectively referred to as the philosophy of technology, the effects of automation are routinely described in terms of a trade-off in which speed, power, and precision are achieved at the expense of creativity, adaptability, and heterogeneity.[12] Traditional film editing is a highly mechanized process, and the physical handling of film is largely restricted to performing a set of routine tasks. In the performance of these tasks physical interaction with the material artifact (or film) is subordinated to the mechanical operation of machines. Editors are far more likely to claim that digital technologies have freed them from the drudgery of mechanical reproduction than they are to express reservations about the disappearance of traditional editing skills. But digital editing not only involves the automation of many activities that were formerly accomplished mechanically (e.g., the threading, syncing, marking, cutting, splicing, trimming, and gluing of film); it also involves interpreting and responding to images in an entirely new way.

Along with the automation of some aspects of the editing process, digital, nonlinear editing systems have also changed the way editors view film images and consequently the way they assemble them into sequences. Liberated from the need to print each cut before viewing it, editors working in the digital realm can experiment with cutting a film in a number of different ways before committing the final version to film. Instead of working through film sequences in a linear fashion, editors have access to the entire film, any element of which can be arranged and rearranged in a fraction of the time that it takes to make changes using mechanical techniques. In addition, the fact that optical effects can be previewed on-screen makes it easier for editors to communicate their ideas about these effects to directors. Here again editors' testimonies overwhelmingly cite greater flexibility and control over their

work as being the main advantages of digital editing. Not surprisingly, any suggestion that these changes might be having more far-reaching—if less tangible—consequences for the craft of editing has been most vigorously resisted by the companies marketing the leading digital platforms (Avid, Lightworks) to the film industry. It has been their claim that (in Hollywood) editing decisions are fundamentally guided by the need to arrange images into sequences that tell a story and that these decisions are not substantially altered by the technologies used to execute them.[13] On this point too editors agree. They have insisted over and over again that the machinery of editing merely represents the editor's tools of the trade. In the words of one Hollywood editor, "The new editing systems are only tools in exactly the same way that a hammer, or a paintbrush or a Moviola is a tool. The tasks we're doing with these devices are much the same as those we did without them, telling compelling, articulate stories with pictures and sound, meaning and rhythm shaping all the ineffable elements that make a motion picture exciting."[14]

While it would be a mistake simply to ignore editors' own accounts of their experiences of using the new digital editing systems, it is just as clearly a mistake to imagine that the craft of assembling stories from images has remained unaffected by changes in the technologies engaged for this purpose. To treat editing technologies simply as tools is to fail to recognize the extent to which the editor's phenomenological relation to the image has been transformed by the transition from mechanical to electronic forms of reproduction. In his well-known philosophical critique of word processing Michael Heim suggests that computational systems represent the very "apotheosis of automation," the most significant consequence of which is "system opacity."[15] According to this argument computerized automation masks the underlying operations of electronic systems to an extent unparalleled by mechanical systems. For users of electronic systems, keeping track of how individual tasks relate to the entire process is mediated by the system's software interface. Users of mechanical systems do not have unmediated access to systems analysis either, but assessment of how one task relates to another is monitored through a more immediate form of engagement in the production process. In the case of mechanical editing, editors continually check off the footage that has been assembled for successive cuts against the offcuts that have been marked for the "trim bin." Monitoring the movement from one location to the other is integrated into every step of the editing process. In some instances interface designers for digital editing software have adopted the iconography of mechanical editing, even naming the windows for viewing the digitized footage "bins" (which can be labeled according to the editor's needs). The computer keeps track of the frames that are moved from one virtual bin to another.

It isn't just the kinds of mechanical activities associated with physically handling film that have been automated in the transition from mechanical to electronic editing. The very human computational powers needed for keeping track of every frame of film footage throughout the long process of assembly have also been displaced in the changeover. Digital editing relies much less on the mnemonic capabilities of editors themselves. Where once editors had to keep track of many different forms of information, the computer's instant playback facilities, random-access memory, and formidable storage and processing power have greatly reduced the necessity for this form of mental activity. Editors no longer have the same need to take copious notes as they work or to make elaborate maps connecting projected sequences together. Freed from this kind of monitoring process, they are also under much less pressure to conceptualize the film in its entirety every time a decision needs to be made. The ease with which decisions can be reversed makes anticipating the consequences of any one decision less important.[16] And in an industry that places enormous pressure on editors to reduce the amount of time a film spends in postproduction, it is not hard to see why a system that renders decision making less of an existential commitment might be attractive.[17]

The automation of many of the mechanical and mental processes associated with mechanical editing systems was not a function of the very first electronic platforms. These early videotape systems lacked the random-access capabilities of digital editing technologies. It was not until the analogue properties of the cinematographic image could actually be digitized and converted into discrete bits of information that nonlinear editing became possible. In trying to think through the consequences of this transformation, it is useful to recall that contemporary critics of the electronic interface have tended to theorize the experience of manipulating images in the digital realm in terms of the weakening of the viewing subject's sense of the spatiotemporal distance between self and object (or user/editor and image/film).[18] That subjects overwhelmingly understand their relation to the computer screen in these terms is indicated by the metaphors that have sprung up to describe this experience. Users of all kinds of electronic systems consistently describe their relation to the electronic interface in terms of navigating an environment. This sense of being immersed in a virtual environment suggests a phenomenology characterized by a diminished sense of mediation. For users of digital editing platforms the sense of being immersed in the system further intensifies the sense of expanded choice and mobility that comes with being freed not only from mechanical tasks but also from the need to work through film footage in a linear, sequential fashion.[19] But determining more specifically what effects this new phenomenology is having on the way films are being

edited is still complicated. There is certainly a case for arguing that digital editing has even further accelerated the breakdown of continuity editing in recent years, fragmenting Hollywood narratives into a series of ever more discrete visual images and shocks. This development is most obvious in those genres that have come to be identified with the new cinema of action attractions: science fiction, horror, and action. More generally, however, the editing of Hollywood films is much less obviously motivated by the desire to maintain visual and narrative continuity than it was even a decade ago. The transition from mechanical to electronic editing is clearly not the sole determining factor in this process. But if the defining features of digital editing systems do not lend themselves particularly well to the kind of linear, sequential thought that editing for continuity demands from editors, neither can it be considered inconsequential.

As long as the phenomenological consequences of the transition from mechanical to electronic editing systems remain unacknowledged, unreflected on, and unaccounted for, there is every reason to believe that editing trends in Hollywood will continue to reflect this state of affairs. Other possibilities do, however, remain. And it is in relation to the aesthetic realm, and in particular in relation to a rethinking of craft, that alternatives to this future can be imagined. To think of craft in relation to digital editing is to ask, first of all, what strategies might be developed for resisting the charm of the electronic interface, with all its power to mask the extent to which thought has become disaggregated from the process of assembly. Any such strategies will necessarily be local, quotidian, and ad hoc, formed out of individuals' workaday engagements with this technology. Opportunities for aesthetic experimentation are limited in Hollywood, but another approach to rethinking editing in the digital realm would be to take up the challenge of turning the phenomenological conditions of digital production to advantage. Instead of seeking to break the charm of the electronic interface, editing might begin, for instance, to explore the kinds of assemblages that enchantment makes possible: not just faster rhythms but new perspectives on montage. Something of this future can be glimpsed in Kyle Cooper's virtuosic (and much emulated) credit sequences for *Seven* (dir. David Fincher, 1995), *The Island of Dr. Moreau* (dir. John Frankenheimer, 1996), and *Mimic* (dir. Guillermo del Torro, 1997). Densely layered and furiously paced, these sequences conjure up the specter of a new kind of digital fugue.[20]

Imagining any future for digital editing that doesn't simply recapitulate present practices is made difficult by the very nature of the form. Virtuosity in editing is most often measured according to degrees of imperceptibility. In other areas of digital postproduction this is even more clearly the case. The

same systems that are used for digital editing are also used to produce a wide variety of visual effects, from wire removal, color correction, and digital compositing to the construction of complex three-dimensional objects and environments. The goal of this type of visual effects production is to integrate the desired effect seamlessly into the cinematographic space of the film, the aesthetic parameters of which vary according to each film's budget, style, and genre. At the other end of visual effects production is the CGI effect.

DISASTER STRIKES

Whether simulationist or technofuturist, CGI effects were not to remain in the charismatic state of grace they enjoyed in the first part of the last decade forever. With its virtuosic CGI sequences depicting Johnny's virtual hack-and-grab race through cyberspace, *Johnny Mnemonic* is perhaps the last Hollywood SF film to be made in this mode. Ironically, the same film prompted Arthur and Marilouise Kroker to declare: "*Johnny Mnemonic*, the movie, is the day when cyberpunk died."[21] In their brief elegy to cyberpunk the Krokers remember a cyberpunk that imbued the glittering digital futures of its creation with "tech charisma." William Gibson, Bruce Sterling, and Lewis Shiner are among the short list of writers who have come to be most strongly identified with the genre. Their earliest fictions imagined posthumanist futures in which human consciousness has disappeared into deterritorialized flows of data. Although none of these dark visionaries is actually referred to by name in the Krokers' elegy, Gibson's *Neuromancer* is cyberpunk's acknowledged ur-text.

The cyberspace of Gibson's *Neuromancer* is figured after the city. It is visualized as a space of "unthinkable complexity. Lines of light ranged in the non-space of the mind, clusters and constellations of data. Like city lights, receding."[22] In the years following *Neuromancer*'s release attempts at visualizing cyberspace began drawing on a number of aesthetic forms that emerged from the shadows of the cyberdelic fringe only to be reinterpreted under the bright lights of Hollywood. In his essay on the popularization of VR technologies, Philip Hayward examines this process, arguing that cyberpunk, music videos, youth culture magazines, psychedelic counterculture, and New Age mysticism were all important contexts for imagining the look of cyberspace.[23] While acknowledging that cyberpunk has provided an important site for visualizing the coordinates of this new electronic space, Hayward's analysis nevertheless suggests that contemporary perceptions of cyberspace owe every bit as much to Hollywood.

Arthur and Marilouise Kroker also give their attention to the discursive

networks that have enabled cyberpunk metaphors to pass into the popular cultural imaginary. But their analysis differs from Hayward's in being directed toward demonstrating that the waning of cyberpunk's charisma can be directly attributed to the way these metaphors have been taken up and interpreted not only by Hollywood but also by the fashion and advertising industries. And like others who have charted cyberpunk's emergence and decline, they give this story a materialist gloss. "Tech charisma," they write, "lasts for only one brief, shining instant, and then it fades away into the grim sociology of rationalized technology or, failing which, it quickly disappears from life."[24] This is in many ways a familiar narrative: driven by market forces, the dread hand of technorationalism drains new technologies of any progressive potentialities that might be imagined for them. According to this narrative, cyberpunk was destined for the dustbin of history as soon as the expanding personal computer, software, and games industries discovered the wellspring of marketing concepts that could be plumbed from its archive.

Seen from this perspective, *Johnny Mnemonic* can't help looking like the museum piece of lost cybernetic possibilities that the Krokers see in it, a "bitter reminder of cyberpunk's decline into the present state of hyper-rational (hyper-marketplace) technology" (par. 4). And yet the computer-generated effects sequences in this film are still very much within the charismatic mode of art-and-effects direction described in the last chapter. And while cyberpunk had a role to play in the development of a specifically electronic aesthetic for the cinema screen, it was mediated by the kind of popular cultural representations of cyberspace that Hayward describes. The hyperreal techno-futurist aesthetic characteristic of the computer-generated imagery created for Hollywood science fiction films in the early part of the 1990s drew as heavily on popular cultural forms such as comics, cartoons, and video games as it did on the literary cyberpunk of Gibson. And even though it failed to recoup blockbuster returns at the box office, *Johnny Mnemonic*'s computer-generated special effects were still wonderful enough to elicit the admiring gaze of cinema audiences. In this sense, then, the film that "testifies to the end of the charismatic phase of digital reality" is not *Johnny Mnemonic* but *Independence Day* (1996) (par. 3).

Independence Day (*ID4*) fused the make-do aesthetic of B-grade SF to the scale and scope of the 1970s' disaster film to produce a cornball pastiche of science fiction cinema in all its many phases of wonder. According to Dean Devlin, the film's producer and cowriter, he and director Roland Emmerich "wanted to have fun and play with the notion of science-fiction in general."[25] The film poaches themes and imagery from a wide range of science fiction films and popular cultural mythologies: from *War of the Worlds, Dr. Strange-*

love, and the *Star Wars* and *Alien* trilogies to ufology, alien abduction narratives, and the many variants of apocalyptic millenarianism feeding the byways of popular culture in the mid-1990s. The result of this mixing of genres, SF themes, and popular cultural imagery is a style that is not so much excessive as indiscriminate. Without a stable center of reference, the film daubs from an expansive cinematic and popular cultural palette.

This refusal to privilege any one dramatic or stylistic convention over another is also reflected in its art-and-effects direction. *Independence Day* marks a radical departure from the presentationist style of exhibition adopted by the SF films made in the early part of the decade. Gone is the emphasis on the aesthetic and technological specificity of the CGI effect. In *ID4* the computer-generated image has no special integrity at all. Instead of foregrounding the exhibition of its CGI, it combines computer-generated images with models and miniatures in complex composite shots that are designed to make it difficult for spectators to distinguish between them. The battle sequence between U.S. F-18 fighters and alien attackers comprises densely layered composite shots combining as many as thirty separate elements. Motion control models of the F-18 fighters and alien attackers have been combined with computer-generated images of these same craft. Of this effects sequence Devlin is reported to have declared: "I defy anyone to tell which ones are the models and which are computer-generated."[26] In fact, however, the issue of whether there is a perceptible difference between the two is not even at stake, because such distinctions become moot within the context of a mode of art-and-effects direction that so consistently and confidently opts for a low-tech aesthetic. Instead of challenging viewers to identify the special effects technologies used in the production of specific images, Devlin might just as well have shown his hand and admitted that it doesn't matter whether they can or not.

The focus of sequences combining computer-generated images with models and background photographic plates is not on the aesthetic integrity of the computer-generated image but on the sheer repetition and proliferation of images.[27] The use of CGI is restricted to effects shots requiring large numbers of objects or to other types of effects shots requiring added detail. However, none of the special effects images in *Independence Day* are treated to the presentationist style of exhibition that was so much a part of art-and-effects direction just a few years earlier. If the film's signature effects image is the image of the White House being blown up by an alien destroyer—a privilege that was confirmed when it was used for the cover of the video release—it is immediately preceded by the destruction of the Empire State Building and does not occupy any special place in the long sequence in which it

appears. The image itself is broken up into four separate shots, each lasting for a matter of seconds. In other shots in this sequence, portions of the alien destroyers can be seen peeking out from between city buildings. The composition of these shots is clearly intended to suggest something of the massive size of these spacecraft, but it also accomplishes something else, for by only revealing portions of the destroyer-ship models in the background of these shots the special effects also never come into view fully enough to distract viewers from the action.

In their next film, Devlin and Emmerich turned the technique of suggesting gargantuan images by revealing them in fragments into an elaborate game of cat and mouse. In the effects sequences in which the rampaging CGI lizard in *Godzilla* (1998) storms Manhattan, a foot or a tail is often as much of the preternatural Godzilla that appears in any one shot. These types of effects shots don't just work mimetically to suggest an uncontainable presence; they also recall a tradition of art-and-effects direction that made the most of a limited budget by strategically using partial models to suggest that an entire monster existed somewhere just off-screen. Art-and-effects direction for the *Gojira/Godzilla* cycle of films made in the 1950s not only turned on the visual rhetorics of "now-you-see-it-now-you-don't" but also on the principle of "what-you-see-is-what-you-get."[28] The effects themselves have generally been remembered as low-tech and even makeshift, but this wasn't necessarily the case. The variety of techniques used to produce the special effects for these films also reflected filmmakers' understanding that different types of shots call for different types of representational strategies. In the early stages of preproduction, Devlin and Emmerich also planned to make use of a wide range of special effects techniques to create their latter-day Godzilla. And in addition to scale models effects designer Patrick Tatopoulos even created a mechanically operated suit. In the end, however, prosthetic and mechanical effects accounted for less than 10 percent of effects shots featuring the monster.[29] Instead, the film's lead character was reanimated after the digital creatures that featured in films such as *Jurassic Park*, *The Lost World*, and *Starship Troopers* (dir. Paul Verhoeven, 1997). For *Godzilla*'s visual effects unit the creation of the computer-generated Godzilla was an exercise in replicating the simulationist aesthetic of this earlier visual effects imagery, an aesthetic that, in Lev Manovich's uncompromising terms, bespeaks nothing so much as the cost of its production.[30] For other CGI effects in this film Devlin and Emmerich again opted for the low-tech aesthetic that made do for so many of the special effects in *ID4*.

Devlin and Emmerich's gargantuan cinematic offerings are not single-handedly responsible for taking the focus of Hollywood art-and-effects direc-

tion off the display of the computer-generated image. These are by no means the only SF films in recent years to have forgone the luminous technofuturist aesthetic of earlier CGI effects for a low-tech retrovisionist pastiche of B-grade effects. These tendencies are, however, more strikingly realized in these films than they are in others. Most disturbingly, perhaps, *Independence Day* and *Godzilla* mark out a future for special effects in which the deskilling of production is the function of an aesthetic as much as an economic demand. *Independence Day* was originally conceived as "an aggressively low-tech affair": more *Plan 9 from Outer Space* than the Academy Award–winning *War of the Worlds*.[31] But the circumstances of its production bear no such resemblance to the domestic mayhem of a Wood production. In the late 1990s Hollywood drew its itinerant labor force from a global ethnoscape that has had to make do as the imaginary sign of a contemporary filmmaking community. Rather than contracting out the effects for *Independence Day* to established special effects companies, each specializing in a different type of effects production, Devlin and Emmerich undercut the cost of producing these effects by negotiating individual contracts for all effects personnel. Among those recruited were a group of German film school students who were contracted to assist in the preliminary design of the film's visual effects. Given the Hughes Corporation's early antilabor policies—with their "creative" techniques for extracting the maximum amount of energy, time, and commitment from employees—it is perhaps fitting that all the effects units for *ID4* were temporarily housed in the Hughes Aircraft complex in Culver City. A newspaper report described this cavernous production compound as a strangely virtual space illuminated "only by a red lava lamp and a small digital clock that flashes 12:00 endlessly" (par. 13). Today, Hollywood lures aspiring computer animators and visual effects designers not with the promise of working through an animation or design problem from conception to rendering but with the hope of securing a place on the production line.

AN AESTHETICS OF SCARCITY

In 1997, in a galaxy far, far away from the Devlin-Emmerich world of fly-by-night visual effects, the chairman of the industry behemoth Industrial Light and Magic (ILM) began to speak of a digital revolution that was about to change feature filmmaking at the most fundamental levels. In an interview for *Wired* magazine, George Lucas speculated about a future in which feature films would not only be edited digitally, feature computer-generated characters, and be assembled from a blend of live-action and computer-generated sets and virtual environments but would also be shot entirely on high-defini-

tion video.[32] The test case for this radical new form of cinema was to be the long-awaited prequel to Lucas's *Star Wars* trilogy. Searching for analogies to describe how digital technologies are transforming contemporary filmmaking practices, Lucas compares digital filmmaking to word processing (putting the lone cinemagician in the position of being able to manipulate his or her film/document at any stage in the production process) but also to painting and sculpture. Here again the advantages of digital over analog systems are described in terms of increased control and flexibility. "Instead of making film into a sequential assembly-line process," it becomes something much more malleable, more amenable to improvisation, and potentially open-ended. Lucas describes digital filmmaking as something "you work on for a bit, then you stand back and look at it and add some more onto it, then stand back and look at it some more. You basically end up layering the whole thing. Filmmaking by layering means you write, and direct, and edit all at once. It's much more like what you do when you write a story" (162, 164).

Although Lucas was not quite the author of *Star Wars: Episode I—The Phantom Menace* in the way that this comparison suggests, his involvement in the production process was widely distributed across the roles of executive producer, director, screenwriter, and editor (uncredited). The analogy between filmmaking and the craft of writing stories is also motivated in another sense, however, because for Lucas, filmmaking *is* storytelling. He rejects the possibility of interactive films out of hand. "Movies," he asserts, "are story-telling; you tell somebody a story. A game is interactive; you participate in some kind of event with a lot of other people or with yourself, or with a machine. Those are two different things, and they've been around forever" (216). Given that it is storytelling that, in Lucas's view, makes film different from other forms of (digital) media, it seems reasonable to be curious about how narrative came to be so attenuated in *The Phantom Menace*. There would be nothing exceptional about this—after all, in many action-driven SF films narrative has been reduced to little more than the temporal unfolding of a series of events—were it not for all the signs that there is in fact a will to tell a story here. This will is nowhere more manifest than in the film's maddeningly detailed articulation of plot. The minutiae of bureaucratic process, of political diplomacy, and cultural lore are laid out layer upon layer upon layer. And yet nothing is to be inferred from any of this detail. An ambitious senator manipulates a queen into advancing his career, and his career advances. A Jedi knight identifies "the force" in a slave boy, and it is later confirmed that "the force is strong in him." A film that is all plot and no narrative defies summarization. To say what it is about is to recall it as it happens. The would-be narrator is compelled to follow the course of Pierre Menard, transcribing every detail of the plot verbatim.[33]

In the midst of all the hype and speculation unfurling around the film in anticipation of its release, the film's narrative shortcomings had already been identified. In *Cinefantastique* one fan warned that "a fundamental mistake has been made, a mistake so simple and basic that its very prosaic nature has provided a dark cloak of subterfuge and deception. And that fundamental mistake is: the decision to go backwards."[34] It was a canny observation. Given its commitment to establishing the back story to the events that take place in the original trilogy, it was indeed inevitable that narrative would to some degree be displaced from film text to megatext in the prequel. But that so many of the events that unfold in *The Phantom Menace* would function only as plot points in the *Star Wars* megatext seemed less certain. The fact that the film's thin story world is in such sharp contrast to its dense layering of plot invites the speculation that this might have had something to do with the way that it was actually written. For could it not be that the very process that Lucas describes—the practice of treating the arranging and rearranging of the elements of a story world as a potentially endless process—can only work with the weakest forms of narrative causality, that is, the temporal succession and spatial locatedness of events? Wouldn't any more strongly determined form of causality be an obstacle to the kind of flexibility being aimed at here? It is surely telling that spatial causality is so important in *The Phantom Menace*, which is structured around the action that takes place on different worlds in the *Star Wars* universe. As the film moves from one locale to another, often crosscutting between parallel lines of action, viewers have no choice but to make identifying where rather than why events are taking place their primary means of orienting themselves to the action.

As much as it may have suited Lucas to be able to break up the film into spatially defined units that could be shuffled around during the plotting and planning stages of the film's development, it particularly suited the film's production needs. One of the things that happens when blockbuster filmmaking tries to move from a production to a postproduction-based medium is that the whole process becomes much more atomized, and for all those responsible for making it work—from the actors and cinematographer to the visual effects supervisor—much less easily apprehended as a whole. Actors move before a blue screen, miming interaction with characters that will be added in later; cinematographers shoot live-action footage that will likewise be composited with any number of visual effects during postproduction; effects departments divide the work up so that each division is only ever responsible for a portion of the film's total effects. On large-scale productions like *The Phantom Menace*—which aimed to be "the biggest effects project ever"—coordinating each of the film's production units is a monumental

task.[35] To deal with the sheer scale of CG effects required for this film, visual effects supervisors at ILM divided up this work by type and location. According to conceptual artist Doug Chiang, Lucas "wanted each location to be readable in terms of style and color, so that when we cut to a new scene, the audience would immediately know they were in a different environment altogether."[36] With this brief, each division was thus granted a relative autonomy, a factor that no doubt helped to expedite the production process by reducing the need for extensive coordination and consultation between them.

None of this is intended to suggest that the aesthetic is ever merely a function of production technology. Only a crude form of technological determinism would insist that it was. Lucas himself is equivocal about the relation between them, arguing, on the one hand, that digital technologies are completely transforming the craft of filmmaking and, on the other, that they are having no impact at all on the types of films that are being made or on what these films look like.[37] On his own testimony, some things do change, though. And it's all the ways that *The Phantom Menace* registers both the effects of these changes and the persistence of other aesthetic codes and conventions that give it the appearance of being both very much of its time and somehow terribly old-fashioned. For to the extent that this film signals the possibility—if not yet the emergence—of an entirely new form of cinema, this new synthetic cinema looks remarkably familiar.

What counts as a special effect in a film in which nearly every shot is an effects shot? Reporting on the effects for *The Phantom Menace* in *American Cinematographer*, Ron Magid unwittingly raised the possibility that it is the live action in this film that is special when he suggested that "in fact, it's easier to spot the few hundred shots that don't feature any CG work at all than the nearly 2,000 shots that do."[38] Superficially, at least, the art-nouveau style of the glittering underwater city of Otoh Gunga is not at all like the dusky, ocher desertscape that is the setting for the pod race sequence on Tatooine. On the other hand, the entire film has something of the look of an animated feature film that has combined live actors with computer-generated characters and 3-D environments. In spite of their meticulously layered detail and carefully thought out design, the film's synthetic sequences all have the same simulationist aesthetic horizon. And it is the unwavering commitment to staying within the aesthetic parameters established by this horizon that gives these sequences their unrelieved sameness. If an effect is only special in relation to something else—something that it isn't—how do viewers decide what is a special effect in this context? Does the scope for the kind of transmutation of the visual field that might make an effect special even exist once a film

begins to be made over in the mode of an animated feature? Do totally animated feature films have special effects? If these questions point to the difficulty of making any kind of novel inscription within the relatively restricted visual field of animation, it should be pointed out that some styles of animation are more restrictive than others. What makes the animation in *The Phantom Menace* particular is its adherence to a set of aesthetic codes and conventions that owe as much to a particular style of feature film animation—what is commonly referred to as the Disney style of animation—as they do to the traditions of effects animation found in SF cinema (with their often much less restrictive demand that effects animation simply achieve a "certain realism").

Although his comments on Disney animation amount to little more than a brief aside in a chapter on historical and fantasy films in his late work *Theory of Film: The Redemption of Physical Reality* (1960), Kracauer recognized very early on what it is about the Disney style of feature film animation that sometimes seems so exhausted and, from a viewer's perspective, so exhausting. Commenting on such classic films as *Snow White and the Seven Dwarfs* (dir. David Hand, 1937), *Bambi* (dir. David Hand, 1942), and *Cinderella* (dir. Clyde Geronimi/Wilfred Jackson, 1950), he noted that "physical detail, which was visibly pencil-born in Disney's early cartoons, merely duplicates life in his later ones. The impossible, once the *raison d'être* of his craft, now looks like any natural object. . . . To intensify this impression Disney shoots his sham nature as he would the real one, with the camera now panning over a huge crowd, now swooping down on a single face in it." The twofold logic of a simulationist aesthetic that has both the reality of the natural world and the reality of the camera world in its sights is from this view doubly disenchanting. Kracauer is, here, happy to take up the role of the polemicist, steadfastly refusing to give way on his sense that this "false devotion to the cinematic approach inexorably stifles the draughtsman's imagination."[39] Today, this is an unfashionable view, seemingly out of step with the contemporary media theorist's understanding of the way all new media repurposes or "remediates" older media. It is possible, however, not only to acknowledge the aesthetic legitimacy of a popular film genre but more particularly the virtuosity of the animator's craft and still argue, as Kracauer has done, that there are limits to what can be achieved in this medium in terms of aesthetic novelty. Kracauer helps us to appreciate more fully why special effects, which rely so strongly on visual novelty to draw the eye and solicit the imagination, simply disappear when all about them is the same photorealistic wallpaper.

It is well known that the inspiration for the original *Star Wars* film came from the popular adventure stories, cartoons, and comics that Lucas grew up

[handwritten margin note: KRACAUER ON DISNEY]

with: Edgar Rice Burroughs, *Buck Rogers*, *Flash Gordon*. In the interview that he did for *Rolling Stone* magazine soon after the film's release he freely admitted that his vision for science fiction was wildly, nostalgically romantic: more fairy tales, dragons, and Tolkein than the science and monsters that he remembered from the science fiction films of the 1950s.[40] In all these popular fictions Lucas identified the kind of adolescent energy and bold expressivity that he hoped to bring to this film, which was intended to appeal not only to children but to "the kid in us all." There was, however, one aspect of Lucas's vision that all but guaranteed this ambition would not survive into the final installment in the trilogy, and that was the creature's anthropomorphosis and domestication. The tide began to turn as soon as Luke Skywalker (Mark Hamill) and Obi-Wan Kenobi (Alec Guinness) walked into a cantina in Mos Eisley at the start of the second act in *Star Wars*. For this scene special makeup artist Stuart Freeborn had created a motley assortment of spooks, ghouls, and alien beasts. Lucas has explained that while he had wanted this to be a much more crowded scene circumstances conspired against it. "You know," he commented, "I really wanted to have horrible, crazy, really staggering monsters. I guess we got some but we didn't come off as well as I had hoped" (38).

Monsters? What monsters? *Star Wars* introduced audiences to a new alien-creature hybrid, a band of confabulating, gesticulating, grog-swilling musicians, mercenaries, and outlaws. These alien-creatures had neither the human—all-too human—subjectivities of the aliens that had populated the *Star Trek* universe in the late 1960s nor the truly alienating otherness of the rampaging monsters in the atomic creature features of the 1950s. Already on the way to morphing into the featureless cartoon characters they would become once the *Star Wars* series of films entered its digital phase—a phase that began with the digital remastering and theatrical rerelease of episodes 4 to 6—these alien-creatures weren't quite human enough to solicit viewers' identification or crafty enough to elicit much more than a passing appreciation of the makeup artist's handiwork. Along with the creature's anthropomorphosis and reanimation much of the craft and wonder of effects animation was drained from science fiction film. The computer-generated characters in *The Phantom Menace*—Jar Jar Binks, Boss Nass, and Watto—look, in Kracauer's words, like any old natural object, their anthropomorphic expressivity and fluid organicism the result of a decade and more of tweaking the same rendering and modeling software. Even the hardware in this film has the same animate organicism. Is it any wonder that in this context it is the digital simulation of a special photographic effect, the flickering blue image generated by a holographic communicator, that still looks special, its simulated degradation of an analog image a rare curiosity (figure 4.1).

FIGURE 4.1 *Star Wars Episode I: The Phantom Menace* (1999, copyright Lucasfilm Ltd.)

THE PUBLIC LIFE OF NUMBERS

From the beginning the introduction of digital imaging technologies raised questions about the future of traditional special effects techniques. In 1991 the expansion of Industrial Light and Magic's computer graphics division resulted in the merging and downsizing of its creature and model shops. And by the following year its matte department was working exclusively with digital imaging systems. The concern for many people trained in the techniques of makeup and prosthetics, model making, and animatronics was that the demand for this type of workmanship would simply disappear altogether should CGI ever prove to be capable of simulating the materiality of physical effects effectively enough to meet with audiences' approval. And this concern has not turned out to be entirely unfounded: the history of special effects is littered with the discarded apparatus and lost or dimly remembered skills associated with special effects techniques that no longer exhibit enough of the requisite mixture of technology and art to be considered state of the art.

Although it is still occasionally used for feature film effects, stop-motion animation is now only dimly remembered as a special effects technique in cult publications like *Classic Images* and, more eerily, in the retrovisionist glow of its computer-generated simulation in Tim Burton's *Mars Attacks!* But it is those special effects techniques that have been developed to create new kinds of images that rely most strongly on the auratic effect of their technological and artistic novelty to capture the eye and arrest the gaze. Other kinds of special effects function less in terms of visual display than in terms of hyperkinetic stimulus. And the techniques used to produce these kinds of effects have in fact changed very little over the years. Many such effects techniques will continue to have a place in blockbuster filmmaking for as long as the demand for the pyrotechnical dramas favored by the current cinema of action attractions prevails. Shots of models and miniatures that have been physically blown up before the camera still have an indexical realism that is a lot more time consuming to try to simulate on a computer.

The aesthetic parameters for different types of effects shots vary in accordance with the degree to which they are exhibited as aesthetic artifacts. For special effects shots in which artifacts function as props for pyrotechnical displays or as background objects, the primary focus of art-and-effects direction is on the integration of the effect into the cinematographic space of the action. In these types of effects shots the drive for realism (and photorealism) is strongest. In the broadest sense, however, all special effects represent a mode of visual display that privileges aesthetic novelty over realism. And in the end this is the reason *Independence Day* always had more chance of succeeding at the box office than *Godzilla* did. At the time, the novelty of *ID4*'s special effects lay in the decision to adapt the make-do aesthetic of B-grade SF to a mainstream, big-budget film. In contrast, the computer-generated Godzilla represented a conservative attempt to pass off an aesthetic that had already lost its auratic power over contemporary audiences. Although the cultural reception of these films can't be entirely understood in terms of how audiences perceive their special effects, the aesthetic choices governing the production of these effects does set the tone for audiences' emotional and intellectual engagement with this cinema. While there is nothing sly about a film like *Independence Day*—the spectatorial pleasures it offers are the patently superficial seductions of pastiche—its aesthetic and stylistic choices simultaneously disavow and reenact a nostalgic relation to a form of cinema that no longer exists.

At the beginning of a new century, it remains for film and cultural critics not only to wonder what the future of CGI might look like but also to try to

understand the cultural and technological pressures that have led to the production of imagery that increasingly looks the same. In the early years of CGI production, before the simulationist aesthetic that now prevails became dominant, it was still possible to imagine an aesthetic that did not turn to simulation to imagine the future. There was still something ambiguous in the hyperrealism of the CGI effects that illuminated science fiction cinema in the early part of the last decade, something that eluded the rational transparency of simulation. We need look no further than *The Phantom Menace* to be reminded of the complex of forces that determine how and in what capacities visual effects are featured in the contemporary SF film. To insist that the possibility of crafting a different future for CGI rests on the identification of craft not just with the pursuit of aesthetic novelty and innovation but more particularly with a refusal to make the kinds of aesthetic choices that put the visual effects image under erasure begs the question of whether the circumstances for such a future even exist in Hollywood.

For Leslie Bishko, a teacher and computer animator, cultivating a sensibility and a craft for working in the medium means not only learning how to treat animation software as an expressive tool but also working on a procedural or algorithmic level to adapt it to suit individual animators' needs.[41] Bishko's reflections on the computer animator's craft draw on the experiences of those animators for whom computer-generated imaging is an expressive activity, not an industrial practice. The circumstances in which computer-generated images are produced for Hollywood cinema, on the other hand, usually involve some sort of tendering process whereby special effects companies bid for contracts in an extremely competitive market. To some extent the tendering process itself is used as a forum for negotiating the aesthetic parameters of the commissioned imagery. And as the pressure to produce this imagery for less money and within shorter and shorter production periods has increased, opportunities for developing customized (or propriety) software have dwindled. The larger effects companies can still afford to devote resources to the research and development of new software, but smaller companies are left to make do with what is available. While science fiction cinema's turn to low tech reneged on the utopian promise of a cinema that has historically made the imaging of the future its most charismatic feature, in this context a low-tech aesthetic can also be seen as a populist alternative to simulation. Although it is at odds with the high-tech virtuosity of a technofuturist aesthetic, it too exhibits a patent disregard for the rational transparency of simulation. Turning necessity to advantage, it is an aesthetic that takes its cues from television, video games, and the World Wide Web:

popular cultural forms that don't just represent sites for the domestic consumption of images but also sites for the articulation of fantasies of home image production.[42]

Audiences' expectations of what the CGI effects for blockbuster cinema should look like are dispersed across a range of possibilities. It is now, however, when the computer-generated image has become decidedly more ubiquitous than charismatic, that it is important to remember that it is because cinema brings a public dimension to the consumption of computer-generated imagery that it continues to act as a particularly charged site for speculation about its future. In the computer-generated simulation of an analog world, it is possible to see—in the mode, for instance, of theory-SF—a terrible will to a machine vision. It is the CGI effects in Hollywood SF, on the other hand, that reveal the link between CGI and simulation to be historical and therefore contingent. Special effects are the future of digital imaging not because they represent the most innovative or the most expressive mode of computer-generated imaging. They are in fact neither of these things. It is rather because they have already exhausted a range of aesthetic possibilities for this new medium that the future has been forced upon them.

CONCLUSION
THE TRANSNATIONAL MATRIX OF SF

The drought in the ever-edgy f/x business had to end sometime, but no one expected the floodgates to open quite so precipitously. The big news: Special effects are back in vogue. Next year already is excitedly being chalked up as "2001: an F/X odyssey," with the major studios greenlighting what is easily the largest batch of computer-generated and visually extensive pics ever at the same time.

Before *Star Wars* came out, skittish studios shied away from expensive, effects-driven pictures, fearing George Lucas's juggernaut, but the success of *The Matrix* and *Gladiator* and *Mission Impossible 2*, which all heavily featured computer-generated imagery, have caused studios to unleash a wide variety of big-budget event pictures that all emphasize CGI, such as *A Perfect Storm*.

—Marc Graser, *Variety*, June 2–July 9, 2000

I t is the job of entertainment journalism to dramatize the business of special effects: to narrate the epic struggles of companies to produce more effects for less money and in less time, to put human faces to the development of new technologies and techniques, and to forecast and defend the inevitability of crisis. The emphasis of industry analysis and review is on growth, development, and flux. A study of an aspect of the cultural reception of CGI effects in Hollywood science fiction film has to try to do something else. Yuri Tsivian has suggested that "the task of those who take up the study of cultural reception" is "to summarize and interpret the recurrent associations and fixed ideas that each culture reads into" the cinema at a particular moment in its history.[1] Ranging across centuries and cultural forms—from popular scientific demonstration to Hollywood science fiction cinema—this book has tried to do just that. It has endeavored to make up for the impossibility of fully accounting for this range by formulating a few provisional hypotheses about what makes certain types of visual effects imagery special, about why this matters, and for whom.

Of course, some things *do* change, and this is also Tsivian's point when he says that "reception works like a diffusing lens: whatever comes into its field 'goes out of focus' and comes to look like something else rather than itself" (11). Some of the more recent publications that have been important for thinking about the cultural reception of special effects either no longer exist (*Sci-Fi Universe*) or no longer have the same hold on the popular technoscientific imaginary that they once did (*Wired*). But the shifting focus of reception is motivated by cultural forces that reach far beyond the popularity and influence of single publications. Cultures of effects connoisseurship, appreciation, and fandom are not monocultures. Their strongest links have traditionally been to popular science and genre film fandom (and in particular to science fiction fandom). In response to the growing popularity of Japanese anime film and Hong Kong action cinema among English-language audiences, signs of a shift in the aesthetic focus of Hollywood science fiction film began to emerge at the end of the last decade. Despite the articulation of the genres of *cinefantastique* to action cinema in the 1990s, science fiction had remained a singularly insular cinema up to this point. Over the same period Hollywood filmmaking in general and visual effects production in particular had increasingly become a transnational concern.[2] With the establishment of major studios in Australia (Warner-Roadshow, Fox), Hollywood filmmakers increasingly moved principal production offshore.[3] Even earlier, however, the establishment of an international standard for the Integrated Services Digital Network (or ISDN) enabled visual effects to be produced remotely by providing digital phone connections that allowed for the high-speed transfer of digital video and real-time videoconferencing. The visual effects credits for any number of Hollywood science fiction films made in the 1990s include companies located in London, Paris, and Sydney.

None of this had made any discernible impression on the way most of the Hollywood science fiction films made in the last decade looked. The reasons for this are complicated. Science fiction cinema has, in Bukatman's words, always been a "deeply American genre."[4] Its stagings of wondrous encounters with futuristic technologies have always refracted American fantasies and anxieties about national security (the atomic bomb, the cold war, Star Wars), about the space program (Mercury, Apollo, SETI), about the possibility of government and military conspiracy (Roswell, JFK, Watergate), about the moral accountability of corporate science (weapons research, biotechnology, genetic engineering), and about the implications of new computer technologies for the future of humanity (AI, VR). It is not only the settings and themes of science fiction that have tended to be recognizably American. From *Star Trek* to *Blade Runner*, Hollywood science fiction film's rendering of the

future has also drawn inspiration from aesthetic traditions that have been recognizably American. Indeed, it is because the American science fiction universe—which extends far beyond film and television to literature, comics, graphic novels, space art, and SF illustration and animation—is so varied and has such a rich history that filmmakers have been able to draw on it for so long. Like all genre film science fiction film has always addressed itself to the aesthetic traditions of the genre.

This makes the recent history of Hollywood science fiction film different from the recent history of Hollywood action cinema more generally. Others may in fact remember the 1990s as the decade of Hong Kong action cinema's second Anglo-American reception. In his essay "The Kung Fu Craze: Hong Kong Cinema's First American Reception," David Desser has identified the economic and cultural circumstances in which the kung fu genre entered American cinemas and Hollywood filmmaking. Desser points out that the popularity of martial arts films in the United States between 1971 and 1973 was initiated by Warner Brothers' distribution of Bruce Lee's films during this period.[5] Thereafter, the commercial impact of the kung fu genre on theatrical screens would largely be confined to U.S. adaptations of the genre, as Hollywood filmmakers reinvented the figure of the action hero to create characters who, like those played by Chuck Norris, Steven Seagal, and Jean-Claude Van Damme, combined muscular masculinity with martial arts training. The second American reception of Hong Kong action cinema, which Desser and Poshek Fu suggest began in 1989 with "the cult discovery of [John] Woo and Tsui Hark," has taken a number of routes.[6]

In the early part of the last decade Quentin Tarantino and Robert Rodriguez acknowledged that much of what seemed vital, stylish, and new about their own approaches to directing the action sequences for such popular films as *Reservoir Dogs* (dir. Quentin Tarantino, 1992), *Pulp Fiction* (dir. Quentin Tarantino, 1994), and *Desperado* (dir. Robert Rodriguez, 1995) had been inspired by the films of John Woo. Even before Woo had established himself as a director of blockbuster action films in Hollywood, all the elements associated with his style of action filming—the meticulous choreographing and musical scoring of hyperkinetic gunplay, the use of slow-motion, and his trademark two-handed shooting—had been introduced to audiences unfamiliar with this director's Hong Kong films by the new auteurs of independent American cinema. Woo's own response to this development in the many press interviews he has given over the years has been to shift the terms for discussing film style away from a language of imitation, appropriation, and derivativeness to one of translation, adaptation, and influence, citing directors as different as Sam Peckinpah, John Ford, Stanley Kubrick,

Akira Kurosawa, and Jean-Pierre Melville as influences on the development of his own style of action filmmaking. His adaptation of this style for such films as *Hard Target* (1993), *Broken Arrow* (1996), *Face/Off* (1997), and *Mission Impossible 2* (2000) has also been important for building his career, gradually becoming a site of recognition and auteurist appreciation for new audiences. With the rise of Jackie Chan's Hollywood star since the box-office success of *Rumble in the Bronx* (dir. Stanley Tong, 1995), the kung fu genre has also found an expanding transnational audience, and like other popular genres it too supports a number of fan publications devoted to its analysis and review.[7]

A study of the reasons Woo and Chan, along with Chow Yun-Fat (the star of some of Woo's best-known Hong Kong films) have so far been successful in their efforts to establish Hollywood careers, where Hark, for instance, has not, is work best left to others, as is the detailed, historical, and contextualizing work of analyzing their cultural reception in English-language countries.[8] Here it is enough to note that much of what was exciting about *The Matrix* (dir. Andy Wachowski/Larry Wachowski, 1999) for science fiction fans drew on the cinema of Woo, Hark, and Chan. The high-flying wire work associated with Hong Kong directors such as Hark and Siu-Tung Ching (*A Chinese Ghost Story*, 1987) had, for instance, been adapted for the film's leading actors, and much of the behind-the-scenes coverage of the film focused on their training under Hong Kong stunt choreographer and action director Yuen Wo Ping.[9] It was the film's appeal to a transnational aesthetic matrix—drawn from Hong Kong action cinema, from Japanese anime, and from the art of American comic artist Frank Miller—that prompted the fan magazine *Cinefantastique* to dub it a science fiction film for "the new millennium."[10] In 1999 *The Matrix* was indeed a rare thing: a Hollywood science fiction film that not only rewarded but demanded the studied attention of fans. Its reworking of aesthetic traditions drawn from Asian and American popular culture was nevertheless only one site of interest. For this was also an unusually literary SF film, lending itself to the close readings and hypertext translations that continue to give it an afterlife on the World Wide Web.

There was something else about this film—something about the spatiotemporal manipulation of the action—that also compelled attention. Although CGI was used for a wide range of effects, including effects animation, much of the visual interest of the film lay in the techniques used to animate the cinematographic image digitally. Visual effects supervisor John Gaeta likened the film to an anime film with live actors. Anime, he explains, "breaks down action into its components and allows those elements to be meticulously controlled to build the most dramatic effect from dynamic

FIGURE C.1 *The Matrix* (1999, copyright Warner Bros.)

movement."[11] What came to be referred to as "Bullet-Time" or "Flow-Mo" was a technique for creating the illusion of movement around objects in the foreground. In defiance of the natural laws of cinematography, elements of the filming could be made to appear to be moving at different speeds, with higher-speed camera moves miraculously tracking slow-motion action scenes.[12] In contrast to the aesthetically moribund *Phantom Menace, The Matrix* featured this technique in a number of key action sequences combining stunts with subtle 2-D and 3-D animation, transforming the cinematographic image into a dynamic and arresting assemblage capable of arousing that old sense of wonder and curiosity about the technology—and art—of cinematic illusion in even some of the most jaded cinemagoers (figure C.1).[13]

I have argued throughout this book that genre film fan cultures have over and over again reiterated their attachment to actually going to the cinema, seeing in this activity an opportunity to enjoy the big screen and surround-sound experience of a cinema theater and to participate in a viewing experience that offers forms of social interaction not available in the domestic sphere of fam-

ily and home. With the increasing popularity of home cinema systems, it is this latter dimension of the public movie-going experience, with its rare opportunity to commune with strangers, that remains the most significant for fans. The cinematic event is itself characterized by other more informal and ad hoc stratifications, with preview screenings and opening nights typically bringing fans together in greater numbers than at other times during the relatively short duration of a film's theatrical release. Generalizations about the relationship between cinema and the variety of home entertainment formats now offered by new media such as video, DVD, and pay television cannot be made on the basis of the viewing activities of fans, but these activities do provide some insight into the residual attractions that this older medium has to offer. In response to changes in film-viewing patterns since the mid-1980s, when revenue for video rentals and sales began to outstrip box-office receipts for theatrical releases of feature films, a number of film scholars have turned their attention to examining the patterns of consumption and social organization shaping the domestic arena of home entertainment and in particular the forms of public discourse giving material expression to the idea of home cinema.[14] Barbara Klinger's research in this area has looked, for instance, at the kinds of appeals advertising for home cinema systems typically make to potential buyers.[15] Her work reveals that consumers are being lured not only with the promise of being able to reproduce the full motion picture experience in their own homes with big-screen or projector televisions and surround-sound systems but also with the assurance that the home cinema experience offers unprecedented mastery and control over both the technology of exhibition and the social conditions of spectatorship.

The latest consumer electronics product to enter the home cinema market has of course been the DVD player, which, in line with Klinger's findings, has been sold on the basis of its superior audio and visual quality and the increased control over the viewing experience that the enhanced features that come with the DVD format offer (among the most standard features are language and subtitle options, scene-by-scene access, theatrical trailers, and biographies of selected cast and crew). "Making-of" and "behind-the-scenes" featurettes, special commentary, outtakes, film stills, production notes, screenplays, screenplay-storyboard comparisons, isolated soundtracks, and alternative versions are just some of the other features that have become increasingly standard for DVD releases of feature films. The marketing of DVD as a connoisseur's medium has no doubt been a key factor in the extraordinarily rapid rate of uptake by consumers.[16] This development highlights the extent to which some form of connoisseurship has increasingly come to define what cinema means for contemporary audiences. For at least

some of these viewers the domestic consumption of films represents an opportunity for more studied, attentive forms of viewing than the public experience of cinema attendance allows for, without necessarily replacing that experience altogether. This has always been the case, for instance, for genre film fans, who have embraced the opportunities that video and DVD offer for repeat viewings and close scrutiny of favorite films. The growth in and diversification of cultures of film connoisseurship that we are witnessing at the present time feeds the expansion of the entertainment and consumer electronics industries in fairly obvious ways, creating demand for ever more state-of-the-art technologies that promise to make attentive, repeat home viewing of films more pleasurable and promoting a consumerist culture of connoisseur-collectors. Here, however, it is important to remember that along with these industries the institutions of film criticism and journalism, film societies and festivals, fan cultures, and film studies courses have also been instrumental in fostering an appreciation of the cinema based on an intellectual and intellectually impassioned engagement with its artifacts.

The DVD release of *The Matrix* will be remembered as having integrated the pleasures of going behind the scenes to explore the ideas and techniques of visual effects production into the home viewing experience more fully than had previously been attempted in this format. Even though the features specifically designed for personal computers tended to be fairly limited in scope, the DVD was also one of the first to take seriously the possibility of viewing film on a computer monitor. More interesting than the links to the official studio and chat Websites and the equally uninspiring attempt to turn exploration of one of the film's central motifs into an interactive feature for users ("Are You the One?") is the essay section of this browser, which has links to reviews published in *Time* and the *New York Times* and short essays on the history of the kung fu and science fiction film genres. Concerned mostly with describing the impact martial arts films have had on the development of new styles of action filmmaking in Hollywood, the essay on kung fu ("Everybody Loves Kung Fu Fighting") reproduces many of the clichés most familiar to East/West dichotomies (Eastern artistic influence vs. advanced Western technology, Western science fiction vs. Eastern mysticism). At the same time it is the language of film style that offers a widely accessible interface for a discourse of cultural syncretism in this essay (articulated in terms of the potential for the "cross-pollenization" and "transcendence" of genre through transnational exchanges of ideas and expertise). The widespread circulation of this discourse in the popular and mainstream press also paved the way for the enthusiastic reception of Ang Lee's historical-fantasy film *Crouching Tiger, Hidden Dragon* (2000) in countries outside Asia, where

Yuen Wo Ping's involvement as stunt choreographer proved to be an especially popular drawing card.

Relishing the opportunities for mischievous wordplay that the situation seemed to invite, *Variety* reported that *Crouching Tiger, Hidden Dragon* was more of a "toothless 'Tiger' " at the Asian box office.[17] The front page article speculated that audiences in Taiwan and Hong Kong had found the film's simple plot, static direction, and stilted dialogue from two of the film's leading actors (Michelle Yeoh and Chow Yun-fat)—whose struggles with the demands of speaking in Mandarin were widely reported on in the English-language press—too "lite" and, like so much "chop suey," too watered down for Western palates to appeal to connoisseurs of more indigenous martial arts films. Lee himself indulged these culinary metaphors to admit that he primarily saw the film, in Rey Chow's terms, as a work of cultural translation.[18] Speaking about the film in a short featurette available on DVD release, Yeoh also described the film's cultural work in these terms, suggesting that in reworking myths, legends, and fairytales for audiences unfamiliar with these stories, *Crouching Tiger, Hidden Dragon* might hope to draw these audiences into a popular cultural imaginary that would bring them to a deeper understanding and appreciation of Asian cultural difference and open up a space for future exchanges.[19]

The utopian dimensions of popular and mass culture are writ largest in these wildly extravagant gestures toward the creation of imaginary spaces of dialogue on the cultural issues raised by popular cinema—issues, it must be said, that are articulated in and through the language of aesthetic appreciation. The DVD release of *The Matrix* made this film's visual effects the site of just such extravagance. "Follow the White Rabbit" is its most imaginative take on the conventional, behind-the-scenes featurette. The montage sequences that can be accessed when the film is viewed in this mode layer shots of the filming and digital processing of visual effects sequences with shots of the same sequences taken from the finished film to create a series of new assemblages that suggest rather than reveal the techniques used to bring these effects to the screen. Shots of live-action filming on a green screen set may be interleaved, for instance, with a shot of a wire-frame, computer-generated previsualization of the same shot. In the absence of any form of commentary or narration, viewers are left to apply their own knowledge and expertise to understanding what they are looking at. By using a visual grammar in these sequences that makes their transparency proportional to viewers' own levels of technical understanding, they are available to be enjoyed as mementos of a process that is already known without having been seen or, alternatively, as incitement to further speculation.

FIGURE C.2 *The Matrix* (1999, copyright Warner Bros.)

More discursive treatment of the visual effects for *The Matrix* is also offered by visual effects supervisor Gaeta, who along with the film's lead actress (Carrie-Anne Moss) and editor (Zach Steinberg), provides the commentary for a scene-by-scene retrospective of the making of the film. It is in this mode that the demand that visual effects production be taken seriously as a cinematic art form moves from tentative to insistent refrain. Gaeta is at his most eloquent discussing the philosophy behind the design for the computer-generated sentinels, which he describes as moving in symmetrical, mathematical patterns expressive of computer-derived life forms (figure C.2), or reprising a decades-old argument for the importance of being able to use conventional visual effects techniques to create images that support a strong narrative instead of calling attention to themselves as artifacts of yet another never-before-seen process or technique. Certain types of films— films that set themselves the task of imagining narrative worlds governed according to different laws, different rules, different orders of time and space—also demand visual effects that can realize this realm of speculation

visually. And at other moments in this commentary Gaeta concedes that it is these effects that are also the riskiest and most satisfying to work on.

But not only to work on. The pursuit of aesthetic novelty, innovation, and invention that ideally characterizes visual effects production also answers a cultural demand for the aesthetic experience of wonder. These aesthetic ideals are not peculiar to special effects. They also draw on the language and mise-en-scène of controlled risk and experiment typical of popular representations of science.[20] The aesthetic parameters for visual effects production are circumscribed by the representational demands of narrative cinema and by the industrial practices of a film industry that is little concerned with filmmakers' and visual effects producers' own attempts to see what they do in creative or artistic terms. What fan discourse on special effects reminds us is that whether they are recognized in these terms by the Hollywood film industry or indeed whether they are so recognized by contemporary film and cultural criticism, popular and mass cultural forms are sites for the articulation of modes of aesthetic criticism and engagement that speak of nothing so much as the longing for a kind of art.

INTRODUCTION

1. John Brosnan, *Movie Magic: The Story of Special Effects in the Cinema* (1974; reprint, New York and Scarborough, Ontario: Plume, 1976).

2. An ambition, he adds, that was bound to be disappointed (176).

3. Within the film and special effects industries, CGI is the industry acronym for "computer-generated imagery." CGI effects are computer-generated images that feature in a film *as* special effects. Although the film industry makes a technical distinction between "special effects" (which are created on set), and "visual effects" (which are created in postproduction), this distinction is never quite maintained in popular discourse.

4. Martin Barker and Kate Brooks, *Knowing Audiences: Judge Dredd, Its Friends, Fans and Foes* (Luton, U.K.: University of Luton Press, 1998), 9–10.

5. See Constance Penley, "Brownian Motion: Women, Tactics, and Technology," in *Technoculture*, ed. Constance Penley and Andrew Ross, Cultural Politics, vol. 3 (Minneapolis and Oxford: University of Minnesota Press, 1991), 135–61; and Penley, "Feminism, Psychoanalysis, and the Study of Popular Culture," in *Cultural Studies*, ed. and

intro. Lawrence Grossberg, Cary Nelson, Paula A. Treichler, with Linda Baughman and assistance from John MacGregor Wise (New York and London: Routledge, 1992); Henry Jenkins, *Textual Poachers: Television Fans and Participatory Culture* (New York: Routledge, 1992); John Tulloch and Henry Jenkins, *Science Fiction Audiences: Watching Doctor Who and Star Trek* (London and New York: Routledge, 1995).

6. Constance Penley, *NASA/Trek: Popular Science and Sex in America* (London and New York: Verso, 1997).

7. This method appears in their list as item h: "Studies of the public face of films, reviews and other critical responses that may help to set the terms of public response—this is a source which Janet Staiger has recently mined to great effect" (Barker and Brooks, *Knowing Audiences*, 10).

8. Robert D. Hume, *Reconstructing Contexts: The Aims and Principles of Archaeo-Historicism* (Oxford and New York: Oxford University Press, 1999), 9, 71.

9. Quoted in Paul Scanlon, "The Force Behind George Lucas," *Rolling Stone* 246 (Aug. 25, 1977): 34.

10. As compared, for instance, with a magazine such as *Cinéaste*. The French film-maker and critic Olivier Assayas has written widely on special effects and science fiction cinema for *Cahiers du Cinéma*. For a comprehensive filmography and bibliography of his work, see "Olivier Assayas Filmography," *Metro* 113–114 (1998): 77–80. Also see the series of articles on special effects in *Libération*, Mar. 8, 1998, 1–4.

11. A good place to start would be *Lune Rouge: Création audio-visuelle*, http//:www.lunerouge.com/liens_f.htm#sfx. This site provides numerous links to science fiction and fantasy e-zines, as well as links to both professional and amateur sites devoted to special effects production.

12. *Photon* 27 (1977): 4.

13. One boy from their Boys' Club focus group commented, for instance: "When I see a film like that [*Judge Dredd*], I tend to think of all the special effects, and how they do it, and stuff like that" (Barker and Brooks, *Knowing Audiences*, 40). Barker and Brooks propose grouping audiences' responses to *Judge Dredd* into "ideal-types," each representing "a set of shareable rules and constraints" (see ch. 7, "The Six Orientations to *Judge Dredd*," in ibid., 153–78).

14. Leger Grindon, "The Role of Spectacle and Excess in the Critique of Illusion," *PostScript* 13.2 (winter/spring 1994): 42.

15. See Theodor Adorno and Max Horkheimer, *Dialectic of Enlightenment*, trans. John Cumming (London: Verso, 1986).

16. Theodor Adorno, "The Schema of Mass Culture," in *The Culture Industry: Selected Essays on Mass Culture*, ed. J. M. Bernstein (London: Routledge, 1991), 54–55.

17. This, Adorno warns, is "how the technological veil and the myth of the positive is woven" (ibid., 55).

18. Adorno, "On the Fetish Character in Music and the Regression of Listening," in *The Culture Industry*, 46.

19. Fredric Jameson's comments on special effects appear in the conclusion to his influential work *Postmodernism; or, The Cultural Logic of Late Capitalism* (Durham, N.C.: Duke University Press, 1991), 384–86. See Herbert I. Schiller, "Media, Technology, and the Market: The Interacting Dynamic," in *Culture on the Brink: Ideologies of Technology*, ed. Gretchen Bender and Timothy Druckrey (Seattle: Bay, 1994), 31–46.

1. MAGIC, SCIENCE, ART: BEFORE CINEMA

1. While a small body of scholarship dealing with Pepper's Polytechnic lectures continues to grow, very little is known about the popular science lectures given by Henry Morton during his period of tenure at the Franklin Institute. I am therefore especially grateful to Simon During for drawing my attention to Morton's lectures and for exciting my curiosity about their phantasmagorical attractions.

2. Iwan Rhys Morus, *Frankenstein's Children: Electricity, Exhibition, and Experiment in Early-Nineteenth-Century London* (Princeton, N.J.: Princeton University Press, 1998), xi.

3. Referring to the ghost illusion, Pepper claimed, for instance, that "as the illusion has apparently left the domain of optical science and is now relegated to the conjuring profession, the author has no hesitation in fulfilling his long-ago promise to the public to let, as Mr. Cremer, jun., says in his most amusing book on 'Conjuring', the cat out of the bag" (John Henry Pepper, *The True History of the Ghost; and all about Metempsychosis* [London, Paris, New York, and Melbourne: Cassell, 1890], 39).

4. Frost describes "the original 'ghost' " as having "made its successful debut under the auspices of Mr. Pepper." He later refers to this illusion as "Silvester's Ghost." See Thomas Frost, *The Lives of the Conjurors* (1876; reprint, London: Chatto and Windus, 1881), 323, 353. According to Pepper, Sylvester "patented the use of looking-glass in the performance of the ghost, which I thought very good, and bought of him—he could only infringe my patent by attempting to use it" (12).

5. Thomas L. Hankins and Robert J. Silverman, "Instruments and Images: Subjects for the Historiography of Science," in *Instruments and the Imagination* (Princeton, N.J.: Princeton University Press, 1995), 4. Contributing in no small part to my own speculation on this topic, Roberta McGrath has argued that "by tracing the history of convergence and later the divergence of amusement and instruction in the nineteenth century we can begin to understand natural magic as a precursor to science fiction" ("Natural Magic and Science Fiction: Instruction, Amusement and the Popular Show, 1795–1895," in *Cinema: The Beginnings and the Future. Essays Marking the Centenary of*

the First Film Show Projected to a Paying Audience, ed. Christopher Williams [London: University of Westminster Press, 1996], 13–14).

6. Nathan Reingold, "Definitions and Speculations: The Professionalization of Science in America in the Nineteenth Century," in *Science, American Style* (New Brunswick and London: Rutgers University Press, 1991), 43.

7. See, for instance, Henry Morton, "Electric Excitement," *Scientific American* 17.8 (Aug. 24, 1867): 117; and "The Magic Lantern as a Means of Demonstration," *Scientific American* 29.11 (Sept. 13, 1873): 163–64. See also the articles on natural history that Louis Agassiz contributed to the *Atlantic Monthly* between 1862 and 1864.

8. J. G. Holland, "The Popular Lecture," *Atlantic Monthly* 15.89 (Mar. 1865): 362–71.

9. Thomas Wentworth Higginson, "The American Lecture-System," reprinted from *Macmillan's Magazine* in *Littel's Living Age* 97.1253 (June 6, 1868): 630. During the Civil War, Higginson was the colonel of the first regiment of black men in the union army. See *The Complete Civil War Journal and Selected Letters of Thomas Wentworth Higginson*, ed. Christopher Looby (Chicago and London: University of Chicago Press, 1999).

10. Lynne Kirby argues that in fact "the progress and modernity of the railroad in and of itself came to stand for *American* progress, an important notion to uphold in the progress-driven, yet angst-ridden 1920s" (*Parallel Tracks: The Railroad and Silent Cinema* (Durham, N.C.: Duke University Press, 1997), 201.

11. Holland, "The Popular Lecture," 362.

12. As he says, "a lecture audience will forgive extravaganza but never dullness" (ibid., 363).

13. The first issue of the *Popular Science Monthly* appeared in 1872.

14. Holland, "The Popular Lecture," 362.

15. E. L. Youmans, "Scientific Lectures," *Popular Science Monthly* 9.9 (Dec. 1873): 242.

16. Erik Barnouw, *The Magician and the Cinema* (New York and Oxford: Oxford University Press, 1981). In many ways Paul Hammond's critical and biographical study of Méliès is an important precursor to this book. See Paul Hammond, *Marvelous Méliès* (London: Gordon Fraser Gallery, 1974).

17. Frost, *The Lives of the Conjurors*, 112.

18. The first English translation of *Natural Magick* was published in London in 1658. See John Baptista Porta, *Natural Magick*, ed. Derek J. Price (New York: Basic, 1957), a Collector's Series in Science reproduction of the anonymous English translation printed in London in 1658. Scot makes explicit reference to Porta in chapter 4, "What Strange things are brought to passe by naturall magicke." See Reginald Scot, *The Discoverie of Witchcraft*, intro. Montague Summers (New York: Dover, 1972), 165.

19. Porta, *Natural Magick*, 1–2. Echoing Porta, Scot writes: "In this art of naturall

magicke, God almightie hath hidden manie secret mysteries; as wherein a man may learne the properties, qualities, and knowledge of all nature" (*The Discoverie of Witchcraft*, 164).

20. See Loraine Daston and Katherine Park's examination of the preternatural philosophy of Porta and his contemporaries in their *Wonders and the Order of Nature, 1150–1750* (New York: Zone; London: MIT Press, 1998), 167–72.

21. David Brewster, *Letters on Natural Magic, Addressed to Sir Walter Scott, Bart.*, new ed. (London: William Tess, 1868), 90.

22. Morus describes this struggle in terms of the lecturer's need to "establish his own credentials as a reliable spokesman for Nature while simultaneously representing Nature as speaking for herself" (*Frankenstein's Children*, 44).

23. Frost, *The Lives of the Conjurors*, 9.

24. Hankins and Silverman, *Instruments and the Imagination*, 12.

25. Brewster, *Letters on Natural Magic*, 172.

26. Jonathan Crary, *Techniques of the Observer: On Vision and Modernity in the Nineteenth Century* (Cambridge, Mass.: MIT Press, 1992), 133.

27. See Christian Metz, "The Filmic *Visée*," in *The Imaginary Signifier: Psychoanalysis and the Cinema*, trans. Celia Britton, Annwyl Williams, Ben Brewster, and Alfred Guzzetti (Bloomington: Indiana University Press, 1982), 138–42.

28. Philip Fisher, *Wonder, the Rainbow, and the Aesthetics of Rare Experiences* (Cambridge and London: Harvard University Press, 1998), 17.

29. Daston and Park have also written eloquently on the subject of wonder, charting the variety of senses that have been attributed to it over its long history. They point out that although medieval and early modern intellectuals regarded wonder to be a cognitive passion—"as much about knowing as about feeling"—since the Enlightenment it has "become a disreputable passion," "redolent of the popular, the amateurish, and the childish" (*Wonders*, 14–15).

30. Pepper, *The True History of the Ghost*, 5.

31. Fisher, *Wonder*, 31.

32. For a revised who's who of early phantasmagoria showmen, see Mervyn Heard, "The Magic Lantern's Wild Years," in *Cinema: The Beginnings and the Future. Essays Marking the Centenary of the First Film Show Projected to a Paying Audience*, ed. Christopher Williams (London: University of Westminster Press, 1996), 24–32.

33. Terry Castle, "Phantasmagoria and the Metaphorics of Modern Reverie," in *The Female Thermometer: Eighteenth-Century Culture and the Invention of the Uncanny* (New York: Oxford University Press, 1995), 144.

34. In contemplation of the sublime, Kant argues that neither the imagination nor reason are adequate: "The feeling of the sublime is therefore a feeling of pain arising from the want of accordance between the aesthetical estimation of magnitude formed by the imagination and the estimation of the same formed by reason" (*Critique of*

Judgment, trans. J. H. Bernard (New York: Hafner Press; London: Collier Macmillan, 1974), 96.

35. See Theodore Barber, "Phantasmagorical Wonders: The Magic Lantern Ghost Show in Nineteenth-Century America," *Film History* 3.2 (1989): 73–83; J. E. Varney, "Robertson's Phantasmagoria in Madrid, 1821 (Part I)," *Theatre Notebook* 9 (1954–1955): 89–95.

36. Cited in Varney, this program refers to a phantasmagoria show staged in Madrid in 1809 ("Robertson's Phantasmagoria," 94).

37. Tom Gunning examines the overlapping technologies of magic, spiritualism, and photography in "Phantom Images and Modern Manifestations: Spirit Photography, Magic Theatre, Trick Films, and Photography's Uncanny," in *Fugitive Images: From Photography to Video*, ed. Patrice Petro (Bloomington and Indianapolis: Indiana University Press, 1995), 42–71. "Inevitably," observes Gunning, "spectacular Spiritualism encountered the nineteenth-century magic show and had a role in transforming it into an intensely visual theatre of illusion" (60).

38. "The Christmas Pantos, Burlesques, &c.," *London Times*, Dec. 27, 1862, 3–4.

39. "Royal Polytechnic Institution," *London Times*, Dec. 27, 1862, 4.

40. For another account of the use of "Pepper's Ghost" in popular theatrical productions, see George Speaight, "Professor Pepper's Ghost," *Theatre Notebook* 43.1 (1989): 16–24.

41. Pepper, *The True History of the Ghost*, 29.

42. Frost, *The Lives of the Conjurors*, 314.

43. "Royal Polytechnic Institution," 4.

44. See "A Brilliant Series of Experiments," *Scientific American* 14.16 (Apr. 14, 1866): 247; and "Professor Doremus' Lectures," *Scientific American* 14.18 (Apr. 28, 1866): 278–79.

45. "Professor Doremus' Lectures," 279.

46. See John Tyndall, *Six Lectures on Light Delivered in America in 1872–1873* (London: Longmans, Green, 1873), 166.

47. Henry Morton, "The Magic Lantern as a Means of Demonstration," *Journal of the Franklin Institute of the State of Pennsylvania, for the Promotion of the Mechanic Arts* 55.4 (Apr. 1868): 277.

48. Bruce Sinclair, *Philadelphia's Philosopher Mechanics: A History of the Franklin Institute, 1824–1865* (Baltimore and London: John Hopkins University Press, 1974), 317n29.

49. Henry Morton, editorial, *Journal of the Franklin Institute of the State of Pennsylvania, for the Promotion of the Mechanic Arts* 54.6 (Dec. 1867): 363.

50. Jacques Derrida, *Archive Fever: A Freudian Impression*, trans. Eric Prenowitz (Chicago and London: University of Chicago Press, 1996), 15.

51. For an account of the interactive aspects of Robertson's "Invisible Woman"

show, see Jann Matlock, "The Invisible Woman and Her Secrets Unveiled," *Yale Journal of Criticism* 9.2 (1996): 184–85.

52. Morton, "The Magic Lantern" (Apr. 1868): 277.

53. Henry Morton, "The Magic Lantern as a Means of Demonstration," *Journal of the Franklin Institute of the State of Pennsylvania, for the Promotion of the Mechanic Arts* 55.5 (May 1868): 346.

54. For a genealogy of the English word "technology," see Leo Marx, "The Idea of 'Technology' and Postmodern Pessimism," in *Does Technology Drive History? The Dilemma of Technological Determinism*, ed. Merritt Roe Smith and Leo Marx (Cambridge, Mass.: MIT Press, 1994), 237–49.

55. See Richard Altick, *The Shows of London* (Cambridge: Harvard University Press, Belknap, 1978), and the essays looking at the history of the moving image in *Cinema: The Beginnings and the Future. Essays Marking the Centenary of the First Film Show Projected to a Paying Audience*, ed. Christopher Williams (London: University of Westminster Press, 1996).

56. He recalls further that "at the Egyptian Hall two of these sketches were preceded by conjuring, and generally there was an interlude of musical sketches at the piano" (David Devant, *My Magic Life*, intro. J. P. Priestly [London: Hutchinson, 1931], 67). Appendixes to *My Magic Life* include a "Programme of Illusions at the Egyptian Hall from 1886–1904" and scripts for several sketches performed over this period.

57. See the chapter entitled "Climax" in Nevil Maskelyne and David Devant, *Our Magic: The Art in Magic, the Theory of Magic, the Practice of Magic* (London: George Routledge and Sons; New York: Dutton, 1911), 98.

58. In addition to the chapter on "Climax," see the earlier chapter on "Surprise and Repetition," 65–76.

59. On dime museums, see Andrea Stulman Dennett, *Weird and Wonderful: The Dime Museum in America* (New York and London: New York University Press, 1997).

60. See "Opening of the Novelties Exhibition, Phil.," *Scientific American* 53.13 (Sept. 28, 1885): 193.

61. Tracing the development of this "incendiary art" to the end of the eighteenth century, Kevin Salatino points out that by the mid-eighteenth century, fireworks displays tended to be supplemented by printed programs distributed for the purpose of clarifying the technicalities of the performance for audiences (*Incendiary Art: The Representation of Fireworks in Early Modern Europe*, Collections of the Getty Research Institute for the History of Art and the Humanities, 3 (Los Angeles: Getty Research Institute for the History of Art and the Humanities, 1997), 19–21. For an account of Brock's and Pain's careers, see Alan St. H. Brock, "The Nineteenth Century, 1861–81," in *A History of Fireworks* (London and Sydney: Harrop, 1949), 84–99.

62. *Scientific American* 55.5 (July 31, 1886): 69.

63. Trevor H. Hall's *Bibliography of Books on Conjuring in English from 1580 to 1850*

(Minneapolis: Carl Waring Jones, 1957) has 323 entries and does not include all the smaller, self-published pamphlets that were sold at magic performances and shops specializing in conjuring books and apparatus.

64. According to Hall, it not only ran to thirty-three editions but was also widely copied without acknowledgment (*Old Conjuring Books: A Bibliographical and Historical Study with a Supplementary Check-list* [London: Duckworth, 1972], 153).

65. Henry Dean, *The Whole Art of Legerdemain; or, Hocus Pocus in Perfection*, 6th ed. (London: L. Howes, S. Crowder, and R. Ware, 1763; facsimile reprint, Omaha, Nebr.: Graham Edition, 1983).

66. Combining instructions for reproducing all the more usual feats of manual dexterity and sleight-of-hand with descriptions of a number of considerably more elaborate science experiments, Cremer's *The Magician's Own Book* (1871) is fairly typical of nineteenth-century conjuring books published before 1876. See W. H. Cremer Jr., ed., *The Magician's Own Book: Containing ample instruction for recreation in chemistry, acoustics, pneumatics, legerdemain, prestidigitation, electricity (with and without apparatus)* (London: John Camden Hatten, 1871).

67. Professor Hoffman, *Modern Magic: Practical Treatise on the Art of Conjuring*, 3d ed. (London and New York: George Routledge and Sons, 1878), 1.

68. Out of the 323 books recorded in Hall's bibliography of conjuring books, only thirty-two had an American imprint, and most of these were simply new editions of English works (*Old Conjuring Books*, 182; also see the bibliography to which he refers).

69. Albert A. Hopkins, *Magic: Stage Illusions, Special Effects, and Trick Photography*, intro. Henry Ridgely Evans (New York: Munn, 1898; reprint, New York: Dover, 1976).

70. In the article "Theatrical Illusions," which was reprinted in *Scientific American* from *La Nature*, the author writes: "An explanation of the illusions employed in theatres is always welcome, and the spectators take more interest in seeing a mystery performed whose hidden working is familiar to them than those who do not possess the key of the enigma" (*Scientific American* 64.7 [Apr. 25, 1891]: 259).

71. "Science in the Theatre," *Scientific American* 65.3 (July 18, 1891): 39.

72. Barbara Maria Stafford, *Artful Science: Enlightenment, Entertainment, and the Eclipse of Visual Education* (Cambridge, Mass., and London: MIT Press, 1994), 70.

73. John Henry Pepper, *The Boy's Playbook of Science: including the various manipulations, arrangements of chemical and philosophical apparatus required for the successful performance of scientific experiments, in illustration of the elementary branches of chemistry and natural philosophy* (London and New York: Routledge, Warne, and Routledge, 1860), p. B.

74. See Susan Sheets-Pyenson's critical survey of the literature in "Popular Science Periodicals in Paris and London: The Emergence of a Low Scientific Culture, 1820–1875," *Annals of Science* 42 (1985): 549–572.

75. *Popular Science Monthly* 3.26 (Aug. 1873): 513.

76. The term "populist" is being used here to describe the magazine's pursuit of a broad-based readership and is not to be confused with the reformist political objectives of the Populist Party formed in the early 1890s.

77. John C. Burnham, *How Superstition Won and Science Lost: Popularizing Science and Health in the United States* (New Brunswick, N.J.: Rutgers University Press, 1987), 130.

78. "Strikes," *Scientific American* 8.8 (Feb. 21, 1863): 121.

79. Trade union demands for an eight-hour workday during the 1870s and 1880s also go unremarked. For a political and historical analysis of trade union activity during the last quarter of the nineteenth century, see Walter Licht, *Industrializing America: The Nineteenth Century* (Baltimore and London: Johns Hopkins University Press, 1995), 166–96.

80. "How Labor Enslaves Itself to Capital," *Scientific American* 24.23 (June 3, 1871): 359.

81. "The Magic Lantern," *Scientific American* 22.1 (Jan. 1, 1870): 13.

82. For an account of the importance that the sciopticon had for the producers of magic lantern shows "in which actors were posed in stage settings representing the various scenes of a narrative story drawn from popular literature, songs, or plays," see Deac Rossell, "The Moving Image in the Nineteenth Century," in *Living Pictures: The Origins of the Movies* (Albany: State University of New York Press, 1998), 24.

83. This is to take up Licht's suggestion that we view the "industrializing of America" in the nineteenth century in terms of "America's passing first from a mercantile to an unregulated and then to a corporately and state-administered market society" (*Industrializing America*, xvi).

84. A retrospective of Faraday's life and work declared that "with him went out the brightest light which had radiated through the chemical and physical sciences for forty years" ("Michael Faraday," *Scientific American* 22.4 [Jan. 22, 1870]: 65).

85. For a general overview of magazine publishing in the United States, see David Reed, *The Popular Magazine in Britain and the United States, 1880–1960* (Toronto and Buffalo: University of Toronto Press, 1997).

86. "Specialistic Journalism," *Scientific American* 22.3 (Jan. 15, 1870): 47.

87. *Scientific American* 8.3 (Jan. 17, 1863): 38.

88. Burnham, *How Superstition Won*, 34.

89. See "English and American Scientific, Mechanical, and Engineering Journalism," *Scientific American* 24.6 (Feb. 4, 1871): 87; and "A Scientific and Technical Awakening," *Scientific American* 24.12 (Mar. 18, 1871): 183.

90. Sinclair, *Philadelphia's Philosopher Mechanics*, 14–15.

91. In commenting on these attempts to articulate the values of a distinctly American science, Sinclair cites Hugo Meier's argument that technology blended "the ideas of republicanism with the rising democratic spirit in the early national period" (ibid.,

3). Also see Howard B. Rock's analysis of the iconography of "artisanal republican-ism" in the early part of the nineteenth century in " 'All Her Sons Join as One Social Bond': New York City's Artisanal Societies in the Early Republic," in *American Arti-zans: Craft and Social Identity, 1750–1850*, ed. Howard B. Rock, Paul A. Gilje, and Robert Asher (Baltimore: Johns Hopkins University Press, 1995), 155–75.

92. "A Scientific and Technical Awakening," 183.

93. "American Technical Journals," *Engineering* 11 (Feb. 17, 1871): 126–27.

94. "English and American Journalism," 87.

95. "Editor's Table: Du Bois-Reymond on Exercise," *The Popular Science Monthly* 21 (1882): 544.

96. Walter Benjamin, "The Task of the Translator: An Introduction to the Trans-lation of Baudelaire's *Tableaux Parisiens*," in *Illuminations*, trans. Harry Zorn, ed. Hannah Arendt (London: Pimlico, 1999), 78.

97. I am thinking, in particular, of Jacques Derrida's and Paul de Man's decon-structive readings of Benjamin's preface. See Jacques Derrida, "Des Tours de Babel," in *Difference in Translation*, ed. Joseph F. Graham (Ithaca, N.Y.: Cornell University Press, 1986), 165–207; and Paul de Man, " 'Conclusions': Walter Benjamin's 'The Task of the Translator,' " in *The Resistance to Theory* (Minneapolis: University of Minneso-ta Press, 1986), 73–105.

98. Benjamin, "The Task of the Translator," 77.

99. Derrida, "Des Tours de Babel," 189.

100. Benjamin, "The Task of the Translator," 79.

101. Benjamin wrote, for instance, that "in its afterlife—which could not be called that if it were not a transformation and a renewal of something living—the original undergoes a change" ("The Task of the Translator," 73).

102. Rey Chow, "Film as Ethnography," in *Primitive Passions: Visuality, Sexuality, Ethnography, and Contemporary Chinese Cinema* (New York: Columbia University Press, 1995), 200.

103. Patricia Zimmerman, *Reel Families: A Social History of Amateur Film* (Bloom-ington and Indianapolis: Indiana University Press, 1995), 7.

104. "Photography of the Invisible," *Scientific American* 29.23 (Dec. 6, 1873): 353.

105. Charles Musser looks at an article in *Scientific American* that describes Hop-kins's presentation of Edison's kinetoscope at the Brooklyn Institute in 1893. See his *Before the Nickelodeon: Edwin S. Porter and the Edison Manufacturing Company* (Berkeley, Los Angeles, Oxford: University of California Press, 1991), 36–39.

106. A phenomenally popular publication, it was reprinted seventeen times in just six years, reaching a total of twenty-three editions in 1902. See George M. Hopkins, *Experimental Science: Elementary, Practical and Experimental Physics*, 23d ed. (New York: Munn, 1902).

107. Hopkins, *Experimental Science*, 81.

108. François Dagognet, *Etienne-Jules Marey: A Passion for the Trace*, trans. Robert Galeta and Jeanine Herman (New York: Zone, 1992), 12.

109. "The Cabaret Du Neant," *Scientific American* 74.10 (Mar. 7, 1896): 152. The illustration has been reprinted many times, appearing in both Albert Hopkins's and Barnouw's very different books on magic and special effects. But some of the novelty of the illusion may have been lost in these subsequent translations, for it was surely not lost on *Scientific American*'s readers that this rather old-fashioned effect seemed to mimic the visual transformations promised by the new X-ray photography. An article published just a few weeks earlier had announced that the "discovery of x ray photography by [Wilhelm] Roentgen will serve not only to immortalize the physicist who so fully developed it before giving it to the public, but it will render the year 1896 distinguished as the 'Roentgen photography year' " ("Roentgen or X Ray Photography," *Scientific American* 74.7 [Feb. 15, 1896]: 103).

110. Hopkins, *Magic*, 362–66.

111. *Scientific American* 55.5 (July 31, 1886): 69.

112. Fisher, *Wonder*, 21.

113. James Cameron, "Effects Scene: Technology and Magic," *Cinefex: The Journal of Cinematic Illusions* 51 (Aug. 1992): 5–7.

114. In a short essay on the history of computer-generated visual effects in Hollywood feature films, Robin Baker credits Cameron with being "almost single-handedly responsible for the resurgence of the computer-generated work at ILM" ("Computer Technology and Special Effects in Contemporary Cinema," in *Future Visions: New Technologies of the Screen*, ed. Philip Hayward and Tana Wollen (London: BFI Publishing, 1993), 39.

115. Cameron, "Effects Scene," 6.

116. Roland Marchand and Michael L. Smith point out that "the metaphor of the scientist as pioneer and explorer" had become so pervasive by the early twentieth century that it was readily adopted by industrial scientists and engineers" ("Corporate Science on Display," in *Scientific Authority and Twentieth-Century America*, ed. Ronald B. Walters (Baltimore and London: John Hopkins University Press, 1997), 149.

117. Cameron, "Effects Scene," 6.

118. Fisher, *Wonder*, 47.

119. Peter Britton, "The Wow Factor," *Popular Science* 243.5 (Nov. 1993): 87.

120. See Bill Sweetman, "The Next Jump Jet," *Popular Science* 243.5 (Nov. 1993): 60.

121. Barry Fox, "It's the Eye that Lies," *New Scientist* 104.1435–1436 (Dec. 20–27, 1984): 38–41.

122. Bob Swain, "Pixel Tricks Enrich Flicks," *New Scientist* 133.1841 (Oct. 3, 1992): 23.

123. See, for instance, Stafford's claim that "no one who has watched the comput-

er graphics and interactive techniques revolution can doubt that we are returning to an oral-visual culture" (*Artful Science*, xxi).

2. FROM CULT-CLASSICISM TO TECHNOFUTURISM

1. Gérard Genette, *The Aesthetic Relation*, trans. G. M. Goshgarian (Ithaca, N.Y., and London: Cornell University Press, 1999), 2.

2. Genette goes on to argue that if the subject is collective, as when an entire cultural group appreciates the same object the same way, this judgment is no less subjective for being collectively—socially—so (ibid., 97, 102).

3. *Computer Illusions* (dir. Alan Bloom, 1998).

4. Jean-Louis Comolli once made the claim that "as far as we know, it is not exactly within the logic of technology, nor within that of the economics of the film industry . . . to adopt (or impose) a new product which in an initial moment poses more problems than the old and hence incurs the expense of adaptation (modification of lighting systems, lenses, etc.) *without somewhere finding something to its advantage and profit*" ("Machines of the Visible," in *The Cinematic Apparatus*, ed. Stephen Heath and Teresa de Lauretis (London and Basingstoke: Macmillan, 1980), 131. While it is certainly the case that Hollywood was also attracted to 3-D because its effects could not be reproduced for television, Comolli's argument fails to recognize the higher risks that accrue to production decisions based on attempts to solicit audiences' attention with novel effects.

5. On the problems that 3-D films presented for exhibitors, see R. M. Hayes, *3-D Movies: A History and Filmography of Stereoscopic Cinema* (Jefferson, N.C., and London: McFarland, 1989), 54–55.

6. Philip Hayward and Tana Wollen, "Introduction: Surpassing the Real," in *Future Visions: New Technologies of the Screen*, ed. Philip Hayward and Tana Wollen (London: BFI Publishing, 1993), 1–9. Also see *Digital Image, Digital Cinema*, supp. issue of *Leonardo* (Oxford, U.K., and Elmsford, N.Y.: Pergamon, 1990).

7. Geoffrey Smith, *Photoshop 5 3D Textures: F/X and Design* (Scottsdale, Ariz.: Coriolis Group, 1999).

8. Genette, *The Aesthetic Relation*, 180.

9. See Lawrence French, "Toy Story Art Direction," *Cinefantastique* 27.2 (Nov. 1995): 33.

10. Henry Jenkins and Greg Dancer, " 'How Many Starfleet Officers Does It Take to Change a Lightbulb?' *Star Trek* at MIT," in *Science Fiction Audiences: Watching Doctor Who and Star Trek*, ed. John Tulloch and Henry Jenkins (London and New York: Routledge, 1995), 229.

11. See Henry Jenkins, " 'Infinite Diversity in Infinite Combinations': Genre and

Authorship in *Star Trek*," in *Science Fiction Audiences Audiences: Watching Doctor Who and Star Trek*, ed. John Tulloch and Henry Jenkins (London and New York: Routledge, 1995), 176; see also 179.

12. Wendell goes on to say, "That is one of the nice challenges—certainly with *Star Trek*, where I did the first two shots for the *Voyager* titles" (*Computer Illusions*).

13. Virilio's influence is, for instance, very much at work in the opening paragraph of Jonathan Crary's much-discussed book *Techniques of the Observer: On Vision and Modernity in the Nineteenth Century* (Cambridge, Mass.: MIT Press, 1992).

14. Among the SF magazine titles that began publication in the 1990s are *Sci-Fi Universe* (1994) and the British magazine *SFX* (1994).

15. Roger Silverstone, "Convergence Is a Dangerous Word," *Convergence: The Journal of Research Into New Media Technologies* 1.1 (spring 1995): 11.

16. In the early 1990s Roger Silverstone and Eric Hirsch argued that "studies of consumption have barely begun to examine the social and social-psychological dynamics of the appropriation and use of objects in general and information and communication technologies in particular" (Roger Silverstone and Eric Hirsch, introduction to *Consuming Technologies: Media and Information in Domestic Spaces*, ed. Roger Silverstone and Eric Hirsch [London and New York: Routledge, 1992], 2). Although this situation has changed somewhat since these comments were made—particularly with respect to research into Internet technologies—this line of research has by no means been exhausted.

17. Thomas Elsaesser, "Cinema Futures: Convergence, Divergence, Difference," in *Cinema Futures: Cain, Abel or Cable? The Screen Arts in the Digital Age*, ed. Thomas Elsaesser and Kay Hoffmann (Amsterdam: Amsterdam University Press, 1998), 12.

18. See Paul Virilio, *War and Cinema: The Logistics of Perception*, trans. Patrick Camiller (London and New York: Verso, 1989); and Virilio, *The Vision Machine*, trans. Julie Rose (Bloomington and Indianapolis: Indiana University Press; London: BFI Publishing, 1994).

19. Virilio, *War and Cinema*, 58.

20. Nora Lee, "Motion Control," *American Cinematographer* 64.5 (May 1983): 60. This reference is also cited in Christopher Finch, *Special Effects: Creating Movie Magic* (New York: Abbeville, 1984).

21. Virilio, *The Vision Machine*, 73.

22. W. J. T. Mitchell, "The Pictorial Turn," in *Picture Theory: Essays on Verbal and Visual Representation* (Chicago and London: University of Chicago Press, 1994), 16.

23. Arthur Kroker, *The Possessed Individual: Technology and Postmodernity* (London: Macmillan, 1992), 27.

24. Andrew Darley, "From Abstraction to Simulation: Notes on the History of Computer Imaging," in *Culture, Technology, and Creativity in the Late Twentieth Century*, ed. Philip Hayward (London, Paris, Rome: Libbey, 1992), 58. Also see Darley,

Visual Digital Culture: Surface Play and Spectacle in New Media Genres (London: Routledge, 2000).

25. Triple-I produced computer graphics sequences for *Futureworld* and *Looker*, while Digital Productions' visual effects credits include *Tron*, *The Last Starfighter*, and *2010* (dir. Peter Hyams, 1984). Digital Productions went out of business in 1986.

26. In 1998 the *Red Herring Magazine* published a list of some of the U.S. companies that made the transition from military, medical, and aerospace vendors to entertainment vendors in the 1990s. See Luc Hatlestad, "Go West Young Military Developer," *Red Herring Magazine* (Jan. 1998), http://hoh99.redherring.com/mag/issue50/west.html.

27. Kathleen O'Steen, "Arms Makers Lay Down Swords for Showbiz," *Variety*, Sept. 19–25, 1994, 15.

28. William Moritz, "Visual Music: Larry Cuba's Experimental Film," from *Mediagramm*, ZKM Karlsruhe (July 1996),
http://www.well.com/user/cuba/Mediagramm.html.

29. William Moritz, "A Brief Survey of Experimental Animation," *Absolut Panushka*, http://panushka.absolutvodka.com/panushka/history/bill/.

30. See Brian Aldiss, *Science Fiction Art* (London: New England Library, 1975), 45.

31. William Moritz, "In the Abstract," *Absolut Panushka*,
http://panushka.absolutvodka.com/panushka/history/storys/1970/abstract.

32. Computer animation by Alvy Ray Smith, Lance Williams, and Garland Stern, New York Institute of Technology, 1979.

33. E. H. Gombrich, *Art and Illusion: A Study in the Psychology of Pictorial Representation* (London: Phaidon; New York: Pantheon, 1960). Manovich's essay can no longer be accessed online. For a more contemporary account of his writing in this area, see his book *The Language of New Media* (Cambridge, Mass., and London: MIT Press, 2001).

34. Gombrich, *Art and Illusion*, 206.

35. See W. J. T. Mitchell, "Looking at Animals Looking: Art, Illusion, and Power," in *Picture Theory: Essays on Verbal and Visual Representation* (Chicago and London: University of Chicago Press, 1994), 329–44.

36. Gombrich, *Art and Illusion*, 360.

37. Mark Frank, "Frankly Speaking," *Photon* 24 (1974): 4.

38. There are twenty-seven issues in total. My own study of this rare publication has been limited to just eight issues: no. 18 (1969), no. 19 (1970), no. 20 (1971), no. 21 (1971), no. 22 (1972), no. 23 (1973), no. 24 (1974), no. 25 (1974), no. 27 (1977).

39. Ronald V. Borst, "The Vampire and the Cinema: Part I," *Photon* 18 (1969): 26–49; Borst, "The Vampire and the Cinema: Part II," *Photon* 19 (1970): 26–49; Borst, "Additions and Corrections to 'The Vampire and the Cinema,'" *Photon* 21 (1971): 25–44.

40. Frederick S. Clarke and Steve Rubin, "Making Forbidden Planet," *Cinefantastique* 8.2–3 (1979): 4–67.

41. See author's byline, Steve Rubin, "Retrospect: The Day the Earth Stood Still," *Cinefantastique* 4.4 (1976): 5.

42. Mark Frank, "Film Fans and Fandom," *Photon* 27 (1977): 3.

43. As estimated by Mark Frank, *Photon* 27 (1977): 4. All further citations refer to this page.

44. David MacDowall, "*2001*: A Critique," *Photon* 16 (1968); reprint, *Photon* 24 (1974): 36.

45. Bill Warren, "The Valley of Gwangi," *Photon* 18 (1969): 15.

46. Paul R. Mandell, "John Can Do Better," *Photon* 25 (1974): 35.

47. Mark Frank, "The Stop-Motion World of Jim Danforth," *Photon* 20 (1971): 12.

48. Ray Devitt, "Movie Magician," *if Magazine* 23 (May 2000): 40.

49. Frank, "The Stop-Motion World of Jim Danforth," 17.

50. Danforth, for instance, recalls that the remake of a film that he had worked on with fellow animator Dennis Muren was "quite different from the original version. . . . We all sort of . . . all of the fans banded together and worked on it in our spare time. It was a cooperative effort that had some crudeness to it but was a lot of fun" (ibid., 18).

51. One reader wrote in a letter to the magazine: "In a sense, I'm an animation fan. I know as much about the process as I can with nothing but amateur experience, and I've been a loyal viewer of animation movies since *Twenty Million Miles to the Earth* gave me a nightmare in the Philippines in 1958. But I find myself somewhat alienated by the whole gestalt and aura of ani-movies to date; not so much the movies, however, as the fringe-fans circulating around them. . . . Some of the exceptions are Dennis Muren, Tom Sherman, Philip Tippett and Dave Allen—all of whom have at least an inkling of what quality is" (Greg Bear, "Reverberations," *Photon* 21 [1971]: 45).

52. Walter Benjamin, "The Work of Art in the Age of Mechanical Reproduction," in *Illuminations*, trans. Harry Zorn, ed. Hannah Arendt (London: Pimlico, 1999), 233–34.

53. See Siegfried Kracauer, "Cult of Distraction: On Berlin's Picture Palaces" (1926), *New German Critique* 40 (winter 1987): 91–114.

54. Johatan Crary, *Suspensions of Perception: Attention, Spectacle, and Modern Culture* (Cambridge, Mass.: MIT Press, 1999), 48.

55. In fact, he had control over visual effects production for the first time on *The Beast from 20,000 Fathoms* (dir. Eugène Lourié, 1953).

56. Les Schwartz, "The Golden Voyage of Sinbad," *Photon* 25 (1974): 13

57. Warren, "The Valley of Gwangi," 16.

58. Susan Sontag, "The Imagination of Disaster," in *Hal in the Classroom: Science Fiction Films*, ed. Ralph J. Amelio (Dayton, Ohio: Pflaum, 1974), 22–38. This essay also

appears in Susan Sontag, *Against Interpretation, and Other Essays* (New York: Farrar, Strauss, Giroux, 1966).

59. Vivian Sobchack points out that it "is this group of films which causes purist critics the most trouble when they try to make abrupt distinctions between" horror and science fiction films (*The Limits of Infinity: The American Science Fiction Film, 1950–75* [South Brunswick, N.J., and New York: Barnes; London: Yoseloff, 1980], 30).

60. Warren, "The Valley of Gwangi," 17.

61. Frank, "The Stop-Motion World of Jim Danforth," 18.

62. Warren, "The Valley of Gwangi," 15.

63. Dave Allen, "Dramatic Principles in Stop-Motion," *Photon* 22 (1972): 28.

64. Devitt, "Movie Magician," 41.

65. See James Daly, ed., "Hollywood 2.0 Special Report: The People Who Are Reinventing Entertainment," *Wired* 5.11 (Nov. 1997): 200–215.

66. For more on the state of the special effects industry at the end of the 1990s, see Kris Goodfellow, "Mayday! Mayday! We're Leaking Visuals! A Shakeout of the Special Effects Houses," *New York Times*, Sept. 29, 1997, C5, C8.

67. See Michelle Quinn, "Beyond the Valley of the Morphs," *Wired* 1.1 (Mar.–Apr. 1993); Matt Rothman, "Digital Deal," *Wired* 1.3 (July–Aug. 1993); Paula Parisi, "Cameron Angle," *Wired* 4.4 (Apr. 1996); Kevin Kelly and Paula Parisi, "Beyond *Star Wars*," *Wired* 5.2 (Feb. 1997); Paula Parisi, "The New Hollywood Silicon Stars," *Wired* 3.12 (Dec. 1995); Burr Snider, "The *Toy Story* Story," *Wired* 3.12 (Dec. 1995).

68. For an overview of some of this criticism see Jon Katz, "Teenage Mutant Power Rangers, Part 1," *Hotwired*, Netizen (May 20, 1996),
http://www.netizen.com/netizen/96/20/katz5a.html.

69. See Paulina Borsook, "The Memoirs of a Token: An Aging Berkeley Feminist Examines *Wired*," in *Wired_Women: Gender and New Realities in Cyberspace*, ed. Lynn Cherney and Elizabeth Reba Weise (Seattle: Seal, 1996), 24–41. In the letters pages of *Wired*'s second issue Peris Morehouse wrote: "One thing really perplexes me . . . where are the women? I'm wondering if we're invited to this 'new society' and in what capacity(s)? The content of your premier issue seems less futurist than typically 'modern'—20th century, rooted in the industrial-military-sexual-male-complex" ("Rants and Raves," *Wired* 1.2 [May–June 1993]: 17). These criticisms were to reverberate throughout the letters pages of many more issues.

70. This review was originally part of a special issue of *Educom Review* that asked writers to respond to the question: "Do We Really Want To Be *Wired*?" *Educom Review* 30.3 (May–June 1995). See Mark Dery, "Wired Unplugged," *Escape Velocity*, http://www.to.or.at/dery/wired/htm.

71. See Mark Dery, *Escape Velocity: Cyberculture at the End of the Century* (London: Hodder and Stoughton, 1996). It is Scott Bukatman, of course, who coined the term

"cyberdrool," in *Terminal Identity: The Virtual Subject in Postmodern Science Fiction* (Durham, N.C., and London: Duke University Press, 1993), 189.

72. Dery, *Escape Velocity*, 15.

73. Dery, "Wired Unplugged," par. 11.

74. For an interview with Carson focusing on *Ray Gun*'s critical reception, see Tom Eslinger and Brian Smith, "American Typo," *World Art* 1 (1995): 72–77.

75. Dery, "Wired Unplugged," par. 2.

76. Keith White, "The Killer App: *Wired* Magazine, Voice of the Corporate Revolution," http://www.base.com/gordoni/thoughts/wired/revolution.html.

77. See Leo Marx, "The Idea of 'Technology' and Postmodern Pessimism," in *Does Technology Drive History? The Dilemma of Technological Determinism*, ed. Merritt Roe Smith and Leo Marx (Cambridge, Mass.: MIT Press, 1994), 238–39.

78. White, "The Killer App," par. 8.

79. Stone describes "this technosocial context—Northern California during the first wave of personal computers" as "a milieu dense and diverse, wild and woolly, a bit crazed in places, and shot through with elements of spirituality and cultural messianism" (*The War of Desire and Technology at the Close of the Mechanical Age* (Cambridge, Mass., and London: MIT Press), 108.

80. See Dery, "Turn On, Boot Up, Jack In: Cyberdelia," in *Escape Velocity*, 49.

81. McKenzie Wark, "Cyberhype," *World Art*, inaugural U.S. ed. (1994), 67.

82. Wark himself has entered the new media arena with his own CD-ROM, *Suck on This: Planet of Noise* (1998), a work that, rather curiously, reproduces the media logic of fragmentation in its very criticism of it.

83. Wark, "Cyberhype," 69.

84. See Gene Youngblood, *Expanded Cinema*, intro. R. Buckminster Fuller (New York: Dutton, 1970); and Douglas Davis, *Art and the Future: A History/Prophecy of the Collaboration Between Science, Technology and Art* (London: Thames and Hudson, 1973).

85. As examples of its domestication and mass production, Davis adds: "Bell Telephone is marketing a low-cost, pocket-sized infrared laser; a firm called Sonovision is marketing for the home an audio-responsive device that converts sound into complex, moving laser patterns on the wall" (*Art and the Future*, 173).

86. Davis draws on Benjamin's and Herbert Read's very different critiques of the cult reception of artworks. Referring to Read's *Art and Industry* (1934) Davis writes: "As for the sacred values assigned uniqueness, 'an esthetically unworthy impulse typical of a bygone individualistic phase of creation,' he insists that it be dismissed. On this ground, Read and Benjamin stand together" (ibid., 176).

87. Daniel Pinchbeck, "State of the Art," *Wired* 2.12 (Dec. 1994), 158.

88. Hayward and Wollen, *Future Visions*, 3.

89. Parisi, "The New Hollywood Silicon Stars," 144.

90. In addition to the essays referred to earlier in this chapter, see Andrew Darley, "Second-Order Realism and Post-Modern Aesthetics in Computer Animation," 39–64, and Lev Manovich, " 'Reality' Effects in Computer Animation," 5–15, in *A Reader in Animation Studies*, ed. Jayne Pilling (London, Paris, Rome: Libbey, 1997).

91. In *Digital Mantras*, Holtzman wrote, for instance, that "we cannot conceive yet of the virtual worlds that are idiomatic to computers. We do no know yet what these worlds will be. The technology for creating virtual realities is in its infancy, and the virtual realities created so far have drawn on models derived from our current understanding of reality" (*Digital Mantras: The Languages of Abstract and Virtual Worlds* (Cambridge, Mass., and London: MIT Press, 1994), 250.

92. See Steve Holtzman, *Digital Mosaics: The Aesthetics of Cyberspace* (New York: Simon and Schuster, 1997), 15.

93. See Jay David Bolter and Richard Grusin, *Remediation: Understanding New Media* (Cambridge, Mass., and London: MIT Press, 1999), 49–50.

94. See Steve Holtzman, "What Is Digital Art, Really?" *Wired* 2.8 (Aug. 1994): 84. The sculpture, entitled *Fractal Fish*, is the work of J. Michael James.

95. Quoted in Paula Parisi, "Shot by an Outlaw," *Wired* 4.9 (Sept. 1996): 204. A video signal is comprised of luminance (brightness), chrominance (color—including saturation and hue), and sync (alignment). While all colored signals have both luminance and chrominance, black and white signals lack chrominance.

96. See the essays on morphing in Vivian Sobchack, ed., *Meta-Morphing: Visual Transformation and the Culture of Quick-Change* (Minneapolis and London: University of Minnesota Press, 2000).

97. Robert Rossney, "Metaworlds," *Wired* 4.6 (June 1996): 140–46.

98. "Absolut Warhol," *Wired* 2.10 (Oct. 1994).

99. See "Absolut Speer," *Wired* 3.5 (May 1995) and 4.2 (Feb. 1996); and "Absolut Kelly," *Wired* 4.7 (July 1996) and 4.8 (Aug. 1996).

100. *Wired* 3.1 (Jan. 1995): 61.

101. See Parisi, "The New Hollywood Silicon Stars," and "Shot by an Outlaw."

102. "Shot by an Outlaw," 140.

103. An article examining this development cites the observations of tertiary teachers of new media: "According to Kathy Cleland, new media curator and lecturer: 'There is a huge student demand for courses at tertiary institutions which have anything to do with multimedia and this is increasing exponentially' " (Josephine Starrs and Leon Cmielewski, "Teaching New Media: Aiming at a Moving Target," *Real/Time* 38 [Aug.–Sept. 2000]: 8).

104. Allen, "Dramatic Principles in Stop-Motion," 25.

105. Jacques Clayssen, "Digital (R)evolution," in *Photography After Photography:*

Memory and Representation in the Digital Age, ed. Herbert v. Amelunxen, Stefan Igl-haut, and Florian Rotzer (Amsterdam: G+G Arts, 1996), 75.

3. THE WONDER YEARS AND BEYOND

1. *Starlog* was also celebrating twenty years of publication that year. Although it was not the first SF fan magazine, it was the first to be sold in the huge Waldenbooks chain of bookstores.

2. *Cinefex: The Journal of Cinematic Illusions* 65 (Mar. 1996).

3. This citation from Harry Knowles originally appeared in a post to rec.arts.sf.starwars.info. It later appeared on the World Wide Web.

4. See Don Shay, "Thirty Minutes with the Godfather of Digital Cinema," *Cinefex: The Journal of Cinematic Illusions* 65 (Mar. 1996): 66.

5. David J. Hargrove, "Special Effects: Anything Can Happen (But Should It?)," *Sci-Fi Universe* 3.5 (Feb. 1997): 63.

6. Mark A. Altman, editorial, *Sci-Fi Universe* 3.1 (Sept. 1996): 6.

7. His response to Lucas's claim that he had to wait until the technology had improved to remake the film the way he had always imagined it was to ask: "Why not harness that vision to create new worlds instead of repainting old ones?" And if Lucas's real objective was to try to sustain interest in the *Stars Wars* saga until the first install-ment of the second trilogy got under way, then why not give younger filmmakers the chance to make a series of spin-off films or "have them shoot an anthology film which could take place in the *Star Wars* universe without being part of the larger saga?" (Mark A. Altman, "*Star Wars* Fever" (editorial), *Sci-Fi Universe* 1.5 [Feb.–Mar. 1995]: 7).

8. Scott Renshaw, "*Star Wars: A New Hope* (Special Edition): A Film Review." Originally posted to rec.arts.movies.reviews, rec.arts.sf.reviews, rec.arts.movies.current-films, copyright 1997.

9. I am indebted to Daren Tofts's essay on Australian artist Troy Innocent for directing me to Mandelbrot. Describing the computer-generated imagery in Inno-cent's work, Tofts writes: "The overwhelming sensation is of 'plastic beauty' (to use a phrase of Mandelbrot's), since we never for a moment doubt their artificiality" ("Troy Story," *World Art* 12 [1997]: 31).

10. Cited in Mark Cotta Vaz and Patricia Rose Duignan, *Industrial Light and Magic: Into the Digital Realm* (New York: Ballantine, Del Rey, 1996), 292.

11. See Brooks Landon, *The Aesthetics of Ambivalence: Re-thinking Science Fiction Film in the Age of Electronic (Re)production* (Westport, Conn., and London: Green-wood, 1992), 66.

12. See Mark Wolf, "Stop Frame: The History and Technique of Fantasy Film Animation," *Cinefantastique* 1.2 (winter 1971): 6–21. Also see Wolf, "Sinbad and the Eye of the Tiger: The Special Visual Effects," *Cinefantastique* 6.2 (1977): 40–46.

13. Kerry O'Quinn, "From the Bridge" (editorial), *Starlog* 228 (July 1996): 10.

14. Originally published by the Sendai Media Group.

15. Kerry O'Quinn, "From the Bridge" (editorial), *Starlog* 214 (May 1995): 24.

16. Mark A. Altman, "Cybertainment" (editorial), *Sci-Fi Universe* 1.6 (Apr. 1995): 7.

17. Altman was cowriter, with Robert Myer Burnett, of *Free Enterprise* (dir. Robert Myer Burnett, 1999).

18. Clarke committed suicide in October 2000. In their remembrance of him, the staff of *Cinefantastique* wrote: "Fred Clarke made it easy. He was never afraid to take a chance, and encouraged those who worked for him to do so as well. If you got him started talking about a particular film or a certain director, the conversation—always sharp, always insightful—could last for hours. Most importantly, if you approached the art of genre film as he did—regarding it as a medium worthy of intelligent exploration and thoughtful critique—he would stick by your efforts with a tenacity and trust rare in any industry. Fred built *Cinefantastique* upon the simplest of precepts: treat the fans of science fiction, horror, and fantasy filmmaking with the respect that any thinking person would demand" (*Cinefantastique* 32.6 [Feb. 2001]: 3).

19. Reprinted as David Macdowall, "*2001*: A Critique," *Photon* 24 (1974): 25–36.

20. On the development of a free online version of the *New York Times*, see Scott Kirsner, "All the News That's Fit to Pixel," *Wired* 8.2 (Feb. 2000): 126–42.

21. Carol Troy, "Homebrew Special Effects à la 'Star Wars,' " *New York Times on the Web*, Mar. 20, 1997, archived at http://www.nytimes.com.

22. See, for instance, Stacy Lu, " 'Star Wars' Are Force on the Web," Taking in the Sites, *New York Times on the Web*, Jan. 27, 1997, archived at http://www.nytimes.com.

23. Brooks Landon looks at the legacy of this film, as well as H. R. Giger's alien designs, in "Sliming Technology," *Cinefantastique* 18.4 (May 1988): 27–28.

24. Jean-Louis Comolli, "Machines of the Visible," in *The Cinematic Apparatus*, ed. Stephen Heath and Teresa de Lauretis (London and Basingstoke: Macmillan, 1980), 139. Comolli's proposal for a materialist theory of the cinema called for identification of the multiple determinations—economic and ideological as much as technological—that govern the development and implementation of new filmmaking techniques. His own accounts of the reasons for early filmmakers' use of deep focus or for the rapid acceptance of panchromatic film stock in the 1920s stress the extent to which these decisions conformed to more widely disseminated codes of analogy and realism. While it may have been Comolli's intention to show that the history of cinema has to be grasped in terms of its multiple articulations of signifying systems (that are not necessarily cinematic), his claim that successive advances in technique reveal a patient accumulation of "realistic supplements which all aim at reproducing—in

strengthening, diversifying, rendering more subtle—the impression of reality" had the effect of making that history appear much less multivalent, much more one-dimensional, than he had intended (133).

25. See Christian Metz's discussion of Mannoni's work in *The Imaginary Signifier: Psychoanalysis and the Cinema*, trans. Celia Britton, Annwyl Williams, Ben Brewster, and Alfred Guzzetti (Bloomington: Indiana University Press, 1982), 69–78.

26. Christian Metz, "*Trucage* and the Film," trans. Françoise Meltzer, *Critical Inquiry* 3 (summer 1977): 657–75.

27. In a review of *Titanic* published in an online visual effects magazine published by Todd Vaziri (1994–1998), Vaziri praised the underwater filming of the wrecked ship in the opening sequence. "The big challenge for this sequence," he noted, "was to cut between the real-life Titanic shots and miniature shots without the audience ever realizing, and the filmmakers succeeded. While the miniature shots shot by [visual effects studio] Digital Domain have slightly smoother camera moves than the real footage, the two sets are nearly indistinguishable" ("*Titanic* FX Review," *Visual Effects Headquarters Archive*, www.vfxhq.com).

28. See Albert J. La Valley, "Traditions of Trickery: The Role of Special Effects in the Science Fiction Film," in *Shadows of the Magic Lamp: Fantasy and Science Fiction in Film*, ed. George S. Slusser and Eric S. Rabkin (Carbondale and Edwardsville: Southern Illinois University Press, 1985), 144.

29. Frederick S. Clarke and Steve Rubin, "Making Forbidden Planet," *Cinefantastique* 8.2–3 (1979): 6.

30. Expenses considered above the line by Hollywood studios included the cost of stars, directors, producers, and writers, personnel typically used to advertise a film above its title. Production costs, including a film's special effects, were typically billed below the title or not all (ibid., 62).

31. La Valley, "Traditions of Trickery," 157.

32. See Joanna Russ, "SF and Technology as Mystification," *Science-Fiction Studies* 5, pt. 3 (Nov. 1978), 252.

33. Constance Penley, *NASA/TREK: Popular Science and Sex in America* (London and New York: Verso, 1997), 9.

34. Kerry O'Quinn, *Future* 23 (Dec. 1980): 4.

35. See Kerry O'Quinn, "The Future Life Philosophy: Part I, 'The Overall Theme,'" *Future* 26 (May 1981): 4; "The Future Life Philosophy: Part II, 'Free Enterprise,'" *Future* 27 (June–July 1981): 4; "The Future Life Philosophy: Part III, 'Individual Liberty,'" 28 (Aug. 1981): 4; "The Future Life Philosophy: Part IV, 'Scientific Progress,'" *Future* 29 (Sept. 1981): 4.

36. O' Quinn, "The Future Life Philosophy: Part III: 'Individual Liberty', 4.

37. Harlan Ellison, "An Edge in My Voice," *Future* 23 (Dec. 1980): 64.

38. Ursula K. Le Guin, "Noise and Meaning in SF Films," *Future* 4 (Aug. 1978): 74.

39. Barbara Krasnoff, "From Housewife to Heroine: Women in SF Media," *Future* 26 (May 1981): 52–55.

40. Mark A. Altman, editorial, *Sci-Fi Universe* 3.3 (Dec. 1996): 6.

41. A *Sci-Fi Universe* feature listing "Fifty Reasons Why We Hate *Return of the Jedi* (and love *Star Wars*...)" begins, for example, with "Ewoks, Ewoks, Ewoks" ("the single clearest example of Lucas's willingness to compromise the integrity of his Trilogy in favor of merchandising dollars"). Also high on the list are the complaints that "The Look is all Wrong" and the film suffers from a "Painful Lack of Innovation" ("When it comes to scavenging, Lucas could teach even the Jawas a thing or two. *Jedi* borrows from *Wars* on levels ranging from conceptual to minute") (Dan Vebber and Dana Gould, "Fifty Reasons Why *Jedi* Sucks," *Sci-Fi Universe* 3.5 [Feb. 1997]: 20–22).

42. The importance of maintaining this legacy also appears in a richly illustrated, folio-sized coffee-table tribute to Industrial Light and Magic. In this book a profile of "The Effects Supervisor" reads: "Most of ILM's supervisors (and many effects artists in general) got their first taste of the magic of effects watching films featuring the work of such stop-motion wizards as Willis O'Brien and Ray Harryhausen" (Vaz and Duignan, *Industrial Light and Magic*, 122).

43. See Don Shay, "Dennis Muren: Playing It Unsafe," *Cinefex: The Journal of Cinematic Illusions* 65 (Mar. 1996): 100–111.

44. See, in particular, Tom Gunning, "The Cinema of Attractions: Early Film, Its Spectator, and the Avant-Garde," in *Early Cinema: Space, Frame, Narrative*, ed. Thomas Elsaesser and Adam Barker (London: BFI Publishing, 1990), 56–62; and Gunning, "An Aesthetic of Astonishment: Early Film and the (In)Credulous Spectator," in *Viewing Positions: Ways of Seeing Film*, ed. Linda Williams (New Brunswick, N.J.: Rutgers University Press, 1994), 114–33. Also see Angela Ndalianis, "Special Effects, Morphing Magic, and the Nineties' Cinema of Attractions," in *Meta-Morphing: Visual Transformations and the Culture of Quick Change*, ed. Vivian Sobchack (Minneapolis: Minnesota University Press, 2000), 251–71; Jay David Bolter and Richard Grusin, "Film," in *Remediation: Understanding New Media* (Cambridge, Mass., and London: MIT Press, 1999), 146–58; and Andrew Darley, "Genealogy and Tradition: Mechanised Spectacle as Popular Entertainment" and "New Spectacle Cinema and Music Video," in *Visual Digital Culture: Surface Play and Spectacle in New Media Genres* (London: Routledge, 2000), 37–57, 102–23.

45. Gunning, "The Cinema of Attractions," 63. For an analysis of the relationship between what Burch calls the "Primitive Mode of Representation" and the "Institutional Mode of Representation," see Noël Burch, "Primitivism and the Avant-Gardes: A Dialectical Approach," in *Narrative, Apparatus, Ideology: A Film Theory Reader*, ed. Philip Rosen (New York: Columbia University Press, 1986), 483–506; and Burch, "Porter; or, Ambivalence," trans. Tom Milne, *Screen* 19.4 (winter 1978–79): 91–105.

46. For a more detailed overview of early film scholarship dealing with these issues,

see Thomas Elsaesser, "General Introduction—Early Cinema: From Linear History to Mass Media Archaeology," and the introduction to the section on film form, in *Early Cinema: Space, Frame, Narrative*, eds. Thomas Elsaesser with Adam Barker (London: BFI Publishing, 1990), 1–7 and 11–27.

47. See, in particular, Miriam Hansen, "Early Cinema, Late Cinema: Transformations of the Public Sphere," in *Viewing Positions: Ways of Seeing Film*, ed. Linda Williams (New Brunswick, N.J.: Rutgers University Press, 1994), pp 134–52; Charles Musser, *Before the Nickelodeon: Edwin S. Porter and the Edison Manufacturing Company* (Berkeley, Los Angeles, London: University of California Press, 1991); and the essays on early cinema in *Cinema: The Beginnings and the Future. Essays Marking the Centenary of the First Film Show Projected to a Paying Audience*, ed. Christopher Williams (London: University of Westminster Press, 1996).

48. See André Gaudreault, "Theatricality, Narrativity, and 'Trickality': Reevaluating the Cinema of Georges Méliès," *Journal of Popular Film and Television* 15.3 (fall 1987): 111.

49. Gunning, "The Cinema of Attractions," 67.

50. Vivian Sobchack, "Postfuturism," in *Screening Space: The American Science Fiction Film* (New York: Ungar, 1987). With the exception of the final chapter, this book was originally published as *The Limits of Infinity: The American Science Fiction Film, 1950–75* (South Brunswick, N.J., and New York: Barnes; London: Yoseloff, 1980).

51. Vivian Sobchack, introduction to *Meta-Morphing: Visual Transformation and the Culture of Quick-Change*, ed. Vivian Sobchack (Minneapolis and London: University of Minnesota Press, 2000), xiv.

52. For an examination of some of the ways film and video games borrow from each other, see Angela Ndalianis, " 'The Rules of the Game'—Evil Dead II . . . Meet Thy Doom," in *Hop on Pop: The Politics and Pleasures of Popular Culture*, ed. Henry Jenkins, Tara McPherson, and Jane Shattuc (Durham, N.C.: Duke University Press, forthcoming). Also see Mark J. P. Wolf, "Inventing Space: Toward a Taxonomy of On- and Off-Screen Space in Video Games," *Film Quarterly* 51.1 (fall 1997): 11–23.

53. For a broader historical overview of this development, see John Belton, *Widescreen Cinema* (Cambridge: Harvard University Press, 1992); and Janet Wasko, *Hollywood in the Information Age: Beyond the Silver Screen* (Cambridge and Oxford: Polity, 1994).

54. John Thornton Caldwell, *Televisuality: Style, Crisis, and Authority in American Television* (New Brunswick, N.J.: Rutgers University Press, 1995).

55. Altman wrote: "The day after the *Voyager* premiere, editorial director Chris Gore bounded into my office to share his feelings about the new *Star Trek* pilot. While we both agreed that it was a terrific *Trek* kick-off, I told him that I felt it was even better on the big screen, having seen it a week earlier at its world premiere in a Paramount screening room. The sound, the visuals, the communal experience of sharing a new

Trek premiere on the big screen made for a delightful evening" ("Screen Test" [editorial], *Sci-Fi Universe* 1.7 [June 1995]: 7).

56. "Behind the Scenes of the Latest Spielberg Blockbuster . . . Sort of," *Sci-Fi Universe* 3.8 (July 1997): 32.

57. See Ron Magid, "Virtual Realities," *American Cinematographer* 80.9 (Sept. 1999): 88. The sequence that Muren refers to is the underwater sequence in which Qui-Gon Jinn (Liam Neeson), Obi-Wan Kenobi (Ewan McGregor), and Jar Jar Binks encounter a series of alien sea creatures.

58. See Scott Bukatman's examination of *Blade Runner* in *Terminal Identity: The Virtual Subject in Postmodern Science Fiction* (Durham, N.C., and London: Duke University Press, 1993), 130–37.

59. Scott Bukatman, "The Artificial Infinite: On Special Effects and the Sublime," in *Visual Display: Culture Beyond Appearances*, ed. Lynne Cooke and Peter Wollen (Seattle: Bay, 1995), 254–89. Douglas Trumball acted as visual effects supervisor on all the films that Bukatman refers to.

60. The decision to describe certain types of computer-generated images as digital artifacts is not one I made without reservations. The potential for confusion over this term arises from the fact that within the special effects industry itself the term "digital artifact" refers to an extraneous digital object that has been marked for removal in the postproduction process. I nevertheless use it here because it draws attention to the display of the CGI effect as an aesthetic object.

61. Sobchack, *Screening Space*, 261.

62. In a discussion about the early cinema of attractions, Miriam Hansen argues that "the display of diversity also means that the viewer is solicited in a more direct manner—as a member of an anticipated social audience and a public, rather than an invisible, private consumer" (*Babel and Babylon: Spectatorship in American Silent Film* [Cambridge and London: Harvard University Press, 1991], 34). Scholarship on early cinema has prompted an ongoing reevaluation of the ways in which all cinema—and not just the cinema of attractions—solicits a spectator who is both a private consumer and a member of one or more social audiences. In "What is Cinema: The Sensuous, the Abstract and the Political," Sylvia Harvey suggests that "it would be absurd, of course, to suggest cinema was in some way more impactful than television, but reasonable to note that the 'big picture' has a cultural force and resonance connected to its mode of exhibition and even to its scarcity. Moreover, any attempt at delineating the qualities of cinema must begin with this mode of exhibition, noting that its promise is a paradoxical one: offering since its earliest days a social space which fosters the most intensely private experience" (in *Cinema: The Beginnings and the Future. Essays Marking the Centenary of the First Film Show Projected to a Paying Audience*, ed. Christopher Williams [London: University of Westminster Press, 1996], 241).

63. See Dennis K. Fischer, "The Last Starfighter," *Cinefantastique* 15.1 (Jan. 1985): 29.

64. See Michelle Quinn, "Beyond the Valley of the Morphs," *Wired* 1.1 (Mar.–Apr. 1993).

65. A "roundtable discussion about why today's science fiction movies are so damned lame" appeared in the May 1997 issue of *Sci-Fi Universe*. When asked to compare *Star Wars* with *Independence Day*, screenwriter Alan Bennert responded: "*Star Wars* is not what I'd call sophisticated SF, but in contrast to the movies that are being done these days, it was set in a completely invented universe. [Sure], George Lucas created a future cobbled together out of bits and pieces of Jack Kirby and 'Doc' Smith, but at least he did it with honesty and intelligence. Jim Cameron did the same in *Aliens*. Both films are set in richly imagined future worlds and that's something that just seems to be lacking these days in movies" (Eric Wallace, "The Script's the Thing," *Sci-Fi Universe* 3.7 [May 1997]: 24).

66. Thomas Doherty summed up the situation when he wrote: "From *Waterworld* to *Strange Days*, theatrical SF is so determinedly downbeat in tone that the field for another vision of the future—like, maybe there *is* one—is pretty much left up to *Star Trek*" (Thomas Doherty, "*Star Trek* the Franchise: Thirty Years in Space," *Cinefantastique* 27.4–5 [Jan. 1996]: 66).

67. Fredric Jameson, "Progress Versus Utopia; or, Can We Imagine the Future?" *Science-Fiction Studies* 9.27 (1982): 151.

68. Mark Dery and Claudia Springer have pointed out that these futures have invariably reproduced phallocentric fantasies about technology and gender. See Mark Dery, *Escape Velocity: Cyberculture at the End of the Century* (London: Hodder and Stoughton, 1996), 264–65; and Claudia Springer, "Virtual Sex," in *Electronic Eros: Bodies and Desire in the Postindustrial Age* (Austin: University of Texas Press, 1996), 94. While these readings are entirely apposite—and even necessary—it has been my contention here that they still haven't quite registered the ways in which visual effects images *mean* for science fiction fans.

69. For a detailed reading of this film, which also looks at the circumstances and implications of its production in Australia, see Tom O'Regan and Rama Venkatasawmy, "Only One Day at the Beach: *Dark City* and Australian Film-making," *Metro* 117 (1998): 17–28.

70. Mark Dery, "Back to the Future," *Nettime* (Sept. 5, 1999), http//:www.nettime.org/nettime.w3archive/199909/msg00042.html.

71. Paul Boutin, "Baby Blue," *Wired* 6.12 (Dec. 1998): 227.

72. Dery, "Back to the Future," pars. 1–2.

73. See Roland Marchand and Michael L. Smith, "Corporate Science on Display," in *Scientific Authority and Twentieth-Century America*, ed. Ronald B. Walters (Baltimore and London: John Hopkins University Press, 1997), 174.

74. Dery, "Back to the Future," par. 6.

75. Judd Hollander and Sue Feinberg, "Men in Black," *Cinefantastique* 29.1 (July 1997): 17.

76. Don Shay, "Dick Smith—Fifty Years in Makeup," *Cinefex: The Journal of Cinematic Illusions* 62 (June 1995): 79–135.

77. Douglas Eby, "MIB The Aliens: Rubber vs. CGI," *Cinefantastique* 29.1 (July 1997): 23–25.

78. Frederick C. Szebin and Steve Biodrowski, "*Mars Attacks*: Tim Burton Sends Up the Bubblegum Alien Invasion Genre," *Cinefantastique* 28.7 (Jan. 1997): 16. See also Chuck Wagner, "Martian Inspiration," *Cinefantastique* 28.7 (Jan. 1996): 19, 61.

4. CRAFTING A FUTURE FOR CGI

1. Istvan Csicsery-Ronay Jr., "The SF of Theory: Baudrillard and Haraway," *Science-Fiction Studies* 18 (1991): 387–403.

2. Ibid., 389*n*3. These comments appear in a footnote appended to Csicsery-Ronay's observation that "both Baudrillard and Haraway have explicitly associated their theoretical work with SF. Both have drawn central concepts from the thesaurus of SF imagery" (ibid., 389).

3. Ron Magid, "Effects Jedi," *American Cinematographer* 80.9 (Sept. 1999): 78.

4. Csicsery-Ronay, "The SF of Theory," 392.

5. Jean Baudrillard, *America*, trans. Chris Turner (London and New York: Verso, 1988); Gilles Deleuze and Félix Guattari, *A Thousand Plateaus: Capitalism and Schizophrenia*, trans. and fwd. Brian Massumi (Minneapolis and London: University of Minnesota Press, 1996).

6. See Martin Heidegger, "The Question Concerning Technology," in *Basic Writings*, ed. David Farrell Krell (San Francisco: HarperCollins, 1993), 307–42. Michael Heim's reading of Heidegger's contribution to a philosophical understanding of technology has also been a stimulus for my thoughts in this area. See his *Electric Language: A Philosophical Study of Word Processing* (New Haven and London: Yale University Press, 1987), esp. ch. 3, "The Finite Framework of Language," 70–94.

7. See Peter Dormer, "Craft and the Turing Test for Practical Thinking," in *The Culture of Craft: Status and Future*, ed. Peter Dormer (Manchester and New York: Manchester University Press, 1997), 138.

8. Sue Rowley makes this point in her introduction to a collection of essays that specifically address the difficulties of theorizing craft in relation to new technologies. See *Craft and Contemporary Theory*, ed. Sue Rowley (St. Leonards, N.S.W.: Allen and Unwin, 1997), xxiii.

9. Sean Cubitt reminds critics that "the purpose of inquiry into the digital arts is

not to affirm what is, but to promote the becoming of what is not-yet, the grounds of the future as they exist in the present" (*Digital Aesthetics* (London, Thousand Oaks, New Delhi: Sage, 1998), x.

10. See Rex Weiner, "Digital (R)evolution Hits the Cutting Edge of Film," *Variety*, June 27–July 3, 1994), 11, 26.

11. Rolf describes the early days of working with Lightworks' digital editing system as being a period in which he missed "having the film in my hands, around my neck, in my mouth" (ibid., 26).

12. See Carl Mitcham's chapter comparing various frameworks for a philosophical analysis of technology in *Thinking Through Technology: The Path Between Engineering and Philosophy* (Chicago and London: University of Chicago Press, 1994). In this chapter Mitcham cites Soetsu Yanagi's claim that "no machine can compare with a man's hands. Machinery gives speed, power, complete uniformity, and precision, but it cannot give creativity, adaptability, freedom, heterogeneity. These the machine is incapable of, hence the superiority of the hand, which no amount of rationalization can negate" (179).

13. This view is expressed, for instance, by Steven Goldsmith, an executive at Avid Technology in Burbank. See Weiner, "Digital (R)evolution," 26.

14. Steven J. Cohen, A.C.E. (editor), cited in Thomas A. Ohanian and Michael E. Phillips, *Digital Filmmaking: The Changing Art and Craft of Making Motion Pictures* (Boston, Oxford, Johannesburg, Melbourne, New Delhi, Singapore: Focal, 1996), 177. This book has of course been conceived and designed for the express purpose of demonstrating the advantages of digital, nonlinear systems over mechanical systems, which means that while opposing viewpoints have not been canvassed, it cannot be assumed they don't exist.

15. "System opacity" is a term that Heim borrows from an unpublished paper by John Seely-Brown; see *Electric Language*, 131.

16. Or, as Heim has so perceptively put it, "revision in the sense of reconsidering and recasting thought in a separate step is unnecessary on the computer" (*Electric Language*, 153).

17. Anne Goursaud, A.C.E. (film director and editor) puts it this way: "Part of an editor's pride is not to have a million splices passing by when you screen the film (it is like showing your dirty laundry!). But with digital, no one is ever going to know how hard you tried, what you had to do to get there" (Ohanian and Phillips, *Digital Film-making*, 177).

18. See, for instance, Vivian Sobchack, "The Scene of the Screen: Envisioning Cinematic and Electronic Presence," in *Materialities of Communication*, ed. Hans Ulrich Gumbrecht and K. Ludwig Pfeiffer (Stanford, Calif.: Stanford University Press, 1994), 83–106.

19. As Heim points out, through his reading of Heidegger, "the temporal mood

of total control and simultaneity is characteristic of the Enframing" (*Electric Language*, 85).

20. See Ray Edgar's discussion of Cooper's work in "MicroFilm," *World Art* 18 (1998): 24–29, 84.

21. Arthur Kroker and Marilouise Kroker, "*Johnny Mnemonic:* The Day Cyberpunk Died," *CTHEORY*, http://www.ctheory.com/event/e017.html.

22. William Gibson, *Neuromancer*, 8th ed. (London: HarperCollins, 1993), 67.

23. Philip Hayward, "Situating Cyberspace: The Popularisation of Virtual Reality," in *Future Visions: New Technologies of the Screen*, ed. Philip Hayward and Tana Wollen (London: BFI Publishing, 1993), 180–204.

24. Kroker and Kroker, "*Johnny Mnemonic*," par. 3.

25. See David E. Williams, "Worlds at War," *American Cinematographer* 77.7 (July 1996): 32.

26. Quoted in Bruce Newman, "Computers Now, Apocalypse Coming Right Up," first published in *New York Times*, June 30, 1996, Ufomind Bookstore, http://www.ufomind.com/area51/events/highway_bill/id4/articles/nyt_960630html.

27. Special effects supervisor Doug Smith commented that CGI had been used in *ID4* "for anything that we needed mass quantities of" (quoted in Mike Lyons, "*ID4* Visual Effects: Supervisors Dough Smith and Volker Engel on Fashioning Alien Armageddon," *Cinefantastique* 27.11–12 [July 1996]: 14–15).

28. This is also to play on Tom Gunning's theorization of the temporality of the cinema of attractions. The attraction or, in this instance, the special effect "can appear or disappear and generally needs to do both. While present on the screen, it may in fact change, but insofar as these changes begin to entail further development, we move out of the structure of attractions and into narrative configuration" (" 'Now You See It, Now You Don't': The Temporality of the Cinema of Attractions," in *Viewing Positions: Ways of Seeing Film*, ed. Linda Williams [New Brunswick, N.J.: Rutgers University Press, 1994], 80).

29. As estimated by Volker Engel, visual effects supervisor on *Godzilla*; see Chuck Wagner, "Godzilla Returns," *Cinefantastique* 30.2 (June 1998): 10–12.

30. With characteristic probity, Lev Manovich argues that "the numbers which characterize digital realism simultaneously reflect something else: the cost involved. More bandwidth, higher resolution and faster processing result in a stronger reality effect—and cost more. The bottom line: the reality effect of a digital representation can now be measured in dollars. Realism has become a commodity. It can be bought like anything else" ("Global Algorithm 1.3: 'The Aesthetics of Virtual Worlds: Report from Los Angeles,' " *CTHEORY*, http://www.ctheory.com/ga1.3-aesthetics.html, par. 21–22).

31. See Newman, "Computers Now," par. 20.

32. Kevin Kelly and Paula Parisi, "Beyond *Star Wars*," *Wired* 5.2 (Feb. 1997): 160–66, 210–17.

33. See Jorge Luis Borges, "Pierre Menard, Author of the *Quixote*," in *Labyrinths*, ed. Donald A. Yates and James E. Irby (London: Penguin, 1985), 62–71.

34. Steven Mallas, "*Star Wars* Forced Backwards," *Cinefantastique* 31.6 (June 1999): 11.

35. Ron Magid, "Effects Jedi," *American Cinematographer* 80.9 (Sept. 1999): 78.

36. Ron Magid, "Virtual Realities," *American Cinematographer* 80.9 (Sept. 1999): 82.

37. See Kelly and Parisi, "Beyond *Star Wars*," 165.

38. Magid, "Effects Jedi," 78.

39. Siegfried Kracauer, *Theory of Film: The Redemption of Physical Reality* (London: Oxford University Press, 1960), 90.

40. See Paul Scanlon, "The Force Behind George Lucas," *Rolling Stone* 246 (Aug. 25, 1977): 31.

41. See Leslie Bishko, "Expressive Technology: The Tool as Metaphor of Aesthetic Sensibility," *Animation Journal* 3.1 (fall 1994): 74–91.

42. The science fiction television series *Babylon 5* has, for instance, made a feature of its low-tech Video-Toaster effects.

CONCLUSION

1. Yuri Tsivian, *Early Cinema in Russia and Its Cultural Reception*, trans. Alan Bodger, fwd. Tom Gunning, ed. Richard Taylor (Chicago and London: University of Chicago Press, 1994), 3.

2. For an analysis of the globalization of the Hollywood film industry and its implications for film and cultural studies analysis, see Simon During, "Popular Culture on a Global Scale: A Challenge for Cultural Studies," *Critical Inquiry* 23 (summer 1997): 808–33.

3. Tom O'Regan and Rama Venkatasawmy have argued that the relocation of Hollywood film production to Australia has facilitated the development of a local special effects industry by providing opportunities to develop local expertise. See Tom O'Regan and Rama Venkatasawmy, "Only One Day at the Beach: *Dark City* and Australian Film-making," *Metro* 117 (1998): 17–28. Also see Toby Miller, "How Do You Turn Indooroopilly into Africa? Mission Impossible, Second World Television, and the New International Division of Cultural Labor," in *Technologies of Truth: Cultural Citizenship and the Popular Media* (Minneapolis and London: University of Minnesota Press, 1998), 141–81.

4. Scott Bukatman, "The Artificial Infinite: On Special Effects and the Sublime," in *Visual Display: Culture Beyond Appearances*, ed. Lynne Cooke and Peter Wollen (Seattle: Bay, 1995), 279.

5. David Desser, "The Kung Fu Craze: Hong Kong Cinema's First American Reception," in *The Cinema of Hong Kong: History, Arts, Identity*, ed. Poshek Fu and David Desser (Cambridge: Cambridge University Press, 2000), 23.

6. This is the year that Woo's film *The Killer* received a commercial release in the United States. Poshek Fu and David Desser argue that "in the wake of 'Woo-mania,' Jackie Chan, denied stardom in the United States in the 1980s would finally find it in the 1990s" (introduction to *The Cinema of Hong Kong*, 4).

7. See, for instance, *Screen Power: The Jackie Chan Magazine*, which is published in Bath, England.

8. See Meaghan Morris, "Learning from Bruce Lee: Pedagogy and Political Correctness in Martial Arts Cinema," *Metro* 117 (1998): 6–15.

9. See, for instance, Dennis K. Fischer's articles on *The Matrix* in *Cinefantastique* 31.5 (May 1999).

10. Dennis K. Fischer, "The Making of the Matrix," *Cinefantastique* 31.5 (May 1999): 16–17, 19–20, 22, 24, 27.

11. This quotation is from a Website called *Marshall Brain's How Stuff Works*. The site covers a broad range of topics, from "How an Internet Search Engine Works" to "How Performance-Enhancing Drugs Work." In 2000 the site reported that "in May 2000, *How Stuff Works* achieved an amazing milestone—more than 1 million people came to visit *How Stuff Works* in a single month, and we moved into the top 1,000 web sites in the United States (according to PCDataOnline.Com). It shows that there are lots of people who, like you and me, are curious and interested in finding out how stuff works" (*Marshall Brain's How Stuff Works*, http://www.howstuffworks.com/hsw.htm).

12. This technique involves the digital sequencing of a series of still photographs shot with multiple cameras. For the rooftop sequence live action was shot against a green screen set and composited with a virtual set constructed from still photographs.

13. Of course, one of the key moments for the presentation of this effect was also made the object of pastiche in the horror film spoof *Scary Movie* (dir. Keenen Ivory Wayans, 2000).

14. See Janet Wasko, "Talkin' 'Bout a Revolution: Home Video," in *Hollywood in the Information Age: Beyond the Silver Screen* (Cambridge and Oxford: Polity, 1994), 113–70. For recent commentary on the ongoing need for more qualitative analysis of the home viewing experience, see William Boddy, "Television in Transit," *Screen* 41.1 (spring 2000): 67–72; and Uma Dinsmore-Tuli, "The Pleasures of 'Home Cinema'; or, Watching Movies on Telly: An Audience Study of Cinephiliac VCR Use," *Screen* 41.3 (autumn 2000): 315–27.

15. Barbara Klinger, "The New Media Aristocrats: Home Theatre and the Domestic Film Experience," *Velvet Light Trap* 42 (fall 1998): 4–19.

16. John Antico, the CEO of Blockbuster Video, estimated that DVD rentals would account for 40 percent of new release videos rented from Blockbuster in 2001 (reported in Paul Sweeting, "Blockbuster Ups Ante in Home Delivery War," *Variety*, Feb. 12–18, 2001, 73). In 2001 most estimations of the proportion of households in the United States (and Australia) that have DVD players or computers with DVD-ROM drives were between 10 and 12 percent.

17. Derek Ellery, "Asia to 'Tiger': Kung-fooey," *Variety*, Feb. 5–11, 2001, 1, 85.

18. Lee is quoted in *Variety* as suggesting that making *Crouching Tiger* was "just like opening a Chinese restaurant (in the West). At the early stage, you offer some chop suey. And little by little you present more delicacies until they become dainty eaters of Chinese food" (ibid., 85). See the first chapter of this book for a discussion of Rey Chow's theorization of translation.

19. In Yeoh's words, "And now what we want to do is we want to share it [these myths, legends, and fairytales] with the rest of the world. . . . When you see what we've grown up with, you understand our culture a little bit more. And that is a way of communication. I think it's very vital for people to have that deeper understanding about why we are different, why we sometimes think differently" (*Crouching Tiger, Hidden Dragon* [dir. Ang Lee, 2001], 119 min.).

20. See Philip Fisher, *Making and Effacing Art: Modern American Art in a Culture of Museums* (New York and Oxford: Oxford University Press, 1991), 32.

BIBLIOGRAPHY

Abbas, Ackbar. *Hong Kong: Culture and the Politics of Disappearance*. Minneapolis and London: University of Minnesota Press, 1997.

Adorno, Theodor W. *Minima Moralia: Reflections from Damaged Life*. Trans. E. F. N. Jephcott. London: NLB, 1974.

——. *Prisms*. Trans. Samuel Weber and Shierry Weber. Cambridge: MIT Press, 1988.

——. *The Culture Industry: Selected Essays on Mass Culture*. Edited by J. M. Bernstein. London: Routledge, 1991.

——. "The Curious Realist: On Siegfried Kracauer." *New German Critique* 54 (fall 1991): 159–77.

Adorno, Theodor W. and Max Horkheimer. *Dialectic of Enlightenment*. Trans. John Cumming. London: Verso, 1979.

Aksoy, Asu and Kevin Robins. "Hollywood for the 21st Century: Global Competition for Critical Mass in Image Markets." *Cambridge Journal of Economics* 16.1 (1992): 1–22.

Aldiss, Brian. *Science Fiction Art*. London: New England Library, 1975.

Allen, Dave. "Dramatic Principles in Stop-Motion." *Photon* 22 (1972): 25–30.

Allen, Richard W. "The Aesthetic Experience of Modernity: Benjamin, Adorno, and Contemporary Film Theory." *New German Critique* 40 (winter 1987): 225–34.

Allen, Robert C. and Douglas Gomery. *Film History: Theory and Practice*. New York: Knopf, 1985.

Altick, Richard. *The Shows of London*. Cambridge: Harvard University Press, Belknap 1978.

Altman, Mark A. "*Star Wars* Fever" (editorial). *Sci-Fi Universe* 1.5 (Feb.–Mar. 1995): 7.

——. "Cybertainment" (editorial). *Sci-Fi Universe* 1.6 (Apr. 1995): 7.

——. "Screen Test" (editorial). *Sci-Fi Universe* 1.7 (June 1995): 7.

——. Editorial. *Sci-Fi Universe* 3.1 (Sept. 1996): 6.

——. Editorial. *Sci-Fi Universe* 3.3 (Dec. 1996): 6.

Amelunxen, Hubertus v., Stefan Iglhaut, and Florian Rötzer, eds. *Photography After Photography: Memory and Representation in the Digital Age*. Amsterdam: G+B Arts, 1997.

Anderson, Benedict. *Imagined Communities: Reflections on the Origin and Spread of Nationalism*. London: Verso, 1983.

Ang, Ien. *LivingRoom Wars: Rethinking Media Audiences for a Postmodern World*. London and New York: Routledge, 1996.

Appadurai, Arjun. *Modernity at Large: Cultural Dimensions of Globalization*. Minneapolis and London: University of Minnesota Press, 1996.

Baird, Robert. "Animalizing *Jurassic Park*'s Dinosaurs: Blockbuster Schemata and Cross-Cultural Cognition in the Threat Scene." *Cinema Journal* 37.4 (summer 1998): 82–103.

Baker, Robin. "Computer Technology and Special Effects in Contemporary Cinema." In Philip Hayward and Tana Wollen, eds., *Future Visions: New Technologies of the Screen*, 31–45. London: BFI, 1993.

Balio, Tino, ed. *Hollywood in the Age of Television*. Boston, London, Sydney, Wellington: Unwin Hyman, 1990.

Ball, Steven. "Can't You Make It Bigger? Part 1: Interactive CD-Roms at Digita." *Metro* 108 (1996): 97–99.

Barber, Theodore. "Phantasmagorical Wonders: The Magic Lantern Ghost Show in Nineteenth-Century America." *Film History* 3.2 (1989): 73–83.

Barker, Martin and Kate Brooks. *Knowing Audiences: Judge Dredd, Its Friends, Fans and Foes*. Luton, U.K.: University of Luton Press, 1998.

Barnouw, Erik. *The Magician and the Cinema*. New York and Oxford: Oxford University Press, 1981.

Batchen, Geoffrey. *Burning with Desire: The Conception of Photography*. Cambridge and London: MIT Press, 1997.

Baudrillard, Jean. *In the Shadow of the Silent Majorities; or, The End of the Social and*

Other Essays. Trans. Paul Foss, John Johnston, and Paul Patton. New York: Semiotext(e), 1983.

——. *Simulations*. Trans. Paul Foss, Paul Patton, and Philip Beitchman. New York: Semiotext(e), 1983.

——. *The Ecstasy of Communication*. Trans. Bernard Schutze and Caroline Schutze. Edited by Sylvère Lotringer. New York: Semiotext(e), 1987.

——. *America*. Trans. Chris Turner. London and New York: Verso, 1988.

——. *The Evil Demon of Images*. Power Institute Publications No. 3. Sydney: Power Institute, 1988.

——. *The Transparency of Evil: Essays of Extreme Phenomena*. Trans. James Benedict. London and New York: Verso, 1993.

Beer, Gillian. *Open Fields: Science in Cultural Encounter*. Oxford and New York: Oxford University Press, 1996.

Belton, John. "Glorious Technicolor, Breathtaking CinemaScope, and Stereophonic Sound." In Tino Balio, ed., *Hollywood in the Age of Television*, 185–211. Boston, London, Sydney, Wellington: Unwin Hyman, 1990.

——. *Widescreen Cinema*. Cambridge: Harvard University Press, 1992.

Benjamin, Walter. *Reflections: Essays, Aphorisms, Autobiographical Writings*. Edited with an introduction by Peter Demetz. New York: Schocken, 1986.

——. *One-Way Street*. Trans. Edmund Jephcott and Kingsley Shorter. London and New York: Verso, 1997.

——. *Illuminations*. Trans. Harry Zorn. Edited by Hannah Arendt. London: Pimlico, 1999.

Bishko, Leslie. "Expressive Technology: The Tool as Metaphor of Aesthetic Sensibility." *Animation Journal* 3.1 (fall 1994): 74–91.

Boal, Iain I. "In the Tracks of *Jurassic Park*: Phil Tippett Interviewed by Iain A. Boal." In James Brook and Iain A. Boal, eds., *Resisting the Virtual Life: The Culture and Politics of Information*, 253–62. San Francisco: City Lights, 1995.

Boddy, William. "Television in Transit." *Screen* 41.1 (spring 2000): 67–72.

Bode, Carl. *The Anatomy of American Popular Culture, 1840–1861*. Berkeley and Los Angeles: University of California Press, 1960.

Bolter, Jay David and Richard Grusin. *Remediation: Understanding New Media*. Cambridge and London: MIT Press, 1999.

Booth, Michael. *Victorian Spectacular Theatre, 1850–1910*. London and New York: Routledge, 1981.

Bordwell, David, Janet Staiger, and Kristin Thompson. *The Classical Hollywood Cinema: Film Style and Mode of Production to 1960*. New York: Columbia University Press, 1985.

Borsook, Paulina. "The Memoirs of a Token: An Aging Berkeley Feminist Examines

Wired." In Lynn Cherney and Elizabeth Reba Weise, eds., *Wired Women: Gender and New Realities in Cyberspace*, 24–41. Seattle: Seal, 1996.

Boultin, Paul. "Baby Blue." *Wired* 6.12 (Dec. 1998): 227.

Brand, Stewart. *The Media Lab: Inventing the Future at M.I.T.* London and New York: Penguin, 1988.

Braude, Anne. *Radical Spirits: Spiritualism and Women's Suffrage in Nineteenth-Century America.* Boston: Beacon, 1989.

Brewster, Sir David. *Letters on Natural Magic, Addressed to Sir Walter Scott, Bart.* New ed. London: William Tess, 1868.

Britton, Peter. "The Wow Factor." *Popular Science* 243.5 (Nov. 1993): 86–91.

Brock, Alan St. H. *A History of Fireworks.* London and Sydney: Harrop, 1949.

Brook, James and Iain A. Boal, eds. *Resisting the Virtual Life: The Culture and Politics of Information.* San Francisco: City Lights, 1995.

Brosnan, John. *Movie Magic: The Story of Special Effects in the Cinema.* 1974. Reprint, New York and Scarborough, Ontario: Plume, 1976.

Brown, N. C. M. "Theorising the Crafts: New Tricks of the Trades." In Sue Rowley, ed., *Craft and Contemporary Theory*, 3–17. St. Leonards, N.S.W.: Allen and Unwin, 1997.

Buchanan, R. A. "Theory and Narrative in the History of Technology." *Technology and Culture* 32.2 (Apr. 1991): 365–76.

Buckland, Warren. "Between Science Fact and Science Fiction: Spielberg's Digital Dinosaurs, Possible Worlds, and the New Aesthetic Realism." *Screen* 40.2 (summer 1999): 177–92.

Buck-Morss, Susan. *The Dialectics of Seeing: Walter Benjamin and the Arcades Project.* Cambridge and London: MIT Press, 1997.

Bukatman, Scott. *Terminal Identity: The Virtual Subject in Postmodern Science Fiction.* Durham, N.C., and London: Duke University Press, 1993.

——. "Mondo Babes and Wired Boys." *Educom Review* 30.5 (May–June 1995). http://www/educause.edu/pub/er/review/reviewArticles/30317.html. 4 Oct. 2000.

——. "The Artificial Infinite: On Special Effects and the Sublime." In Lynne Cook and Peter Wollen, eds., *Visual Display: Culture Beyond Appearances*, 255–89. Seattle: Bay, 1995.

——. "Zooming Out: The End of Offscreen Space." In Jon Lewis, ed., *The New American Cinema*, 248–71. Durham, N.C. and London: Duke University Press, 1998.

——. "Taking Shape: Morphing and the Performance of Self." In Vivian Sobchack, ed., *Meta-Morphing: Visual Transformation and the Culture of Quick-Change*, 225–49. Minneapolis and London: University of Minnesota Press, 2000.

Burch, Noël. "Porter; or, Ambivalence." Trans. Tom Milne. *Screen* 19.4 (winter 1978–79): 91–105.

——. "Primitivism and the Avant-Gardes: A Dialectical Approach." In Philip Rosen,

ed., *Narrative, Apparatus, Ideology: A Film Theory Reader,* 483–506. New York: Columbia University Press, 1986.

Burnham, John C. *How Superstition Won and Science Lost: Popularizing Science and Health in the United States.* New Brunswick, N.J.: Rutgers University Press, 1987.

Butsch, Richard. "Introduction: Leisure and Hegemony in America." In Richard Butsch, ed., *For Fun and Profit: The Transformation of Leisure into Consumption,* 3–27. Philadelphia: Temple University Press, 1990.

Byrne, John. "The Objective of Art in the Age of Digital Revolution." *Convergence: The Journal of Research Into New Media Technologies* 3.3 (autumn 1997): 17–21.

Caldwell, John Thornton. *Televisuality: Style, Crisis, and Authority in American Television.* New Brunswick, N.J.: Rutgers University Press, 1995.

Cameron, James. "Effects Scene: Technology and Magic." *Cinefex: The Journal of Cinematic Illusions* 51 (Aug. 1992): 5–7.

Castle, Terry. *The Female Thermometer: Eighteenth-Century Culture and the Invention of the Uncanny.* New York: Oxford University Press, 1995.

Chanan, Michael. "The Treats of Trickery." In Christopher Williams, ed, *Cinema: The Beginnings and the Future. Essays Marking the Centenary of the First Film Show Projected to a Paying Audience,* 117–22. London: University of Westminster Press, 1996.

Chartier, Roger. *Cultural History: Between Practices and Representations.* Trans. Lydia G. Cochrane. Oxford: Polity, 1988.

——. *Forms and Meanings: Texts, Performances, and Audiences from Codex to Computer.* Philadelphia: University of Pennsylvania Press, 1995.

Chittock, John. "Back to the Future: the Cinema's Lessons of History." In Christopher Williams, ed., *Cinema: The Beginnings and the Future. Essays Marking the Centenary of the First Film Show Projected to a Paying Audience,* 217–27. London: University of Westminster Press, 1996.

Chow, Rey. *Primitive Passions: Visuality, Sexuality, Ethnography, and Contemporary Chinese Cinema.* New York: Columbia University Press, 1995.

Clarke, Frederick S. and Steve Rubin. "Making Forbidden Planet." *Cinefantastique* 8.2–3 (1979): 4–67.

Clarke, John. "Pessimism Versus Populism: The Problematic Politics of Popular Culture." In Richard Butsch, ed., *For Fun and Profit: The Transformation of Leisure into Consumption,* 28–44. Philadelphia: Temple University Press, 1990.

Clayssen, Jacques. "Digital (R)evolution." In Herbert v. Amelunxen, Stefan Iglhaut, and Florian Rotzer, eds., *Photography After Photography: Memory and Representation in the Digital Age,* 73–76. Amsterdam: G+G Arts, 1996.

Comolli, Jean-Louis. "Machines of the Visible." In Stephen Heath and Teresa de Lauretis, eds., *The Cinematic Apparatus,* 121–41. London and Basingstoke: Macmillan, 1980.

——. "Technique and Ideology: Camera, Perspective, Depth of Field (Parts 3 and 4)." In Philip Rosen, ed., *Narrative, Apparatus, Ideology: A Film Theory Reader*, 421–43. New York: Columbia University Press, 1986.

Conley, Verena Andermatt, ed. *Rethinking Technologies*. Minneapolis and London: University of Minnesota Press, 1993.

Cowan, Ruth Schwartz. "The Consumption Junction: A Proposal for Research Strategies in the Sociology of Technology." In Wiebe E. Bijker, Thomas P. Hughes, and Trevor J. Pinch, eds., *The Social Construction of Technological Systems: New Directions in the Sociology and History of Technology*, 261–80. Cambridge and London: MIT Press, 1987.

Coyle, Rebecca. "The Genesis of Virtual Reality." In Philip Hayward and Tana Wollen, eds., *Future Visions: New Technologies of the Screen*, 148–65. London: BFI, 1993.

Crary, Jonathan. *Techniques of the Observer: On Vision and Modernity in the Nineteenth Century*. Cambridge: MIT Press, 1992.

——. *Suspensions of Perception: Attention, Spectacle, and Modern Culture*. Cambridge: MIT Press, 1999.

Cremer, W. H. Jr., ed. *The Magician's Own Book: Containing ample instructions for recreations in chemistry, acoustics, pneumatics, legerdemain, prestidigitation, electricity (with and without apparatus)*. London: John Camden Hatten, 1871.

Crispin Miller, Mark, ed. *Seeing Through Movies*. New York: Pantheon, 1990.

Csicsery-Ronay, Istvan Jr. "The SF of Theory: Baudrillard and Haraway." *Science-Fiction Studies* 18 (1991): 387–403.

Cubitt, Sean. *Digital Aesthetics*. London, Thousand Oaks, New Delhi: Sage, 1998.

——. "Introduction. Le réel, c'est l'impossible: The Sublime Time of Special Effects." *Screen* 40.2 (summer 1999): 123–30.

Dagognet, Franáois. *Etienne-Jules Marey: A Passion for the Trace*. Trans. Robert Galeta and Jeanine Herman. New York: Zone, 1992.

Daly, James, ed. "Hollywood 2.0 Special Report: The People Who Are Reinventing Entertainment." *Wired* 5.11 (Nov. 1997): 200–215.

Darley, Andrew. "From Abstraction to Simulation: Notes on the History of Computer Imaging." In Philip Hayward, ed., *Culture, Technology, and Creativity in the Late Twentieth Century*, 39–64. London, Paris, Rome: Libbey, 1992.

——. "Second-Order Realism and Post-Modern Aesthetics in Computer Animation." In Jayne Pilling, ed., *A Reader in Animation Studies*, 16–24. London, Paris, Rome, Sydney: Libbey, 1997.

——. *Visual Digital Culture: Surface Play and Spectacle in New Media Genres*. London: Routledge, 2000.

Daston, Loraine and Katherine Park. *Wonders and the Order of Nature, 1150–1750*. New York: Zone; London: MIT Press, 1998.

Davis, Douglas. *Art and the Future: A History/Prophecy of the Collaboration Between Science, Technology and Art*. London: Thames and Hudson, 1973.

Dean, Henry. *The Whole Art of Legerdemain; or, Hocus Pocus in Perfection.* 6th ed. London: L. Howes, S. Crowder, and R. Ware, 1763. Facsimile reprint, Omaha, Nebr.: Graham, 1983.

de Man, Paul. " 'Conclusions': Walter Benjamin's 'The Task of the Translator.' " In *The Resistance to Theory*, 73–105. Minneapolis: University of Minnesota Press, 1986.

Dennett, Andrea Stulman. *Weird and Wonderful: The Dime Museum in America.* New York and London: New York University Press, 1997.

Derrida, Jacques. "Des Tours de Babel." In Joseph F. Graham, ed., *Difference in Translation*, 165–207. Ithaca, N.Y.: Cornell University Press, 1986.

——. *Archive Fever: A Freudian Impression.* Trans. Eric Prenowitz. Chicago and London: University of Chicago Press, 1996.

Dery, Mark. *Escape Velocity: Cyberculture at the End of the Century.* London: Hodder and Stoughton, 1996.

——. "Industrial Memory." *21-C* 1 (1996): 50–53.

——. "Wired Unplugged." *Escape Velocity.* http://www.to.or.at/dery/wired/htm. Oct. 4, 2000.

——. "Back to the Future." *Nettime.* Sept. 5, 1999. http//:www.nettime.org/nettime.w3archive/199909/msg00042.html. 4 Oct. 2000.

Desser, David. "The Kung Fu Craze: Hong Kong Cinema's First American Reception." In Poshek Fu and David Desser, eds., *The Cinema of Hong Kong: History, Arts, Identity*, 19–43. Cambridge: Cambridge University Press, 2000.

Devant, David. *My Magic Life.* Intro. J. P. Priestly. London: Hutchinson, 1931.

Devitt, Ray. "Movie Magician." *if Magazine* 23 (May 2000): 40–41.

Dewdney, Andrew and Frank Boyd. "Television, Computers, Technology and Cultural Form." In Martin Lister, ed., *The Photographic Image in Digital Culture*, 147–69. London and New York: Routledge, 1995.

Digital Image, Digital Cinema. Supp. issue of *Leonardo.* Oxford, U.K., and Elmsford, N.Y.: Pergamon, 1990.

Dinsmore-Tuli, Uma. "The Pleasures of 'Home Cinema'; or, Watching Movies on Telly: An Audience Study of Cinephiliac VCR Use." *Screen* 41.3 (autumn 2000): 315–27.

Doherty, Thomas. "*Star Trek* the Franchise: Thirty Years in Space." *Cinefantastique* 27.4–5 (Jan. 1996): 64–66.

Donald, James, ed. *Fantasy and the Cinema.* London: BFI, 1989.

Dormer, Peter, ed. *The Culture of Craft: Status and Future.* Manchester and New York: Manchester University Press, 1997.

Dunlap, William. *History of the American Theatre and Anecdotes of the Principle Actors.* 2d ed. New York: Burt Franklin, 1963.

During, Simon, ed. *The Cultural Studies Reader.* London and New York: Routledge, 1993.

———. "Popular Culture on a Global Scale: A Challenge for Cultural Studies." *Critical Inquiry* 23 (summer 1997): 808–33.

Edgar, Ray. "MicroFilm." *World Art* 18 (1998): 24–29, 84.

Eby, Douglas. "*MIB* The Aliens: Rubber vs. CGI." *Cinefantastique* 29.1 (July 1997): 23–25.

Elsaesser, Thomas. "Cinema Futures: Convergence, Divergence, Difference." In Thomas Elsaesser and Kay Hoffmann, eds., *Cinema Futures: Cain, Abel or Cable? The Screen Arts in the Digital Age*, 9–26. Amsterdam: Amsterdam University Press, 1998.

———. "Fantasy Island: Dream Logic as Production Logic." In Thomas Elsaesser and Kay Hoffmann, eds., *Cinema Futures: Cain, Abel or Cable? The Screen Arts in the Digital Age*, 143–58. Amsterdam: Amsterdam University Press, 1998.

———. "Louis Lumière—the Cinema's First Virtualist?" In Thomas Elsaesser and Kay Hoffmann, eds., *Cinema Futures: Cain, Abel or Cable? The Screen Arts in the Digital Age*, 45–62. Amsterdam: Amsterdam University Press, 1998.

Elsaesser, Thomas and Adam Barker, eds. *Early Cinema: Space, Frame, Narrative*. London: BFI, 1990.

Eslinger, Tom and Brian Smith. "American Typo." *World Art* 1 (1995): 72–77.

Featherstone, Mike. "Localism, Globalism, and Cultural Identity." In Rob Wilson and Wimal Dissanayake, eds., *Global/Local: Cultural Production and the Transnational Imaginary*, 46–77. Durham, N.C., and London: Duke University Press, 1996.

Ferguson, Charles H. and Charles R. Morris. *Computer Wars: The Fall of IBM and the Future of Global Technology*. New York: Times, Random House, 1994.

Finch, Christopher. *Special Effects: Creating Movie Magic*. New York: Abbeville, 1984.

Fischer, Dennis K. "The Last Starfighter." *Cinefantastique* 15.1 (Jan. 1985): 24–36.

———. "The Making of *The Matrix*." *Cinefantastique* 31.5 (May 1999): 16–18.

———. "Matrix Martial Arts." *Cinefantastique* 31.5 (May 1999): 26.

Fisher, Kevin. "Tracing the Tesseract: A Conceptual Prehistory of the Morph." In Vivian Sobchack, ed., *Meta-Morphing: Visual Transformation and the Culture of Quick-Change*, 103–29. Minneapolis and London: University of Minnesota Press, 2000.

Fisher, Michael. "Ey(I)ing the Sciences and Their Signifiers (Language, Torpes, Auto-biographers): Interviewing for a Cultural Studies of Science and Technology." In George E. Marcus, ed., *Technoscientific Imaginaries: Conversations, Profiles, and Memoirs*, 42–82. Chicago and London: University of Chicago Press, 1995.

Fisher, Philip. *Making and Effacing Art: Modern American Art in a Culture of Museums*. New York and Oxford: Oxford University Press, 1991.

———. *Wonder, the Rainbow, and the Aesthetics of Rare Experiences*. Cambridge and London: Harvard University Press, 1998.

Fitzgerald, Percy. *The World Behind the Scenes*. London: Chatto and Windus, 1881.

Foucault, Michel. *Technologies of the Self: A Seminar with Michel Foucault.* Edited by Luther H. Martin, Huck Gutman, and Patrick H. Hutton. Amherst: University of Massachusetts Press, 1988.

——. *The Archaeology of Knowledge.* Trans. A. M. Sheridan Smith. London and New York: Routledge, 1989.

Fox, Barry. "It's the Eye that Lies." *New Scientist* 104.1435–1436 (Dec. 20–27, 1984): 38–41.

Frank, Mark. "The Stop-Motion World of Jim Danforth." *Photon* 20 (1971): 11–26.

——. "Frankly Speaking." *Photon* 24 (1974): 4.

——. "Film Fans and Fandom." *Photon* 27 (1977): 3.

French, Lawrence. "Toy Story Art Direction." *Cinefantastique* 27.2 (Nov. 1995): 32–33.

French, Neal. "CADCAM and the British Ceramics Tableware Industry." In Peter Dormer, ed., *The Culture of Craft*, 158–67. Manchester and New York: Manchester University Press, 1997.

Friedman, Ted. "Making Sense of Software: Computer Games and Interactive Textuality." In Steven G. Jones, ed., *Cybersociety: Computer-Mediated Communication and Community*, 73–89. Thousand Oaks, London, and New Delhi: Sage, 1995.

Frost, Thomas. *The Old Showmen and the Old London Fairs.* London: Tinsley Brothers, 1874.

——. *The Lives of the Conjurors.* 1876. Reprint, London: Chatto and Windus, 1881.

Frow, John and Meaghan Morris, eds. *Australian Cultural Studies.* Sydney: Allen and Unwin, 1993.

Garenne, Henri. *The Art of Modern Conjuring, Magic and Illusions: A Practical Treatise on the art of parlour and stage magic, illusions, spiritualism, ventriloquism, through reading, mesmerism, mnemotechny, etc. etc.* London: Ward Lock, 1876.

Gaudreault, André. "Theatricality, Narrativity, and 'Trickality': Reevaluating the Cinema of Georges Méliès." *Journal of Popular Film and Television* 15.3 (fall 1987): 110–19.

Genette, Gérard. *The Aesthetic Relation.* Trans. G. M. Goshgarian. Ithaca, N.Y., and London: Cornell University Press, 1999.

Gibson, William. *Neuromancer.* London: HarperCollins, 1984.

——. *Neuromancer.* 8th ed. London: HarperCollins, 1993.

——. *Burning Chrome.* London: HarperCollins, 1988.

Gill, Pat. "Technostalgia: Making the Future Past Perfect." *Camera Obscura* 40–41 (May 1997): 163–79.

Gombrich, E. H. *Art and Illusion: A Study in the Psychology of Pictorial Representation.* London: Phaidon; New York: Pantheon, 1960.

Goodfellow, Kris. "Mayday! Mayday! We're Leaking Visuals! Shakeout of the Special Effects Houses." *New York Times*, Sept. 29, 1997, C5, C8.

Green, Lelia and Roger Guinery, eds. *Framing Technology: Society, Choice and Change.* St. Leonards, N.S.W.: Allen and Unwin, 1994.

Greenblatt, Stephen. *Marvelous Possessions: The Wonder of the New World.* Chicago: Chicago University Press, 1991.

Grindon, Leger. "The Role of Spectacle and Excess in the Critique of Illusion." *Postscript.* 13.2 (winter–spring 1994): 35–43.

Grossberg, Lawrence. *We Gotta Get Out of This Place.* New York and London: Routledge, 1992.

Grossberg, Lawrence, Cary Nelson, and Paula A. Treichler, with Linda Baughman and assistance from John MacGregor Wise, eds. *Cultural Studies.* New York and London: Routledge, 1992.

Gunning, Tom. "The Cinema of Attractions: Early Film, Its Spectator and the Avant-Garde." In Thomas Elsaesser and Adam Barker, eds., *Early Cinema: Space, Frame, Narrative,* 56–62. London: BFI, 1990.

——. "An Aesthetic of Astonishment: Early Film and the (In)Credulous Spectator." In Linda Williams, ed., *Viewing Positions: Ways of Seeing Film,* 114–33. New Brunswick, N.J.: Rutgers University Press, 1994.

——. " 'Now You See It, Now You Don't': The Temporality of the Cinema of Attractions." In Linda Williams, ed., *Viewing Positions: Ways of Seeing Film,* 71–84. New Brunswick, N.J.: Rutgers University Press, 1994.

——. "Phantom Images and Modern Manifestations: Spirit Photography, Magic Theatre, Trick Films, and Photography's Uncanny." In Patrice Petro, ed., *Fugitive Images: From Photography to Video,* 42–71. Bloomington and Indianapolis: Indiana University Press, 1995.

——. " 'Animated Pictures': Tales of Cinema's Forgotten Future." *Michigan Quarterly Review* 24.4 (fall 1995): 464–85.

Gye, Lisa. "Can't You Make It Bigger? Part 2: Digita Online." *Metro* 108 (1996): 100–101.

Habermas, Jürgen. *The Theory of Communicative Action.* Vol. 1, *Reason and the Rationalization of Society.* Trans. Thomas McCarthy. London: Heinemann, 1981.

——. *The Philosophical Discourse of Modernity: Twelve Lectures.* Trans. Frederick Lawrence. Oxford and Cambridge: Polity, 1987.

Hall, Trevor H. *A Bibliography of Books on Conjuring in English from 1580 to 1850.* Minneapolis: Carl Waring Jones, 1957.

——. *Old Conjuring Books: A Bibliographical and Historical Study with a Supplementary Check-list.* London: Duckworth, 1972.

Hankins, Thomas L. and Robert J. Silverman. *Instruments and the Imagination.* Princeton, N.J.: Princeton University Press, 1995.

Hansen, Miriam. *Babel and Babylon: Spectatorship in American Silent Film.* Cambridge and London: Harvard University Press, 1991.

——. "Early Cinema, Late Cinema: Transformations of the Public Sphere." In Linda Williams, ed., *Viewing Positions: Ways of Seeing Film,* 134–52. New Brunswick, N.J.: Rutgers University Press, 1994.

Hardison, O. B., Jr. *Disappearing Through the Skylight: Culture and Technology in the Twentieth Century*. New York: Viking, 1989.

Harley, Ross Rudesch. "Entertainment of Wonders and the Conflux of Apparent Miracles: Magic, Cinema and Illusion in Turn-of-the-Century Performance." *Metro* 113–114 (Jan. 1998): 48–53.

——. "That's Interaction! Audience Participation in Entertainment Monopolies." *Convergence: The Journal of Research Into New Media Technologies* 2.2 (summer 1996): 103–23.

Hargrove, David J. "Special Effects: Anything Can Happen (But Should It?)." *Sci-Fi Universe* 3.5 (Feb. 1997): 63.

Harris, Neil. *Humbug: The Art of P. T. Barnum*. Boston and Toronto: Little, Brown, 1973.

Harvey, Sylvia. "What Is Cinema? The Sensuous, the Abstract and the Political." In Christopher Williams, ed., *Cinema: The Beginnings and the Future. Essays Marking the Centenary of the First Film Show Projected to a Paying Audience*, 228–52. London: University of Westminster Press, 1996.

Hatlestad, Luc. "Go West Young Military Developer." *Red Herring Magazine* (Jan. 1998). http://hoh99.redherring.com/mag/issue50/west.html. July 3, 1998.

Hayes, R. M. *3-D Movies: A History and Filmography of Stereoscopic Cinema*. Jefferson, N.C., and London: McFarland, 1989.

Hayward, Philip. "Situating Cyberspace: The Popularisation of Virtual Reality." In Philip Hayward and Tana Wollen, eds., *Future Visions: New Technologies of the Screen*, 180–204. London: BFI, 1993.

——, ed. *Culture, Technology and Creativity in the Late Twentieth Century*. London, Paris, and Rome: Libbey, 1992.

Hayward, Philip and Tana Wollen, eds. *Future Visions: New Technologies of the Screen*. London: BFI, 1993.

Heard, Mervyn. "The Magic Lantern's Wild Years." In Christopher Williams, ed., *Cinema: The Beginnings and the Future. Essays Marking the Centenary of the First Film Show Projected to a Paying Audience*, 24–32. London: University of Westminster Press, 1996.

Heidegger, Martin. "The Question Concerning Technology." In David Farrell Krell, ed., *Basic Writings*, 307–42. San Francisco: HarperCollins, 1992.

Heim, Michael. *Electric Language: A Philosophical Study of Word Processing*. New Haven and London: Yale University Press, 1987.

Hickey, Gloria. "Craft Within a Consuming Society." In Peter Dormer, ed., *The Culture of Craft*, 83–100. Manchester and New York: Manchester University Press, 1997.

Higginson, Thomas Wentworth. "The American Lecture-System." *Littel's Living Age* 97.1253 (June 6, 1868): 630–37.

Hillier, Jim, ed. *Cahiers du Cinéma*. Vol. 2, *1960–1968*. London: Routledge and Kegan Paul, 1986.

Hoffman, Professor. *Modern Magic: Practical Treatise on the Art of Conjuring.* 3d ed. London and New York: George Routledge and Sons, 1878.

Hohendahl, Peter U. "The Displaced Intellectual? Adorno's American Years Revisited." *New German Critique* 56 (spring–summer 1992): 77–100.

Holland, J. G. "The Popular Lecture." *Atlantic Monthly* 15.89 (Mar. 1865): 362–71.

Hollander, Judd and Sue Feinberg. "Men in Black." *Cinefantastique* 29.1 (July 1997): 16–31.

Holtzman, Steve, R. *Digital Mantras: The Languages of Abstract and Virtual Worlds.* Cambridge and London: MIT Press, 1994.

——. *Digital Mosaics: The Aesthetics of Cyberspace.* New York: Simon and Schuster, 1997.

Hopkins, Albert A. *Magic: Stage Illusions, Special Effects, and Trick Photography.* Intro. Henry Ridgely Evans. New York: Munn, 1898. Reprint, New York: Dover, 1976.

——. "The Scientific Use of the Toy Magic Lantern." *Scientific American* 56.13 (Mar. 26, 1887): 198.

——. "Microscopic Projection." *Scientific American* 56.25 (June 18, 1887): 393.

——. "Optical Projection of Opaque Objects." *Scientific American* 64.14 (Apr. 4, 1891): 259.

Hopkins, George M. *Experimental Science: Elementary, Practical and Experimental Physics.* 2 vols. 23d ed. New York: Munn, 1902.

Houghton, Miss. *Chronicles of the Photographs of Spiritual Beings and Phenomena Invisible to the Material Eye.* London: E. W. Allen, 1882.

Huhtamo, Erkki. "Seeking Deeper Contact: Interactive Art as Metacommentary." *Convergence: The Journal of Research Into New Media Technologies* 1.2 (autumn 1995): 81–104.

Hume, Robert D. *Reconstructing Contexts: The Aims and Principles of Archaeo-Historicism.* Oxford and New York: Oxford University Press, 1999.

Inglesby, Pamela. " 'A Photograph Is Not a Picture': Distinguishing Anarchy from Art in the Late Nineteenth Century." In Larry Gross, ed., *On the Margins of Art Worlds,* 167–82. Boulder, Colo., San Francisco, Oxford: Westview, 1995.

James, Edward. *Science Fiction in the Twentieth Century.* Oxford and New York: Oxford University Press, 1994.

Jameson, Fredric. "Progress Versus Utopia; or, Can We Imagine the Future?" *Science-Fiction Studies.* 9.27 (1982): 147–66.

——. *Postmodernism; or, The Cultural Logic Of Late Capitalism.* Durham, N.C.: Duke University Press, 1991.

Jay, Martin. *Permanent Exiles: Essays on the Intellectual Migration from Germany to America.* New York: Columbia University Press, 1985.

Jeffords, Susan. "Can Masculinity Be Terminated?" In Steven Cohan and Ina Rae Hark, eds., *Screening the Male: Exploring Masculinities in Hollywood Cinema,* 245–62. New York and London: Routledge, 1993.

Jenkins, Henry. *Textual Poachers: Television Fans and Participatory Culture.* New York: Routledge, 1992.

———. " 'Infinite Diversity in Infinite Combinations': Genre and Authorship in *Star Trek.*" In John Tulloch and Henry Jenkins, eds., *Science Fiction Audiences: Watching Doctor Who and Star Trek,* 175–95. London and New York: Routledge, 1995.

Jenkins, Henry and Greg Dancer. " 'How Many Starfleet Officers Does It Take to Change a Lightbulb?' *Star Trek* at MIT." In John Tulloch and Henry Jenkins, eds., *Science Fiction Audiences: Watching Doctor Who and Star Trek,* 213–36. London and New York: Routledge, 1995.

Jensen, Paul M. *The Men Who Made Monsters.* New York: Twayne, 1996.

Kant, Immanuel. *Critique of Judgment.* Trans. J. H. Bernard. New York: Hafner; and London: Collier Macmillan, 1974.

Katz, Jon. "Teenage Mutant Power Rangers, Part 1." *Hotwired.* Netizen. (May 20, 1996). http://www.netizen.com/netizen/96/20/katz5a.html. Oct. 4, 2000.

———. "Teenage Mutant Power Rangers, Part 2." *Hotwired.* Netizen. (May 21, 1996). http://www.netizen/96/21/katz1a.html. Oct. 4, 2000.

———. "Teenage Mutant Power Rangers, Part 3." *Hotwired.* Netizen. (May 22, 1996). http://hotwired.lycos.com/netizen/96/21/katz2a.html. Oct. 4, 2000.

Kelly, Kevin and Paula Parisi. "Beyond *Star Wars.*" *Wired* 5.2 (Feb. 1997): 160–66, 210–17.

Kinder, Marsha. *Playing with Power in Movies, Television, and Video Games: From Muppet Babies to Teenage Mutant Ninja Turtles.* Berkeley, Los Angeles, and London: University of California Press, 1991.

Kirby, Lynne. *Parallel Tracks: The Railroad and Silent Cinema.* Durham, N.C.: Duke University Press, 1997.

Kittler, Friedrich A. *Discourse Networks 1800/1900.* Trans. Michael Metteer and Chris Collins. Fwd. David E. Wellbery. Stanford, Calif.: Stanford University Press, 1990.

Klein, Norman M. "Animation and Animorphs: A Brief Disappearing Act." In Vivian Sobchack, ed., *Meta-Morphing: Visual Transformation and the Culture of Quick-Change,* 21–39. Minneapolis and London: University of Minnesota Press, 2000.

Klinger, Barbara. "The New Media Aristocrats: Home Theatre and the Domestic Film Experience." *Velvet Light Trap* 42 (fall 1998): 4–19.

Kracauer, Siegfried. *Theory of Film: The Redemption of Physical Reality.* London, Oxford, New York: Oxford University Press, 1978.

———. "Cult of Distraction: On Berlin's Picture Palaces" (1926). *New German Critique* 40 (winter 1987): 91–114.

Krasnoff, Barbara. "From Housewife to Heroine: Women in SF Media." *Future* 26 (May 1981): 52–55.

Kroker, Arthur. *The Possessed Individual: Technology and Postmodernity.* London: Macmillan, 1992.

Kroker, Arthur and Marilouise Kroker. "*Johnny Mnemonic*: The Day Cyberpunk Died." *CTHEORY*. http://www.ctheory.com/event/e017.html. Oct. 4, 2000.

Landon, Brooks. "Sliming Technology." *Cinefantastique* 18.4 (1988): 27–28.

——. *The Aesthetics of Ambivalence: Re-thinking Science Fiction Film in the Age of Electronic (Re)production*. Westport, Conn., and London: Greenwood, 1992.

La Follette, Marcel C. *Making Science Our Own: Public Images of Science, 1910–1955*. Chicago and London: University of Chicago Press, 1990.

La Valley, Albert J. "Traditions of Trickery: The Role of Special Effects in the Science Fiction Film." In George S. Slusser and Eric S. Rabkin, eds., *Shadows of the Magic Lamp: Fantasy and Science Fiction in Film*, 141–57. Carbondale and Edwardsville: Southern Illinois University Press, 1985.

Law, John. "Theory and Narrative in the History of Technology: Response." *Technology and Culture* 32.2 (Apr. 1991): 365–84.

——, ed. *A Sociology of Monsters: Essays on Power, Technology and Domination*. London and New York: Routledge, 1991.

Lee, Nora. "Motion Control." *American Cinematographer* 64.5 (May 1983): 60–61.

Leebaert, Derek, ed. *Technology 2001: The Future of Computing and Communications*. Cambridge: MIT Press, 1991.

Le Guin, Ursula K. "Noise and Meaning in SF Films." *Future* 4 (Aug. 1978): 18, 74.

Licht, Walter. *Industrializing America: The Nineteenth Century*. Baltimore and London: Johns Hopkins University Press, 1995.

Lipton, Lenny. *Foundations of the Stereoscopic Cinema: A Study in Depth*. New York: Van Nostrand Reinhold, 1982.

Lister, Martin, ed. *The Photographic Image in Digital Culture*. London and New York: Routledge, 1995.

Lyons, Mike. "*ID4* Visual Effects: Supervisors Doug Smith and Volker Engel on Fashioning Alien Armageddon." *Cinefantastique* 27.11–12 (July 1996): 14–15.

MacDonald, Sharon, ed. *The Politics of Display: Museums, Science, Culture*. London and New York: Routledge, 1998.

McDougall, Walter A. *The Heavens and the Earth: A Political History of the Space Age*. New York: Basic, 1985.

MacDowall, David. "*2001*: A Critique." *Photon* 16 (1968). Reprint, *Photon* 24 (1974): 25–36.

McGrath, Roberta. "Natural Magic and Science Fiction: Instruction, Amusement and the Popular Show, 1795–1895." In Christopher Williams, ed., *Cinema: The Beginnings and the Future. Essays Marking the Centenary of the First Film Show Projected to a Paying Audience*, 13–23. London: University of Westminster Press, 1996.

McLuhan, Marshall and Bruce R. Powers. *The Global Village: Transformations in World Life and Media in the Twenty-First Century*. New York and Oxford: Oxford University Press, 1986.

Magid, Ron. "Effects Jedi." *American Cinematographer* 80.9 (Sept. 1999): 78–81.

——. "Virtual Realities." *American Cinematographer* 80.9 (Sept. 1999): 82–93.

Mandell, Paul R. "John Can Do Better." *Photon* 25 (1974): 31–35.

Mallas, Steven. "*Star Wars* Forced Backwards." *Cinefantastique* 31.6 (June 1999): 11.

Manovich, Lev. "The Automation of Sight: From Photography to Computer Vision." In Timothy Druckrey, ed., *Electronic Culture: Technology and Visual Representation*, 229–39. New York and London: Aperture Foundation, 1996.

——. " 'Reality' Effects in Computer Animation." In Jayne Pilling, ed., *A Reader in Animation Studies*, 5–15. London, Paris, Rome, Sydney: Libbey, 1997.

——. "Towards an Archaeology of the Computer Screen." In Thomas Elsaesser and Kay Hoffmann, eds., *Cinema Futures: Cain, Abel or Cable? The Screen Arts in the Digital Age*, 27–43. Amsterdam: Amsterdam University Press, 1998.

——. "What Is Digital Cinema?" In Peter Lunenfeld, ed., *The Digital Dialectic: New Essays on New Media*, 172–92. Cambridge and London: MIT Press, 1999.

——. "Global Algorithm 1.3: 'The Aesthetics of Virtual Worlds: Report from Los Angeles.' " *CTHEORY*. http://www.ctheory.com/ga1.3-aesthetics.html. Oct. 4, 2000.

——. *The Language of New Media*. Cambridge and London: MIT Press, 2001.

Marchand, Roland and Michael L. Smith. "Corporate Science on Display." In Ronald B. Walters, ed., *Scientific Authority and Twentieth-Century America*, 148–253. Baltimore and London: John Hopkins University Press, 1997.

Marien, Mary Warner. *Photography and Its Critics: A Cultural History, 1839–1900*. Cambridge: Cambridge University Press, 1997.

Marvin, Carolyn. *When Old Technologies Were New: Thinking About Electrical Communication in the Late Nineteenth Century*. New York and Oxford: Oxford University Press, 1998.

Marx, Leo. "The Idea of 'Technology' and Postmodern Pessimism." In Merritt Roe Smith and Leo Marx, eds., *Does Technology Drive History? The Dilemma of Technological Determinism*, 237–49. Cambridge: MIT Press, 1994.

Maskelyne, Nevil and David Devant. *Our Magic: The Art in Magic, the Theory of Magic, the Practice of Magic*. London: George Routledge and Sons; New York: Dutton, 1911.

Massey, Doreen, Paul Quintas, and David Wield, eds. *High Tech Fantasies: Science Parks in Society, Science and Space*. London and New York: Routledge, 1992.

Matlock, Jann. "The Invisible Woman and Her Secrets Unveiled." *Yale Journal of Criticism* 9.2 (1996): 175–221.

Mayer, Paul A. "Typologies for the Analysis of Computer Media." *Convergence: The Journal of Research Into New Media Technologies* 3.2 (summer 1997): 82–101.

Metz, Christian. "*Trucage* and the Film." Trans. Françoise Meltzer. *Critical Inquiry* 3 (summer 1977): 657–75.

——. *The Imaginary Signifier: Psychoanalysis and the Cinema*. Trans. Celia Britton, Annwyl Williams, Ben Brewster, and Alfred Guzzetti. Bloomington: Indiana University Press, 1982.

Miller, Angela. "The Panorama, the Cinema, and the Emergence of the Spectacular." *Wide Angle* 18.2 (Apr. 1996): 34–69.

Miller, Toby. *Technologies of Truth: Cultural Citizenship and the Popular Media.* Minneapolis and London: University of Minnesota Press, 1998.

Mitcham, Carl. *Thinking Through Technology: The Path Between Engineering and Philosophy.* Chicago and London: University of Chicago Press, 1994.

Mitchell, W. J. T. *Picture Theory: Essays on Verbal and Visual Representation.* Chicago and London: University of Chicago Press, 1994.

Moritz, William. "In the Abstract." *Absolut Panushka.* http://panushka.absolutvodka.com/panushka/history/storys/1970/abstract. Oct. 4, 2000.

——. "A Brief Survey of Experimental Animation." *Absolut Panushka.* http://panushka.absolutvodka.com/panushka/history/bill/. Oct. 4, 2000.

——. "Visual Music: Larry Cuba's Experimental Film." From *Mediagramm,* ZKM Karlsruhe (July 1996). http://www.well.com/user/cuba/Mediagramm.html. Oct. 4, 2000.

Morris, Meaghan. "Learning from Bruce Lee: Pedagogy and Political Correctness in Martial Arts Cinema." *Metro* 117 (1998): 6–15.

Morton, Henry. "The Magic Lantern as a Means of Demonstration." *Journal of the Franklin Institute of the State of Pennsylvania, for the Promotion of the Mechanic Arts* 53.1 (Jan. 1867): 55–58.

——. "The Magic Lantern as a Means of Demonstration." *Journal of the Franklin Institute of the State of Pennsylvania, for the Promotion of the Mechanic Arts* 53.3 (Mar. 1867): 200–203.

——. "The Magic Lantern as a Means of Demonstration." *Journal of the Franklin Institute of the State of Pennsylvania, for the Promotion of the Mechanic Arts* 53.4 (Apr. 1867): 280–82.

——. "The Magic Lantern as a Means of Demonstration." *Journal of the Franklin Institute of the State of Pennsylvania, for the Promotion of the Mechanic Arts* 53.5 (May 1867): 356–58.

——. "The Magic Lantern as a Means of Demonstration." *Journal of the Franklin Institute of the State of Pennsylvania, for the Promotion of the Mechanic Arts* 53.6 (June 1867): 413–14.

——. "The Magic Lantern as a Means of Demonstration." *Journal of the Franklin Institute of the State of Pennsylvania, for the Promotion of the Mechanic Arts* 53.6 (June 1867): 413–14.

——. "The Magic Lantern as a Means of Demonstration." *Journal of the Franklin Institute of the State of Pennsylvania, for the Promotion of the Mechanic Arts* 54.2 (Aug. 1867): 130–34.

——. "Electric Excitement." *Scientific American* 17.8 (Aug. 24, 1867): 117.

——. "The Magic Lantern as a Means of Demonstration." *Journal of the Franklin Institute of the State of Pennsylvania, for the Promotion of the Mechanic Arts* 54.2 (Sept. 1867): 206–208.

——. "The Magic Lantern as a Means of Demonstration." *Journal of the Franklin Institute of the State of Pennsylvania, for the Promotion of the Mechanic Arts* 54.4 (Oct. 1867): 278–81.

——. "The Magic Lantern as a Means of Demonstration." *Journal of the Franklin Institute of the State of Pennsylvania, for the Promotion of the Mechanic Arts* 54.5 (Nov. 1867): 339–42.

——. "The Magic Lantern as a Means of Demonstration." *Journal of the Franklin Institute of the State of Pennsylvania, for the Promotion of the Mechanic Arts* 54.6 (Dec. 1867): 361–63.

——. "The Magic Lantern as a Means of Demonstration." *Journal of the Franklin Institute of the State of Pennsylvania, for the Promotion of the Mechanic Arts* 54.1 (Jan. 1868): 62–66.

——. "The Magic Lantern as a Means of Demonstration." *Journal of the Franklin Institute of the State of Pennsylvania, for the Promotion of the Mechanic Arts* 54.3 (Mar. 1868): 206–208.

——. "The Magic Lantern as a Means of Demonstration." *Journal of the Franklin Institute of the State of Pennsylvania, for the Promotion of the Mechanic Arts* 55.4 (Apr. 1868): 277–78.

——. "The Magic Lantern as a Means of Demonstration." *Journal of the Franklin Institute of the State of Pennsylvania, for the Promotion of the Mechanic Arts* 55.5 (May 1868): 345–47.

——. "The Magic Lantern as a Means of Demonstration." *Journal of the Franklin Institute of the State of Pennsylvania, for the Promotion of the Mechanic Arts* 54.6 (June 1868): 420–22.

——. "The Magic Lantern as a Means of Demonstration." *Scientific American* 29.11 (Sept. 13, 1873): 163–64.

Morus, Iwan Rhys. *Frankenstein's Children: Electricity, Exhibition, and Experiment in Early-Nineteenth-Century London.* Princeton, N.J.: Princeton University Press, 1998.

Moskowitz, Sam. "The Origins of Science Fiction Fandom: A Reconstruction." In Joe Sanders, ed., *Science Fiction Fandom,* 17–33. Westport, Conn.: Greenwood, 1994.

Murphy, John W., Algis Mickunas, and Joseph J Pilotta, eds. *The Underside of High-Tech: Technology and the Deformation of Human Sensibilities.* New York: Greenwood, 1986.

Murray, Timothy. *Like a Film: Ideological Fantasy on Screen, Camera, and Canvas.* London and New York: Routledge, 1993.

——. "Digital Incompossibility: Cruising the Aesthetic Haze of the New Media (Part 1)." *CTheory, Technology and Culture* 23.1–2, Article 77. http://www.tao.ca/fire/ ctheory/0110.html. Oct. 4, 2000.

——. "Digital Incompossibility: Cruising the Aesthetic Haze of the New Media (Part 2)." *CTheory, Technology and Culture* 23.1–2, Article 77. http://www.tao.ca/fire/ ctheory/0111.html. Oct. 4, 2000.

Musser, Charles. *Before the Nickelodeon: Edwin S. Porter and the Edison Manufacturing Company.* Berkeley, Los Angeles, Oxford: University of California Press, 1991.

Myers, David. "Chris Crawford and Computer Game Aesthetics." *Journal of Popular Culture* 2 (fall 1990): 17–33.

Myerson, Jeremy. "Tornadoes, T-squares and Technology: Can Computing Be a Craft?" In Peter Dormer, ed., *The Culture of Craft*, 176–86. Manchester and New York: Manchester University Press, 1997.

Nagle, Manfred. "The Science-Fiction Film in Historical Perspective." *Science-Fiction Studies* 10 (1983): 262–77.

Ndalianis, Angela. "Special Effects, Morphing Magic, and the Nineties' Cinema of Attractions." In Vivian Sobchack, ed., *Meta-Morphing: Visual Transformations of the Culture of Quick-Change*, 251–71. Minneapolis: Minnesota University Press, 2000.

——. " 'The Rules of the Game'—Evil Dead II . . . Meet Thy Doom." In Henry Jenkins, Tara McPherson, and Jane Shattuc, eds., *Hop on Pop: The Politics and Pleasures of Popular Culture.* Durham, N.C.: Duke University Press, forthcoming.

Neale, Steve. *Cinema and Technology: Image, Sound, Colour.* London: BFI, 1985.

——. "Questions of Genre." *Screen* 31.1 (spring 1990): 45–66.

Neale, Steve and Murray Smith, eds. *Contemporary Hollywood Cinema.* London and New York: Routledge, 1998.

Negroponte, Nicholas. *Being Digital.* Sydney: Hodder and Stoughton, 1995.

Nelson, Cary and Dilip Parameshwar Gaonkar, eds. *Disciplinarity and Dissent in Cultural Studies.* New York and London: Routledge, 1996.

Newman, Bruce. "Computers Now, Apocalypse Coming Right Up." First published in *New York Times*, June, 30, 1996. Ufomind Bookstore. http://www.ufomind.com/area51/events/highway_bill/id4/articles/nyt_960630html. Oct. 4, 2000.

Norris, Christopher. *Uncritical Theory: Postmodernism, Intellectuals, and the Gulf War.* Amherst: University of Massachusetts Press, 1992.

Ohanian, Thomas A. and Michael E. Phillips. *Digital Filmmaking: The Changing Art and Craft of Making Motion Pictures.* Boston, Oxford, Johannesburg, Melbourne, New Delhi, Singapore: Focal, 1996.

O'Quinn, Kerry. "The Future Life Philosophy: Part I, 'The Overall Theme.' " *Future* 26 (May 1981): 4.

——. "The Future Life Philosophy: Part II, 'Free Enterprise.' " *Future* 27 (June–July 1981): 4.

——. "The Future Life Philosophy: Part III, 'Individual Liberty.' " *Future* 28 (Aug. 1981): 4.

——. "The Future Life Philosophy: Part IV, 'Scientific Progress." *Future* 29 (Sept. 1981): 4.

O'Regan, Tom and Rama Venkatasawmy. "Only One Day at the Beach: *Dark City* and Australian Film-making." *Metro* 117 (1998): 17–28.

O'Steen, Kathleen. "Arms Makers Lay Down Swords for Showbiz." *Variety*, Sept. 19–25, 1994, 15, 20.

Owen, Alex. *The Darkened Room: Women, Power, and Spiritualism in Late Victorian England*. Philadelphia: University of Pennsylvania Press, 1990.

Parisi, Paula. "The New Hollywood Silicon Stars." *Wired* 3.12 (Dec. 1995): 142–45. 202–10.

——. "Cameron Angle." *Wired* 4.4 (Apr. 1996): 130–35, 175–79.

——. "Shot by an Outlaw." *Wired* 4.9 (Sept. 1996): 136–41, 200–206.

Patton, W. P. "The Davenport Tricks." *Scientific American* 26.6 (Feb. 3, 1872): 84.

Penley, Constance. *The Future of an Illusion: Film, Feminism, and Psychoanalysis*. London: Routledge, 1989.

——. "Brownian Motion: Women, Tactics, and Technology." In Constance Penley and Andrew Ross, eds., *Technoculture*, 135–61. Cultural Politics, vol. 3. Minneapolis and Oxford: University of Minnesota Press, 1991.

——. "Feminism, Psychoanalysis, and the Study of Popular Culture." In Lawrence Grossberg, Cary Nelson, and Paula A. Treichler, with Linda Baughman and assistance from John MacGregor Wise, eds. (with intro.), *Cultural Studies*, 479–500. New York and London: Routledge, 1992.

——. *NASA/Trek: Popular Science and Sex in America*. London and New York: Verso, 1997.

Penley, Constance and Andrew Ross, eds. *Technoculture*. Cultural Politics, vol. 3. Minneapolis and Oxford: University of Minnesota Press, 1991.

Penny, Simon. "Consumer Culture and the Technological Imperative: The Artist in Dataspace." In Simon Penny, ed., *Critical Issues in Electronic Media*, 47–74. New York: State University of New York Press, 1995.

——, ed. *Critical Issues in Electronic Media*. New York: State University of New York Press, 1995.

Pepper, John Henry. *The Boy's Playbook of Science: including the various manipulations, arrangements of chemical and philosophical apparatus required for the successful performance of scientific experiments, in illustration of the elementary branches of chemistry and natural philosophy*. London and New York: Routledge, Warne, and Routledge, 1860.

———. *Scientific amusements for young people comprising chemistry, crystallization, coloured fires, curious experiments, optics, camera obscura, microscope, kaleidoscope, magic lantern, electricity, galvanism, magnetism, aerostation, arithmetic, etc.* London and New York: Routledge, Warne, and Routledge, 1861.

———. *The True History of the Ghost; and all about Metempsychosis.* London, Paris, New York, and Melbourne: Cassell, 1890.

Persons, Dan. "Starship Troopers: Sony Imageworks, Taking the Troopers to Outer Space." *Cinefantastique* 28.8 (Dec. 1997): 24–25, 60.

Pinchbeck, Daniel. "State of the Art." *Wired* 2.12 (Dec. 1994): 156–58, 206–208.

Porta, John Baptista. *Natural Magick.* Edited by Derek J. Price. New York: Basic, 1957.

Price, Kenneth M. and Susan Belasco Smith, eds. *Periodical Literature in Nineteenth-Century America.* Charlottesville: University Press of Virginia, 1995.

Prince, Stephen. "True Lies: Perceptual Realism, Digital Images, and Film Theory." *Film Quarterly* 49.3 (spring 1996): 27–36.

Prindle, David F. *Risky Business: The Political Economy of Hollywood.* Boulder, Colo., San Francisco, and Oxford: Westview, 1993.

Reed, David. *The Popular Magazine in Britain and the United States, 1880–1960.* Toronto and Buffalo: University of Toronto Press, 1997.

Reingold, Nathan. *Science in America Since 1820.* New York: Science History, 1976.

———. *Science, American Style.* New Brunswick and London: Rutgers University Press, 1991.

Rheingold, Howard. *Virtual Reality.* London: Mandarin, 1991.

Robertson, Barbara. "Studios on the Cutting Edge." *Computer Graphics World* (July 1994): 31–48.

Robins, Kevin. "The Virtual Unconscious in Post-Photography." *Science as Culture* 3.14 (1992): 99–115.

Rock, Howard B. " 'All Her Sons Join as One Social Bond': New York City's Artisanal Societies in the Early Republic." In Howard B. Rock, Paul A. Gilje, and Robert Asher, eds., *American Artizans: Craft and Social Identity, 1750–1850,* 155–75. Baltimore: John Hopkins University Press, 1995.

Rodowick, D. N. *The Crisis of Political Modernism: Criticism and Ideology in Contemporary Film Theory.* Urbana: University of Illinois Press, 1989.

Rojek, Chris and Bryan S. Turner, eds. *Forget Baudrillard?* London and New York: Routledge, 1993.

Rosenberg, Scott. "*Wired* Unbound." *Salon.* Media Circus. http://www.salon1999. com/media/media961002.html. Oct. 4, 2000.

Ross, Andrew. *No Respect: Intellectuals and Popular Culture.* New York and London: Routledge, 1989.

———. *Strange Weather: Culture, Science and Technology in the Age of Limits.* London and New York: Verso, 1991.

———. "Introduction: Science Wars." *Social Text* 46–47, vol. 14, nos. 1 and 2 (spring/ summer 1996): 1–13.

Rossell, Deac. *Living Pictures: The Origins of the Movies.* Albany: State University of New York Press, 1998.

Rossney, Robert. "Metaworlds." *Wired* 4.6 (June 1996): 140–46.

Routledge, Robert. *A Popular History of Science.* 2d ed. London: George Routledge and Sons, 1891.

Rowley, Sue, ed. *Craft and Contemporary Theory.* St. Leonards, N.S.W.: Allen and Unwin, 1997.

Rubin, Steve. "Retrospect: The Day the Earth Stood Still." *Cinefantastique* 4.4 (1976): 5.

Russ, Joanna. "SF and Technology as Mystification." *Science-Fiction Studies* 5, pt. 3 (Nov. 1978): 250–60.

Ryfle, Steve. "A Tale of Two Godzillas." *Cinefantastique* 30.2 (June 1998): 13, 61.

Salatino, Kevin. *Incendiary Art: The Representation of Fireworks in Early Modern Europe.* Collections of the Getty Research Institute for the History of Art and the Humanities, 3. Los Angeles: Getty Research Institute for the History of Art and the Humanities, 1997.

Sassen, Saskia. *The Global City: New York, London, Tokyo.* Princeton, N.J.: Princeton University Press, 1991.

Scanlon, Paul. "The Force Behind George Lucas." *Rolling Stone* 246 (Aug. 25, 1977): 28–36, 38–39.

Schiller, Herbert I. "Media, Technology, and the Market: The Interacting Dynamic." In Gretchen Bender and Timothy Druckrey, eds., *Culture on the Brink: Ideologies of Technology,* 47–74. Seattle: Bay, 1994.

Schwartz, Les. "The Golden Voyage of Sinbad." *Photon* 25 (1974): 11–14.

Scot, Reginald. *The Discoverie of Witchcraft.* Intro. Montague Summers. New York: Dover, 1972.

Scranton, Philip. "Determinism and Indeterminacy in the History of Technology." In Merritt Roe Smith and Leo Marx, eds., *Does Technology Drive History? The Dilemma of Technological Determinism,* 143–68. Cambridge: MIT Press, 1994.

Seaman, William R. "Active Audience Theory: Pointless Populism." *Media, Culture, and Society* 14 (1992): 301–11.

Segal, Howard P. *Technological Utopianism in American Culture.* Chicago and London: University of Chicago Press, 1985.

Segrave, Kerry. *American Films Abroad: Hollywood's Domination of the World's Movie Screens.* Jefferson, N.C., and London: McFarland, 1997.

Shapin, Steven. *The Scientific Revolution.* London and Chicago: University of Chicago Press, 1996.

———. "Rarely Pure and Never Simple: Talking about Truth." *Configurations* 7.1 (1999): 1–14.

Shay, Don. "Thirty Minutes with the Godfather of Digital Cinema." *Cinefex: The Journal of Cinematic Illusions* 65 (Mar. 1996): 58–67.

——. "Dennis Muren: Playing it Unsafe." *Cinefex: The Journal of Cinematic Illusions* 65 (Mar. 1996): 98–111.

Sheets-Pyenson, Susan. "Popular Science Periodicals in Paris and London: The Emergence of a Low Scientific Culture, 1820–1875." *Annals of Science* 42 (1985): 549–572.

Sheff, David. *Game Over: Nintendo's Battle to Dominate an Industry.* London, Sydney, and Auckland: Hodder and Stoughton, 1993.

Shohat, Ella and Robert Stam. "From the Imperial Family to the Transnational Imaginary: Media Spectatorship in the Age of Globalization." In Rob Wilson and Wimal Dissanayake, eds., *Global/Local: Cultural Production and the Transnational Imaginary,* 145–70. Durham, N.C., and London: Duke University Press, 1996.

Silverstone, Roger. "Convergence Is a Dangerous Word." *Convergence: The Journal of Research Into New Media Technologies* 1.1 (spring 1995): 11–13.

Silverstone, Roger and Eric Hirsch, eds. *Consuming Technologies: Media and Information in Domestic Spaces.* London and New York: Routledge, 1992.

Sinclair, Bruce. *Philadelphia's Philosopher Mechanics: A History of the Franklin Institute, 1824–1865.* Baltimore and London: John Hopkins University Press, 1974.

Smith, Merritt Roe and Leo Marx, eds. *Does Technology Drive History? The Dilemma of Technological Determinism.* Cambridge: MIT Press, 1994.

Smith, Stephanie, A. "Morphing, Materialism, and the Marketing of *Xenogenesis.*" *Genders* 18 (winter 1993): 67–86.

Smith, Terry. *Making the Modern: Industry, Art, and Design in America.* Chicago: University of Chicago Press, 1993.

——. "Craft, Modernity and Postmodernity." In Sue Rowley, ed., *Craft and Contemporary Theory,* 18–28. St. Leonards, N.S.W.: Allen and Unwin, 1997.

Snider, Burr. "The *Toy Story* Story." *Wired* 3.12 (Dec. 1995): 146–50, 212–16.

Sobchack, Vivian Carol. *The Limits of Infinity: The American Science Fiction Film, 1950–75.* South Brunswick, N.J., and New York: Barnes; London: Yoseloff, 1980.

——. *Screening Space: The American Science Fiction Film.* New York: Ungar, 1987.

——. "Introduction: The 'Silent' Cinema." *Journal of Popular Film and Television* 15.3 (fall 1987): 101.

——. "The Scene of the Screen: Envisioning Cinematic and Electronic Presence." In Hans Ulrich Gumbrecht and K. Ludwig Pfeiffer, eds., *Materialities of Communication,* 83–106. Stanford, Calif.: Stanford University Press, 1994.

——. " 'At the Still Point of the Turning World': Meta-Morphing and Meta-Stasis." In Vivian Sobchack, ed., *Meta-Morphing: Visual Transformation and the Culture of Quick-Change,* 131–58. Minneapolis and London: University of Minnesota Press, 2000.

——, ed. *Meta-Morphing: Visual Transformation and the Culture of Quick-Change.* Minneapolis and London: University of Minnesota Press, 2000.

Soloman, Matthew. " 'Twenty-Five Heads Under One Hat': Quick-Change in the 1890s." In Vivian Sobchack, ed., *Meta-Morphing: Visual Transformation and the Culture of Quick-Change,* 3–20. Minneapolis and London: University of Minnesota Press, 2000.

Sontag, Susan. "The Imagination of Disaster." In Ralph J Amelio, ed., *Hal in the Classroom: Science Fiction Films,* 22–38. Dayton, Ohio: Pflaum, 1974.

Speaight, George. "Professor Pepper's Ghost." *Theatre Notebook* 43.1 (1989): 16–24.

Spielmann, Yvonne. "Expanding Film into Digital Media." *Screen* 40.2 (summer 1999): 131–45.

Springer, Claudia. *Electronic Eros: Bodies and Desire in the Postindustrial Age.* Austin: University of Texas Press, 1996.

Spufford, Francis and Jenny Uglow, eds. *Cultural Babbage: Technology, Time and Invention.* London and Boston: Faber and Faber, 1996.

Stafford, Barbara Maria. *Artful Science: Enlightenment, Entertainment, and the Eclipse of Visual Education.* Cambridge and London: MIT Press, 1994.

Starrs, Josephine and Leon Cmielewski. "Teaching New Media: Aiming at a Moving Target." *Real/Time* 38 (Aug.–Sept. 2000): 8.

Staudenmaier, John. *Technology's Storytellers: Reweaving the Human Fabric.* Cambridge: MIT Press; London: Society for the History of Technology, 1985.

Stern, Michael. "Making Culture Into Nature; or, Who Put the 'Special' into 'Special Effects'?" *Science-Fiction Studies* 7 (1980): 263–77.

Stewart, Garrett. "The 'Videology' of Science Fiction." In George S. Slusser and Eric S. Rabkin, eds., *Shadows of the Magic Lamp: Fantasy and Science Fiction in Film,* 159–207. Carbondale and Edwardsville: Southern Illinois University Press, 1985.

Stone, Allucquère Rosanne. *The War of Desire and Technology at the Close of the Mechanical Age.* Cambridge and London: MIT Press, 1995.

Studlar, Gaylyn. "The Perils of Pleasure? Fan Magazine Discourse as Women's Commodified Culture in the 1920s." In Linda Williams, ed., *Viewing Positions: Ways of Seeing Film,* 263–97. New Brunswick, N.J.: Rutgers University Press, 1994.

Swain, Bob. "Pixel Tricks Enrich Flicks." *New Scientist* 133.1841 (Oct. 3, 1992): 23–27.

Swartz, Mark E. "An Overview of Cinema on the Fairgrounds." *Journal of Popular Film and Television* 15.3 (fall 1987): 102–109.

Szebin, Frederick C. and Steve Biodrowski. "*Mars Attacks*: Tim Burton Sends Up the Bubblegum Alien Invader Genre." *Cinefantastique* 28.7 (Jan. 1997): 16–18.

Tasker, Yvonne. *Spectacular Bodies: Gender, Genre and the Action Cinema.* London and New York: Routledge, 1993.

Telotte, J. P. "The Tremulous Public Body." *Journal of Popular Film and Television* 19.1 (spring 1991): 14–23.

Thompson, Gary. "Lost the Plot." *Weekend Australian*, Aug. 15–16, 1998, IT, 11.

Thompson, Kristin. "Implications of the Cel Animation Technique." In Stephen Heath and Teresa de Lauretis, eds., *The Cinematic Apparatus*, 106–20. London and Basingstoke: Macmillan, 1980.

Tofts, Darren. "Troy Story." *World Art* 12 (1997): 29–33.

Tsivian, Yuri. *Early Cinema in Russia and Its Cultural Reception*. Trans. Alan Bodger. Fwd. Tom Gunning. Edited by Richard Taylor. Chicago and London: University of Chicago Press, 1994.

Tulloch, John and Henry Jenkins. *Science Fiction Audiences: Watching Doctor Who and Star Trek*. London and New York: Routledge, 1995.

Turner, Graeme. " 'Look Mum, No Hands': The Trivial Pursuit of Textual Analysis." *Cultural Studies* 6. (1992): 503–505.

Tyndall, John. *Six Lectures on Light Delivered in America in 1872–1873*. London: Longmans, Green, 1873.

Varney, J. E. "Robertson's Phantasmagoria in Madrid, 1821 (Part I)." *Theatre Notebook* 9 (1954–1955): 89–95.

Vaz, Mark Cotta, and Patricia Rose Duignan. *Industrial Light and Magic: Into the Digital Realm*. New York: Ballantine, Del Rey, 1996.

Vebber, Dan and Dana Gould. "Fifty Reasons Why *Jedi* Sucks." *Sci-Fi Universe* 3.5 (Feb. 1997): 18–31.

Vernal, David. "War and Peace in Japanese Science Fiction Animation: An Examination of Mobile Suit Gundam and the Mobile Police Patlabor." *Animation Journal* (fall 1995): 56–83.

Virilio, Paul. *War and Cinema: The Logistics of Perception*. Trans. Patrick Camiller. London and New York: Verso, 1989.

——. *The Vision Machine*. Trans. Julie Rose. Bloomington and Indianapolis: Indiana University Press; London: BFI, 1994.

Vogel, Harold L. *Entertainment Industry Economics: A Guide for Financial Analysis*. Cambridge: Cambridge University Press, 1990.

Wark, McKenzie. "Lost in Space: Into the Digital Image Labyrinth." *Continuum: The Australian Journal of Media and Culture* 7.1 (1993): 140–60.

——. *Virtual Geography: Living with Global Media Events*. Bloomington and Indianapolis: Indiana University Press, 1994.

——. "Cyberhype." *World Art*, inaugural U.S. ed. (Nov. 1994): 64–69.

Warren, Bill. "The Valley of Gwangi." *Photon* 18 (1969): 15–17.

Wasko, Janet. *Hollywood in the Information Age: Beyond the Silver Screen*. Cambridge and Oxford: Polity, 1994.

Webster, Frank. *Theories of the Information Society*. London and New York: Routledge, 1995.

Weiner, Rex. "Digital (R)evolution Hits the Cutting Edge of Film." *Variety*, June 27–July 3, 1994, 11, 26.

White, Keith. "The Killer App: *Wired* Magazine, Voice of the Corporate Revolution." http://www.base.com/gordoni/thoughts/wired/revolution.html. Oct. 4, 2000.

Whitney, John. "Computation Periodics." In Ruth Leavitt, ed., *Artist and Computer*, 80. New York: Harmony, 1976.

Williams, Christopher, ed. *Cinema: The Beginnings and the Future. Essays Marking the Centenary of the First Film Show Projected to a Paying Audience.* London: University of Westminster Press, 1996.

——. *Realism and the Cinema: A Reader.* London and Henley: Routledge and Kegan Paul, 1980.

Williams, David E. "Worlds at War." *American Cinematographer* 77.7 (July 1996): 32.

Williams, Raymond. *Towards 2000.* London: Chatto and Windus, 1983.

Wilson, Garff B. *Three Hundred Years of American Drama and Theatre.* Englewood Cliffs, N.J.: Prentice-Hall, 1973.

Wilton, H. B. *The Somatic Conjuror: A Treatise on Natural and Scientific Magic, Including the Latest Novelties.* Melbourne: Clauscen, Massinia, 1870.

Wolf, Mark. "Stop Frame: The History and Technique of Fantasy Film Animation." *Cinefantastique* 1.2 (winter 1971): 6–21.

——. "Sinbad and the Eye of the Tiger: The Special Visual Effects." *Cinefantastique* 6.2 (1977): 40–46.

Wolf, Mark J. P. "Inventing Space: Toward a Taxonomy of On- and Off-Screen Space in Video Games." *Film Quarterly* 51.1 (fall 1997): 11–23.

——. "A Brief History of Morphing." In Vivian Sobchack, ed., *Meta-Morphing: Visual Transformation and the Culture of Quick-Change*, 83–101. Minneapolis and London: University of Minnesota Press, 2000.

Wollen, Tana. "The Bigger the Better: From Cinemascope to IMAX." In Philip Hayward and Tana Wollen, eds., *Future Visions: New Technologies of the Screen*, 10–30. London: BFI, 1993.

Woolley, Benjamin. *Virtual Worlds: A Journey in Hype and Hyperreality.* Oxford and Cambridge, Mass.: Blackwell, 1992.

Wyatt, Justin. *High Concept: Movies and Marketing in Hollywood.* Austin: University of Texas Press, 1994.

Yoshimoto, Mitsushiro. "Real Virtuality." In Rob Wilson and Wimal Dissanayake, eds., *Global/Local: Cultural Production and the Transnational Imaginary*, 107–18. Durham, N.C., and London: Duke University Press, 1996.

Youmans, E. L. "Scientific Lectures." *Popular Science Monthly* 9.9 (Dec. 1873): 242.

Youngblood, Gene. *Expanded Cinema.* Intro. R. Buckminster Fuller. New York: Dutton, 1970.

Zimmerman, Patricia. *Reel Families: A Social History of Amateur Film.* Bloomington and Indianapolis: Indiana University Press, 1995.

INDEX